MUSEUM|CULTURE

Histories

Discourses

Spectacles

Daniel J.
Sherman
and
Irit
Rogoff
editors

London

Published by the University of Minnesota Press
2037 University Avenue Southeast, Minneapolis, MN 55455-3092
Printed in the United States of America on acid-free paper

Simultaneously published in the United Kingdom
by Routledge
11 New Fetter Lane, London EC4P 4EE

British Library Cataloguing in Publication Data

A catalogue record for this book is available from the British Library

ISBN 0-415-09273-6 (hbk)
ISBN 0-415-09274-4 (pbk)

MuseumCulture

Contents

Acknowledgments

This book grew out of a conference, "The Institutions of Culture: The Museum," held at the Center for European Studies at Harvard University in March 1988. We are grateful for the encouragement and assistance of the center's chairman, Stanley Hoffmann, its assistant director, Abby Collins, and its staff members, especially Ceallaigh Reddy, JoAn Beaton, Jacqueline Brown, Ana Popiel, and John Andrus. We would like to thank the Ford Motor Company Fund and the Samuel H. Kress Foundation for supporting the conference and for allowing us to use surplus funds for translations and other expenses connected with bringing the volume to press. Our thanks also to the chairs and discussants at the conference, Carol Duncan, Peter Paret, Danielle Rice, Alan Shestack, and Paul Hayes Tucker; to its keynote speaker, Hans Haacke; and to Edward Kaufman and Patricia Mainardi, whose contributions could not be included in this volume. The heated debates generated by the conference spurred us on in our belief that this was a field that we were compelled to explore further.

Five years in preparation, this book differs considerably from the conference program. While our work on the project has been a rich and wide-ranging exploration, the result is intended only as a mapping out of a field still in formation, rather than as the summary of a concluded investigation. We would like to thank all of our collaborators on this volume, as well as the students in our seminars, for expanding our perception of this field of inquiry and for sustaining our sense of its energy and contemporaneity.

We very much appreciate the willingness of the original conference participants to rework their papers for publication; special thanks to Chantal Georgel and Dominique Poulot, who, in addition to the editors, wrote entirely new essays for the volume. Our gratitude also goes to Ariella Azoulay, Walter Grasskamp, and Boris Groys, who, joining the

project after the conference, kindly agreed to contribute their insights to the book; to our translators, Elliott A. Green, Marc Roudebush, Thomas Seifrid, and Michael Shae; and to Janet Wolff, for her helpful suggestions. The support and assistance of Lisa Freeman, Janaki Bakhle, and Robert Mosimann of the University of Minnesota Press was invaluable. Daniel Sherman would like to thank Allene Biehle, for her efficient management of the publication fund at Rice, and Edward Douglas, for his support of many kinds. Our final thanks must go to each other, for putting up with each other's habits, quirks, and temperaments; both our friendship and, we hope, this book are richer for our peculiar but fruitful collaboration.

Introduction: Frameworks for Critical Analysis

Daniel J. Sherman and Irit Rogoff

The past generation has seen both an unparalleled increase in the number of museums throughout the world and an unprecedented expansion and diversification of their activities. As a natural consequence, museums have become the object of considerable, and constantly increasing, attention both in the mass media and in scholarly and critical writing. But most of these considerations have remained within the boundaries of particular disciplinary concerns: they have looked at museums as sites, whether of architecture, of exhibitions, of national or cultural narratives, or of political and pedagogical projects aimed at different constituencies.[1] This collection of essays, in contrast, focuses on museums as the intricate amalgam of historical structures and narratives, practices and strategies of display, and the concerns and imperatives of various governing ideologies. We seek to formulate terms and questions that can be applied both to exhibited culture, what museums and others put on display, and to exhibition culture, the ideas, values, and symbols that pervade and shape the practice of exhibiting. In asking how museums accord objects particular significances, in examining the politics of museum exhibitions and display strategies, and in comparing policies and attitudes toward museum publics over time, we are attempting an inquiry into modes of cultural construction from an innovative and increasingly important vantage point.

Clearly, the interrogation of museum practice cannot be separated from the larger terrains of cultural history, theory, and criticism. But the essays in this volume cohere around the reformulation of these discourses in terms specific to museums. We do not, of course, claim credit for this reformulation, which is the product of a critical intervention as old as the developments that prompted it. Over the past twenty years a broad range of critical analyses have converged on the museum, unmasking the

structures, rituals, and procedures by which the relations between objects, bodies of knowledge, and processes of ideological persuasion are enacted. This process of unmasking, which continues to evolve and unfold around us, provides the basis for our inquiry.

For what characterizes the present moment is not only the unparalleled expansion of museum activity but also the growing awareness of the persistent critical discourse that has accompanied it since the time of the French Revolution. This discourse has itself taken part in, and been informed by, the elaboration of other critical discourses of cultural value, epistemic structures, and modes of representation. This book, then, joins the recently initiated charting of both a historical and a contemporary "museum discourse" in terms of its connections to other significant cultural discourses. By focusing on a number of institutional cases and a series of important texts, we seek both to interrogate concrete histories through concepts of knowledge, representation, fiction, consciousness, and desire and to reinscribe such histories in those concepts.

Museums' multiple histories lie in the evolving interplay between the basic notions of collecting, classifying, displaying, and, on the part of the public, receiving that underlie their institutional practices. All of the essays in the book share the conviction not only that museums have a history, but also that their enterprise entails an attempt to conceal it, "to transform," in Daniel Buren's terms, "History into Nature."[2] Recovering the history of the museum, which is not the same as the histories of individual institutions but can be regarded as their ultimate objective, one shared by our contributors, consequently involves a certain amount of deconstruction. This book accordingly offers not simply a collection of narrative accounts but also a collective critique of the materials and strategies museums employ to naturalize the concreteness of the social and historical processes in which they participate. In this light, the concept of the museum emerges as a field of interplay between the social histories of collecting, classifying, displaying, entertaining, and legitimating.

Museums embody a number of fundamental notions or concepts, which together constitute the basis of an institutional practice or politics. Although it is possible to theorize these notions in a variety of ways, recent critical and historical work on the museum has delineated four broad groups that arguably encompass museums' most important relationships. First, museums invariably base their enterprise on a certain notion of objects and on a system for classifying them. Classification functions through the imposition of order and meaning on objects and through the

positing of objects as triggers of ideas. Although museums seek to characterize their classification as somehow inherent in the objects they present, it always takes place, at least in the first instance, within some externally constructed discursive field, such as the "nation," the local "community," "culture" as opposed to some aspect of the "natural world," a historical "epoch" or "period," or the categories of "artistic school" or "style." This is the second set of concepts that museums institutionalize: the context, usually constructed as some kind of community (of people or of values), that objects are held to signify. The museum, by representing it, of course participates in the construction of this notion, and in the historical shifts it undergoes. It does so in the name of a third concept, that of the public or audience it claims to serve, and in terms of whom it defines the public sphere in which it operates. The way in which the audience or public receives the displays and meanings that are offered in turn constitutes a fourth pole of museums' discourse and practice.

The functions of categorization and classification, as Ludmilla Jordanova has argued, are indelibly interconnected. Classification functions at various levels: first, the entire institution may be placed in a category such as natural history, fine arts, design, or historical re-creation (theme parks). Within, the museum may be organized around internal groupings such as periods, schools, styles, or national cultures. Finally, at the level of individual objects, labels, catalogs, and other ancillary materials offer a "context" in which an object can be read, thus investing it with authenticity, authorship, antiquity, and value.[3] The museum, in other words, while seemingly representing objectively and empirically located contexts for the objects it displays, actually participates in the construction of these categories and in the numerous internal shifts and differentiations they are held to contain. Equally, museums contribute to and perpetuate the dividing practices of historical periodization, providing centennial categories with the cultural cohesion of dominant styles.

This critical analysis owes much to the early work of Michel Foucault, who used a linguistic model to thematize the relations between epistemic structures, disciplinary boundaries, the construction of internally coherent discourses, and the play of power relations.[4] This model illuminates the ways museums both sustain and construct cultural master narratives that achieve an internal unity by imposing one cultural tendency as the most prominent manifestation of any historical period. Thus the classification of an object involves the choice of a particular kind of presentation, which then establishes a museological context that provides the ob-

ject with meaning. At the same time, the context works to determine the selection of viewing public and the cultural capital that this public gleans from the museum.

The museological context, in other words, exists within a larger signifying process that invokes notions of community. This may be a transhistorical community of art lovers, a local community that has formed the collection, a national community that the objects represent, a politically aspirant community that seeks alternative forms of representation and alternative identities, or some combination of all four. But by presenting objects as signifiers within an artificially created institutional frame, museums underline their irretrievable otherness, their separation from the world of lived experience. In so doing, museums simultaneously construct a self, the viewer, or in collective terms a public. The processes of reception of the display strategies that museums present also participate in the constitution of a museum culture.

All of the museum's strategies of display involve assumptions, often unacknowledged, about the community the museum is addressing, which is not necessarily (and indeed not usually) coterminous with the community it is representing. The former is conventionally labeled a "public," in Thomas Crow's sense of a "representation of the *significant totality*" of a potential audience that "appears via the claims made to represent it."[5] But the very notion of a public, the subject of several essays in this volume, itself often conceals important contradictions. As Vera Zolberg's essay in this volume makes clear, museums have typically represented the public as a constituency to whom they provide some kind of education. Yet the historical dichotomy between art, which is associated with pleasure, and artifact, connoting instruction, has made it difficult for museums to sustain this definition, which also constitutes one of their fundamental self-justifications.

The structuring components of museums and the museum discourse have until this point involved supposedly objective and verifiable elements. With the public, however, questions of subjectivity, and notably of the ways in which audiences' varying receptions of museum displays gratify particular subjective desires, enter into the discussion. As several of the essays in this volume argue, museums can serve as a site for the construction of fictitious histories that respond to unconscious desires. Simultaneously, as Theodor Adorno realized in using the term "museal" to describe objects to which the viewer no longer has a vital relationship and that consequently are dying, strategies of display can make museums the funerary site for uncomfortable or inconvenient historical narratives,

what Denis Adams refers to as "the architecture of amnesia."[6] In Germany, as the essays by Detlef Hoffmann, Walter Grasskamp, and Irit Rogoff suggest, these desires have taken a number of forms. Hoffmann describes the pursuit of an elusive collective and national identity, Grasskamp a longing for membership in a broader, largely depoliticized culture classified under the rubric of modernism, Rogoff the need to transcend or bypass inconvenient histories.

The signifying processes through which museums endow objects with meaning also act, through such basic forms of social organization as gender, race, and class, to privilege and exclude certain kinds of viewing and thus to construct their audiences in historically specific ways as interpretative communities. It is important, for example, to distinguish between the display of other people's cultures and the consequent construction of their identities within a Western cultural discourse and the problematics of displaying cultural appropriation, such as "primitivism," within dominant cultural practices. For in such distinctions the contemporary political significance of the interplay between such categories as objects, contexts, and publics or interpretative communities can be discerned.

In addition, however, another level of interplay takes place within our conceptualization of this collection and its structure. For the book exists at the intersection between the aforementioned categories of analysis and the enveloping groupings of histories, discourses, and spectacles that contain them. We have refrained from constituting categories that in any way confine, define, or interpet the essays, precisely in order to point to the plurality of national cultural, individual, and group subject positions assembled here. The very organization of the volume thus serves to acknowledge that the questions raised—their historical formation, political urgency, and the fields of inquiry they form—differ in each case, and that this difference is of primary importance. Clearly, we who work within the critical analysis of culture have shared a certain intellectual formation. Many of us have benefited from the readings of several generations of Marxist and materialist analyses, from the application of linguistic models to the understanding of cultural and epistemic structures, and from the perception of difference and subjectivity offered by critical studies of gender and of colonialism. But these have been simply our building blocks, our points of entry into the discussion of displayed culture. Rather than confining or enclosing our discussions, the full range of our categories of analysis operates within and across a plurality of histories, theories, and discourses.

The four structuring concepts of object, context, public, and reception occupy a central place in much of the critical analytical apparatus that all the essays activate. Their centrality in turn makes these terms the inescapable basis for a book conceived as an interrogation of museums' histories and practices. While focusing on one or another of these themes, all the essays in this book share a consciousness of their interrelatedness. They are, however, broad and general categories, and we need to examine the actual practices that inform their internal functioning and the critical theories that have worked to make them apparent.

In addition to theories of classification inspired by Foucault, several other kinds of theoretical work have played an important part in the conceptualization of museums. Writers of the Frankfurt school used both Marxist and Hegelian thought to articulate a critique of museums as institutions and to theorize collecting as a cultural practice of broad significance. The early critical analysis of collecting, that of Adorno and Walter Benjamin, conceives of "collecting" as an activity that defies capital's insistence that the object be possessed by the collector, and that it serve some useful purpose. In a series of essays from the 1920s and 1930s, both argue for a certain "uselessness" of collected objects, which enables the countertype collector to unravel the secret historical meanings of the things accumulated. In the *Passagenwerk*, File H, Benjamin writes:

> In the act of collecting it is decisive that the object be dissociated from all of its original functions in order to enter into the closest possible relationship with its equivalents. This is the diametrical opposite of use, and stands under the curious category of completeness. What is this "completeness"? It is a grandiose attempt to transcend the totally irrational quality of a mere being-there through integration into a new, specifically created historical system—the collection. And for the true collector every single thing in this system becomes an encyclopedia of all knowledge of the age, of the landscape, the industry, the owner from which it derives. . . . Everything remembered and thought, everything conscious, now becomes the socle, the frame, the pedestal and the seal of his ownership. . . . Collecting is a form of practical memory and among the profane manifestations of "proximity" the most convincing one. Therefore, even the minutest act of political commemoration in the commerce in antiques becomes in a sense epochal. We are here reconstructing an alarm clock that awakens the kitsch of the past century into "re-collection."[7]

So the museum treats its objects independently of the material conditions of its own epoch, in what Adorno called "a culturally conservative practice that lacks a critique of political economy even though it speaks of

the accumulation of excessive and therefore unusable capital."[8] In Benjamin's collection, objects are "given their due," re-collected in accordance with the political perception of the moment. The difference is that, for Benjamin, "historicism presents an eternal image of the past, historical materialism a unique engagement with it. . . . The task of historical materialism is to set to work an engagement with history original to every new present. It has recourse to consciousness of the present that shatters the continuum of history."[9]

Another body of work has the distinction of joining artistic practice and theoretical critique. The interventions of artists such as Daniel Buren, Marcel Broodthaers, and Hans Haacke have, in Douglas Crimp's words, "worked to reveal the social and material conditions of art's production and reception–those conditions that it has been the museum's function to dissemble."[10] Haacke's notion of museums as "managers of consciousness" derives from Hans Magnus Enzensberger's 1960s concept of the "consciousness industry." This project has had two main tenets: first, to alert the viewing public to the ever-increasing complexity of the relations between corporate sponsorship, museums, and the national/ international political and economic policies that serve to frame them. Second, Haacke in particular has worked in great detail to expose the *forms* of museum exhibition and installations, from banners to frames, from labels and layouts to display cases and invitation cards, as active agents of ideological persuasion.[11]

Over the past decade, artists and critics concerned with exhibition culture have further refined this perspective through models of gender-specific analysis. The New York branch of the Guerrilla Girls, for example, has documented the continuing absence of women artists from both permanent collections and temporary exhibitions within mainstream American museum culture. The Canadian artist Vera Frenkel offers another example in her documentary project, accompanied by videos and performance activity, entitled "The Cornelia Lumsden Archive." Frenkel traces, through her veritable absence, the shadowy presence of a fictive twentieth-century woman writer; she does this by scrupulously emulating the archival modes that would have preserved her had she existed.[12] At the same time, feminist theory has begun to move beyond the issue of the absence of women from canonical displays of cultural production to inquire into the gendered nature of the very *categories* of periodization, style, and the authoritative status of the artifact that museums establish. Pursuing this line of investigation, Anne Higonnet's essay in this volume examines the gendering of display and marketing practices by museums

in the names of particular recuperative projects, while Irit Rogoff probes the hidden potential of reading the presentation of historical narratives in gendered modes of display.

All this work on museums makes clear that, just as certain core concepts lie at the heart of the museum's ideology, certain activities play a central role in giving that ideology shape. Daniel Buren has described these activities as collecting, preservation, and the provision of a refuge that is also a frame. Carol Duncan and Alan Wallach, in their ground-breaking work of the late 1970s, added to the notion of refuge that of ceremonial space, which invites, indeed impels, visitors to experience the visit as a ritual.[13] These activities remain fundamental to museums because they derive from the concatenation of political, social, and economic forces that have produced museums as public institutions since the eighteenth century.

The dynamics of these processes have emerged with theoretical clarity and historical precision in the new history of museums that followed on and paralleled Duncan and Wallach's analyses. Initially, much of this work, such as that of Édouard Pommier on France and Françoise Forster-Hahn on Germany, was concerned with elucidating the political stakes of the major national institutions, so carefully occluded by the triumphalist history produced around them.[14] In the United States, sociologists like Paul DiMaggio and Vera Zolberg, clearly influenced by the work of Pierre Bourdieu, played a key role in developing a critical history of museums.[15] Thus issues of aspiration to status and social mobility tended to dominate the pioneering scholarly studies of American museums, which, with the exception of Neil Harris's suggestive essays, were less concerned with the politics of display.[16] Recently, historians such as Annie Coombes, working on museums in Britain, and two of the contributors to this volume, Dominique Poulot and Daniel Sherman, working on France, have sought to merge these two levels of analysis so as to reconfigure the history of museums in terms of a broad understanding of cultural politics. Both in America and in Europe, they have argued, nation-states, emergent bourgeois elites, and wealthy individuals have used museums to legitimate their hegemony with the aura of culture. In the process these groups have endowed museums with considerable authority to define and to represent the cultural sphere.[17]

The new history of museums, which focuses largely, if not exclusively, on art museums, has been informed by a host of historical studies and critical interventions concerning a wide variety of institutions, including

historical museums, ethnographical and anthropological museums, and museums of natural history. Douglas Crimp, James Clifford, Hal Foster, Donna Haraway, Walter Grasskamp, and many others have dealt at length with the ideological underpinnings of collecting and display refracted through models of class, sexual, and cultural difference. Clifford, Foster, and Haraway have examined in particular the fate of "other" artifacts, notably tribal cultural artifacts.[18] Imported through the political economies of colonialism, constructed through pseudoscientific discourses as the irrational opposites of the post-Enlightenment legacy of Western humanism and its claim to "progress," such artifacts at present serve to legitimate modernist claims to have glimpsed the dark heart of a "primal urge" to create and express its own condition.

Beyond the residue of their historical investments, the strategies museums deploy have been, and remain, contingent and variable. The developing field of cultural studies, for example, has made it increasingly clear that culture operates through spectacle and through the ceaseless re production of mass-media practices. Blockbuster exhibitions and stylish and atmospheric depictions of the cultures of peoples such as the ancient Egyptian, the African, and the Native American function in tandem with consumer advertising to produce culture as spectacle so that spectacle can be marketed as a form of cultural legitimacy. The modern museum occupies a unique place within this process: it is the home and defining source of the phenomenon of the *original* while simultaneously generating its circulation in reproduced form as a part of commodity culture. Thus the museum functions as a central power in what Jean Baudrillard has termed "the transition from use value to a philosophy of wish fulfillment" through advertising practices.[19]

The sections into which we have divided the book are of course artificial; not only the central themes outlined here but also a number of common insights related to them link together the essays both within and across the three parts. Part I seeks to confront the multiplicity of the histories in which museums have participated. Detlef Hoffmann considers the relationship between the emergent and developing institution of the art museum and the problematic construction of German national identity in the nineteenth and twentieth centuries. The essays by Seth Koven, Vera Zolberg, and Dominique Poulot consider three very different attempts—in Victorian Britain, the United States since the nineteenth century, and contemporary France—to bridge the gap between the museum and its public. In all cases attempts at museological innovation have to deal with the inertia of museums' prior institutional investments,

whether in class-bound notions of cultural and political authority or in conservative constructions of cultural patrimony. Ariella Azoulay's examination of Israeli historical museums provides a fitting coda to this exploration by conjoining the problematics of the public, museological innovation, and national identity.

The essays in Part II all have to do in some way with the claims museums make about their enterprise, with the discursive and other strategies they employ in the process, or with the continuities and inflections of the museum discourse and its critiques. As Chantal Georgel argues in her essay, museums appropriate from other sites and activities such as exhibitions, department stores, and libraries habits of looking that also constitute power relationships. Georgel illuminates this phenomenon from the reverse angle of the discursive reappropriation of the museum by cognate institutions. Daniel Sherman's essay examines what might be called, following Benjamin, the prehistory of the critical discourse of museums, drawing parallels between the work of one of the earliest critics of museums, the French art theorist Quatremère de Quincy, and the later insights of Marx and Benjamin. The two remaining essays in Part II both examine the relations between museums and certain discourses that have used them for purposes of legitimation within particular national communities. Boris Groys considers the ways in which the museum displays of the Soviet Union reformulated modes of perception and classification in the service of Stalinist ideology. Walter Grasskamp's essay on Documenta examines the politics of the museological embrace of modernism in the Federal Republic of Germany.

Part III offers a number of instances in which strategies of cultural display embrace the technologies of spectacle, as Guy Debord has given us to understand the term. Frederick Bohrer's essay again represents a kind of prehistory of museum display as spectacle, examining one of its most prevalent forms, exoticism, at the moment of its transformation by the emergent popular press. The essays by Irit Rogoff and Anne Higonnet explore the ways in which categories of gender, themselves refracted through the practices of spectacle, take part in the construction of museum audiences through the manipulation of the desires and subjectivities of the varying groups that constitute their publics. Finally, Brian Wallis shows how, in the recent era of mass communication and global polarization, the act of exhibiting serves to legitimate particular constructions of national identity within the international arena.

This book does not simply mark the coming of age of museum studies as a discipline in its own right; that is, indeed, only another example of

the rapidly expanding influence of the institution. Nor does it simply fill an important need for cultural historians, art historians, and critics. We had, in conceiving our project, hoped for more than that, hoped that these essays would call attention to the museum's presence and power in the broadest conceivable configuration of contemporary culture. Given our perception of the centrality of the institution, the questions we raise, the problems we consider, and the strategies, even tentative ones, we propose have a significance, and an urgency, that go far beyond the museum; they are, we believe, essential to an understanding of our culture that is itself a prerequisite to changing it.

Notes

1. This is notably true of several recent anthologies concerning museums: Robert Lumley, ed., *The Museum Time-Machine* (London and New York, 1988); Peter Vergo, ed., *The New Museology* (London, 1989); Warren Leon and Roy Rosenzweig, eds., *History Museums in the United States: A Critical Assessment* (Urbana and Chicago, 1989); Ivan Karp and Steven Lavine, eds., *Exhibiting Cultures: The Poetics and Politics of Display* (Washington, D.C., 1991).

2. Buren, "Function of the Museum," *Artforum* 12, no. 1 (September 1973): p. 62.

3. Ludmilla Jordanova, "Objects of Knowledge: A Historical Perspective on Museums," in Vergo, ed., *The New Museology*.

4. See especially Foucault, *The Archaeology of Knowledge and the Discourse on Language*, trans. A. M. Sheridan Smith (New York, 1972).

5. Crow, *Painters and Public Life in Eighteenth-Century Paris* (New Haven, Conn., 1985), p. 5.

6. Adorno, "Valéry Proust Museum," in his *Prisms*, trans. Samuel and Sherry Weber (Cambridge, Mass., 1981), p. 175; *Denis Adams: The Architecture of Amnesia* is the title of a collection of Adams's projects up to the late 1980s (New York, 1990).

7. Translation from Douglas Crimp, "This Is Not a Museum of Art," in Marge Goldwater et al., *Marcel Broodthaers* (Minneapolis and New York, 1989), pp. 71-72.

8. Adorno, "Valéry Proust Museum," p. 176.

9. Benjamin, "Eduard Fuchs, Collector and Historian," in his *One-Way Street and Other Writings*, trans. Edmund Jephcott and Kingsley Shorter (London, 1979), p. 352.

10. "The Postmodern Museum," *Parachute*, no. 46 (March-May 1987): p. 62.

11. Hans Haacke, *Unfinished Business* (Cambridge, Mass., and New York, 1987).

12. Vera Frenkel, "The Cornelia Lumsden Archive," in *Museums by Artists* (Montreal, 1984).

13. "The Museum of Modern Art as Late Capitalist Ritual: An Iconographic Analysis," *Marxist Perspectives* 1, no. 4 (Winter 1978): pp. 28-51; and "The Universal Survey Museum," *Art History* 3, no. 4 (December 1980): pp. 448-69.

14. See, for example, Pommier, "Naissance des musées de province," in *Les lieux de mémoire*, vol. 2: *La nation* (3 books), ed. Pierre Nora (Paris, 1986), book 2, pp. 451-95.

15. DiMaggio, "Cultural Entrepreneurship in Nineteenth-Century Boston: The Creation of an Organizational Base for High Culture in America," *Media, Culture and Society* 4 (1982): pp. 33-50; Zolberg, "Tensions of Mission in American Art Museums," in *Nonprofit Enterprise in the Arts: Studies in Mission and Constraint*, ed. Paul J. DiMaggio (New York, 1986), pp. 184-98. It is worth noting that Bourdieu published, with Alain Darbel, an im-

portant work on museum publics well before his more theoretical writing on distinction and cultural capital: *L'Amour de l'art: Les musées d'art européens et leur public* (Paris, 1966).

16. See, for example, Harris, "The Gilded Age Revisited: Boston and the Museum Movement," *American Quarterly* 14 (1962): pp. 545-64; Harris, "Museums, Merchandising and Popular Taste," in *Material Culture and the Study of American Life*, ed. Ian M. G. Quimby (New York, 1978), pp. 140-73.

17. See, for example, Coombes, "Museums and the Formation of National and Cultural Identities," *Oxford Art Journal* 11 (1988): pp. 57-68; Poulot, "L'invention de la bonne volonté culturelle: L'image du musée au XIXe siècle," *Le mouvement social*, no. 131 (April-June 1985): pp. 35-64; Poulot, "Musée et société dans l'Europe moderne," *Mélanges de l'École française de Rome–Moyen age/Temps modernes* 98 (1987): pp. 991-1096; Sherman, *Worthy Monuments: Art Museums and the Politics of Culture in Nineteenth-Century France* (Cambridge, Mass., 1989).

18. Among the most important recent contributions in this field are Clifford, *The Predicament of Culture: Twentieth-Century Ethnography, Literature, and Art* (Cambridge, Mass., 1988); Foster, "White Skins, Black Masks," in *Recodings: Art, Spectacle, Cultural Politics* (Seattle, 1985); Haraway, *Primate Visions: Gender, Race, and Nature in the World of Modern Science* (New York, 1989); Susan Hiller, ed., *The Myth of Primitivism* (New York, 1991); Sally Price, *Primitive Art in Civilized Places* (Chicago, 1989); and Marianna Torgovnick, *Gone Primitive: Savage Intellects, Modern Lives* (Chicago, 1990).

19. "The System of Objects," in *Jean Baudrillard: Selected Writings*, ed. Mark Poster (Stanford, Calif., 1988), pp. 10-28.

Part I

Histories

1

The German Art Museum and the History of the Nation

Detlef Hoffmann

Art museums developed, alongside other museums in the modern sense,[1] out of the chambers of art and curiosities collected during the late Middle Ages and the early modern period. The increasing specialization —as the basis of autonomy[2]—of all domains in the eighteenth century not only led to a separation of science from art and of both from practical life; it also subdivided science and art into sciences and arts. Thus, by the end of the nineteenth century we may still encounter art museums, but we find that the subdivision into painting galleries, collections of sculpture, and museums of applied art has become the rule.

It is no coincidence that we associate the emergence of the art museum with the French Revolution. Even though the yearning for a German nation-state is older, it has only been a manifestly political demand since the early nineteenth century. Historical reflection on the German nation had already begun in the eighteenth century, and indeed had occurred sporadically since the beginning of the sixteenth century. It was not until after the French Revolution and the Wars of Liberation, however, that we witness a serious contemplation of national history.[3]

In 1859, Julius Grosse described the situation as follows:

When the Holy Roman Empire finally disintegrated, everything that was once great and powerful, laudable and genuine, gained new value in the imagination of the impoverished heirs. The empire had become childish in its extreme old age, but it had secretly buried and hidden its indestructible treasures. The old man had been ridiculed and derided, but when he was dead, the memory awakened of the simplicity and strength of his days of youth, of his heroic deeds, buildings and imperial victories; as they carried his corpse to the gates of the cemetery, the modern heirs began to sing the first songs of reverence, to raise voices of praise and glory.[4]

This text, dating from the time following the suppressed revolution of 1848–49, which was as much a movement for national unity as for revolutionary reform, compares the end of the empire in 1806 to a funeral procession. As in all obituaries, the deceased was shown a degree of respect that he never received while he was alive. And if that was not enough to resurrect him, there was at least an attempt to conserve what he had left behind. It is no coincidence that Grosse speaks of bequeathed "treasures." He goes on to equate material remains—"buildings"—with records of events—"heroic deeds," "imperial victories." This conservation of the remnants of national—especially medieval—history contrasts sharply with developments in France, where iconoclasm and the destruction of medieval sculptures and buildings were important elements in the emergence of the nation.

As early as the seventeenth century, the German yearning to create a single nation out of the innumerable principalities, both large and small, that occupied German territory at that time manifested itself in the form of efforts to cultivate a common language and a common literature. In the reception of Tacitus and in the imaginative interpretation of archaeological finds, the Germanic tribes became ancestors. Throughout this period, France was looked upon with envious yearning as the exemplary enemy. Just as Arminius stood in opposition to the Romans, yet thereby occupied a place within the context of the classical world, so the notion developed of a German cultural nation engaged in struggle against the despised French language—which was rejected as a fashionable affectation—yet modeled to a certain extent on the French cultural nation. The situation in the enlightened eighteenth century was similarly complex. The idea of a global humanity also reinforced the love of differentiation. Every form of otherness was celebrated as yet another facet in the overall picture of the human species. World citizenship and national pride were not necessarily mutually exclusive. On the contrary, they were contingent on one another. At the turn of the eighteenth and nineteenth centuries, the effect of the revolutionary wars and the Napoleonic Wars, and in this connection the anti-French Wars of Liberation— although these were fueled by revolutionary ideas—was to bring forth the demand not merely for cultural or military unity but also for a politically unified nation, a demand that always implied struggle against the particularistic potentates, the princes. In the course of secularization, which included the dissolution of monasteries, medieval works of art were also detached from their original context. There were few people alive at that time who appreciated the aesthetic quality of Stephan Loch-

ner or Albrecht Dürer. The Boisserée brothers[5] were among those few, and it was their collection that provided the nucleus for the Alte Pinakothek in Munich. Another prominent figure whose love of the German nation manifested itself in the form of an art collection was Baron von Stein, the Prussian reformer and, for a short time, minister. The paintings he assembled at his castle in Cappenberg near Dortmund expressed the continuity of nationhood by depicting events from German imperial history. Even if the following anecdote is not true, it is symptomatic of the different ways of dealing with these material records. In the summer of 1814, Stein traveled down the Rhine in the company of Goethe, by then an old man. The two of them met Ernst Moritz Arndt in Cologne, who reports:

> There next to him [Stein] stood the greatest German of the 19th century, Wolfgang Goethe, viewing the cathedral. And Stein [said] to us: Quiet, dear children, quiet! Please don't mention anything political. He doesn't like that sort of thing. I admit it is not something we can praise him for, but he really is too great.[6]

This highlights a fundamental problem. Many of those who saved endangered artworks, who committed themselves to housing artworks in public collections, divorced national past from national future, which could only come about as the result of political actions—or political restraint, for in the domain of politics, failure to make decisions can have consequences just as far-reaching as decisions actually made. Applied to our example, this means that those who collected art as an alternative to fighting for German unity in the political arena were in fact, despite intentions to the contrary, helping to seal the victory of the old feudal powers.

The word most frequently used to denote medieval artworks was *Altertümer*, "antiquities," and less often *Antiquitäten*, "antiques." This word *Altertümer* meant more than simply artworks, as is apparent from the memorandum drawn up by the Hessian landscape painter Georg Wilhelm Issel in 1817. It was entitled "On German People's Museums [*Über deutsche Volksmuseen*]: A Few Pious Words on Museums of German Antiquities and Art" and in it he demanded

> the clearest compilation of all that is able to characterize and to make available to the senses:
> a) the history of the nobility and the people;
> b) the men who have most served in the fame and development of the land;

c) the state of art and literature;

d) the most important inventions and discoveries;

e) the customs and traditions of the fatherland from the most ancient up to more recent times.[7]

Goethe, however, in his essay titled "On Art and Antiquity in the Rhine and Main Areas," written in 1816, describes the Boisserée collection as a piece of art history. He completely ignores any connection to the history of the nation.[8]

Thus we are already able to identify a very clear distinction being made between "art" on the one hand and "history of the nation" on the other. Increasingly, "antiquities" were understood as artifacts, as illustrations or sources of reference that could be used to confirm knowledge gained independently of these national remnants, mostly through the study of texts. The purpose of these objects in Issel's program, it will be remembered, was to "make historical facts available to the senses." "Art" was increasingly regarded as a separate quality of being, accessible only through contemplation, not through an inquisitive curiosity. For instance, in his *Herzensergießungen eines kunstliebenden Klosterbruders* (Outpourings from the heart of an art-loving Friar), written in 1797, Wackenroder likens the gallery to a "fair." He demands, however, that galleries become "temples" where, in silent humility and in heart-raising seclusion, one could take pleasure in marveling at the greatest artists as the highest of earthly beings.[9] This position, vehemently supported by the German romanticists, marked the parting of the ways between the artifacts of historical research on the one hand and art on the other. The consequence of this separation was not only that the artwork was no longer consulted as a historical source, but also that the aesthetic quality, that the form, was no longer a source of historical insight. "Art" took on the status of something standing apart from history (as something transhistorical, existing on a metahistorical level).

Consequently, from the viewpoint of the collectors, the museum devoted to the past of the nation, the Germanic National Museum (Germanisches Nationalmuseum) in Nuremberg, was primarily a collection of historical objects.[10] Its founder, Baron Hans von Aufsess, had to propagate the idea of a national museum for decades before it was finally realized in 1852. It is no coincidence that the first outwardly visible step in this direction was the appearance, in 1832, of a periodical entitled *Gazette for the Study of the Middle Ages* (*Anzeiger für die Kunde des Mittelalters*). Progress toward the foundation of this museum with national focus was

actually achieved by the citizens (*Bürger*), who were often members of historical societies. In addition to the first difficulty of gaining acceptance for the idea of a national institution (as opposed to a regional one), another major obstacle had to be overcome. In this land of many divided states, there was no single capital city in which the museum could have been established. There was no common state; even ideas of who should and would want to belong to this state diverged greatly. Therefore, the baron chose a city in his native Franconia: Nuremberg, which he called "the most German of all cities." Although art played a major role in this decision (one need only think of Albrecht Dürer and the Dürer cult in the nineteenth century),[11] von Aufsess never spoke of an art museum. At one stage he referred to his venture by the picturesque name of Conservatory for Antiquities, hoping thus to attain the unity of German citizens. In a circular, dated 1846, to the General Assembly of German Legal Scholars, Historical and Linguistic Researchers in Frankfurt, he demanded "the establishment of a great historical and antiquarian national museum." Following its foundation in 1852, the decision was taken on April 20, 1857, to house the museum in the Carthusian monastery, where it is still located to this day.[12]

Let us contrast the Germanic National Museum with the "historical museum in Versailles," where art was also used as a vehicle for imparting history. Louis Philippe established this "museum for the history of France" ("à toutes les gloires de la France") between 1833 and 1837.[13] Here, in the former palace of the French kings, which was an exhibition piece in itself, huge paintings illustrated events taken from French history—from Clodwig to the Crusades and from Joan of Arc to the revolution. But the museum did not limit itself to the past; the respective present was also depicted up until the time of Napoleon III, which explains why the series of pictures ends with the *Battle of Solferino 1859*. The paintings were augmented by originals and plaster casts of statues and busts. Thus, whereas Goethe hated the very mention of politics, the Versailles collection set out to combine history with the politics of the day. Franz Kugler, who describes this museum in a lecture held in 1846, emphasizes its primarily artistic character.[14] He feels overwhelmed by its richness and says: "It drives us to search for a thread that could guide us through this labyrinth of art, a certain, intellectually stimulating conclusion to bring home with us from the observation of this world of art, which is combined with so much intellectual aspiration and intention." Kugler analyzes the paintings as works of art, examining them for their

content of truth. He then applies these concepts to Germany, again under the aspect of art criticism:

> A *German* historical museum would have to be founded from the start on essentially different principles. Here, in accordance with the German national character, we would have to take as our base the ennobling meaning of history, portrayals that hold the inner core of historical life, that bring the poetic element of popular life to awareness. . . . Other principles could be applied artistically as well in approaching the treatment of the individual in German art . . . the style of grandeur, the direction of universal validity predominates. Most of the historical questions which appear in Germany have been handled by our painters in such a manner.

This severely abbreviated text is the only conception known to me of a potential unity of national art and national history. Clear differences between Germany and other nations are to be observed in terms not only of contents but also of form. Two years before the Revolution of 1848-49, Kugler[15] formulated his vision of a congruence of German history and art—housed in a national museum. What was supplied by Wilhelminian pomp after 1870-71 is not to be confused with Kugler's ideas.

Kugler became a professor at the Berlin Akademie der Künste in 1835 and in 1843 took charge of the art department in the Prussian Ministry of Cultural Affairs. There could be no more telling documentation of his combined interest in both theory and political practice than these two professional positions. His *Manual of Art History*, published in 1841-42, was not only significant for being the first systematic history of art; his view of the development of art reveals a philosophical conception in which we find unmistakable parallels with Hegel. His politics also reflected a belief that nothing could stand in the way of the continued development of bourgeois democratic power. This political conception is embedded in the idea of a national museum.

The Germanic National Museum in Nuremberg remained the only museum to have the past of the entire land as its subject until after the Second World War. In the German Democratic Republic, in East Berlin, the Museum of German History was founded in what had originally been an arsenal (*Zeughaus*) on which restoration work was completed in 1967. From 1876 to 1880, this building had been converted into an arms museum attached to a "hall of fame" that, following the example of Versailles, celebrated great Prusso-German feats. It was only logical and fitting that this should become the place where the East German regime wielded its interpretational power in documenting German history. This

museum was, to a much higher degree than the one in Nuremberg, a collection of historical objects and relics. No conscious attempt was made to incorporate a specifically artistic dimension.[16]

In the year of German (re)unification, the discussion surrounding the German Historical Museum, which the West German chancellor, Helmut Kohl, had presented to the city of West Berlin in 1986, was placed in a completely new context.[17] When a majority of East Germany's first democratically elected parliament voted for union with the west, the power to define German history, as portrayed in the German Historical Museum, was also surrendered to the west. What was planned in 1986 as an antithesis, as a competitive instrument of the west against the east, came to an end with the victory of the west. At times it seemed ominously likely that the board of directors would be dominated by historians, that is, by people whose academic training was text-based, and there remains a very real danger of objects being displayed in order to illustrate preconceived ideas of history. Now that the liberal museum has moved into the building on Unter den Linden formerly occupied by the communist museum, however, works of art can expect to receive a more discerning reception than could have been hoped for only a short time ago. It remains to be seen whether the collection is capable of encouraging the citizens of western and eastern Germany to "identify" with the enlarged Federal Republic, or indeed with German history.

Both the West German and the East German foundations were intended as purely historical museums, not as museums for the "antiquity and art of the Fatherland." As early as 1919, in *Art Museums and the German People*, an anthology that is very important for the questions we are discussing here, Otto Lauffer drew a distinction between two types of historical museum. The first he called "museums following the Nuremberg model":

> They contain simultaneously art collections, sections for crafts and finally groups of archaeological and regional historical memorials. The common thread that binds these different sections together is the native origin.
> They make use in part of the happy position in which they see themselves to be as a result of the variety of their possessions.[18]

Thus, "artistic value and historical learning become linked." A distinction is made, therefore, between "value" and "learning," which can be seen as a parallel to the division between form and content. Here art is assigned to the realms of form and value, while history denotes content and learning. The fact that even as perceptive a museologist as Otto

Lauffer makes this distinction without question shows how deeply Kugler's ideas were concealed in the past. But later in the text, Lauffer widens and sharpens the division still further by imputing a specific order to each of his three groups of objects. He writes:

> When they [the museums] exhibit the objects of the different sections in separate groups, the order of each section will come entirely of itself: the art historical order of the painting galleries, the historico-stylistic and technological order of the crafts museums for the crafts sections and finally the historico-cultural order of archaeological museums for the regional historical and archaeological sections.

Besides these "museums of the Nuremberg type," there are the "collections consisting purely of antiquities." Of these, Lauffer says that they invite "their visitors not to artistic enjoyment but to rational learning." Art is therefore assigned to pleasure, to emotion, to value, to form; history to reason, to contents, to learning. The historical objects, says Lauffer in the subsequent passage, are primarily defined by a form appropriate to their purpose. And it is this dualism of "enjoyment" versus "learning," corresponding to emotion versus reason, and finally to art versus academic knowledge, especially history, that determines the discussion even today. In this division—and how could it be otherwise?—the history of the art museum mirrors the developments I have outlined thus far.[19]

In the nineteenth century, historical objects and artworks, which had still been treated equally in the "collection of national antiquities," became increasingly separated. The endearing chaos that once characterized the collection of antiquities, and that was still predominant in romanticism, now gave way to an academically ordered system. This endearing chaos allowed the collections to reflect the many-faceted richness of the human species (*Gattung Mensch*), as Georg Forster put it. Romantic collectors became more strongly and selectively interested in the history of the nation and especially in the Middle Ages, but this too could be interpreted in terms of a desire to develop a more precise definition of the concept of the human species. With each new object, the idea of humankind naturally became richer and more varied, and therefore also truer.[20] Although romanticism narrowed the scope down to the nation, the element of curiosity and the pleasure derived from collecting remained the same. The relationship to the objects collected was not selective but integral.

The nineteenth-century segmentation of science and art, to which I briefly referred at the beginning of this essay, was not only a question of drawing a distinction between nature and culture. Just as, for example,

zoology was separated from botany, so art was separated from history. Lauffer's classification of historical objects according to their function led to collections of arms in one room, while the next might contain everything pertaining to guilds, to be followed by an exhibition of tools, which might be further subdivided according to the various trades.

Thus, what we find is an object-oriented positivism that not only left unanswered the question of how the various groups of objects were interconnected, but also declined even to attempt to paint—and reproduce in the museum—a scientific picture of history founded on material evidence and thus also on works of art. The emphasis on amassing parts necessarily precluded a coherent picture, or indeed any pictures at all, of the whole. Under these circumstances, the museums—even the art museums—were places of learning not only for the academic few, but also for a bourgeois public who were able to incorporate the objects they found there into their view of a liberal society and thus extrapolate this view into the past. At the same time, however, this meant that the museum neither drew attention to gaps in the bourgeois male's view of the world nor relativized this view. If social groups or cultural forms were absent, this absence was not made manifest. It was not until after 1968—if I may briefly be allowed to leap forward in time in my brief sketch of the history of German museums—that attention was first drawn to gaps in the contents of the collections, that omissions became a topic of interest. The first discovery of the late-1960s reform movements was the absence of the working class from the arena of representation, an absence of a social group that from the point of view of the late-1960s neo-Marxist critiques was largely synonymous with politically organized men. In the struggle by various student reform movements against the establishment, which they came to equate with "fascism," national socialism was reduced to nothing more than a variation on the normal mode of capitalist rule, a local variant of a larger economic and political paradigm. In viewing fascism as a primarily economic and political construct and in not paying sufficient attention to the virulant racism that played an equally important part in its ideology, the student movement ran the extreme danger of somehow reproducing the anti-Semitism of their parents. Thus, for example, their support of the Palestinian cause and its linked and vehement anti-Israeli politics, in the name of an antifascist and anticapitalist struggle ignored the anti-Semitic past of the very fascism they were trying to protest and came close to reproducing its racial prejudices. My purpose in describing this in such detail is to bring out the fact that when people talked of a "critical coming to

terms with the past"—"kritische Aufarbeitung" was the contemporary catchphrase—there could be two (or more) sides to these efforts. For example, it was not until the late 1970s that museums first took up the subject of nineteenth-century bourgeois society's denial of civil rights to women, a theme that began to be reflected in exhibition and collection concepts.[21] Suffice it to note here that the ostensibly neutral positivism of the museum prior to the turn of the last century transpires in practice to be an uninterrupted series of omissions.

Around 1900, reformers of the art museum (on which I shall now concentrate) reacted to the status quo by trying to make it possible again for people to visit museums without any prior knowledge. Alfred Lichtwark, for example, declared knowledge of the history of art to be unessential, indeed even harmful,[22] as did his contemporary Heinrich Wölfflin. Art history was said to be the exclusive preserve of the academic. Nonetheless, cultivated—that is, trained—eyes made it possible for people to develop a cultivated taste and thus derive enjoyment from art. Cultivation of artistic taste meant, on the one hand, the possibility of overcoming the separation of time between past works and present observers, and, on the other, of reuniting art with life. "Life" in this conception—as exemplified by Lichtwark—referred exclusively to the present. The nation played an important role in this. Its capacities were to be optimized in competition for world markets. The national past had no place in this idea of the art museum; it was a topic best left to the museum in Nuremberg, to the Hall of Fame in the *Zeughaus*, and to painters of historical scenes.

After the Second World War, historical museums were staffed mainly by art historians. The historical objects drifted into the storeroom. The main focus was on local or regional art history. The Germanic National Museum was also a good example of this; from 1933 to 1945—although the seeds were probably sown before 1933—the name was associated with such nasty concepts that many were glad to flee to the ivory tower of analysis of artistic form.

Finally, not only the museum but also art itself changed during the last hundred years, and this change deserves a brief description. Art had long ago become independent not only of the wholeness of life, but also of history. The assumption that art is autonomous is in itself a significant historical phenomenon, evident since the end of the eighteenth century and rooted in the Renaissance. Since the second half of the nineteenth century at the latest, more and more artists in Western society have insisted on the autonomy of art. They describe it as a way of being independent of nature and history. (This undialectic argument will have to

suffice in the interests of brevity.) They think of the fine arts as a "universal language" that is capable of overcoming social, cultural, and temporal boundaries. This explains why concrete objects in a specific manifestation have been accorded less significance, as they always signal a particular place in time, in a society and a culture. The universal has consisted increasingly of the language of art itself, the style, the manner. Interest was lost in *what* was depicted; what mattered was *how* it was depicted. But, while they hoped to gain universality through autonomy, artists lost the wider audience that, through the mediation of the object, they had still been able to reach in the nineteenth century.[23]

Whether we welcome it or not, this development cannot be undone. Anyone who wishes to understand art and its languages must—paradoxical though it might have sounded to Lichtwark's ears—acquire a knowledge of its histories. He or she must be or must become a specialist in art. Again and again artists have tried to break out of this bind, to make an unmediated intervention in life, to become understandable to, to be received by and accepted in everyday culture. They have often found, however, that the field was already occupied. As art became autonomous and free from function and idealization, the terrain it had vacated had been developed not only by applied art but also by modern representational pictorial media—ranging from photography to film and including everything we have come to call "mass media" and "the popular arts" (which undoubtedly culminate in the object-addicted *gesamtkunstwerk* known as Disney World). It need hardly be emphasized that the nature of the relationship between autonomous art and functional art or, at least, representational art, is not static but dialectic.

Before I formulate my question, I must first describe an attempt, earlier this century, to reverse this development using not only the state's total monopoly of power, but also the instruments of terror. I am referring, of course, to the National Socialist policy toward art. The impatience of the "petty bourgeois" with the efforts required for comprehension of modernist art, together with the radical assertion of racist politics, led to a fusion of the art museum with the national past. By purging German art museums of "degenerate art"—"entartete Kunst"—and by staging the Great German Art Exhibition to promote paintings and sculptures that were loyal to the party line, the Nazis hoped to make it possible for visitors to the art museum to feel in harmony with their purified history. The price to be paid for this was the denial of the complexity not only of art but also of history. Appearance was sold as reality—and there-

after became reality, with the brutal consequence that reality was transformed by political terror ("blood and iron") into appearance.

If one takes note of this historical inventory, then the question of the relationship between the German art museum and the national past seems absurd. On entering the new building of the Art Collections of North Rhine Westphalia in Düsseldorf, the Alte or Neue Pinakothek in Munich, or the Staatsgalerie in Stuttgart, only an expert will be able to discern the structures of collection histories that these three museums have in common, and that separate them from the Art Gallery in Manchester, the Musée d'Art et d'Histoire in Geneva, or Walker's Art Gallery in Liverpool. Naturally, the respective local traditions are in evidence, but this illustrates the differences between the cities and *not* between the countries. The art historian knows why *St. Peter's Altar* by Konrad Witz is in Geneva, why the *Portinari Altar* by Hugo van der Goes is in Florence, and why Dürer's panels of the Apostles are in Munich rather than Nuremberg. To know the answers to these questions, like knowing why Dürer's stag-beetles can be seen in Malibu, of all places, is to have precise knowledge of the national past. That which was acquired and collected at a certain period of history provides an accurate documentation of the cultural mentality of that time. For the initiate, though hardly for the educated visitor, the structure of the collection of an art museum is an essential part of a regional or national past.

Moreover, there was and is no national art museum in Germany to compare with those in Paris, London, Edinburgh, and Amsterdam—a situation Germany shares with Italy. If there is a national signature of German art museums at all, then it is international variety combined with local history.

If one actually wanted to make the national past into a topic for a German art museum (in the form of either a rotating or a permanent exhibition, a desire that would seem unnecessarily excessive to me), one would have to include exhibits showing how the structure of the collections developed over the course of history—not exactly the kind of spectacular subject that would inspire the general public.

Just how difficult it is to exhibit a historical "art-political" topic in an art museum is shown by the various attempts during 1988 to put together an exhibition commemorating the Nazis' campaign against "degenerate art." The exhibitions followed one of three basic models: (1) only the pictures condemned by the Nazis were exhibited, as happened in Düsseldorf, so that the visitor could have been forgiven for thinking he or she was wandering through an exhibition entitled Art of the Weimar

Republic; (2) Nazi art à la Ziegler was juxtaposed to Dix and Kirchner, thus avoiding, through a kind of exhibition guidance strategy, any danger that, after comparing the two sides, the observer might uphold the Nazis' verdict by handing the laurels to Ziegler; or the original Entartete Kunst exhibition of fifty years earlier was reconstructed and called a historical—as opposed to an art—exhibition.[24]

The most recent, and undoubtedly the most thoroughgoing, attempt to deal with this subject was on show to the public during the spring of 1992 at the Altes Museum in Berlin.[25] Like the democracy that was instated in 1945, this attempt to subject Nazi policy on art to a visual form of critical appraisal came from the United States. On this occasion the effort at a cultural revision was encountered from within a recently reunited Germany, in itself a state of historical revision. Judging by my own observations of the public at the exhibition, which were confirmed by the organizers, the first part of the exhibition, the documentary section, aroused intense interest among visitors. Younger people in particular were prepared to spend considerable time reading the newspaper articles and broadsheets and studying the posters and photographs. The second section, showing the incriminated art of 1938, did not seem to hold the visitors' attention to the same degree. Yet the strict dividing line that was drawn in this exhibition between political information and artistic presentation brought to light a further problem. As we entered the second section, we found ourselves in an exhibition of 1920s art that mirrored—albeit with positive rather than negative overtones—the selection made in 1938 by the National Socialist judges of artistic merit. What was condemned at the time as bad art must now be made to appear unconditionally good in the eyes of the German public—especially in the eyes of the older, guilt-ridden generation of Germans. The Nazis' black-and-white oversimplification thus served as a model for the exhibition of 1992 (I refer throughout to the second part of the reconstructed exhibition). The problem of expressionism and its relationship to currents of Nazi weltanschauung was dealt with on a textual level in the first section, but not on a visual level in the second. The fact that many Nazi painters (Ziegler and Peiner, to name but two) were actually much closer to Neue Sachlichkeit than the post-1945 legends would have us believe was a lesson that apparently could not be conveyed in visual terms. Yet at least the younger members of the public have a right to a differentiated portrayal; otherwise it would look as though the "degenerate art" of 1938 represented all that was good in Germany, whereas the organizers of that time felt it represented all that was evil. Let it be noted that one means of ascertaining the

health of the German nation is to use its reaction to modern art as a clinical barometer. A slightly raised temperature is apparently normal, but from time to time the chart shows a steeply rising curve, and it is then that vigilance is called for. It is not the evaluation of artworks that is decisive here; of vital importance is the actual political and cultural use that is made of them. Paradoxical though it may sound, on the question of "degenerate art" the German art museum is congruent with the history of the nation.

There are other ways for the art museum to deal effectively with the national past. Allow me to begin with a personal example. At the hearings organized by West Berlin's senator for cultural affairs on January 13, 1984, to discuss the German historical museum project, I proposed that contemporary artists be commissioned to record events from German history in a fashion similar to what was done in Versailles 150 years ago.[26] The reaction of historian Hagen Schulze was interesting. He described such pictures as a "collection of sources for present reflections on history," a definition with which I would concur. The pictures in Versailles, he continued, were a "collection for the depiction of historical myths" that served to legitimate present ideologies. Here too I would concur. However, I would take issue with the assumption that while artists create myths, scholars and scholarship do not. The supposedly "authentic" past received through scholarship is just as much a myth as the present one. Titian's portrait of Charles V (1532-33) is no less a subject for criticism than Alfred Rethel's 1840 painting in the emperor's hall in Frankfurt; David's *Marat* or *Napoleon* is as much a constitution of myths as the Wallenstein biography by Golo Mann or the book on Bismarck by Lothar Gall. Truth always becomes evident if myths are subjected to critical comparison. The art museum can make such comparison possible, but the visitors themselves must engage in the work of comparing.

If we do not want to deny the development toward autonomous art— and this development also shapes the visitor's habits of perception—then such a comparison can only be carried out intelligently if we understand *aesthetic categories* as *historical categories*, that is, if we understand the formal structure of an artwork, a picture, as a statement about its place in society and the time in which it was created. Those who know the difficulty art historical literature has in treating aesthetic categories as historical ones will appreciate how much work has to be done to make this a didactic concept for the museum.

This final section deals with what I call an aesthetic biography. No extensive or thorough art historical research has yet been conducted on this

topic. Each biography consists of pictures, images that may be banal or demanding, famous or unknown. Not all of these pictures necessarily belong solely to an individual. Indeed, it is quite possible for certain pictures to belong to a whole generation (at least from a particular region or nation). If these personal pictures could be integrated into exhibitions of officially sanctioned pictures, they would add a historical dimension to aesthetic dimensions. These personal pictures are sometimes connected with the national past, but mostly the officially constituted national aspect of the past is weaker in people's imaginations than the local or social aspect. Nevertheless, the qualities of both would be the value of this aesthetic biography. The fund of personal pictures could, for example, be investigated for late nineteenth century Germany in terms of the number of reproductions of Böcklin or Thoma printed. In the postwar period, my generation—I was born in 1940—attached great value to Franz Marc's (representational and yet simultaneously modern) pictures, but what do they actually portray for my generation? In what sense do I—together with many western Germans of my age—see Franz Marc's pictures differently than the French, Italians, or Swedes would see them?

For many people who were young during the Weimar Republic, youth was identified with particular forms, with modern buildings (flat roofs) and modern art, which meant both expressionism and the new functionalism (Neue Sachlichkeit). When the Nazis condemned these pictures, many felt (as I know from members of the banned young workers' movement of the period) that a piece of their own history was being destroyed. Artworks were, in this case, actually something like coded memories of one's life history.

But besides these, very different memories of pictures exist—paintings like the ones that hung in school or in church, that one always looked at, often because boredom made it impossible to do otherwise. It could be the unfinished painting of George Washington in an American schoolroom or of the Virgin Mary of Lourdes in a Catholic church. It might be the belling stag hanging in the traditional German living room or the Dance of the Elves in the parents' bedroom; perhaps the soft beard and mother-of-pearl eyes of Karl Marx, or Che Guevara staring down from an offset poster; or it could be Marilyn Monroe as a pinup, or an Andy Warhol painting. Or a combination of all of these. In the subjective emotional store of treasures, these pictures can stand on an equal footing alongside more famous, publicly respected ones. Here, local painters or schools of painting—hardly known beyond the region—gain meaning in the lives of many people, although their influence when measured interna-

tionally is as yet marginal. Here again, the style of such pictures matches—with a time lag—those that are more well known. The question of how, or indeed whether, a more precise knowledge of these phenomena could in fact promote the treatment of national history in the art museum remains.[27]

Art plays a fairly marginal role in most people's lives. Like monuments[28] and buildings, like landscapes and roads, artworks are not consciously looked at; they are simply there. On only two occasions do they arouse greater interest: when they appear in the limelight of public attention, and when they disappear. When the Lenbachhaus in Munich purchased Joseph Beuys's *Zeige Deine Wunde*[29] the acquisition was met with a wave of public indignation (in which arguments were often brought forward echoing those once leveled against "degenerate art"). Yet the museum's directors stuck to their guns, and now, years later, the work stands quietly in its room, seldom receiving close attention. Only if it were to be removed again—perhaps at the hands of an overly zealous cleaner—would the debate that would allow us to count the people to whom this work means something reemerge. It is only when dormant objects are activated that their significance—and that includes their historical significance—becomes apparent. As long as latencies do not become manifest, art will remain in a realm of its own, far removed from history. This is a description that holds good, if not among museums cognoscenti, at any rate among the vast majority of people.

If, however, we broaden the concept of art, as I have tried to do here, to allow images from the private sphere, from advertising and film to dwell under the same roof, then the eminent significance of these "pictorial treasures" is beyond question. Yet can they be collected in an art museum? And if so, would they then have something to do with the history of the nation? Is the nation not a fiction that falls apart at the very moment we attempt to link it to experience, to visual experiences? Or is it that fictions, precisely because they are unreal, have a particular suggestive force, like a drug that is mistaken for food? The events that took place in the Soviet Union after Mikhail Gorbachev introduced his reform program and the consequences they have had for Eastern Europe have left us—not only, but also, in Germany—with more questions and fewer answers.

Notes

1. See Volker Plagemann, *Das deutsche Kunstmuseum* (Munich, 1967), especially pp. 11–22; the recognized authority is still Julius von Schlosser, *Die Kunst- und Wunderkammern der Spätrenaissance: Ein Beitrag zur Geschichte des Sammelwesens* (Leipzig, 1908).

2. Michael Müller, ed., *Autonomie der Kunst: Zur Genese und Kritik einer bürgerlichen Kategorie* (Frankfurt, 1972).

3. For more detail, see Detlef Hoffmann, "Germania: Die vieldeutige Personifikation einer deutschen Nation," in the exhibition catalog *Freiheit, Gleichheit, Brüderlichkeit: 200 Jahre Französische Revolution in Deutschland* (Nuremberg, 1989), pp. 137-55.

4. Julius Grosse: *Die deutsche allgemeine und historische Kunstausstellung zu München im Jahre 1858*, Studien zur Kunstgeschichte des 19. Jahrhundert (Munich, 1959), p. 39.

5. Gudrun Calov, ed., *Museen und Sammler des 19. Jahrhunderts in Deutschland* (Berlin, 1969) (= *Museumskunde* 1-3, 1969), especially pp. 74-92.

6. Quoted in Peter Bloch, "Über die Kunstbestrebungen und die Sammeltätigkeit des Reichsfreiherrn vom Stein," in the exhibition catalogue *Meisterwerke mittelalterlicher Glasmalerei aus der Sammlung des Reichsfreiherrn von Stein* (Hamburg, 1966), pp. 9-13, especially p. 10.

7. Georg Wilhelm Issel, *Über deutsche Volksmuseen 1817*. Einige fromme Worte über Museen deutscher Altertümer und Kunst. Quoted in Plagemann, *Das deutsche Kunstmuseum*, pp. 28f.

8. Johann Wolfgang Goethe, "Über Kunst und Altertum in den Rhein-und Maingegenden," first published in *Morgenblatt für gebildete Stände*, March 9-12, 1916, reprinted in *dtv Gesamtausgabe* of the complete works of Johann Wolfgang Goethe, vols. 33 and 34: *Schriften zur Kunst*, part 2 (Munich, 1962), pp. 18-27.

9. Wilhelm Heinrich Wackenroder and Ludwig Tieck, *Herzensergießungen eines kunstliebenden Klosterbruders* (Berlin, 1797; Stuttgart, 1979), pp. 71f.

10. The history of the Germanisches Nationalmuseum has often been recorded. August Essenwein's introduction to the first volume of the *Anzeiger des Germanischen Nationalmuseums* (vol. 1, nos. 1 and 2, January and February 1884, pp. 1-9) describes the change of the concept of collecting between him and von Aufsess.

11. Under the aegis of Dürer's name, art-concentered and nationalist values of the nineteenth century unite. See *Dürers Gloria*, exhibition catalog (Berlin [West], 1971); *Nürnberger Dürerfeiern 1828-1928*, exhibition catalog (Nuremberg, 1971); Matthias Mende and Inge Hebecker, eds., *Das Dürer-Stammbuch von 1828* (Nuremberg, 1973). Even Julius Langbehn's Rembrandt-mysticism was adapted by him to Dürer; see Julius Langbehn and Momme Nissen, *Dürer als Führer: Vom Rembrandtdeutschen und seinem Gehilfen* (Munich, 1923).

12. See the introduction by Gerhard Bott in *Schatzkammer der Deutschen*, aus den Sammlungen des Germanischen Nationalmuseums (Nuremberg, 1982). The choice of this title (Treasury of the Germans) in the ninth decade of the twentieth century is rather naive, but the book was sponsored by a large mail order firm.

13. Th. Gaethgens, *Versailles als Nationaldenkmal: Die Galerie des Batailles im Musée Historique von Louis-Philippe* (Antwerp, 1984).

14. Franz Kugler, *Kleine Schriften und Studien zur Kunstgeschichte*, part 3 (Stuttgart, 1854), pp. 476-87; before the German Revolution of 1848 the relation between a national subject and a national style was intensively discussed; see Detlef Hoffmann, "Germania zwischen Kaisersaal und Paulskirche: Der Kampf um Vergangenheit und Gegenwart (1830-1848)", in the exhibition catalog *Trophäe oder Leichenstein? Kulturgeschichtliche Aspekte des Geschichtsbewußtseins in Frankfurt im 19. Jahrhundert* (Frankfurt, 1978), pp. 83-133, especially pp. 99-106.

15. Franz Kugler (1808-58) was an art historian. In 1833 he became professor of art history at the academy and at the University in Berlin; in 1842 he was appointed a member of the Senate of the Academy. In the following years he became the person responsible for cultural affairs and for art projects in the Prussian Ministry. His *Handbuch der Geschichte der Malerei, von Konstantin d. Gr. bis auf die neuere Zeit* (Berlin, 1837) made him one of the founders of art history as a scientific discipline. The second edition (1847) was revised by

Jacob Burckhardt, who on Kugler's side took part in the discussion about the way historical paintings are devoted to the idea of the nation; see Rainer Schoch, "Die belgischen Bilder," in *Städel-Jahrbuch* n.s. 7 (1979): pp. 171-86. Kugler edited the *Handbuch der Kunstgeschichte* (Stuttgart, 1841-42), which influenced German art historians up to the First World War; every educated home had a copy of it. The fifth edition was revised by Wilhelm Lübke, 1871-72. His *Geschichte der Baukunst*, vols. 1-3 (Berlin, 1855-60), was completed and revised by Jacob Burckhardt, Wilhelm Lübke, and Cornelius Gurlitt. Kugler wrote poetry as well as art history and criticism.

16. The history of the Museum für deutsche Geschichte in East Berlin has not been written. The artistic interpretation of the *Zeughaus* from 1876 to 1880 as well as the interpretation after 1967 has to be reconstructed by means of guidebooks such as, for example, *Das Königliche Zeughaus: Führer durch die Ruhmeshalle und die Sammlungen* (Berlin, 1907). Guidebooks for the communist museum, including conceptual declarations, are *Kaiserreich Kapitalismus Klassenkampf 1871-1900 (1967); Imperialismus Krieg Revolution 1914-1919* (ca. 1971); *1933-1945* (ca. 1969).

17. The extensive discussions about this museum are documented in Christoph Stölzl, ed., *Deutsches Historisches Museum: Ideen-Kontroversen-Perspektiven* (Frankfurt and Berlin, 1988).

18. Otto Lauffer, "Historische Museen," in *Die Kunstmuseen und das deutsche Volk*, ed. Deutscher Museumsbund (Berlin, 1919), pp. 169-84.

19. Volkhard Knigge and I argue against this silly opposition; see "Museumspädagogik," in *Kulturpädagogik und Kulturarbeit: Grundlagen, Praxisfelder, Ausbildung*, ed. Sebastian Müller-Rolli (Weinheim and Munich, 1988), pp. 119-28.

20. This spirit is to be seen in Richard D. Altick, *The Shows of London: A Panorama History of Exhibitions, 1600-1862* (London and Cambridge, Mass., 1978).

21. The Historisches Museum Frankfurt with its director, Dr. Hans Stubenvoll, was the opinion leader in the discussion about museums of the seventies in West Germany. See Detlef Hoffmann, Almut Junker, and Peter Schrimbeck, *Geschichte als öffentliches Ärgernis, oder: Ein Museum für die demokratische Gesellschaft* (Steinbach, 1974). In *Frauenalltag und Frauenbewegung 1890-1980* (Frankfurt, 1981), the museum revised its ten-year-old exhibition. The whole development in West Germany is analyzed in Detlef Hoffmann, "Von der Museumsreform zur Wende," in *Kritische Berichte* 18, no. 3 (1990): pp. 46-52.

22. The opinion of Alfred Lichtwark, the famous director of the Kunsthalle in Hamburg, of the role of the art museum in the context of national economics is described in Irene Below, "Probleme der 'Werkbetrachtung'—Lichtwark und die Folgen," in *Kunstwissenschaft und Kunstvermittlung*, ed. Irene Below (Giessen, 1975), pp. 83-136.

23. See Detlef Hoffmann, "Immer ein Stiefkind der großen Kunst. Malerei, Buchillustration und Kinderbuch im 19. Jahrhundert," in Detlef Hoffmann and Jens Thiele, *Künstler illustrieren Bilderbücher* (Oldenburg, 1986), pp. 17-34. A discussion that deals with this problem on a large scale is Werner Busch, *Die notwendige Arabeske: Wirklichkeitsaneignung und Stilisierung in der deutschen Kunst des 19. Jahrhunderts* (Berlin, 1985).

24. West German books and catalogs dealing with "degenerate art" in the context of Nazi art politics are f.e. Klaus Backes, *Hitler und die bildenden Künste, Kulturverständnis und Kunstpolitik im Dritten Reich* (Cologne, 1988); *Verfolgt und verführt: Kunst unterm Hakenkreuz in Hamburg*, exhibition catalog (Hamburg, 1983); Peter-Klaus Schuster, ed., *Die "Kunststadt," München 1937: Nationalsozialismus und "Entartete Kunst"* (Munich, 1987).

25. Stephanie Barron, ed., *Entartete Kunst: Das Schicksal der Avantgarde im Nazi-Deutschland*, exhibition catalog (Los Angeles and Berlin, 1992).

26. Detlef Hoffmann, "Probleme des Aufbaus einer Sammlung zu einem 'Deutschen Historischen Museum,'" Discussion in *Protokoll der Anhörung zum Forum für Geschichte und*

Gegenwart, Tagung im Reichstagsgebäude am 13. Januar 1984 (Berlin, 1984), pp. 26-34, especially pp. 31 and 32.

27. Sometimes artists have collected objects with this biographic background—for example, Daniel Spoerri, *Le musée sentimental de Cologne* (Cologne, 1979). See also Detlef Hoffmann, "Kulturelle Identifikation," in *Kunst und Alltagskultur*, ed. Jutta Held and Norbert Schneider (Cologne, 1981), pp. 122-31.

28. See "Der Fall der Denkmäler," *Kritische Berichte* 3, 1992.

29. Joseph Beuys, *Zeige Deine Wunde*, vol. 1 photos, vol. 2 reactions (Munich, 1980).

2

The Whitechapel Picture Exhibitions and the Politics of Seeing

Seth Koven

Oh! East is East, and West is West
as Rudyard Kipling says.
When the poor East enjoys the Art
for which the rich West pays,
See East and West linked in their best!
With the Art-wants of Whitechapel
Good Canon Barnett is just the man
who best knows how to grapple.
So charge this Canon, load to muzzle,
all ye great Jubilee guns.
Pictures as good as sermons? Aye,
much better than some poor ones.
Where Whitechapel's darkness the weary eyes
of the dreary workers dims,
It may be found that Watts' pictures
do better than Watts' hymns.[1]

In the spring of 1881, the rooms of St. Jude's parish school, Whitechapel, in the very heart of "outcast London," underwent a remarkable transformation. The usually bare walls were covered with paintings by the "best" modern British artists and a smattering of old masters. A battalion of men and women from the fashionable West End of London agreed to serve as guards in morning, afternoon, and evening shifts. At the public opening of the picture exhibition, the prominent Liberal politician Lord Rosebery declared that yet another good thing had befallen the East End thanks to the vicar of St. Jude's and his wife, Samuel and Henrietta Barnett.

The Whitechapel Fine Art Loan Exhibition (also called the St. Jude's Picture Exhibition) and its successor, the permanent Whitechapel Free Art Gallery, were explicit attempts to use the display of art objects and

the creation of a working-class art public to promote social reclamation and urban renewal. They grew out of the Barnetts' passionate commitment to John Ruskin's theories about the transforming power of art and culture. Among the most respected social reformers of their generation, the Barnetts wielded their enormous influence not only through close personal ties with leading politicians, journalists, and intellectuals who sought out their views, but also as founders of Toynbee Hall. Toynbee Hall was the first university settlement, established in 1884 for recent male graduates of Oxford and Cambridge as a residence hall and center of social welfare services and investigation in East London.[2]

The Barnetts promoted the exhibitions, along with university extension lectures, clubs, debating societies, and classes in arts and crafts, in an attempt to build a national culture based not on the competing interests of class, but on consensual citizenship. At a time when the British elite witnessed violent confrontations between labor and capital, the Barnetts argued that culture, shared by all but defined according to each person's own lights, would help rich and poor to transcend class divisions and together forge a nation.

Neither the Barnetts nor their followers, however, were so naive as to believe that pictures alone would solve the problems confronting the poor of East London. The exhibitions and later the permanent gallery must be seen as pieces of a much larger project to reshape the interior and exterior landscapes of the urban poor. The Barnetts were leaders in the movement to build free libraries, establish urban open spaces, and design and construct municipally subsidized housing in East London. Some of their programs required massive state and local government expenditure. Samuel Barnett was an early and vocal supporter of old age pensions and helped develop labor colonies for the unemployed. Library and museum would replace music hall and pub as the centers of civic life for the newly enfranchised working-class citizens of the 1880s and 1890s.

The history of the Whitechapel Picture Exhibitions and Gallery can be told in many ways, and from many points of view. The Barnetts tended to use comedy to describe the exhibitions. In their accounts, which they spiced with a fair bit of humor and self-mockery, the disorder of the weeks preceding the exhibitions yielded to the order of the event itself. The orderliness of the exhibitions reinforced their point that the exhibitions encouraged the cultural and spiritual elevation of East Enders and, more generally, the foundation of harmonious social relations between rich and poor. With some justification, they saw the exhibitions and later the permanent gallery as triumphs against adverse circumstances. Frances

Borzello, a recent historian of the exhibitions, adopted tragedy as her narrative mode: tidy- but small-minded people and ideas inexorably produced a messy and unfortunate legacy of popular alienation from art.[3] But in many respects, satire seems better suited to an account of the exhibitions. Satire in part relies on the distance separating what is said — in this case, the ideological apparatus and rhetoric of the exhibitions — from what actually is — the ways in which people experienced the exhibitions. Satire also allows, perhaps even demands, the coexistence of many and often contradictory meanings and realities. If the organizers scripted the text of the exhibitions by selecting, exhibiting, and describing the pictures, the working-class public could and did read against this text by bringing the realities and presuppositions of their own lives to bear on what they saw. This essay explores the tensions between the founders' ideological aspirations and the ways in which different groups of people experienced and gave meaning to the exhibitions.

It is easy to understand why late-Victorian social reformers turned to the ostensibly apolitical arena of culture to deflect intensifying class conflict away from hustings and workplace. But saying this does not explain why many social reformers were, and perhaps still are, so committed to the idea that rich and poor literally shared a common culture and heritage — physically realized in art objects. The exhibitions were unabashed attempts to apply theories about the political and social uses of art and its public display to the problems of class relations in late-Victorian London. The exhibition promoters believed that art objects, if they were properly displayed and explained to the working-class public, would serve as the medium through which misunderstanding and hatred between rich and poor could be translated into mutual appreciation for the transcendent truths and beauties of art. This shared aesthetic and moral experience would, they hoped, lead to political, social, and economic solidarity. Using what fragmentary sources exist about the ways in which East Londoners interpreted their experiences at the exhibitions, I attempt to assess the extent to which the promoters' aspirations were realized.

Many historians have argued cogently that the late-Victorian metropolitan working class lived a "life apart" from the middle and upper classes.[4] Others, G. S. Jones prominent among them, have argued that a kind of Faustian bargain was implicitly struck between elites and the working class. The working class accepted the political and economic authority of elites and, unlike its Continental counterparts, did not support in large numbers genuinely radical and revolutionary movements. Ac-

cording to this account, the working class turned inward to construct an insular "culture of consolation," centered in pubs and music halls and impervious to the cultural imperialism of bourgeois social reformers.[5] The prevailing historiography, therefore, underlines the cultural gulf separating rich and poor and suggests that forms of cultural behavior and activities were specific to social classes. Within this framework, the ritual of museum going, like temperance or attending university extension lectures, is read as a sign of either bourgeois status or of co-optation by bourgeois cultural values. In neither case can it be viewed as an expression of working-class culture or desire.

This study of the Whitechapel Exhibitions builds on but also interrogates these influential paradigms of class and cultural relations in the metropolis. It suggests that placing bourgeois and working-class culture in binary opposition to one another obscures the ongoing and negotiated character of authority to define the meaning of cultural objects and products. Seen in this light, even museums, then as now citadels of elite cultural authority and self-representation, become sites of cross-class exchange as well as contestation.

John Ruskin and the Poetry and Politics of Sight

The Whitechapel Picture Exhibitions represented the Barnetts' and Toynbee Hall's most ambitious and articulate endeavor to apply the aesthetic theories of the preeminent art critic John Ruskin to slum work. Ruskin argued in *Modern Painters* and more fully in *Stones of Venice* that the production of art and the ability to understand and see it reflected the moral values and socioeconomic conditions of the artist and the artist's society. Ruskin insisted that ethics, aesthetics, and godliness were intertwined, so when he declared in *Modern Painters* that "the greatest thing a human soul ever does in this world is to *see* something" he meant much more than perceiving a set of visual sensations. "To see clearly," he explained, "is poetry, prophecy, and religion." For Ruskin, sight engaged the moral and physical capacities of individuals, who therefore actively experienced and participated in their own education. The visual sense was paramount to unlocking the visible and invisible truths of God.

Toynbee residents strove to help the poor of Whitechapel "see" in this Ruskinian sense of the word. By so doing, they attempted to expand and redefine the "seeing," museum-going public to include the working class. In establishing the picture exhibitions, moreover, the Barnetts looked not only to Ruskin's aesthetics, but also to his pronouncements

about how a museum or gallery ought to be arranged. Few thinkers in
Victorian Britain had more to say about the social, moral, educational,
and aesthetic functions of museums.

Ruskin financed and opened the museum at Walkley near Sheffield in
1878 to illustrate the laws propounded by his "grammars" for the work-
ing class and to serve as a storehouse of national treasures, a whimsical
antidote to the national debt. Several factors undermined its effectiveness
as an institution for uplifting the working class. Objects appeared to be
organized in a haphazard fashion that made it difficult to construct a co-
herent narrative out of the experience.[6] Furthermore, Ruskin located his
museum three miles outside of town, and up a steep hill. The ascent to
knowledge, he explained, should always be strenuous.[7] It is little wonder
so few Sheffield ironworkers decided to educate themselves at the mu-
seum.

In *Deucalion*, Ruskin's geology "grammar" for laboring people, which
he began writing in 1875, he outlined most fully his conception of mu-
seums. "Above all, let all things, for popular use, be beautifully exhib-
ited," he insisted. "To teach our people rightly, we must make it a true
joy to them to see the pretty things we have to show: and we must let
them feel that, although, by poverty they may be compelled to the pain
of labour, they need not, by poverty, be debarred from the felicity and
the brightness of rest."[8] Education took precedence over recreation for
Ruskin, though ideally the two were complementary. As he admonished
a correspondent planning an art gallery in Leicester, "You must not make
your Museum a refuge against either rain or ennui, nor let into perfectly
well-furnished, and even, in the true sense, palatial, rooms, the utterly
squalid and ill-bred portion of the people."[9]

If the Barnetts found much in Ruskin to inspire them in their daring
scheme, they also recognized his limits as a practical guide. To refuse to
admit the "squalid and ill bred" and to place obstacles in the paths of
those who cared to visit the pictures would obviously have undermined
their whole purpose. While Ruskin spoke of the steep climb to knowl-
edge, Henrietta Barnett more sensitively observed that working people
did not seek out the "West End Art Treasures" of the British Museum
and National Gallery because of

> the expense of transit; the ignorance of ways of getting about; the
> shortness of daylight beyond working hours . . . the impression that the
> day when they could go is sure to be the day when the Museum is closed
> to the public—all these little discouragements become difficulties,

especially to the large number who have not yet had enough
opportunities of knowing the joy which Art gives.[10]

The Whitechapel Picture Exhibitions celebrated Ruskin's ideals—but
only after they had been carefully and selectively sifted by the Barnetts.[11]

"Lessons in Seeing"

The Barnetts believed that great art transcended social divisions and cre-
ated a pool of shared emotions, thoughts, and sensations that would tie
all men and women together. Art spoke directly to the instincts and sym-
pathies of all people in a way that literature and history could not. At
times the Barnetts even romanticized the instinctual abilities of laboring
people to understand the language of art. Free from self-conscious artifice
(i.e., the burden of civilization in a Rousseauian sense), they could go
"straight to the point, and perhaps . . . reach the artist's meaning more
clearly than some of those art critics whose vision is obscured by thought
of 'tone, harmony, and construction.' "[12]

At a time when anthropology was just emerging as a science and stud-
ies like *The Origin of Civilisation and the Primitive Condition of Man: Mental
and Social Conditions of Savages* (first published in 1870) by the Barnetts'
friend Sir John Lubbock enjoyed enormous popularity, the Barnetts en-
dowed the London working class with the virtues and vices of a primi-
tive people. In a curious reversal of roles, however, it was the "primi-
tive" East Enders who were invited to view the cultural artifacts of elite
life. The simplicity and honesty of the working class at once served to
rebuke the shams of capitalism and demanded the guidance and cultiva-
tion of those, like the Barnetts, whose family fortunes were made
through manufacture and industry.

The discursive imagining of the working classes as "primitive" and as
the "other" awkwardly affirmed and challenged some key ideological
premises of the exhibitions. The exhibitions aimed to legitimate visibly
the organizers' claims to be insiders within their adopted communities.
One leader of the settlement movement even described settlers as "the
squires of East London,"[13] thereby suggesting that they were the resident
urban gentry of East London. It was normal behavior from midcentury
onward for leaders of the resident urban gentry of provincial towns to
express their civic pride, power, and self-confidence by founding cultural
institutions like museums and libraries.[14] But by viewing East London-
ers as primitives, the Whitechapel Exhibitions also unintentionally em-

phasized the organizers' status as outsiders, as temporary visitors and as would-be colonizers of Darkest London. Not surprisingly, the exhibition promoters sometimes found it rather difficult to negotiate their conflicting claims to be part of and yet superior to East London.

These contradictions were reproduced by their conflation of "self" and "other" in describing East Londoners' relationship to great British art. Just as settlers claimed to be insiders, so too they insisted that the paintings on display were part of the cultural inheritance of East Londoners themselves. In the eyes of Henrietta and Samuel Barnett, great British art, regardless of its actual legal status, was the property of the nation as a whole. Their link between the display of British art and the promotion of national identity and unity reflected wider debates in the 1880s over competing proposals to establish a new state-owned art gallery that, unlike the so-called National Gallery, would be "truly national" in that it would show only great works of British art.[15] While the art establishment struggled to define a canon of exemplary British art, the Barnetts insisted that the paintings they selected for their loan exhibitions captured those best qualities of being British that the "cultured classes" held in common with East Londoners. But it was difficult to sustain, even in rhetoric, the illusion that the fine art on display constituted a fragment of East Londoners' "self." After all, the canvases were imported to East London precisely because they were neither the property nor the products of East Londoners' lives and imaginings. The promoters of the exhibitions readily acknowledged that the paintings materialized values and ideals that they saw as alien to most East Londoners. The art objects were intended to represent those ideals that the organizers wished East Londoners would embrace as their own, not those ideals they believed East Londoners actually valued.

Thus, despite their admiration for the ability of working people to understand the essence of art, the Barnetts did not trust to their untutored instincts alone. They shared with Ruskin a belief in the need to educate instincts, to provide well-chosen works of art to stimulate an appreciation for what they believed to be the best. Ruskin interpreted a work of art not only as the creation of the artist, but also as an object that acted upon the imagination of the beholder. The Barnetts translated Ruskin's theoretical emphasis on the social causes and effects of art into the educational format of the exhibitions. " 'Lessons given here in seeing' might have been put upon the sign board outside our Picture Exhibition," the Barnetts wrote in 1889. "Many people would have laughed, thinking it a

great joke that anyone should need to be taught to see."[16] But for Ruskin and the Barnetts, seeing was no laughing matter.

If art spoke equally to rich and poor, settlers nonetheless believed that as men of culture, they had special wisdom to offer working people.[17] Imbued with a keen sense of their role as bearers of what Matthew Arnold had called the "best that had been thought and said," the exhibitions' promoters and supporters proposed to illuminate the dark and unruly corners of London with the light of culture. Toynbee settlers and associates (male and female) served as both docents and guards.[18] The combination of these two roles was particularly apt and paralleled Arnold's own conception of the redemptive and disciplinary functions of culture. Settlers were literally both guardians and interpreters of culture. In the role of guardians, they protected works of art—as valuable commodities—from possible appropriation or abuse by working people and thereby satisfied the requirements of insurance policies. As interpreters of culture, they were to unlock the spiritual, immaterial mysteries of art to unknowing eyes.

Some of Toynbee's helpers chafed at their roles and suspected that their exalted social status alone did not qualify them to make artistic pronouncements. "Of course, being a cultured person, I know all about Art," recalled one guide in gentle self-mockery. "Someone explained to me, however, that technical knowledge was not really necessary; general intelligence and plenty of imagination were the main things." The unlucky docent, with bemused self-awareness of his own cultural posturing, then recounted the various ways in which the supposedly ignorant East End schoolchildren exposed his own ignorance of art during the course of the guided tour.[19] The guide's narrative highlights the limits of his authority to speak about—and, in a sense to claim cultural ownership of—the objects displayed. His story challenges the conflation of class position and cultural authority on which the exhibition enterprise was based.

Samuel Barnett drew enormous crowds as he led his neighbors through the exhibition.[20] He had rather different reasons for feeling uneasy in his role. "It is interesting to watch the effect of Art as a teacher," he mused.

> I can't make up my mind whether it needs the spoken word or not. Today, people have been so taught to value the surface that unless a word suggests the underneath, people are likely only to think of sound and colour. On the other hand a word may mislead and destroy the silent, far off working of the soul of the painter.[21]

Barnett's indecision stemmed from ambiguities in his understanding of art and the working class. Viewing art, unlike university extension classes, did not demand that working people master skills such as reading and writing that required precious time and space away from the bustle of day-to-day survival. Art spoke in a universal language, so Barnett believed, that transcended the divisive particularities of class and nicely complemented his aspiration that "all sorts and conditions" of men and women would find in art the means to create a shared life. In late-Victorian East London, the spoken and written word palpably reinforced the sense of class difference separating highly literate Oxbridge organizers from their mostly uneducated cockney public. The inarticulateness of art — that is, the inability to articulate its meaning in words — suggested that great art would also be the ideal teacher for, and perhaps even more fully appreciated by, the inarticulate masses of East Londoners. And yet these views were difficult to reconcile with Barnett's belief that the working class desperately needed the guidance of men like himself, who were the true stewards of culture, and with his firm conviction, derived from Ruskin, that the visual sense needed to be trained and exercised. In the event, Barnett's distrust outweighed his faith in both East Londoners' instinctual appreciation for art and the transcendent power of art to speak to working people. East Londoners' access to the paintings was mediated by the ubiquitous voices of the organizers, not only as docents but also as authors of the catalogs.

Guides to the Perplexed: The Exhibition Catalogs

Over the years, producing the catalogs was the task most crucial to the educational goals of the exhibitions. Despite months of advance planning, the conditions under which they were written were far from ideal. They were necessarily composed in the short interval between the arrival of the pictures and the opening, since until that time, the organizers could not be sure exactly which paintings were arriving, what they looked like, and where they could best be displayed. Almost three hundred people were enlisted to help with preparations. Firms including Liberty and Company and William Morris and Company donated their time and goods to ensure that the rooms were ready to receive the precious paintings. Several subcommittees divided the work, which included procuring and insuring paintings, watch and guide work, hanging and decorating, and writing and distributing catalogs.[22]

The catalogs made explicit exactly how Toynbee Hall wanted the poor of Whitechapel to see art. They are extraordinary for their candid revelation of the authors' didactic intentions. The motto for the exhibition, prominent on the cover every year, was Ruskin's aphorism, "Life without industry is guilt, and industry without art is brutality." Quotes from Ruskin's writings dominated the inside and back covers and many entries. Choice selections from Arnold, Browning, Carlyle, Keats, and Plato were also interspersed—the mix of occasional classical references with those drawn from nineteenth-century Britain suggesting that modern Britain was the lineal heir to the great Western tradition.

Approximately half of the paintings were described in the catalogs. The *Toynbee Journal* in May 1886 explained that the catalog

> is intended to teach the people how to look at pictures, and though
> perhaps it points more to the moral than the artistic side of the picture,
> yet it certainly suggests ideas which add an additional charm to the hours
> spent in the room, as well as food for reflection on later days.[23]

There were several qualitatively different kinds of entries that were meant to satisfy the varying levels of sophistication of the viewers: biographical and historical, didactic, narrative and explanatory, hortatory and spiritual.[24] While most entries reflected the interpretive prejudices of their authors, some merely expanded on the themes suggested by the frames that were commissioned by many Victorian artists or purchasers, which sometimes had lines of poetry or prose on them.

Virtually the entire philosophy underlying the settlement movement and its intellectual antecedents could be extrapolated from the choice of paintings and their descriptions. The exhibition committee placed a high value on paintings depicting London life and labor. Committee members favored academic art that, compared to the work of social realists, tended to idealize even scenes of daily life. These canvases were intended to spark immediate recognition from working-class Londoners. Such paintings explicitly connected the rarefied world of artistic high culture with the homely activities and sights of working people: after all, viewers were seeing the landscapes of their own lives before them. Or were they? The very fact of seeing such scenes depicted on canvases in St. Jude's parish schoolrooms, owned by wealthy people who were clearly not their neighbors, emphasized that working people had no control over the artistic representation of the landscapes of their lives. While the actual places depicted were familiar to East Londoners, their representation by "great" artists was not. The authors of the catalogs encouraged the illu-

sion of familiarity between the working-class public and the art objects so that working people would see London, and their place in it, through the eyes of great artists as interpreted to them by the exhibition organizers.

Scenes of the Thames and its bridges were particularly popular, perhaps because they offered a picturesque image that softened the hardness of metropolitan life. According to the catalog, painter W. L. Wyllie, in *A Thames Wharf*, "has found a picture where we find only smoke and swamps, steamers and barges. . . . Here the longer one looks at the pictures, the more one sees how the light . . . pervades even the darkest places."[25] The entry enjoins the viewer to participate actively, to look "longer" at the picture and share the Barnetts' untarnished optimism about the pervasiveness of light. The longer viewers studied the picture, catalog in hand, the more likely that the light of Toynbee Hall culture would penetrate their sensibilities. And the organizers, like most social reformers in Victorian Britain, tended to see laboring people as denizens of dark places. The entry betrays no self-consciousness in its positioning of the viewer as at once a product of darkness and the beneficiary of the literal and figurative light cast both by the painting and by the catalog itself.

The entries make no mention of style, form, or color. This is somewhat less surprising when one realizes that Samuel Barnett, the driving force behind the exhibitions, was color-blind. Barnett literally saw paintings with his moral faculty, since he was physically incapable of appreciating one of the most important elements of painting. But even if Samuel had not been color-blind (Henrietta was not), it is unlikely that the catalogs would have read any differently. Each picture became a vehicle for Toynbee Hall's moral aesthetics and social philosophy, which held that goodness, truth, and beauty were universal.

For all their high seriousness, the Barnetts recognized that their zeal to moralize sometimes led to rather comic distortions of the meaning of a painting. They enjoyed the parodies at their expense that enlivened West End drawing rooms and appeared in *Punch*. Henrietta recalled the reception of one of their too-hopeful descriptions. She had described a bloody scene of Christian martyrdom thus: "God kissed the man and he slept." One viewer thought she might more appropriately have written that "the tiger clawed him and he died."[26]

Nearly every exhibition included portraits of beloved and popular imperial heroes and politicians as well as social thinkers and reformers. According to the catalog, Carlyle was a "man worn with the shams and sorrows of his age" whose books "affect the common opinions and make

their mark on legislation and policy." F. D. Maurice was "one of the world's great Teachers. 'A righteous man, who loved God and Truth above all things . . . stern to all forms of wrong and oppression.' "[27] The Whitechapel Exhibitions could not hope to aspire, as G. F. Watts and the National Portrait Gallery did, to represent all those men of genius who had shaped the destiny and greatness of the British nation.[28] Nevertheless, the catalogs clearly suggested, with no trace of irony or apology, that working–class viewers should be grateful for the sacrifices of elite people like the organizers themselves. It certainly never occurred to the Barnetts and their friends that the laboring classes had made important sacrifices and contributions to the story of Victorian Britain's triumphs.

Other paintings, according to the catalog, demonstrated social principles in action. Langee's *The Widow*, a welfare scene, became a lesson on the nature of true versus false charity: "the woman is giving bread and not love; and neither widow nor child is touched." The entry is more concerned with being faithful to the Barnetts' principles of charity than with exploring the artistic merits of the painting.[29] The catalog entry, then, literally represents the art object not as the artist's work, but as an occasion to offer a concise polemic about a concept of singular political and practical importance to the Barnetts.

Many of the paintings selected for the exhibitions lent themselves to the allegorical and moralistic interpretations Toynbee Hall was anxious to give them. The aesthetics articulated in the catalog reflected not only the cultural philosophy of Toynbee Hall, but also the sensibilities of many of the most important artists of the late-Victorian period. The works of the Pre-Raphaelites, championed by Ruskin, and of the great symbolist painter George Frederick Watts, were conspicuous year after year. Many of these artists were friends and acquaintances of the Barnetts. Holman Hunt, Leighton, and Burne-Jones, among others, served as keynote speakers at opening ceremonies or came to Toynbee Hall during the year to expound their ideas about art and society. Given the Barnetts' prominence in the world of social reform, it is reasonable to assume that their own ideas contributed to the ways in which their artist friends grappled with social issues on their canvases from the 1880s onward.

Watts was a particularly close friend of the Barnetts, and his second wife was a devoted East End social worker.[30] His monumental allegories depicted the cosmic forces of the spiritual universe in various struggles: Love, Life, Death, Time, Beauty, Truth, and Judgment. The Barnetts felt such a close affinity to Watts that a copy of one of his greatest paintings, *Time, Death, and Judgment*, was executed in mosaics on the porch of St.

Jude's. Like the frescoes of medieval Venice, Watts's work was intended to be a public treasure enjoyed daily by the passing workers. Matthew Arnold came to Toynbee Hall to unveil the mosaic. "The standard of life must be raised," he announced, "the domestic affections and the social impulses cultivated and purified, the sense of beauty quickened." The Whitechapel Picture Exhibitions, Arnold observed, "appealed to the sense of beauty." But "the feeling for beauty" and "social sympathies" were "ineffectual and superficial" unless they were touched, as Watts's art was, with "a deep connection with religion."[31]

Men Pickaback Angels: Responses to the Picture Exhibitions

In late-Victorian Britain, the boundaries between the secular and religious domains were increasingly difficult to determine. Secular institutions, like settlements and polytechnics, claimed to tend to the spiritual needs of the poor while slum churches (including St. Jude's) served secular functions as centers for the improvement and entertainment of surrounding working-class communities.[32] Museums in late-Victorian Britain reflected the confusion and overlap between secular and sacred institutions, especially in their aspiration to represent the cultural life of the nation.

Carol Duncan argues that museums function as sites of quasi-religious rituals of secular citizenship.[33] Her position aptly characterizes the Barnetts' conception of their exhibitions. The Barnetts held their exhibitions around Easter in part because they felt that "pictures in the present day take the place of [biblical] parables."[34] The Barnetts saw the exhibition as a kind of surrogate religious experience, one that would attract a much wider public than sermons and sacraments. By explicitly linking Easter — the most significant ritual event in the Anglican calendar — with the exhibitions, the Barnetts implied a kind of equivalence between the expression of God's universal and impartial truth and love of the people through communion and through viewing great art.

Many of the Barnetts' contemporaries felt that pictures were a poor substitute for sermons and criticized the exhibitions for contributing to the dangerous blurring of the sacred and the profane. For their critics, the sacramental language the Barnetts used to describe the effects of great art and their insistence on keeping the exhibitions open on Sundays confirmed the enormity of their error. John Girton, the ever-vigilant secre-

tary of the Lord's Day Observance Society, wrote to the bishop of London denouncing the Barnetts in May 1881:

> The Committee have watched with great regret the Sunday concerts of which for some years St. Jude's Schools have been the scene, and they regard this recent Sunday Art Exhibition as only more serious and flagrant instance of contempt for the sacred character of the Lord's Day. Barnett's ties with Lord Rosebery and the President of the Royal Academy—so closely associated with the Exhibition—vexes more.[35]

Girton found a sympathizer in the bishop. Barnett was forced into a stance of respectful disagreement with his episcopal father. Sunday was the sole day free from the burdens of work for most East Londoners. Barnett could not "think that you [the bishop of London] would say 'It is better for the sake of old Sunday associations to keep the people amid the paralysing and degrading sights of our streets' rather than bring them within view of good and perfect gifts of God.' "[36] "Old Sunday associations" were more important to Bishop Jackson than Barnett supposed. He was angry at Barnett but did not ban the exhibitions outright. Barnett persevered and, in 1892, the archbishop of Canterbury lent his prestige to the event by inaugurating the exhibition on a Sunday afternoon.[37]

While the exhibitions focused debate within the Anglican community about the religious or irreligious effects of art and culture, the Barnetts and Toynbee Hall residents were unequivocally pleased with their work. And so, apparently, was most of East London. Attendance rose dramatically during the first decade: 10,000 in 1881; 26,000 in 1882; 46,763 in 1885. In 1886, three rooms were added to the school to accommodate the huge crowds, which peaked at 73,271 in 1892. In April 1890, the *Toynbee Record* described the visitors:

> The rooms present the same spectacle as in other years: family groups; parties of school children, brought by teachers or friends who value the power on young minds of sights of beauty and of truth; working men who turn in from their day's work to spend half-an-hour in another world; young men who are finding life hard and vice easy; and others, with their sweethearts, who are travelling prosperously along; working women, house-wives, factory girls, shopkeepers, teachers, these and a hundred others are there, and, either by themselves or by getting help from others, are in some way and in some measure enjoying the pictures.[38]

What drew these crowds into St. Jude's? The *Toynbee Record* offered its own rather self-satisfied explanation: "Sunday opening, a simple catalogue, willing helpers, and a firm determination on the part of those

around to make it a success, have brought more to it [the exhibition of 1891] in three weeks than go to the National Gallery in three months."[39] Even more remarkably, approximately one in three visitors purchased an exhibition catalog that cost one penny.[40] Since many visitors came in families or in groups of schoolchildren with their teachers, virtually every visitor would have had access to the catalog. Observers without fail mentioned the zealous attention working people gave to the catalogs.

Toynbee residents were very anxious to gauge the tastes of Whitechapel. Visitors were asked before leaving the exhibition to vote for their favorite pictures; children's votes were kept separate from those of adults. In 1894, for example, 20 percent of the visitors voted, most of them men. Narrative paintings always headed the poll, while landscapes were consistently the least popular. Bourgain's *Washing the Deck* narrowly edged out S. S. Solomon's *Orpheus* and Hacker's *Annunciation* in 1894. The *Toynbee Record* believed that Bourgain's picture was the favorite because it appealed "to men by its cleverness, its action and its interesting detail; perhaps too the lucid and picturesque description in the catalogue may have had something to do with its popularity."[41] Only two years later, however, the *Toynbee Record* conceded that the favorite-picture poll is "hardly the accurate test of the preference of East Londoners that it was intended to be."[42] While the *Record* did not explain its change in views about the accuracy of the polls, Frances Borzello aptly suggests that the placement of pictures, more than East Londoners' genuine preferences, determined their popularity in the poll.[43]

By statistics alone, the exhibitions appear to have been an overwhelming success. And yet the surprisingly large attendance raises several questions. Was Toynbee Hall tapping a demand for viewing art that already existed in East London? Was a taste for viewing art compatible with working-class life and culture? Or had the settlement succeeded in stimulating a desire for narrative and academic art? Statistics alone offer little guidance in answering such questions. They say nothing about what working people thought about the exhibitions and the paintings. The fragmentary anecdotal evidence about working-class responses to the pictures suggests, not surprisingly, that working people brought their own problems and needs to bear on how they interpreted art.

Part of the success of the exhibitions must be attributed to the fact that Toynbee Hall made few demands on visitors. Unlike in the National Gallery and the British Museum, no hushed and reverential silences were enforced or desired. Only unaccompanied schoolchildren were turned away, and, according to the surviving sources, no incidents of unruliness

marred the exhibitions. The *Toynbee Record* observed, without condemnation, that

> for some their hour of picture seeing is a time to laugh and talk; for
> others a time to take their pleasure sadly; and for a few (if the watchers
> be not wary) a time to sleep . . . and for those who laugh always, or are
> wholly sad—and even for the sleepers, if they do but dream—this hour
> among the pictures is not without a benefit.[44]

Henrietta Barnett recognized that despite the guidance offered by docents and catalogs, working people had their own ideas about what they saw. One man felt that Watts's *Sleep and Death* violated good taste: "I don't call it proper, anyhow, to see a man pickaback of an angel!"[45] Some of the comments Barnett overheard obviously pleased her. She felt that Schmalz's painting *Forever*, which depicted a dying girl and her lute-playing suitor who vows eternal love, stirred new feelings in two working girls:

> I was standing outside the Exhibition in the half-darkness, when two
> girls, hatless, with one shawl between them thrown round both their
> shoulders, came. . . . 'Real beautiful, ain't it all?' said one. 'Ay, fine, but
> that 'Forever,' I did take on with that,' was the answer. What work is
> there nobler than that of the artist who, by his art, shows the degraded
> the lesson that Christ Himself lived to teach.[46]

Comments were usually more practical. The probable value in pounds sterling of the paintings and their frames evoked considerable attention. Henrietta Barnett mentioned working-class interest in the frames to add a piquant and condescending tone to her story; but in fact the ornate gold frames favored by Victorians did call attention to the monetary value of both frame and painting—and, implicitly, to the wealth of the owners as well. Many East End visitors assured the Barnetts, to their annoyance, that their lovely show was sure to make good money, notwithstanding the free admission. Working people viewed paintings as yet another type of commodity they were intended to consume. For example, a young woman "thought she gave proof of unusual intelligence by remarking of Mr. Albert Moore's three classic maidens *Waiting to Cross* that 'they reminded her of nothing so much as the United Kingdom Tea advertisement.' "[47] Such comments suggest that at least some working people believed that the exhibitions were intended to substitute the commodities of culture for the commodities of industrial capitalism served up to them at great profit by pubs and music halls. In this way, the art-viewing audience in Whitechapel subverted the Barnetts' vision of culture as a means

to transcend the degradation of a commodity culture. If, as Carol Duncan has argued, the museum context seeks to convert "what were once displays of material wealth and social status into displays of spiritual wealth,"[48] the responses of some East Enders indicate their refusal to be fooled.

For some East Londoners, the exhibitions were at once painful and re-velatory experiences. Clara Grant, a schoolteacher and settlement worker in South London who served as a docent for the St. Jude's Exhibitions, recalled the impact of several paintings as well as her words on a man in the furniture repair trade. What makes Grant's account so stirring is not only the man's complex experience of the paintings, but also the extent to which this encounter shaped Grant's own views about museums, museum audiences, and the politics of class and culture.

The painting *The Legend of Provence*, Grant recalled, "tells of Sister Angela, the convent child, enticed away by a young foreign knight."

> In after years she returns to the convent, disillusioned and hopeless, to beg readmission, and waiting at the gate, she sees a vision of herself as she might have been, and a greater vision of the Blessed Virgin who assures her that none within know of her absence, for she kept her place.[49]

"This story thrilled many of the visitors and I told it to group after group," Grant wrote. In a world where prostitution and petty theft were all too often economic necessities, this vision of redemption, and Grant's noncondemnatory reading of the painting, spoke to genuine concerns of East Londoners. "One evening," Grant continued, "I noticed a man, apparently a workman, with a remarkably fine face."

> He lingered until I was alone, and then said, "do you think that a true and safe doctrine to teach, that we can start again after wrong doing?" I tried, unavailingly I think, to make him see that, though scars may remain, justice demands and the Christian faith confirms, the right to a fresh start. Later in the evening I found him in another room wrapped in thought before the *Prodigal Son*.[50]

The denouement of this extraordinary exchange occurred a year later when Grant met the man again and agreed to have tea at his house. He confessed to her that he was still tormented by guilt because he had stolen a book from a wealthy home several years ago.

This story shows that at least some East Londoners were deeply engaged by the paintings and saw in them commentaries on their own lives. Clearly, this man discovered contradictions in the exhibition that were deeply rooted not only in his own experience as a laboring person,

but also in the ideology of its promoters and organizers. His own experience of alienation and exclusion belied the naively optimistic message of social and spiritual betterment preached by docents and catalogs. He could only gain access to the culture symbolized by the stolen book by violating the moral and legal codes of the literate world in which he sought to participate. In this way, he remained caught between his desires to share in the culture of the elite and the economic realities of his life, which materially excluded him from this culture.

The encounter also affected Grant's ideas about museums and art. She inveighed against the concentration of art in large national galleries and in private collections:

> How delightful it would be if every town and village had its own little museum and art gallery, enshrining natural products, its local history and folk-lore, and its crafts and industries illustrated by local talent or by actual specimens, together with a few masterpieces housed permanently or on loan.[51]

Perhaps the most poignant response was that of a docker who ventured into the exhibition during the year of the Great Dock Strike of 1889. As many historians have noted, the dock strike was a turning point in the history of labor and contributed to growing public sympathy for independent industrial and political action by laboring people. The docker stopped to look at *The Bridge of Life* by a friend of the Barnetts, the socialist–idealist artist Walter Crane. The catalog entry explained that "worn by weakness, the man depends on a woman's help till lighted by religion alone he is again embarked on the stream of eternity." Apparently, the stevedore was not convinced. He told John Burns, leader of the strikers, that he "wished I hadn't come here. My house'll seem a deal more squalid and dreary now that I've seen a picture like this."[52]

This episode suggests that at least to some extent the exhibitions were instruments of social control. It can be argued that the organizers attempted to use Crane's painting to present working-class East Londoners with a passive, private, and nonconflictual solution to their economic misery. For this docker, who would participate in one of the great dramas of class politics in Victorian Britain, the interpretation of Crane's painting — and presumably of the social role of art as well — offered by the organizers was not convincing. His thoughts were not directed to "the stream of eternity" but instead to the very real and immediate squalor of his own circumstances. This evidence suggests that the catalog descriptions and the exhibitions as a whole strove to create the illusion that

workers were actively promoting their self-betterment by viewing art while in fact they were being diverted from more directly challenging the basis of power in society.

This reading, however, is incomplete because it fails to consider the role played by the Barnetts and Toynbee Hall during the strike. Samuel Barnett was among the most influential figures to support the cause of the strikers, and residents, including Hubert Llewellyn-Smith and Vaughan Nash, were key actors as organizers and historians of the event.[53] Despite the settlement's official stance of political neutrality, Barnett's heart was clearly with the dockers, and he wondered, in private, "how to give those feelings expression."[54] In his annual parochial address to St. Jude's, he stressed that the dockers had "felt the ennobling impulse which belongs to common action and common suffering."[55] So direct economic and political action by laboring people, and not only their viewing of great art, could generate the "ennobling impulse[s]" that Barnett believed were essential to remaking East London.

How then should we assess the ambiguities of the statistical and anecdotal evidence of working-class response to the exhibitions? The exhibitions were blockbusters that galvanized the attention of the press as well as very large numbers of East Londoners. Statistical evidence tells us that the exhibitions were undeniably popular and that working people enjoyed going to see the pictures. This finding is in itself notable, for it disaggregates specific cultural activities like museum going as the exclusive behavior of the bourgeoisie. There is no reason to believe that in attending the exhibitions working-class East Londoners were betraying (or seeking to escape from) their culture or class.

Anecdotal evidence suggests that Toynbee Hall could not dictate to working people how to feel about art or culture. While visitors scrutinized the catalogs, they attached to the paintings their own meanings, which grew out of their life experiences and social-economic position. Toynbee Hall hoped to connect lofty interpretations of art with a morality tale of everyday life; but working people tended to link what they saw to the concrete economic and political struggles of daily life in East London.[56]

Small Doses of Culture, Charity, and Amiability

Critic Robert Lumley has argued that "museum architecture provides a useful point of entry into the discussion of the visiting public because it stands metaphorically as well as physically for the structures that define

the boundaries between 'inside' and 'outside.' "[57] Lumley might have added that it is also a useful point of entry for illuminating the aspirations of the museums' founders. This is certainly true of the Whitechapel Free Art Gallery, the permanent picture gallery that evolved out of the St. Jude's Picture Exhibitions. The Barnetts had long cherished hopes of building a permanent gallery, which, like T. C. Horsfall's in Manchester, would be associated with their settlement house. From the outset, they hoped that their friend and fellow worker C. Harrison Townsend would design the building.[58] By 1898 Barnett persuaded Passmore Edwards to give money for a gallery to be erected adjacent to the public library he had financed several years earlier.[59]

Wedged into a narrow space on Commercial Street, the gallery, according to Nikolaus Pevsner, is "an epoch making building."[60] Townsend attempted to translate the spirit and ideology of the arts and crafts and settlement movements, with their many common sources, into architecture.[61] The building is self-consciously asymmetrical in the placement of its windows and entrances (fig. 2.1). Its neo-Romanesque arched doorway with a glass-paneled half-moon window was one of Townsend's signature motifs. Trees of life, suggesting the letter 'T' for Toynbee as well as the mythical Igdrasil (the tree of life of Norse mythology) of Carlyle's *Past and Present* and William Lethaby's *Art, Architecture and Mysticism*, wind their way on either side of the edifice.[62] A large blank space was left on the portico between the two towers to be decorated with a mosaic by Walter Crane proclaiming "The Sphere and Message of Art."[63] Crane's mosaic, never executed for lack of funds, was meant to illustrate the close relationship between the working class and culture, which, personified as a goddess, sat enthroned in the center of the design.

Townsend was equally attentive to the "artistic effect" of the interior. A writer for the *Sunday School Chronicle* praised the "artistically toned walls" and the plentiful light from the vaulted skylight.[64] But the reporter for the *Saturday Review* found the whole atmosphere strained and unnatural. He wondered whether

the prophets of the Arts and Crafts Movement have any qualms when they see the 'cosy corners' of suburban villas expanded into this sort of thing. The walls were coloured with picture-extinguishing hues of crimson and brick red, and hung, under raking top lights.[65]

How are we to interpret the meaning of this building? Townsend's design captures an essential paradox of the cultural mission of the exhibitions and later the gallery. While they strove to create a common culture,

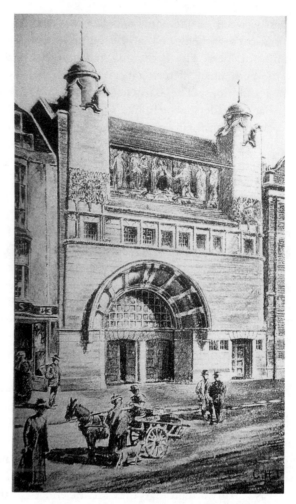

Fig. 2.1. This artist's drawing of the Whitechapel Fine
Art Gallery appeared in the *Daily Chronicle* on December
10, 1898, and, rather wishfully, included Walter Crane's
design for the mosaic "The Sphere and Message of Art."
Photograph: Hampstead Garden Suburb Archives Trust.

to bring the joys and beauties of art to the people of London, they re-
mained committed to their own cultural forms. The design of the gallery,
both interior and exterior, can be fully understood only within the idiom
of arts and crafts architecture of the turn of the century. Few were trained
to decipher the supposedly universal and democratic messages of the
building itself.

A South Hackney artisan who attended many of the cultural offerings at Toynbee Hall offered an unusually virulent assessment of the politics of class and culture of the promoters of the exhibitions and later the gallery. He remarked, in undisguised annoyance at the idealism of the Barnetts, that "if you are naked and hungry and foolish, in need of everything, it may not be helpful to start with the certain persuasion [as Toynbee men did], that you are rich and in need of nothing." He continued, "The failure in culture is somewhat greater in the case of the cultured, ruling, ordained, reputable classes than it is even among working and drunken classes."[66] While the writer of these letters exaggerated the Barnetts' reliance on cultural philanthropy and ignored their commitment to bettering the material conditions of East End life, he nonetheless raised profound questions about the relationship of working-class and bourgeois cultural practices. We do not know what the recipient of this provocative tirade, William Beveridge, father of the post–World War II welfare state and at that time a settler at Toynbee Hall, wrote in reply. But we can gauge the extent to which the elite men and women who organized and staffed the exhibitions were affected by their perceptions of working-class responses to their efforts.

From the outset, the organizers consciously attempted to create a context for viewing art that would minimize working people's discomfort and sense of unfamiliarity. Sunday openings, no admission charge, doors open to all, encouragement of commentary and conversation, the refusal to criticize those who came merely for shelter—all of these policies reveal a commitment to mold the exhibitions to the perceived needs of its intended working-class audience. The exhibition policies of the permanent Whitechapel Free Art Gallery incorporated lessons learned from the exhibitions. The leaders of the gallery launched a path-breaking educational program that included loans of high-quality reproductions to poor people, free magic-lantern lectures, and exhibitions of work by local artists and children from the local Board (publicly funded) schools. In this way, East Enders were recognized as producers of art, not just consumers. In response to the high density of Jewish immigrants in Whitechapel, the gallery opened a highly acclaimed exhibition on Jewish life and art—all the more remarkable because this was a period of growing tension between Jews and non-Jews competing for jobs in East London.

If culture was the talisman of the first generation of Toynbee settlers, two decades in East London chastened even the most starry-eyed dreamers. At the turn of the century, William Beveridge, recently up from Balliol College, explained to his disappointed mother why he had aban-

doned his legal career to live and work at Toynbee Hall. "I am not going to Toynbee Hall to help in soup kitchens, or bestow genial smiles on horny handed mechanics," he insisted. "If anyone ever thought that co- lossal evils could be remedied by small doses of culture and charity and amiability, I for one do not think so now."[67] Beveridge's dismissal of cul- ture as a remedy for "colossal evils" and his marked preference for social scientific investigation and economic solutions were more sweeping and disdainful than the attitudes of most of his contemporaries.[68] But his re- marks draw attention to a subtle and evolving shift in the way Victorian social reformers, including the Barnetts, approached poverty. As reform- ers deemphasized personal contact and cultural philanthropy, they turned increasingly to those bureaucratic and statist measures that we so rightly associate with Beveridge's own contributions to the making of modern Britain.

The exhibitions, like other late-Victorian museums, undeniably aimed to promote, in the words of Tony Bennett, "a general acceptance of rul- ing-class cultural authority."[69] Unlike other galleries and museums, however, the exhibitions and their promoters were highly critical of the callous selfishness of their own class for failing to offer remedies to the spiritual and cultural poverty of the urban poor.

The Barnetts and their supporters realized, albeit incompletely, that perceptions of the meaning and purpose of the exhibitions and paintings were mediated by individuals' class positions and experiences. Canvases that they insisted on seeing as uplifting morality tales sometimes merely reminded working-class East Londoners of the poverty and hopelessness of their lives. What evidence survives suggests that working-class East Londoners challenged the ideological underpinnings of the exhibitions and, by implication, the organizers' authoritative claims to control the meaning of the paintings. Significantly, however, it must also be admit- ted that the organizers were unusually attentive to and respectful of what their public said and thought about the exhibitions and that, by any stan- dards, they succeeded in encouraging large numbers of laboring people to choose to use their limited leisure time to view fine art at least once a year.

There is much about the history of the St. Jude's Picture Exhibitions that must strike us today as absurd or condescending. The sheer wishful- ness of the enterprise evokes contempt as much as admiration. Yet, it would be an error to dismiss the exhibitions as a "misuse" of art—as a kind of mad hatters' tea party emblematic of misguided Victorian do- gooders. Museums still must grapple with many of the problems that the

Barnetts confronted in the 1880s. In some respects, the history of the exhibitions offers lessons to museums today as they come to terms with accusations of elitism and insensitivity to the cultural aspirations of their diverse publics.

Notes

I would like to thank Daniel Sherman for his insightful and patient criticisms of this essay and Maghan Keita and Adele Lindenmeyr for their helpful comments.

1. *Punch*, April 24, 1897.

2. Clement Attlee, William Beveridge, and R. H. Tawney are but a few of those whose influential careers in British politics and social reform began under the Barnetts' tutelage as residents at the settlement. There are two recent published studies of Toynbee Hall: Asa Briggs and Anne MacCartney, *Toynbee Hall, The First One Hundred Years* (London, 1984); and Standish Meacham, *Toynbee Hall and the Search for Community* (New Haven, Conn., 1987). See also Seth Koven, *Culture and Poverty: The London Settlement House Movement, 1870 to 1914* (forthcoming).

3. The only other study of the exhibitions is by Frances Borzello, *Civilizing Caliban, The Misuse of Art 1875-1980* (London, 1987). As her title makes evident, Borzello believes that there are correct and incorrect uses of art. My aim is not to argue that the Barnetts' use of art was "correct," but rather to reject such issues as irrelevant to the historian's task. Borzello imposes an artifical distinction between art as "elevation" and as "education" and ascribes the former notion to the Barnetts, the latter, more democratic, to William Morris. In fact, the Barnetts were anxious to promote East Londoners' direct participation in the production of art as well as their instruction in its appreciation. While C. R. Ashbee was a resident at Toynbee Hall, and with Samuel Barnett's initial support and approval, Ashbee established the Guild and School of Handicraft, which provided East Londoners with training in arts and craftsmanship. At the turn of the century, the Whitechapel Free Art Gallery encouraged East Londoners to produce their own art through periodic shows devoted to local artists, both adults and children. By failing to place the St. Jude's Exhibitions within the larger context of the Barnetts' efforts, moreover, several of Borzello's criticisms fall wide of their mark. For example, Borzello asks rhetorically, "What would happen, they [reformers] wondered, if we were to concentrate on improving the poor's characters instead of their material surroundings" (p. 30). But in fact reformers did not isolate cultural philanthropy from a much more complex and comprehensive program of reform.

4. See Standish Meacham's excellent *A Life Apart, The English Working Class 1890-1914* (London, 1977).

5. See Gareth Stedman Jones, *Outcast London, A Study in the Relationship between Classes in Victorian Society* (Oxford, 1971); and "Working-Class Culture and Working-Class Politics in London, 1870-1900: Notes on the Remaking of a Working Class," *Journal of Social History* 7, no. 4 (Summer 1974).

6. See Catherine Williams Morley, *John Ruskin: Late Work 1870-1890, The Museum and Guild of St. George: An Educational Experiment* (New York, 1984), p. 75. Morley's book, which is a reprint of her 1972 thesis at the Courtauld Institute, is a fascinating though uneven study of the later works of Ruskin, especially strong at showing Ruskin's borrowing from Plato, his ideas about music, and the interconnections between the grammars and the Guild Museum at Walkley. She claims that only Ruskin himself understood the display of objects at the museum.

7. According to E. T. Cook, editor of Ruskin's works and the Barnetts' chief lieutenant in arranging the exhibitions in Whitechapel for several years, Ruskin was pleased with the

location of his museum. The site chosen was characteristic. The museum was worth walking a mile or two to see, Ruskin thought, and he perched it therefore on a hill. It was a stiff climb to Walkley. This was symbolic, Ruskin used to say: "The climb to knowledge and truth was ever steep, and the gems found at the top are small, but precious and beautiful." (John Ruskin, *Collected Works*, ed. Cook and Wedderburn, [hereafter cited as *Ruskin*], vol. 30, p. xliii.

8. *Ruskin*, vol. 26, p. 204.

9. *Ruskin*, vol. 34, p. 250.

10. Henrietta Barnett, "Pictures for the People," *Cornhill Magazine*, March 1883, reprinted in *Practicable Socialism* (London, 1888), p. 109.

11. One of Ruskin's self-chosen disciples, T. C. Horsfall, offered the Barnetts a more practical example of how to translate his principles into reality. The Barnetts were longtime friends of Horsfall, and Toynbee residents often visited Horsfall's museum, which later was closely linked to the Ancoats University Settlement. Since the late 1870s, Horsfall had insisted on connecting high art and popular culture along Ruskinian lines. See T. C. Horsfall, *An Art Gallery for Manchester* (Manchester, 1877), and Horsfall, "Painting and Popular Culture," *Fraser's Magazine*, June 1880, p. 849. See also Michael Harrison, "Art and Philanthropy: T. C. Horsfall and the Manchester Art Museum," in *City, Class and Culture, Studies of Social Policy and Cultural Production in Victorian Manchester*, ed. Alan Kidd and K. W. Robert (Manchester, 1985).

12. Henrietta Barnett, "Pictures for the People," p. 113.

13. Scott Holland quoted in James Adderley, *In Slums and Society* (London, 1916), p. 48.

14. While there is no similar study for Britain, Daniel Sherman has explored the phenomenon of provincial art museums with insight in *Worthy Monuments: Art Museums and the Politics of Culture in Nineteenth-Century France* (Cambridge, Mass., 1989).

15. For an interesting summary of this controversy and various philanthropic bequests of art to the nation, including that of Henry Tate, see Mark Reid, "A Gallery of British Art," *MacMillan Magazine*, November 1890, pp. 73–80.

16. *St. Jude's Parish Magazine*, May 1889, p. 44.

17. Henrietta Barnett believed that women as "pleasure-givers" were in fact particularly well suited to serve as "cicerone" in explaining the beauties of art to the poor. See Henrietta Barnett, "Women as Philanthropists," in *The Woman Question in Europe, A Series of Original Essays*, ed. Theodore Stanton (Syracuse, N.Y., 1895), p. 125. Internal evidence suggests strongly that the essay was written in 1883, though this is not noted anywhere in the volume.

18. Henrietta Barnett, "Pictures for the People," p. 177.

19. "The Experiences of a Guide at the Picture Exhibition," *Toynbee Record*, April 1901, pp. 83–85. By 1901 the exhibition was held in the newly opened Whitechapel Art Gallery, not in the St. Jude's schoolrooms.

20. See the *Pall Mall Gazette*, April 28, 1886, p. 2 for a description of Barnett leading East Enders through the pictures. A Frenchman visiting Toynbee Hall in 1897 also left a vivid account of the exhibitions and Barnett's explanations of pictures: M. Guerin, "Un settlement anglais: Notes sur Toynbee Hall," *Musée Social*, August 1897, pp. 371–72. See also Henrietta Barnett, *Canon Barnett: His Life, Work, and Friends*, 2 vols. (London, 1918), vol. 2, pp. 154–55.

21. Samuel Barnett to Francis Barnett, April 19, 1884, F/Bar/8, Barnett Papers, Greater London Record Office, hereafter cited as GLRO.

22. Henrietta Barnett, "Pictures for the People," pp. 176–78. See also Henrietta Barnett, *Canon Barnett, His Life, Work and Friends* (New York, 1921), chapter 40.

23. "The Exhibition Catalogue," *Toynbee Journal*, May 1886, p. 65.

24. Comparisons with contemporary catalogs from other exhibitions indicate just how different the Whitechapel Exhibition catalogs were. The catalog for Royal Academy of Arts exhibitions cost one shilling and occasionally matched a quote from the Bible or an eminent historian to a biblical or historical canvas. These entries have no didactic or interpretive quality. The catalogs of the Society of British Artists limit themselves to the price of the painting, the name of the painter, and the title of the painting, with a very occasional thematic quote.

25. Exhibition catalog, Whitechapel Fine Art Loan Exhibition 1885, p. 10. Whitechapel catalogs hereafter cited as Catalog.

26. *Life*, vol. 2, p. 160.

27. Catalog 1883, p. 16; 1889, p. 32; 1891, p. 13.

28. Watts's painting of Samuel Barnett eventually joined the pantheon of portraits at the National Gallery.

29. Catalog 1883, p. 8.

30. See Mary S. Watts, *George Frederick Watts*, vol. 2 (London, 1912), pp. 57–58.

31. "Matthew Arnold in Whitechapel," *Charity Organization Reporter*, December 6, 1884, p. 399.

32. See Jeffrey Cox, *The English Churches in a Secular Society* (New York, 1982).

33. See Carol Duncan, "Art Museums and the Ritual of Citizenship," in *Exhibiting Cultures*, ed. Ivan Karp and Steven Lavine (Washington, D.C., 1991), chapter 6.

34. Samuel Barnett to Bishop Jackson, April 3, 1882, Fulham Papers, vol. 2, Lambeth Palace.

35. John Girton to Bishop Jackson, May 10, 1881, Fulham Papers, vol. 2, Lambeth Palace.

36. Barnett to Jackson, May 13, 1881, Fulham Papers, vol. 2, Lambeth Palace.

37. *Daily Chronicle*, April 5, 1892; *Daily Telegraph*, April 6, 1892. On this controversy, see Charles Hill to Archbishop Benson, April 7, 1892, John Girton to Archbishop Benson, undated, Spring 1892; Benson to Hill, draft letter, Spring 1892. Benson Papers, vol. 28, Lambeth Palace.

38. *Toynbee Record*, April 1890, p. 82.

39. *Toynbee Record*, April 1891, p. 79.

40. The ratio of catalogs sold to number of attendees is fairly constant: 34 percent of visitors in 1885 bought catalogs; 32 percent in 1890; 28 percent in 1893; 35 percent in 1895.

41. *Toynbee Record*, May 1894, p. 112.

42. *Toynbee Record*, May 1896, p. 94.

43. For example, Holman Hunt's *Triumph of the Innocents*, the top vote getter one year, was "screened off from the rest of the collection." Borzello raises the question "whether it was pictures as expressions of thought which appealed or pictures hung in eye-catching positions" (*Civilizing Caliban*, p. 102).

44. *Toynbee Record*, April 1893, p. 80.

45. Ibid., p. 116.

46. Henrietta Barnett, "Pictures for the People," p. 121.

47. *Toynbee Record*, May 1895, p. 103.

48. Duncan, "Art Museums and the Ritual of Citizenship," p. 95

49. Clara Grant, *Farthing Bundles* (London, 1931) p. 122.

50. Ibid., pp. 122–23.

51. Ibid., p. 124.

52. Walter Crane, *An Artist's Reminiscences* (New York, 1907), p. 357.

53. Their account was published as *The Great Dock Strike* (London, 1889) and is still considered a classic study in labor history.

54. *Life*, vol. 2, p. 66.

55. *17th Pastoral Address, St. Jude's, Whitechapel*, 1889–1890, p. 26.

56. Barnett himself confessed that "Watts is above the people [coming to the exhibition] or rather he makes a demand on thought which people are too tired or too busy to give" (Samuel Barnett to Francis Barnett, April 23, 1897, F/Bar/170, Barnett Papers, GLRO).

57. Robert Lumley, ed., *The Museum Time-Machine* (London, 1988), p. 8.

58. In 1893, Samuel Barnett and his friend Charles Harrison Townsend, a prominent arts and crafts architect, had already begun planning the gallery (C. Harrison Townsend to Samuel Barnett, March 13, 1894). Townsend submitted plans to Barnett for a proposed art gallery, vestry offices, and a public hall at the Baptist Chapel in Commercial Street (Archives of the Whitechapel Art Gallery). Townsend was an obvious choice for Barnett. He had a deep sympathy for the settlement movement, was known at Toynbee as a lecturer and associate of the settlement, and had served with his sister, Miss Douglas Townsend, on the Picture Exhibition Committee since its inception.

59. Edwards watched his money carefully and never fully approved the avant-garde style and the expense of the Townsend design. See William Blythe to Samuel Barnett, August 5, 1898, quoting Passmore Edwards (Archive of the Whitechapel Art Gallery). Edwards subsequently squabbled bitterly with Barnett and his committee over the name of the gallery, which he rather immodestly wanted named for him. (See Passmore Edwards-Samuel Barnett correspondence, Whitechapel Art Gallery Archives.)

60. Nikolaus Pevsner, *Buildings of London* (London, 1952), p. 421.

61. The writings of Ruskin and William Morris are the most obvious common source of inspiration for many involved in both movements.

62. Lethaby's quirky universalist interpretation of architectural symbols and their application exerted a powerful influence over a small but very talented group of English architects in the 1890s, many of whom produced buildings connected to settlements. The most outstanding example is the Passmore Edwards Settlement (now called the Mary Ward House) in Bloomsbury.

63. The *Daily Chronicle* devoted an entire page to plans for the gallery on December 10, 1898. They included a reproduction of Crane's mosaic with his explanation of the elaborate iconography.

64. "Art in the East End," *Sunday School Chronicle*, March 21, 1901.

65. "East End and West," *Saturday Review*, March 16, 1901, p. 5.

66. M. N. Calman (uncertain attribution because signature is very difficult to decipher) to William Beveridge, December 11, 1904, Beveridge Papers, IIb/4, British Library of Political and Economic Science (BLPES).

67. William Beveridge to his parents, Henry and Annette Beveridge, April 28, 1903, Beveridge Papers, IIa/37, BLPES.

68. For an illuminating portrait of Beveridge and his Toynbee Hall years, see José Harris, *William Beveridge, A Biography* (Oxford, 1977).

69. Tony Bennett, "Museums and 'The People,' " in Lumley, ed., *The Museum Time-Machine*, p. 64.

3

"An Elite Experience for Everyone": Art Museums, the Public, and Cultural Literacy

Vera L. Zolberg

Art museums have the dubious distinction of winning accolades for cultural merit and brickbats for cultural exclusiveness. On the one hand, they are praised for collecting and preserving works of art for a discerning public; on the other, they are called upon to draw into that public a population with little understanding of fine art. How can the art museum provide a safe haven for high art while catering to a crowd it did not select? Achieving one aim may be at the expense of the other. Placing these issues in the context of larger debates about cultural literacy and equality of opportunity sheds light on the role the art museum plays in creating and maintaining the public's variable aptitude for "appreciating" art.[1]

Democratizing art, in the words of Joshua Taylor, then director of the National Collection of Fine Arts at the Smithsonian Institution, means providing "an elite experience for everyone."[2] As opposed to accepting visitors who come of their own accord, the art museum's duty should be to seek out those who would normally not enter. But in the face of pressure to educate the public, the standards of quality that museum professionals themselves have participated in establishing may seem to be imperiled. Reformers have called for both democratization *and* professionalization. In times of scarcity, however, when museums face hard choices, it is almost always the public mission of democratization that is set aside.

To understand these patterns, it is useful to begin by disaggregating the notion of the art museum's "public." Although some American art museums were once unique in undertaking to educate what they defined as the public, they are no longer alone. Similar developments also have been taking place in European art museums. Comparing American and European art museums reveals, however, that everywhere they have a long way to go to accomplish their democratizing mission. In part this is

because, unlike education more generally, art education is not defined as a social right that either the state or cultural institutions should be called upon to implement.

In addressing the problem of the museum's dual mission from the standpoint of the public, I want to argue that the art museum owes that public more than many museum people care to acknowledge. Misunderstanding of the public and its wishes is endemic to museum professionals, both in the United States and in Europe. Nevertheless, as recent practice shows, when art museums initiate effective programs, they bring the goal of democratization closer to reality. Paradoxically, the controversial nature of these policies may be a sign that accomplishing the public mission is closer to attainment than seemed possible only a few years ago. In the process, however, conventional ideas about elite art and popular culture are being challenged and reconstructed.

What Public? What Art Museum?

Speaking of the museum public and the museum's public mission has little meaning unless we look at how the public is defined in relation to the museum and the museum's commitment to educational practice. Relatively speaking, major American public art museums have a considerable track record in the field of education, even though the level of implementation and the type of public to which educational services are effectively directed are often less impressive than is claimed. Understanding these patterns is made difficult by the fact that art museums vary so much that it is nearly impossible to consider them under one rubric. They range from huge "public" institutions with encyclopedic collections to small ones hardly removed from galleries. Their collections may be so specialized that they contain the oeuvre of only a single artist, or they may have no permanent collection at all.[3]

Typically, the public for art museums has tended to consist of a body of visitors and members who enter museums of their own volition and, until recently, with little active effort by the art museums themselves to seek others beyond this self-selected core. In recent years many art museums and other cultural institutions have undertaken, for various reasons, to study their visitors and members. These studies vary in quality and depth, but despite some methodological failings, they provide a basis for assessing the character of museum publics.

The results of many studies on the publics of performing arts (theater, music) and a broad range of museums carried out over several years were

carefully reanalyzed by sociologists Paul DiMaggio, Michael Useem, and Paula Brown. Among their findings was that art forms and institutions vary in their attraction to a broad cross section of society. Their publics are stratified according to income or educational attainment or both. Live performing arts events tend to draw more affluent groups because of their relatively high ticket prices. High-culture music and theater, in addition, appeal to a well-educated, largely professional or managerial segment of the public.[4]

On the whole, museum publics are somewhat more representative of the American population generally than are the ticket-buying public for performances. They include a younger, less affluent cross section of society. Much of the difference, however, is accounted for by the fact that, unlike most other cultural activities, museums attract many school-age children brought in class groups.[5] Moreover, science and history museums attract a more popular stratum than do art museums. In fact, of the more than three hundred studies from all sorts of cultural institutions, government agencies, and performing groups that were examined, art museums were among the least likely to bring members of lower-status groups into their purview. Instead, the authors note that "the publics for art museums were better educated, wealthier, older, and composed of more professionals than visitors to history, science, or other museums." Despite increasing pressure to open access to as wide a social spectrum as possible, and even though large numbers of visitors have flooded in since World War II, art museums have made fewer inroads into the lowest-social-status groups than might be expected. Other reliable surveys generally confirm the findings of DiMaggio et al.[6]

It is worth considering why there are differences between museums. Is art so much more abstruse than science and history that understanding it requires more training of the general public? It is clear that the complexity of the subject matter of these fields is not at issue. On the other hand, the relationship between art museums and the world of art differs from that between science museums and science or between history museums and history. These differences shape the manner in which works are presented to the public, and what kind of public is the target. As a rule, science, natural history, and history museums are much more oriented to the general public than to professional scientists or historians. They devote a great deal of attention to educational programs and, until recently, less to collecting "genuine" specimens. Art museums, on the other hand, appeal to artists, art historians, collectors, and a well-educated public because they display "authentic" works. Given these conditions, it is nec-

essary to ask whether art museums really want to attract the kinds of visitors who are least likely to come of their own accord, or if they should try to do so.

Considerable evidence, both in the United States and in Europe, casts doubt on art museums' desire to devote themselves seriously to the goal of reaching out to the uninitiated. Benjamin Ives Gilman, secretary of the Museum of Fine Arts in Boston, stated in 1915 that "the acceptance of the aesthetic theory may at present be assumed complete. It is not to be expected that any museum restricted to works of fine art will hereafter elect to regard and treat itself as at bottom an educational institution."[7] More recently, in Europe, F. Schmidt-Degener echoed a similar sentiment, which he rationalized by arguing that "if works of art are allowed to express their natural eloquence, the majority of people will understand them; this will be far more effective than any guidebook, lecture or talk."[8] In a public forum held before a lay audience in the early 1970s, the director of the museum of the State University of New York at Purchase stated, "I find it difficult to be a populist . . . I slightly freeze up. The real crises of what face us are not museums at all, but education. More and more are being worse and worse educated. . . . Processes of education shouldn't go on in the museum; in fact, the entry of people could be done best after written or oral general examination." After enthusiastic applause by the audience, Thomas Messer, then director of the Guggenheim Museum, asked, "But *after* they'd paid their admission?"[9] In light of the apparent consensus that the audience reaction represented, it is not surprising that an American art museum educator has said, "Not for nothing is the 20th century art museum likened to the Cathedral and Temple of ages past. It is in the priests' interest to keep the meaning of art a mystery."[10]

Although less-than-welcoming attitudes are not necessarily representative of all museum professionals, they underlie the reluctance of many art museums to support major educational efforts. Just as they differ in what and how they collect, art museums do not offer a single educational program. Some have virtually none, whereas others have implemented elaborate regular activities. In many cases the main purpose of establishing educational programs of whatever scale is to qualify for state and national grants of various kinds. The same reasoning governs why certain American art museums have been counting the numbers of visitors and members for nearly a century. Aside from the self-congratulatory aspect of the exercise, it was a means of certifying to the public authorities of the city or state in which they were located that the museums deserved pub-

lic funds because of the service they provided the community. If they could prove that they were making an important contribution, in many cases they could be exempt from paying real estate taxes, and even gain public funds to cover part of their operating expenses.[11]

Aside from these instrumental goals, however, and despite the perfunctory character of some educational programs, many museum people worry about what notions visitors take away from the museum. They believe that the museum educator is the advocate of the visitor, while the curator is the advocate of the artwork. It does not bode well for the educational mission that in the hierarchy of status internal to the art museum, educators are by far outclassed by curators, both in the United States and elsewhere. Since the museum educator is frequently viewed as a technician at best, and is subordinate to the *real* purpose of the museum, which is to acquire and care for artworks, democratization has a long way to go.

A Devalued Profession

Many museum professionals take the attitude that everyone in an art museum, by the nature of the institution, is an educator. This helps determine the scope allowed educators and education departments in dealing with the public. Whereas some museums seem to believe that merely providing walls, lighting, and labels for pictures is enough education, others organize docent tours, special didactic displays, video presentations, and lecture series. Some museums even carry outreach beyond their buildings to schools or adult groups. Nevertheless, many art museums are more interested in having art historians on their staffs than in hiring educators who have ideas about the public and school programs and contacts with teachers and school bureaucracies. It is not surprising, therefore, that museum educators feel like outsiders in relation to other museum priorities. Yet there is agreement on the need for research on how art is understood so that the creative hunches of effective museum professionals can be systematized and better disseminated to other museums.[12]

Some museum educators characterize their profession as a stepchild discipline because they are the first to feel the ax when budgets are tight, their career ladder within museums is limited and truncated, and external legitimacy for their profession is weak. A museum director summed up this situation thus:

There is no system of accrediting museum educators. There is no system of establishing a measurement of an achievement in the field. There is no career track in most education departments and we find, and it is a source of a lot of talk and discussion, educators wanting to move out of education as quickly as possible because of a certain sense of unworthiness or dead endedness. There is this mood in the field that has been there for the last several years.[13]

In France the profession of museum educator is even less developed than in the United States. Whereas future art museum staff members receive training in art, administrative regulations, and laws related to art, they have hardly any training at all in museum education. A Ministry of Culture publication laying out a development program for museums reminds curators that they are obligated to educate the public in an active manner, reaching out to, especially, young people. They are urged to do this both on the museum's premises and through itinerant programs ("museo-buses") but are given little guidance. Even the state-certified aspirants to the new occupation of *animateur* (guide-organizer) received little information and not much training.[14]

Professionals gain standing and self-esteem in part from contact with their clientele, but art museum educators, poorly rewarded materially, are also short on symbolic support compared to other museum professionals. In the United States, unlike curators whose expertise provides valuable service to donors, museum educators have a clientele that is among the least prestigious groups who come to art museums. Education specialists train part-time volunteers and guide school groups and adult dilettantes through the collections. If educators were more closely integrated with other museum people—curators, directors, administrators, and trustees—their morale might be enhanced and their usefulness to the institution might be better recognized. Their standing is not helped by the attitude of some museum people who continue to believe that education is something that "you have got . . . or you ain't got . . . and you are not going to train it into a person."[15]

The hierarchical ordering within the museum parallels that found in the field of education more generally, where teaching a *subject* competes with teaching a *pupil*. Proponents of the former assume that if students are not prepared to learn, then there is no point in wasting scarce resources on them; those favoring the latter may have skills for "reaching" the pupil but little substance to give.[16] At best the already motivated pupil gains; at worst nothing is taught. It is no surprise that the biggest losers are the children who are most poorly prepared for education. As long

as the situation is not improved, the schools can truly be said to have failed in their democratizing mission. Can the same be said of museums?

Conventional wisdom holds that art museums should not be held to the same standard as instruction with immediate practical consequences for the individual and the society. The assumption underlying this commonly held view is that a taste for the kind of artworks found in museums should be treated as an individual matter with no social consequences. Since, from this perspective, the culture of art museums is not a necessity but a matter of taste, museums should not be blamed for allocating relatively less time, money, and expertise to the broad public than to potential donors. Not everyone agrees with this view. The most influential voice speaking against it has been that of the French sociologist Pierre Bourdieu, whose book *Distinction* sums up his argument in the form of a general treatise on the social embeddedness of taste and its consequences for maintaining inequality in society. His thesis is foreshadowed in one of his first important studies, on the art museum and its publics. Although he conducted his museum research in the 1960s, the findings provide a baseline for comparison with more recent observations.[17]

Taste as Cultural Capital

Bourdieu's project of social analysis (*socioanalyse*) is embedded in a frame that sees a relationship between culture and power in the reproduction of inequality. The art museum has been a link by helping to propagate and maintain certain controlling myths, which Bourdieu charges sociology with the task of exploding. Specifically, the myths he pursues in his research on museums are the following: greatness in art is grasped by some innate quality of the human spirit, not through learning, but through something akin to grace; merely by having access to art, those with this special gift are enabled to manifest this capacity, whereas those lacking it gain nothing and expose themselves to ridicule; since taste is innate, ineffable, and spontaneous, it is difficult to define or specify. In a Kantian sense, those who have the gift compose a quasi aristocracy who have arrogated to themselves the right to withhold their discourses from those outside.

For Bourdieu, the falseness of these ideas derives from their assumption that these capacities are inherent and natural. If taste is innate, or the result of a gift of grace, there is not much one can do to develop it. The myth justifies the maintenance of hierarchical distinctions among different social categories. It has such force that it has come to be imposed on

the self-conceptions of members of groups excluded from access to the fine arts. The acceptance by the excluded of their own denigration and, hence, justification of their subordinate position, makes them no match for those who benefit from their parents' wealth or connections as well as from their own demeanor, or *habitus*.

Habitus, a central concept as Bourdieu defines it, is rich in connotations. It encompasses the idea of "habit," but also much more: a sort of total cultural baggage, varying from stratum to stratum, which is socially valued or devalued by comparison with the *habitus* of others. It is developed in large part by individuals on the basis of their capital. Beyond economic capital (wealth), social capital (connections or networks), and cultural capital (knowledge), individuals have different levels or kinds of ability to manipulate those assets. Their *habitus* varies according to their upbringing, which those to the manner (whether manor or some lesser abode) born carry lightly, as if without thinking. Even though the capital of expertise and wealth may be more directly germane to one's social advancement, competence alone does not determine whether or not one gains and retains employment, nor does cash alone elicit the trappings of status and courteous treatment. Since those who are relatively deprived of economic, social, and symbolic capital have been socialized into the same society as their "judges," they are likely to share a similar assessment of their own standing, and the result is that they feel ill at ease in milieus associated with a status higher than their own. Because art museums have come to stand for the idea of excellence in a highly valued form of culture, to the extent that they fail to distribute their cultural capital in an understandable way to visitors who lack the *habitus* of the regular public, they help to perpetuate the status quo.

These ideas constitute the frame within which Bourdieu and his associates studied many art museums in several countries that at the time differed widely in political orientation: France, Greece, Poland, Spain, and the Netherlands. Despite their many differences, the governments of these countries supported the ideal of opening access to culture for all and actively sought out Bourdieu's research team as a source of counsel. What the researchers found must have caused dismay: their shared ideal notwithstanding, in all the countries the art museums attracted a public that, though not altogether homogeneous, included very few poorly educated individuals from lower-status groups.

One myth to which most give lip service is that artistic preference is an individual matter. If so, it follows that each individual experiences art in a unique manner, and that this occurs randomly, regardless of social back-

ground. The researchers refuted this, finding instead that the experience of visiting an art museum conformed to the social background of their respondents, according to the attributes they *systematically shared* with others. The most salient of these attributes were their family background, educational attainment, occupational status, and dwelling in a small town or a big city. This combination of social characteristics shaped visitors for the experience of visiting the museum, their degree of comfort there, and their overall perception of the museum.

The highly educated, according to Bourdieu and Darbel, came already quite knowledgeable about what works were in the collection; they were likely to have planned their visit to focus on specific works; and they were more familiar with the names of more artists, schools of art, and styles than any of the other groups. They felt at ease, remained longer than other visitors, preferred being far from crowds, and tended to visit either alone or with a competent friend. On the whole, they avoided docents and museum handouts and pamphlets, relying on their own prior reading of scholarly books.

The next-largest category of visitors came from a middle-level occupational background. They shared a high level of intellectual aspiration and were eager to grasp what they could by reading guidebooks, learning from docents, and absorbing information, even if it was not at as sophisticated a level as that of better-educated visitors.

The least educated found the art museum experience unsettling. To them the museum had the qualities of a cathedral, but not the inviting cathedral of Abbot Suger, who designed the Basilica of Saint-Denis to be as attractive as possible to the many, filling it with extravagant sights and sounds, a Disneyland with real gold. Rather, it was more like the austere Cistercian abbey from whose sanctuary Saint Bernard vituperated against gold objects as distractions from devotion and excluded frivolous communicants.[18] Poorly educated blue-collar workers and rural dwellers were ill at ease, felt intimidated by the solemnity they attributed to the surroundings, and were unprepared for the esoteric qualities of the works and unable to understand poorly marked directions, inadequate labels, and seemingly hostile guards. Not daring to ask questions of tour guides for fear of exposing their ignorance, they could not benefit even from what few services were then available. As opposed to the highly educated who preferred a solitary visit, or the middle classes who avidly sought the help of docents, the least educated were more comfortable surrounded by family members and friends. They preferred folklore muse-

ums, whose handicrafts encompassed skills and refinements they could appreciate.[19]

Whereas each art museum presented a single format to its visitors, the predominant *subjective* quality of reception differed sharply for each segment of the public. Perhaps European art museums did not intend to intimidate the less educated, but they made little effort to ease the path for those unaccustomed to the atmosphere they had created.

A New Welcome to the Public?

Reaching out to visitors and providing informative amenities were activities in which most European art museums had lagged behind those in the United States. Studies such as Bourdieu's, commissioned or supported by the cultural services of the countries studied, have led to the adoption of policies intended to overcome their elitism. Although it is not necessarily as a direct result of this research and its recommendations, their galleries are now more likely to combine the paintings of high art with homelier objects such as furniture and ceramics, thereby contextualizing rather than fetishizing art. French art museums are now increasingly being advertised on television, their special exhibits featured on news broadcasts and in other popular media, practices introduced earlier in the United States.

In light of these changes, it would be incorrect to assume that the conditions Bourdieu found many years ago hold for all time, in all places, under divergent institutional and political conditions. In fact, it may be a sign of art museums' success in attracting larger numbers of visitors that they have begun to be criticized for turning fine art into mass entertainment. This accusation has been leveled in particular at the Centre Pompidou in Paris.

By comparison with the usual French art museums, the Centre Pompidou, also known as Beaubourg, is unique in its deliberate commitment to attract a large public by providing the atmosphere of a supermarket of events and exhibitions. It shows art forms and styles that incorporate everyday experience (pop art), new art forms (photography and video art), and "marginalized" art (by women and ethnic and racial minorities) that may be understood without reference to the scholarly aestheticizing discourse of modern art. The center also presents movies and houses the leading French center for experimental music, a public library and reading room, an interactive children's museum, restaurants, and gift shops. These strategies, intended to attract and please new publics, especially of

unschooled museum goers, might be expected to overcome the elitism of ordinary museums and bring in a more popular audience. Unfortunately, this is not altogether the case as the center's own research and that of others reveals.

As Claude Pecquet and Emmanuel Saulnier point out, the achievement of the Centre Pompidou is not in the same class as the late-nineteenth-century French educational reform that rapidly brought about universal literacy. The causes of its failure are embedded in its structure and outlook: "Beaubourg is not national but Parisian in its orientation . . . [it] has absolutely no popular ambition . . . but is exclusively oriented in an elitist direction, and finally . . . Beaubourg has no pedagogic vocation, but is dedicated to what is immediately playful, aestheticizing and consumerist." Their observation is supported by data on leisure practices derived from independent surveys compiled by Gérard Mermet. When urban-rural location is considered, Paris turns out to be the only place where over 50 percent of the inhabitants say they have visited a museum in the previous twelve months.[20]

A separate analysis of the Centre Pompidou's visitors' behavior found that their large numbers were deceptive. Instead of getting the hoped-for democratizing experience, visitors tended to carve out a minimuseum for themselves corresponding to their *habitus*. Nathalie Heinich notes that "the specific audiences for the principal activities have approximately the same characteristics as the audiences for these activities elsewhere: the art gallery audience is similar to art gallery audiences everywhere and the library users are like other library users." She confirms Mermet's observation that "cultural activities (music, theater, museums, etc.) separate the most educated from the less educated French people." In occupation, 60 percent of museum goers are executives or professionals and 49 percent are middle management. The proportion of visitors drops dramatically for lower-level salaried employees and skilled, unskilled, and farm-related workers.[21]

Attractive surroundings, labels, gallery lectures, video presentations, and pamphlets do not prove that either in Europe or in the United States art museums are "reaching" the least reachable. Yet like educational institutions they are increasingly expected to help their public to acquire ease in their relations with colleagues from a variety of milieus — at work or, perhaps even more importantly, in leisure activities — by providing them the substance of a common cultural background. Given the increasing importance attributed to such cultural competence, and its spillover effects on political, economic, and social activities more generally,[22] and

in light of the generosity of the system of public taxation to cultural institutions such as art museums directly through grants and indirectly through tax breaks, it seems obvious that they must give a great deal in return.

This obligation may seem more applicable to nations such as France and some other European countries, where the bulk of cultural support comes from the public coffers, but even in the United States taxpayers sustain art museums in less overt ways. In principle, sources of support for American art museums are more diverse since they, as well as other nonprofit cultural institutions, depend to a considerable degree upon private donations. But as economists such as Dick Netzer and J. Mark Davidson Schuster have pointed out, donors gain a great deal in return. In addition to the symbolic reward of social esteem, they receive the right to deduct a much higher portion of their donations from their taxable income than do most Europeans. From the standpoint of other taxpayers, this constitutes considerable forgone public income and represents hidden subsidies to donors.[23]

The lost income makes poignant the gap between the ideal of democratization and the reality of limited access. This gap is most clearly recognized in the educational institutions that prepare the young for citizenship and occupational roles. It is important to place art museum education in the context of the aspirations for public education more generally.

The Educational Mission: Ideal and Practice

Among social theorists and educational reformers after World War II, T. H. Marshall made one of the clearest statements in support of expanding access to public education. He related education directly to legal, political, and economic rights in order that opportunities for improved social status be enlarged and society function smoothly.[24] Marshall neglected what Bourdieu sees clearly, that the capacity of members of deprived groups to "receive" school culture is already biased by their social origins through their *habitus*. Moreover, even in his own utilitarian and functionalist terms, Marshall did not foresee the changes in modern economies that render obsolete an education destined chiefly to prepare for occupations of manual labor.

By now the importance of educational attainment as a means of rising above a modest background has come to be nearly universally acknowledged. "Cultural deprivation," too, is recognized as hindering members

of the lower classes, especially those who are also members of minority groups, from benefiting from such education as is available to them. Increasingly, higher education is becoming a requirement for a greater proportion of available jobs. When governmental policies do little to help citizens who are in marginal economic circumstances, it is not surprising that many find themselves "truly disadvantaged."[25]

These material problems may seem remote from other forms of cultural capacity such as knowledge, understanding, and appreciation of the arts. Despite recent evidence, the arts continue to be considered a matter of *personal* taste, much as is the preference for certain styles of clothing, furniture, and domestic architecture.[26] These beliefs are contested by reformers who recognize that with the continued expansion of leisure time and of employment made up of work not sharply distinguished from play, education for "quality" or constructive leisure needs to be treated as a necessity rather than a luxury. Yet, typically, education for leisure has been confined almost exclusively to private schools, whereas public educational systems, particularly in poor school districts, treat amateur artistic leisure as a frill.[27]

Education in the broad sense of the term involves acculturation or integration into a common culture, and that acculturation is not confined to formal schooling alone.[28] Having a museum membership or symphony subscription does not open all doors, but just as technical expertise is required at work, cultural competence has social advantages as well. Neither in the United States nor elsewhere, however, have the full implications of this idea been taken into account as a way of improving the professional status of aspiring art museum educators.

Even though art museums are more affected by the trends of society than responsible for them, they are called upon to play a role in preparing the many nonelites of society, including the disadvantaged, to use such opportunities as may become available. One way to do this is to revalorize the art museum's public mission by enhancing education as a legitimate function. How this might be accomplished is the subject of my concluding comments.

Conclusion

It would be easy to brush off the suggestion that the art museum should provide "an elite experience for everyone." Not only does this idea sound utopian, but the central terms of the statement, "elite" and "everyone," seem to constitute mutually exclusive categories. On the other

hand, if instead of the art museum the statement were applied to schools and universities, in light of meritocratic traditions, no political leader would dare suggest that it is acceptable to give up hope of making higher education a possibility for everyone. Yet those who claim that "the love of art" is innate or a gift of grace are doing just that.

It is paradoxical that many American art museum professionals speak as if it is natural and acceptable for those outside their usual public to stay there. They forget that in the United States, a country that only a century and a half ago was characterized as lacking culture, art museums have succeeded, with considerable help from local, state, and, sometimes, national governments, in widely disseminating a belief in the importance of art. Having formed the public for art among the willing by attracting those who would not have entered spontaneously, they now face the more daunting task of creating new publics without jeopardizing the status of the art they are expected to preserve.

Despite the pessimism of supporters of increasing access to art museums, there is reason to believe that enlargement of the pool from which the art museum public is drawn is possible. Concerted efforts by art museums have led to the implementation of imaginative programs and the opening of their halls to new art forms. By giving freer rein to educators to initiate programs that appeal to those outside the ordinary museum networks, they have been surprisingly successful. Acting as intermediaries, educators have coordinated with and introduced exhibits on themes of interest to ethnically and racially diverse groups through churches and other groups. Among prominent museums that have launched initiatives of this kind, the Brooklyn Museum has organized exhibits jointly with smaller, specialized museums and cultural centers to ease entry of new groups into the art museum.

Aware of the multicultural character of its city, the Los Angeles Museum of Contemporary Art now prints educational materials for parents and children in several of the most prevalent local languages, including Spanish, Chinese, Japanese, and Korean. More controversially, art museums committed to acting as alternative spaces, such as the New Museum of Contemporary Art in New York, have reached out to groups excluded on political grounds by organizing exhibits and other programs that focus on gender, AIDS, and political themes.

In their various ways, programs of this kind overcome the persistent expectation that either the public is motivated and educated to begin with or the museum owes them little or nothing. If museums pursue such educational policies more actively, despite the tendency of new visitors to

stay in the areas with which they are most familiar, as Nathalie Heinich shows to be the case in the Centre Pompidou, they would still be taking a step toward the democratization that many museum educators wish to achieve.

There is, however, the persistently evoked danger that democratization is being accomplished at the expense of the "elite" experience. Some fear that the museum may become, instead of a serious institution, a place of popular entertainment with no standards of quality to govern the selection of artworks. It would be an error to treat this as a minor problem, as if art was simply reducible to an item of political patronage. For those who take the arts seriously as potentially valuable cultural creations, the esteem that cultural institutions lend them is not to be lightly discarded. Yet the days when the art museum was the final arbiter of aesthetic quality, if that was ever substantially the case, are over. Increasingly, universities, governmental agencies, foundations, media critics, dealers, art advisers, and artists lend their voices in the ongoing processes of making art and the establishment of reputation and standards.

It may be argued that a postmodern world encompasses more than one elite culture, just as there coexist parallel, "nonelite" minority cultures. In some cases, proponents of the latter seek entry into the most prestigious institutions both for their artworks and their supporters. Although the works may be viewed with horror by conservative critics such as Hilton Kramer who deride art based on ethnicity or politics,[29] in light of the enrichment that it has brought to the domain of art in the past, accepting new forms into the museum world hardly seems threatening. They should be viewed as the successors to previously excluded forms transformed into art by the museum: "primitive" artifacts, photographs, films, videos, verbal expressions. But whereas earlier works entered as disembodied objects without their makers, the new arts are accompanied by their creators and supporters. It is by interpreting these works and developing appropriate aesthetic discourse and meanings for its publics, old and new, that the art museum may help to create an elite experience for everyone.

Notes

1. Among the works that deal with these issues are César Graña, *Fact and Symbol, Essays in the Sociology of Art and Literature* (New York, 1971) and Vera L. Zolberg, "Tensions of Mission in American Art Museums," in *Nonprofit Enterprise in the Arts: Studies in Mission and Constraint*, ed. Paul J. DiMaggio (New York, 1986).

2. Zolberg, "Tensions of Mission," p. 192.

3. Founded and governed by wealthy men as their personal possessions, art museums have sought to transform themselves into relatively autonomous, professionally run organizations focused on a core of high-quality artworks. This process is analyzed in Graña, *Fact and Symbol*, and Zolberg, "Tensions of Mission."

4. Paul J. DiMaggio, Michael Useem, and Paula Brown, *Audience Studies in the Performing Arts and Museums: A Critical Review* (Washington, D.C., 1978).

5. DiMaggio et al., *Audience Studies*, p. 33.

6. For corroborating evidence from the early 1980s, see John Robinson, editor of the Survey Research Center publication *Public Participation in the Arts: A Project Summary* (College Park, Maryland, n.d.).

7. Cited in Vera L. Zolberg, "The Art Institute of Chicago: The Sociology of a Cultural Organization" (Ph.D. dissertation, University of Chicago, 1974), p. 42.

8. Cited in Pierre Bourdieu and Alain Darbel et al., *The Love of Art: European Art Museums and Their Public* (Stanford, Calif., 1990 [1969]), p. 1.

9. This exchange, reported in Zolberg, "Tensions of Mission," pp. 194–95, took place in the course of a 1972 discussion at the New School for Social Research concerning the "museum crisis."

10. Cited in E. W. Eisner and S. M. Dobbs, "The Uncertain Profession: Observations on the State of Museum Education in 20 American Art Museums," A Report to the J. Paul Getty Center for Education in the Arts, 1984, pp. 6–7.

11. These statistics help improve their fund-raising abilities and determine whether their marketing is paying off. Most importantly, as indicated by the reanalysis of such studies sponsored by the National Endowment for the Arts, museums use their audience research to justify their worthiness to public funding agencies. See Zolberg, "Art Institute of Chicago."

12. Reported in Eisner and Dobbs, "Uncertain Profession," p. 44.

13. Cited in Eisner and Dobbs, "Uncertain Profession," p. 33.

14. *Animateurs* are expected to hold a diploma in education or obtain training while studying art or general education. Ministry of Culture, *Faire un musée: Comment conduire une opération muséographique?* (Paris, 1986), pp. 51–60.

15. A director of a major art museum in a large American city said, "I honestly don't know what museum education departments are supposed to do." Cited in Eisner and Dobbs, "Uncertain Profession," p. 7.

16. This is an old complaint of discipline-oriented educators, particularly in high schools. It has gained further currency in recent years, from political positions as diverse as those of (on the "right") Allan Bloom in *The Closing of the American Mind* (New York, 1987), and (in the "center") E. D. Hirsch, Jr., in *Cultural Literacy: What Every American Needs to Know* (Boston, 1987).

17. Bourdieu and Darbel were the principal authors of *The Love of Art*, translated into English and published in 1990 by Stanford University Press. Bourdieu's *Distinction: A Social Critique of the Judgement of Taste* (Cambridge, Mass., 1984) was first printed in France in 1979.

18. Erwin Panofsky, *Gothic Architecture and Scholasticism* (New York, 1957).

19. As Daniel Sherman points out in his *Worthy Monuments: Art Museums and the Politics of Culture in Nineteenth-Century France* (Cambridge, Mass., 1989), p. 320, a museum like the Louvre, which was not designed to be a museum, was intimidating because of "its labyrinthine layout and colossal size, and only secondarily . . . [because of] elements deliberately conceived in the design of the museum."

20. Claude Pecquet and Emmanuel Saulnier, "Le vide beaubourgeois," *Autrement*, no. 18 (April 1979): p. 172, my translation. Gérard Mermet, *Francoscopie: Les Français, Qui sont-ils? Où vont-ils?* (Paris, 1985).

21. Nathalie Heinich, "The Pompidou Centre and Its Public: The Limits of a Utopian Site," in *The Museum Time-Machine: Putting Cultures on Display*, ed. R. Lumley (New York, 1988), pp. 199–212; Mermet, *Francoscopie*, pp. 350–51.

22. These are among the theses of Daniel Bell, *The Cultural Contradictions of Capitalism* (New York, 1976) and explicitly of Hirsch, *Cultural Literacy*.

23. This is suggested by Dick Netzer in *The Subsidized Muse: Public Support for the Arts in the United States* (New York, 1978) and J. Mark Davidson Schuster, "Tax Incentives as Arts Policy in Western Europe," in DiMaggio, *Nonprofit Enterprise*, p. 324.

24. See T. H. Marshall, *Class, Citizenship and Social Development* (Garden City, N.Y., 1965 [1950]).

25. William J. Wilson characterizes the black lower classes in American cities in this way in *The Truly Disadvantaged* (Chicago, 1987). As Wilson argues, whites who are disadvantaged are even more numerous.

26. Many social thinkers have dealt in one way or another with the relationship among social constraints, opportunities, and individual action in producing the "individual" endowed with "taste" and the social consequences of the process. Among the most prominent are Thorstein Veblen, *The Theory of the Leisure Class* (New York, 1931); Max Weber, *From Max Weber: Essays in Sociology*, ed. and trans. H. H. Gerth and C. Wright Mills (New York, 1946); and C. Wright Mills, *The Power Elite* (New York, 1956).

27. Whereas skills in leisure activities including the arts are a fixture of prep school education, as Peter Cookson and Carolyn Hodges Persell show in *Preparing for Privilege: The Elite Prep Schools* (Chicago, 1985), in the inner city the arts tend to be eliminated in favor of the "basics," and sports are granted importance largely if they are competitive occasions for the glory of the school. In any case, they are generally not available for all students, but only for (mostly male) star talents, who are encouraged to view them as professions, not as leisure activities. To some extent this is also the case for performance arts

28. This has been pointed out by Pierre Bourdieu and J.-C. Passeron, *The Inheritors: French Students and Their Relation to Culture* (Chicago, 1979); Christopher Jencks, *Inequality* (New York, 1972); and Jerome Karabel and A. H. Halsey, eds., *Power and Ideology in Education* (New York, 1977).

29. Kramer was particularly incensed at a major exhibition of Latin American artists' works at the Brooklyn Museum. "Brooklyn Museum Hispanic Show: A UNESCO-Type Approach to Art," *New York Observer*, July 3–10, 1989, p. 1.

4

Identity as Self-Discovery: The Ecomuseum in France

Dominique Poulot

Within the past ten years, museums have taken on striking importance in French cultural life. The openings of Beaubourg, the Musée d'Orsay, and the Grand Louvre, to cite only the most prominent, met with enthusiastic public response. The polemics surrounding these projects, far from marring their effects, only increased public awareness of the issues at stake. Parallel to these events, the past two decades have witnessed a dramatic growth in the number of museums of all kinds — the so-called museological boom of the 1970s and 1980s. During this period, provincial museums succeeded in extricating themselves from a situation that had been worrisome at best, at times catastrophic. The 1970s also witnessed the advent of a radically new phenomenon in the French museological landscape: the ecomuseum.[1]

The stated purpose of the ecomuseum was to provide "a mirror in which a population could seek to recognize itself and explore its relationship to the physical environment as well as to previous generations; also an image offered to visitors to promote a sympathetic understanding of the work, customs and peculiarities of a population."[2] Curator F. Hubert defined the ideal ecomuseum as a composite, including

> a historical museum, a geographical museum [*musée du temps, musée de l'espace*], a field laboratory or workshop, branch offices or affiliations in the community, tours and suggested itineraries. The project as a whole would be managed by three committees (users, managers, and scientists) designed to ensure "mutual learning" and the participation of all; the ultimate goal would be the development of the community.[3]

This new approach was directed, a priori, against the image of the classical museum; it envisioned nothing less than a radical departure from

tradition. Not without reason, on the occasion of the first Conference on Ecomuseums in 1986 an official of the Department of French Museums [*Direction des Musées de France*] half-jokingly, half-sarcastically character-ized his interlocutors as advocates of the "antimuseum."[4] The debate over the ecomuseum that began in the 1970s thus situated itself within the long and rich history of the idea of the museum in France; at stake were nothing less than the changing assumptions and practices of the field of museology.

The ecomuseum was part of a broader movement known as the "new museology." According to UNESCO's International Council of Muse-ums (ICOM), the new museology "appeared in specialized circles in France during the 1980s" and represented "a movement of criticism and reform" aimed at incorporating new developments in the social and hu-man sciences; revitalizing techniques of display, exhibition, and commu-nication; and, ultimately, altering the traditional relationship between the institution and the public.[5] Jean-Michel Barbe writes that the movement "included rural and urban ecomuseums, as well as industrial, neighbor-hood, special interest [*les musées d'identité*], and national park museums. One spoke of active museology, popular museology, experimental mu-seology, and anthropological or ethnographic museology."[6] An abun-dant professional (less often academic) literature suggested the vitality of what Hugues de Varine-Bohan, a member of the ICOM, calls the "anx-ious and passionate search for a revitalized museum, one that could be affirmed as a necessary and useful social service"—a vision consistent with the plan for a "complete museum" developed in 1972 by the UNESCO-initiated round table of Santiago.[7]

The international adoption, after 1972, of goals comparable to those of the ecomuseum by a variety of institutions should not eclipse the key role played by Georges-Henri Rivière. Rivière, who died in 1985, cofounded the Musée de l'Homme with Paul Rivet before World War II, founded the National Museum of Popular Arts and Traditions (the ATP, currently housed in the Bois de Boulogne, Paris), and was the first director of UNESCO's International Council of Museums. In these capacities, he defined the scope, inspired the philosophy, and envisioned the practical applications of the ecomuseum.[8] But France was more than the "theoret-ical" home of the ecomuseum. The sheer quantity of ecomuseums cre-ated in France over the past twenty years has made the country a virtual laboratory for the study of contemporary questions of "cultural heri-tage" and museological change.[9]

Genesis

The classical museum of the nineteenth century was designed to inculcate a feeling of identification with civilization, an idea more or less conflated with that of the French nation. The ideals of beauty and the Enlightenment were disseminated through mediocre but cherished institutions that rivaled each other in professing their social utility. Still, the initiation to museum culture never acquired the character of a canonical apprenticeship, as in the humanities. While students inducted to the "program" of French texts learned to appreciate "the universally acknowledged sacrality of literature," no such program existed for official instruction in the arts and archaeology.[10]

Armand Dayot, inspector general of fine arts, thus observed in 1931 that "if, one day, a proper student were to enter the Louvre, he would immediately be scandalized and confounded by the piling up of these paintings about which he is told nothing, neither the origin, the period, nor even the name of the artist."[11] Consistent with this point of view, the interwar years witnessed the appearance of a "scientific" theory of the museum, or museography, which advocated achieving museological modernity through the blending of pleasure and knowledge. New rules began to govern the arrangement of paintings at the Louvre. Works were hung "at eye-level, without crowding" and "the rooms of honor reserved exclusively for masterpieces" (a privilege made possible by the invention of storage). "Selected works" appeared, for pedagogical reasons (they summarized what it was necessary to know), but also because the explanatory mode came to define a legitimate relationship to the work.[12]

But it was in the domain of the museum of rural culture or folklore that aspirations to a more scientific and democratic theory of the museum proved to be of greatest consequence. The contemporary idea of linking a collection to the culture of a specific region can be traced to the 1880s and 1890s. In 1887 images of traditional peasant work were exhibited for the first time in the *salle de France* of the Trocadero's Museum of Ethnography. In 1899 Frédéric Mistral opened the Muséon Arlaten, a museum of Provençal culture in Arles. Although the regionalist movement that subsequently swept France, for all its political ramifications,[13] had only limited impact on museum theory, the Basque Museum of Bayonne was founded in the early 1920s.

By the early 1930s, when Georges-Henri Rivière and A. Varagnac created the National Museum of Popular Arts and Tradition, the concept of an outdoor museum became a reality. In 1937, in the *Centre rural* (or "ru-

ral wing") of the Paris International Exposition, a teachers' group presented the first *musée de terroir*, or museum of rural culture. In the same year, the Congress on Folklore, mobilizing peasant choruses and workers' groups, provided an opportunity to celebrate and assess the impact of the first European park-museum dedicated to rural architecture and traditional life-styles, the Swedish Skansen.[14] In each of these attempts at pedagogical display, the museography of the period "steadily distanced itself from the concern with reconstructing the past which motivated the original curators of ethnographic and folkloric museums; objects were now being collected and juxtaposed in typological series, or according to functional or evolutionary sequences."[15]

This new approach, which would triumph after the war in the halls of the ATP, drew on the intellectual groundwork of the French ruralist school. The school encompassed both geographers, who furnished interpretative models for the study of peasant architecture typologies, and historians, who, following Marc Bloch, had begun to define the "unique characteristics" of the French countryside.[16] During these years, the enterprise also profited from the achievements of a nascent scientific ethnography, which received official recognition and subsidies both in France and abroad.[17] Beginning in the late 1920s, "the concept of culture was used to challenge traditional assumptions concerning the hierarchy of societies and consequently to promote a relativist understanding of humanity."[18] In France, this idea developed within the context of a humanist ethnography committed to the study of universal Man.[19]

Paradoxically, it was under the Vichy regime that an activist museography got off the ground. The National Peasant Corporation and the Ministry of National Education encouraged the creation of regional museums of popular art and tradition modeled on Mistral's project as well as a network of smaller, local collections intended to promote and "root" the movement "back to the land." Like certain provincial museums linked to the earlier "regionalist" movements, the Vichy regime celebrated peasant life and artisans' work; the difference was that now the idea of a return to the land had been enlisted to promote Vichy's "national revolution." Vichy's museum policy illustrated the decisive impact of authoritarian regimes on European museums during the interwar period. In fascist Italy's Museo di Roma and Nazi Germany's network of *Heimatmuseums* (literally, homeland museums), the museum had been transformed into an instrument of state policy.[20]

The actual effects of this new status on the working goals and methods of the museum suggest the ambiguity of the relation between techno-

cratic "modernization" and political conservatism. Before the war, Rivière hailed the *Heimatmuseum* as an innovative harbinger of the truly "modern" museum.[21] Consistent with Rivière's vision, the new institutions under Vichy were designed to be vigorous and practical, the better to promote a national renaissance.[22] Their reactionary political goals, however, discredited them in the eyes of the Annales historian Marc Bloch (shot for his participation in the Resistance); his antipathy for Vichy's cynical brand of populism led him to call them "vast junk museums."

For its annual meetings, the National Peasant Corporation envisioned a "living museum," designed to hold folk festivals and cultural activities, as well as the offices of a "peasant guild." The best illustration of the issues at stake in Vichy's modernization project, however, was the Paper Museum built near Ambert in 1943. The exhibition included antique tools and machinery, as well as a cardboard factory housed in an old, restored mill. By turning the abandoned site into a forum for demonstrating traditional skills, the planners hoped to revive forgotten procedures and restore artisanal practices to contemporary ends.

After the war, the milieu of the ATP was able to realize its museological aspirations as a result of a favorable intellectual climate and the considerable influence and energy of its leaders. The mandate of the cultural wing of the National Museum of Popular Arts and Traditions was "to provide an overview of pre-industrial French culture." The theory was to "bring displayed objects to life by situating them in context . . . i.e., by reconstructing the setting from which they had been extracted: a fire was lit in the fireplace, a bird was caught in the trap, the tool was set to work on raw materials."[23] For the first time, the museum deployed techniques of commercial display—the use of nylon thread to position artifacts, for example—to its own ends. Methodologically, the new collection and acquisition strategies implied an "ecological" approach far removed from the traditional "treasure hunt" for isolated works. It has justly been argued that the new field of prehistoric archaeology significantly influenced the new museology, in particular the Pincevent dig directed by André Leroi-Gourhan, which aimed at an exhaustive mapping and inventory, if not the total reconstruction of the site through casts.[24]

The Technocratic Moment

Neither an archaeologist nor an ethnologist invented the specific term "ecomuseum," however. The term was forged during the ninth general

meeting of the International Council of Museums in Grenoble in 1971, when the idea of heritage [*patrimoine*] linked to specific communities and localities had begun to interest the French Ministry of the Environment and high officials in charge of the nation's physical resources.[25]

With roots in the 1940s, the history of French territorial development officially began in 1949, amid economic instability, with the creation of the National Development Administration. Only with the acceleration of economic growth and urbanization in 1954–55, writes geographer Marcel Roncayolo, "were regional planning and development incorporated into a larger political perspective."[26] Finally, in 1963, the Development Administration's successor, the Delegation for National Development and Regional Action, or DATAR in its French abbreviation, received real political authority. Olivier Guichard, a key DATAR official and leading Gaullist politician, summarized the situation: "National development was favored by general economic growth, . . . the State was as yet uninhibited in its interventionism, and above all . . . the administrative system was highly centralized and versatile, capable of intervening at almost every level, including the most local."[27]

Only in the mid-1970s, however, did the idea of protecting the nation's natural resources begin to carry social, political, and symbolic weight. In 1975 a system of regional parks was established "to preserve nature; to protect and promote traditional customs (especially agricultural); and to encourage the study and understanding of the natural and human environment." A flexible administrative structure was devised to manage an environment credited with offering "unique opportunities for rest, relaxation, education and tourism, by virtue of the excellence of its natural and cultural resources." The new framework provided the ecomuseum, which first appeared as a visitor center, with unique opportunities for development. Based on the idea of a community's geographical specificity, the new institution represented a significant update of the original plan for national development, which was based on regional planning.

The Definition of the Ecomuseum

In fact, during the 1970s, the ecomuseum spawned a distinctive conception of identity, according to which the preservation of culture was a kind of social responsibility. In this connection, the ecomuseum of the community of Le Creusot-Montceau-les-Mines, created in 1974 by Marcel Evrard in collaboration with G.-H. Rivière, served as a model. The founders envisioned four distinct fields of activity:

—Remembrance (the inventory of surrounding cultural and material resources)

—Understanding [*la connaissance*] (promoting a deeper awareness of the environment through research and education)

—The joint management and development of the locale by the inhabitants and a team of scientists (resulting in museum installations, exhibitions, publications and documentation)

—Artistic creation (artists' retreats; creative arts projects linked to local industry and technology).[28]

The critical innovation of this project was its orientation toward the community, expressed both in its specific geographical scope and in the emphasis placed on participation by the inhabitants. Accordingly, its plan of social action postulated that "the public was capable of moving from the role of consumer to that of actor, and even author of the museum."[29] Henceforth, museum planning would develop as a function of the synergy between different vocations exhibited throughout a given region. Hugues de Varine-Bohan, then director of the ICOM, saw in the ecomuseum the first truly "fragmented" museum, a pluridisciplinary and versatile institution, congruent with contemporary representations of culture and, as such, a model for the French Musée de l'Homme, or Museum of Man.[30] The ecomuseum would thus represent the final metamorphosis of the French tradition of the Musée de l'Homme, begun as a centralizing and universalist institution under the Popular Front.

In 1980 Georges-Henri Rivière took up these themes in the following terms:

> The ecomuseum is a tool which a government and population fashion and make use of together; . . . an expression of both man and nature; . . . an expression of time, with a view toward the future (though it does not pose as arbiter, only as a source of information and critical analysis); an interpretation of space. . . . This laboratory, this conservatory, this school share a common set of principles. Each aspect of the ecomuseum identifies a broadly defined common culture, seeking to communicate its dignity and artistic expression whatever the sources of that culture amid the different strata of the population.[31]

Quickly adopted as standard, Rivière's definition was dutifully reiterated, and eventually became canonical.

When François Mitterrand and his socialist majority came to power in 1981, a new program of cultural preservation was inaugurated. In his report to the minister of culture, *Pour une nouvelle politique du patrimoine* (Reforming cultural policy), the official Max Querrien reiterated the vo-

cation of the ecomuseum: "to provide a coherent overview of the customs, skills, struggles, subjective experiences and socio-cultural resources [*références*] of a given population." The report recommended that "the local population take charge of the activities of the ecomuseum through an appropriate organization (typically, a voluntary association), and that workers participate in its research and training programs." The ecomuseum, Querrien suggested, should concern itself with the "preservation of traditional skills" rather than the "museumification of objects": "its true charge is the collective memory, the source of a people's identity."[32] Querrien's formulation reflected a desire to differentiate the sociocultural goals of the new government from those of its predecessor, which pursued a traditional policy of monument preservation: former president Valéry Giscard d'Estaing had decreed an *Année du Patrimoine*, or National Heritage Year. The report recommended a reorientation of government policy in favor of community and working-class values — values excluded, defeated, or ignored by the dominant high culture. Finally, Querrien presented his proposal during a period of intensified reflection upon the question of French identity, the surest foundation for which, given the decline in nationalist-republican feeling over the past century, appeared to be collective memory. Significantly, *Les lieux de mémoire*, the multivolume collection devoted to collective memory edited by Pierre Nora, began to appear in 1985.[33]

In an effort to "stay the course" of museological activism, the directors of the ecomuseums of France held their first national gathering in November 1986 under the paradoxical slogan Forward, Memory! [*En avant la mémoire*] One of the conference organizers, Philippe Mairot, then director of the Ecomuseum of the Nord-Dauphiné and later president of the General Association of French Ecomuseums, observed that the ecomuseum had come to occupy an important place in the French cultural landscape, not only in relation to museum culture, "to which it has contributed significant reforms," but also in relation to rural life and economic development, to which it had contributed the appreciation and mobilization of inherited culture, the development of scientific and technological knowledge, and the improvement of tourism.[34] In 1990, the minister of culture, Jack Lang, described the federation issued from this conference as "a new generation of museums in which the object retains its context, bearing witness to a specific culture, population and physical environment." The minister attributed the popularity of the ecomuseum to its "practical and sensible approach to local identities [*identités de territoires*]." Finally, he declared his belief that "the immersion in practices of

the past, far from being nostalgic, awakens us to the problems of the present."[35]

The question of definition is thus in itself a central issue in the debate over the ecomuseum. To propose or defend a definition means to choose sides, to affirm a philosophy, and, ipso facto, to activate the fault lines between conflicting theories of the museum, theories whose ideological and scientific terms are inextricably linked. The first such dispute, dating from the nineteenth century, was a struggle between monarchists and republicans over who should control the museum enterprise, and—concurrently—how to define the problem of vandalism. A second polemic pitted the statist vision of the museum as a product of Jacobin solicitude against the liberal vision of a natural product of the passions and interests of civil society.

More fundamentally, the idea of the museum as sanctuary itself has aroused opposition since its inception. Some critics argued that the preservation of artifacts in a museum supposed a break with traditional culture, implying cultural desperation, if not the decline of civilization. Indeed, criticism of the transfer to museums of works other than easel paintings (exceptions by virtue of their long subjection to the vicissitudes of the market and private collections) and resolute opposition to the dismemberment of cultural entities continues today. Other critics have pointed to the intimate connections between the birth of the museum and the bourgeois condemnation of popular culture.

At stake in these battles were judgments concerning the role of the museum as a public or democratic institution and the "legitimacy" of the culture it defined and displayed. By the twentieth century, four distinct perspectives had emerged. First, in the spirit of claims advanced in the eighteenth and nineteenth centuries, the "orthodox" interpretation holds that the museum educates its visitors and thus democratizes a high culture that would otherwise remain the exclusive preserve of the wealthy and privileged. Second, the traditional liberal position, by contrast, argues that the museum alters culture in the name of social utility. Only through the reappropriation or reconquest of culture could society achieve an authentic cultural renaissance. A third position is that of the radical school, which claims that the museum is *potentially* democratic but has remained a tool of the privileged classes, who used it to appropriate cultural legitimacy to their own ends. Only through a suitable system of education could the appreciation of high culture be truly democratized. Finally, the traditionalist or counterrevolutionary position

refuses to invest any interest or hope whatsoever in the development of the institution. Amid this quartet of interpretations, the ecomuseum occupies a unique position, one that helps to explain some of the confusion surrounding it as well as its unique success. For the ecomuseum combines the most radical aspects of two otherwise incompatible positions: it seems to attack the museum establishment both in terms of its cultural legitimacy (the liberal position) *and* in terms of its relation to the public (the radical position).[36]

The ecomuseum is thus no stranger to traditional representations of the French cultural heritage, but proposes a different approach to them. Against the idea of distributing the nation's cultural heritage without attention to regional specificity—the idea of the classical museum—the ecomuseum pits its own concept of the refraction of museum culture in discrete environments, each respectable on its own terms. For Jean Clair, "the [classical] museum dismantles whole cultural systems and subordinates their fragments to a single authority," while the ecomuseum respects a culture's organic integrity.[37]

Following this approach, a new class of curators has appeared, at times provoking spectacular controversies; the phenomenon is limited, to be sure, but heralds a fundamental shift in the profession. The "new" curators, even as they accept the logic of the "private" or associational museum, which placed them in a role comparable to that of the entrepreneur in civil society, are above all concerned with promoting the self-discovery and development of the community. The results of their labors are varied and sometimes unexpected. In the new town of L'Isle-d'Abeau, created to relieve the overcrowding of Lyon, the Ecomuseum of the Nord-Dauphiné has presented a number of exhibits on local identity. A 1988 exhibit, *Quand le vin est tiré* (When the wine has been pressed), concerned the tradition of local wines in the Nord-Dauphiné. In the same year, *Le patrimoine s'affiche* (Our heritage on display) mobilized prints taken from approximately one hundred negatives of local historic photos and exhibited them simultaneously in factories, *Maison des Jeunes et de la Culture* (youth cultural centers), and multipurpose community rooms. These projects succeeded in furthering the ecomuseum's goal of fostering the awareness and communication of culture, writes their producer, Philippe Mairot, precisely "because they were tied to local skills and forms of knowledge."[38]

Such projects became less effective and harder to justify "in contexts where the attachment to the local culture had diminished in comparison

to newer, more compelling identities: we the unemployed, we the youth, we women, or we consumers." In response to this problem, an exhibit entitled *Salut la classe* (Hi, class!) sought to place modern rites of passage into anthropological perspective by suggesting parallels between "primitive" initiation rites and modern rites like military service or computer literacy classes.[39] Given the mandatory military service in France, the word *class* signifies all boys born in the same year in a particular city or town who perform their service together; it reflects a kind of generational solidarity cemented by the rite of passage of military service. Another, bolder response was the exhibit Truckdriving [*Les routiers*], on a trade whose spatial parameters hardly corresponded to the site of the ecomuseum—even though the curators drew on memories of local industry—but that, in the distorted mirrors of the media and modern "folklore," still evoked an image of distinct professional identity. In this case, the ecomuseum borrowed not only from the disciplines of ethnology, sociology, and the history of technology, but also from art, for it included a series of portraits of the drivers by their trucks. The final "rendering" of this technologico-economic culture took the spectacular form of an exhibition mounted on four trailers, displayed first on the square of the *Cité* of science and industry at La Villette (Paris) and then, during the 1988 summer vacation rush, at two strategic highway rest areas in France.[40]

The new institution thus professes a commitment to subverting traditional representations of the social order: it aims not to attain knowledge but to achieve communication. Just as often during the 1980s, however, the capacities of the ecomuseum to reconstruct identities and illuminate cultural resources critically were applied to the challenge of repairing the torn fabric of a society in crisis. They were given the task of "softening" such consequences of technological change as the demise of certain industries and the sociocultural conflicts resulting from economic crisis, unemployment, and immigration. In sum, they were supposed to alleviate the identity crisis of the "victims" of the new economic situation and help populations in transition, especially in the *villes nouvelles*, or new towns. Unwittingly, the ecomuseum came to be identified with sites of industrial conversion: Roanne, with its crisis of textile production, Chazelles-sur-Lyon, with the decline of the hat industry, and so on.

The new generation of ecomuseums has raised serious doubts among the leaders of the previous generation. They are criticized for trying to cover "a topic or technology rather than a region," and for "failing to comprise more than a building and a fixed staff, thus excluding the pop-

ulation, except as a client." In itself, the idea of linking the ecomuseum to a specific technology or activity seems anathema to the "holistic" principles of the "classical" ecomuseum.[41] The Querrien report had cautioned against "industrial ecomuseums," warning that "the history of technologies would overtake the anthropology of human experience, the hard sciences would overtake history and pedagogy would overtake culture." But the main perceived danger was that, in response to social pressures, the institution would attempt to "exorcise anxieties about the future by glorifying the values of the past." The "nostalgic" ecomuseum, critics argue, "deviates" from the spirit of a project originally conceived in a context of confidence in the future: it represents, like its predecessors of the 1930s, a poor remedy for social crisis, not a museological practice worthy of the name.[42]

These arguments raise an issue of central concern to the ecomuseum: the "manufacture" of a public heritage out of various private patrimonies, that is, the construction of a representation of public-democratic values.[43] The ecomuseum has consistently seen itself as a social process of interpretation of the past and present, aimed at designating what is collectively memorable, at producing an image of the collectivity. It can be found "wherever social groups seek to master—i.e., to understand and consciously adjust—their social relationships; wherever a self-representation of the community allows it to move from the domain of social relationships to that of political strategies."[44] Such was the principal issue at stake in the studies the Mission du Patrimoine (Commission on Ethnographical Heritage) has commissioned on the practices and cultural politics of identity, and on the internal polemics of the professional world of the ecomuseum.[45]

The ecomuseum has indeed participated in reshaping the social uses of "heritage" in French society. In particular, it has given practical weight to a new interpretation of heritage as a process, the process by which, through a continuing reevaluation of its "belongings" [propriétés], society comes to know itself.[46] If the classical museum, in Freddy Raphaël's excellent phrase, was a "challenge to memory,"[47] a goad for mobilizing the past in the service of the future, the ecomuseum implies a reign of the present, an agenda determined exclusively by the demands of the day.

Rejecting the traditional museum's identification with the ciphers of a faded past, ecomuseum exhibits are fashioned in the here and now, out of institutionally produced representations. In the past century, the museum, pervaded by a sense of urgency and immanent loss, sought to

speak on behalf of silent monuments and other remnants of the past. Time was the beautifier of all things. The past [*champ patrimonial*] was "another country," more beautiful for seeming lost and estranged.[48] In this spirit, even nascent ethnography was modeling itself after archaeology: to interview a Breton peasant was to examine a strange and ancient relic, a representative of the distant past.[49]

Whereas, by definition, the traditional monument had to be visible, the ecomuseum searches, above all, to engage [*voir faire*] its audience in the social process; only secondarily does it seek to represent [*faire voir*] that process, mirroring it for its participants. Today, the aim of the ecomuseum is to make society aware of the wealth of resources it unknowingly possesses; the old task of salvaging and recording has been replaced by the business of discovering and interpreting culture. Under these conditions, the inscription of heritage can only have meaning when it is situated within a theoretically informed effort to reconstruct the practices that make everyday life meaningful.

The traditional classification of museum objects by material is being replaced by a new catalog of methods and philosophies mandated by the Federation of Ecomuseums. The process of institutional selection no longer depends either on the type of exhibit, or on the type of museum, but on the type of communication promoted by the museum. Rather than classing museums by specialty, region, or status, administrators are seeking to identify, among the widest variety of conditions and sites, examples of comparable cultural achievements and strategies for shaping social reality. At least one facet of G.-H. Rivière's rich legacy is recognizable in this approach; as Isac Chiva subtly put it, Rivière "treated theories and ideas as museum objects and museum objects as tangible ideas."[50]

Outside visitors to the ecomuseum immediately recognize their exteriority to the community; yet, simultaneously, the representation of everyday objects and of the cultural cohesion implied in shared interests and practices invite them to identify with it. Consistent with this paradox, the aforementioned definition of the ecomuseum as a mirror held simultaneously to the community and to others suggests not only a process of self-discovery and recognition, but also the development of representations suited to communicating with others. In sum, the ecomuseum is governed in part by a concern with achieving critical perspective, and in part by the imperatives of rhetorical coherence.

There is an apparent contradiction between, on the one hand, the process of self-recognition, which implies a sort of introversion of the community, a concern exclusively with its own history and geography, and,

on the other hand, the desire to represent oneself, that is, to compose and project images for the consumption of others. In other words, the particularity of the ecomuseum resides in a play of mirrors capable of both inspiring the members of a community with a secure sense of shared identity and characterizing that community's life-style in the eyes of strangers. Where ethnologists begin with social differences, which they seek to render comprehensible and even familiar (through description, denomination, classification, interpretation),[51] the ecomuseum, on the contrary, works toward a fully explicit and theorized representation of things that were at first ordinary and familiar. In this sense the French ecomuseum differs from the "cultural identity museums" of Germany and Northern Europe.[52] Rather than affirm the specific values associated with a discrete area, the ecomuseum participates in the tradition of abstract civic pedagogy characteristic of French politico-administrative culture. Its ultimate purpose is to foster self-knowledge in any given population by implementing a pertinent scholarly analysis of the operative practices, habits, and "embodied knowledge"[53] of the culture. A kind of state-sponsored public works project, the representation of "cultural" values (meant here always in the anthropological sense) can thus be understood as a program of "cultural development"[54] of the citizen, conceived within a paradoxically universalist intellectual framework.

In twenty years, the ecomuseum has become a fact of life, as much by virtue of the achievements of particular institutions as through the confusion surrounding the gradual mythification of the term. Its deeper roots lie in the resilience of a dissident regionalism opposed to the French Jacobin tradition, though on behalf of contradictory ideologies; in the development of a cultural theory that combined folklore studies, geography, and an interest in the collection of objects; in the study of "ways of life" associated with Vidal de la Blache; and in the systematic survey of rural architecture. The appearance of the discipline of ethnography and its associated institutions also had a decisive impact, through the mediations of pioneers like G.-H. Rivière. Innovative and democratic developments in the interwar period, though cut short, found an investment, under the adverse conditions of the national revolution, in the first organizations ever created for the evaluation and revitalization of traditional cultures — including agricultural, artisanal, and regional cultures.

After the war, the modernization of research institutions contributed significantly to the recognition and development of French ethnology; moreover, the National Center for Scientific Research forged links be-

tween the emerging discipline and the world of the Museum of Popular Arts and Traditions (ATP). Nonetheless, the concept of the ecomuseum developed independently of both the ATP and the university environment. Within the context of national economic development, it was born as a sort of French adaptation of foreign models of the national park, the visitor center, and the outdoor museum. G.-H. Rivière then succeeded in synthesizing the concerns of a section of museum professionals who had high-level contacts in UNESCO and in various government agencies.

The ideological context of the 1970s, which included the values of self-management and greater participation, offered the ecomuseum a militant new audience, eager to participate in voluntary associations, users' committees, and the like. Many of these initiatives had regionalist motivations and advanced themselves as alternatives to the traditional museum. A set of characteristic oppositions emerged: the museum versus the ecomuseum, the building versus the locale, the collection versus heritage, and the public versus the inhabitants. It was within this context that the "classic" definition of the mirror-museum was eventually articulated.

With the advent of decentralization and the attenuation of associational voluntarism in the 1980s, however, the cultural planners lost much of their energy. The very concept of the ecomuseum was threatened in newly created institutions by their need to respond to the social crisis that accompanied the bankruptcy of traditional industries. Activities previously associated with progressivism and the revitalization of culture were being replaced by an artificial and manipulative atmosphere of nostalgia. The ecomuseum was falling victim to the contradiction between its function as representative of specific communities and its role in the scholarly construction of an ethnology of France. Above all, the attempt by communities to reappropriate their cultural heritage proved difficult to reconcile with the need to promote tourism.

The creation of the Federation of Ecomuseums reaffirmed the "philosophy" of the institution, as well as the necessity and integrity of its museological and cultural programs. Only the ecomuseum label could give symbolic unity to "collections" that include architecture, interiors, crafts and skills, and landscapes. The social value of the ecomuseum resides essentially in its ability to give meaning to the spectacle of things and practices—what Arnold Van Gennep described in 1907 as the charm of ethnography: "once assumptions and methodical considerations are understood, daily life appears in a different light."[55]

The ecomuseum ultimately assumes that things and their uses have meaning—a reassuring proposition often applied optimistically to soci-

ety's wounds. Little by little, it weaves a "pattern in the carpet" that confers meaning on everyday life, a pattern we discern or decipher through the succession of exhibits, points of view, and approaches to framing a people and locale. The ecomuseum participates in the metaphysics of the mirror image, in a Socratic process of drawing out the cultural wisdom that everyone possesses but too rarely is aware of.

<div align="right">Translated by Marc Roudebush</div>

Notes

1. For a general view, see the following articles by André Desvallées: "Les écomusées," *Universalia* (Paris, 1980), pp. 421–22; "Muséologie nouvelle," *Encyclopaedia Universalis*, supplement 1981, pp. 958–61; "L'ecomusée: Degré zéro ou musée hors les murs?" *Terrain* 5 (1985): pp. 84–86. The following two conferences may serve to situate contemporary reflections on the relation between "classical" museums and the ecomuseum: *Quels musées pour quelles fins, aujourd'hui*, (Paris, 1983); *Ecomusées en France, Actes des premières rencontres nationales des écomusées, L'Isle d'Abeau, 13-14 novembre 1986* (Grenoble, 1987). For more recent developments in the field, see *Musées et sociétés: Actes du colloque de Mulhouse (juin 1991) et répertoire analytique des musées de société en France, 1980-1993* (Paris, 1993) and the special issue of *Publics et Musées* (no. 2, 1993), "Regards sur l'évolution des musées." Both of these publications appeared as this essay was going to press.

2. See *La muséologie selon Georges Henri Rivière. Cours de Muséologie/Textes et témoignages* (Paris, 1989), p. 142.

3. Hubert, "Du réseau de musées à l'écomusée," *Ethnologie française* 17, no. 1, pp. 67–74. See the classic article by H. de Varine-Bohan, "Ecomusée," *Gazette de l'Association des musées canadiens* 10, no. 2 (1978): pp. 29–40, and J. Davallon's remarkable commentary, "Philosophie des écomusées et mise en exposition," in *Claquemurer, pour ainsi dire, tout l'univers: La mise en exposition*, ed. J. Davallon (Paris, 1986), pp. 105–26.

4. E. Pommier in *Ecomusées en France*, p. 133.

5. See the editorial "Images de l'écomusée," *Museum* 148 (1985): p. 184.

6. J.-M. Barbe, "Présence et avenir du passé: Contribution à une problématique des nouvelles muséologies," *Les cahiers de l'animation* 3, no. 51 (1985): pp. 55–64. See also J. C. Duclos, "Les écomusées et la nouvelle muséologie," in *Ecomusées en France*, pp. 61–71.

7. H. de Varine-Bohan, "Le musée moderne: Conditions et problèmes d'une rénovation," *Museum* 28, no. 3 (1976): pp. 127-39.

8. Among the numerous summary articles, see I. Chiva, "Georges Henri Rivière: Un demi-siècle d'ethnologie de la France," *Terrain* 5 (1985): pp. 76-83. The journal *Ethnologie française* has devoted a special issue to G.-H. Rivière, vol. 17, no. 1 (1987).

9. For an inventory of these institutions, see A. Thibault, "Les écomusées français," *L'information géographique* 49 (1985): pp. 63–69; see also *Ecomusées en France*, pp. 141–81.

10. Mona Ozouf, "Le Tour de France par deux enfants," in *Les lieux de mémoire*, vol. 1, *La Republique*, ed. P. Nora (Paris, 1984), p. 312. On the history of the museum in nineteenth-century France, see D. J. Sherman, *Worthy Monuments: Art Museums and the Politics of Culture in Nineteenth-Century France* (Cambridge, Mass., 1989).

11. *Le Musée du Louvre*, "Les grands musées du monde illustrés en couleurs" (Paris, 1931), p. 6.

12. G. Bazin, "Musées d'hier et d'aujourd'hui," *Musées et collections publiques en France* 168 (1985): pp. 7-10.

13. See especially T. Flory, *Le mouvement régionaliste français: Sources et développements* (Paris, 1966), pp. 87-109. On the interpretation of "cultural heritage" see the exhibition catalog *Hier pour demain: Arts, traditions, patrimoine* (Paris, 1980); I. Chiva, ed., "Les régions de la France," *Le monde alpin et rhodanien* 1 (1981); "Régionalismes," *Ethnologie française* 3 (1988).

14. See Peter Burke's brief synthesis, "Popular Culture in Norway and Sweden," *History Workshop* 3 (Spring 1977), pp. 143-47. See also G. H. Rivière, "Les musées de folklore à l'étranger et le futur 'Musée français des Arts et traditions populaires,' " *Revue de folklore français et de folklore colonial* 3 (May-June 1936): pp. 55-71.

15. G. Collomb, "Les fêtes de battage et la production d'une image du travail paysan en France aujourd'hui," *Museum* 143 (1984), pp. 156-60.

16. Marc Bloch's 1929 lectures at the Institute for the Comparative Study of Civilizations in Oslo have been published in book form: *Les caractères originaux de l'histoire rurale française*, 1931. Translation by J. Sondheimer, *French Rural History: An Essay on Its Basic Characteristics* (Berkeley, 1966).

17. J. Cuisenier and M. Segalen, *Ethnologie de la France* (Paris, 1986).

18. P. Benneton, *Histoire de mots: Culture et civilisation* (Paris, 1975), p. 137.

19. See James Clifford, "On Ethnographic Surrealism," *Comparative Studies in Society and History* 1981, pp. 539-64.

20. A. S. Wittlin, *The Museum: Its History and Its Tasks in Education* (London, 1949), pp. 185-89.

21. Cited in M. Roth, "Collectionner ou accumuler? A propos des musées ethnographiques et historiques régionaux en Allemagne et en France," *Terrain* 12 (1989): pp. 125-37. For a more general view, see also I. Chiva and U. Jeggle, eds., *Ethnologies en miroir, la France et les pays de langue allemande* (Paris, 1987).

22. C. Faure, *Le projet culturel de Vichy: Folklore et révolution nationale, 1940-1944* (Lyons, 1989), pp. 231-37: "This kind of museography was a harbinger of [the] ecomuseum."

23. Official museum brochure. See G. H. Rivière and J. Cuisenier, "Le musée des arts et traditions populaires, Paris," *Museum* 24, no. 3 (1972): pp. 181-84. See also J. Cuisenier, ed., *Muséologie et ethnologie* (Paris, 1987), and, by the same author, "Exhiber et signifier: Sémantique de l'exposition dans les musées d'agriculture," *Museum* 143 (1984): pp. 130-37.

24. A. Desvallées, "Les galleries du Musée national des arts et traditions populaires," *Musées et collections publiques de France* 134 (1976).

25. An account of the origin of the term by H. de Varine-Bohan can be found in *Museum* 148 (1985): p. 185. On natural resources management, see J. P. Laborie, J. F. Langumier, and P. de Roos, *La politique française d'aménagement du territoire de 1950 à 1985* (Paris, 1985). A more geographical and political analysis may be found in "L'aménagement du territoire en France et en Europe," *L'espace géographique* 18, no. 4 (1989).

26. Maurice Roncayolo, "L'aménagement du territoire (XVII-XX siècle)," in *Histoire de la France*, vol. 1, *L'espace français*, ed. André Burguière and Jacques Revel (Paris, 1989), pp. 511-647, especially pp. 608-9.

27. O. Guichard, *Aménager la France, inventaire de l'avenir* (Paris, 1965), cited in Roncayolo, "L'aménagement," p. 617.

28. On the first ecomuseums, see J. P. Gestin, "Le parc naturel régional d'Armorique et la conservation du patrimoine," *Agressologie* 12, no. 1 (1971); "Musée et environment," *Museum* 25, nos. 1-2 (1973). See also G. H. Rivière, "Une expérience muséologique de l'environnement: Le Musée de plein air des Landes de Gascogne," *Ethnologie française* 1 (1971): pp. 87-95.

29. M. Bellaigue-Scalbert, "G. H. Rivière et la genèse de l'ecomusée de la Communauté Le Creusot-Monceau-les-Mines," *La muséologie selon G. H. Rivière*, pp. 164-65. See also

J. C. Beaune, "Perspective contemporaines sur la recherche-formation, l'Institut J.-B. Dumay," *Milieux* 13 (February-May 1983).

30. Two outstanding articles on Le Creusot: Hugues de Varine-Bohan, "Un musée 'éclaté': Le Musée de l'homme et de l'industrie, Le Creusot-Monceau-les-Mines," *Museum* 25, no. 4 (1973): pp. 242-49; J. Clair, "Histoire d'un marteau-pilon," *Art Vivant* 51 (1974): pp. 12-16. See also the summary by M. Evrard, "Le Creusot-Monceau-les-Mines: La vie d'un ecomusée, bilan d'une décennie," *Museum* 32, no. 4 (1980): pp. 226-34.

31. Reprinted in *La muséologie selon G. H. Rivière*, p. 142

32. M. Querrien, *Pour une nouvelle politique du patrimoine: Rapport au ministre de la culture* (Paris, 1982); and "Ecomusées," *Milieu* 13 (February-May 1983). For an overview, see "*La politique culturelle en France: L'action du Ministère de la culture et de la communication* (Paris, 1981).

33. See Pierre Nora's translated introductory essay, "Between Memory and History," *Representations* 26 (Spring 1989): pp. 7-25.

34. *Ecomusées en France*, p. 88.

35. Preface to the brochure for the Federation of Ecomuseums (Paris, 1990).

36. A more complete discussion of these interpretations may be found in Dominique Poulot, "Le musée entre l'histoire et ses légendes," *Le débat* 49 (March-April 1988): pp. 69-83.

37. Jean Clair, "Histoire d'un marteau-pilon."

38. Jacques Vallerant, "Un ecomusée pour le Nord-Dauphiné," *Evocations* 2 (1982); *Le Nord-Dauphiné: Points de vue* (Ecomusée Nord-Dauphiné, March 1984).

39. *Salut la classe! Rites et passages de conscripts*, exhibition catalog, Ecomusée Nord-Dauphiné, 1986.

40. *L'aventure de routiers*, Ecomusée Nord Dauphiné (Grenoble, 1988). See also two articles: Ph. Mairot, "L'aventure des routiers," *Terrain* 11 (November 1988): pp. 106-9, which discusses the theory underlying the exhibit, and G. Althabe, "Quelque remarques sur l'exposition," *Terrain* 11 (November 1988): pp. 110-12, which concludes that the ecomuseum here implies "a different mode of appropriation of the text," becoming "the site of an, at times singularly corrosive, intervention, into which the visitor is drawn, like a spectator who becomes an actor in the spectacle."

41. See, for example, A. Desvallées's criticisms in "L'esprit et la lettre de l'écomusée," in *Ecomusées en France*, pp. 51-55.

42. A position shared by F. Hubert, "Les écomusées après vingt ans," *Ecomusées en France*, pp. 56-61, and by H. P. Jeudy in *Mémoire du social* (Paris, 1986) and especially "Le malin génie d'un lieu réinventé," *Autrement* 115 (May 1990): pp. 50-55.

43. For a similar view, see M. Bommes and P. Wright, "Charms of Residence: The Public and the Past," in *Making Histories: Studies in History-Writing and Politics* (London, 1982), pp. 253-302.

44. "Philosophie des écomusées," in Davallon, ed., *Claquemurer*, p. 121.

45. Cf. *Terrain* 5 (October 1985): p. 5 and the 1990 proposals of the Mission du patrimoine ethnologique, "Les pratiques et politiques culturelles de l'identité."

46. See especially the position of *Terrain*, the journal of the Mission du patrimoine ethnologique, or Commission on Ethnological Heritage: Elizabeth Fleury, "Avant-propos," *Terrain* 11 (1988): pp. 5-7. An overview of this approach to ethnology may be found in M. Segalen, ed., *L'autre et le semblable* (Paris, 1989); and *L'ethnologie de la France: Besoins et projets*, preface by R. Benzaid (Paris, 1980).

47. F. Raphaël and G. Herberich-Marx, "Le musée, provocation de la mémoire," *Ethnologie française* 17, no. 1 (1987): pp. 87-95.

48. David Lowenthal, *The Past Is a Foreign Country* (Cambridge, 1985).

49. M. N. Bourget, *Déchiffrer la France: La statistique départementale à l'époque napoléonniene* (Paris, 1988), pp. 287-99.

50. Chiva, "Georges Henri Rivière," p. 83.

51. Cf. Clifford, "On Ethnographic Surrealism."

52. Cf. B. Trinder, "Museums: Industrial Conversion and Industrial History, Reflections on the Ironbridge Gorge Museum," *History Workshop* 2 (1976): pp. 171-76.

53. Pierre Bourdieu, *Outline of a Theory of Practice* (Cambridge, 1977), p. 96.

54. *Développement culturel* is the title of the official journal of the commission on research and education of the French Ministry of Culture.

55. N. Belmont, *Arnold Van Gennep, le créateur de l'ethnographie française* (Paris, 1974), p. 18.

5

With Open Doors: Museums and Historical Narratives in Israel's Public Space

Ariella Azoulay

Israeli society's preoccupation with its relation to the past and its continuous efforts to anchor this past concretely as a series of representations within its public space are an integral part of the processes through which the state was formed.

The Zionist movement, which emerged at the end of the nineteenth century, strived to return the Jewish people to "the land of Israel," a return to the "historic" and "geographic" space of Judaism, as this space was defined by its authors and politicians. Zionist ideologists and public activists have since continuously tried to determine the organization and meaning of this space or of this land, as part of the attempt to achieve sovereignty over it. The transformation of the geographic space was carried out not only in order to make the land inhabitable for a growing number of Jewish immigrants; it has always served as a testimony of the special link between the Jewish people and its land. Some of the practices that shaped the public space, created its Jewish meaning, and signified its Zionist identity were creating a continuum of settlements, archaeological sites, and guided hikes in every part of Israel; distributing path indicators; setting up public structures and monuments; and reshaping urban and rural spaces.

Israeli history museums have played a major role in this enterprise. The first part of this paper introduces an example of the constitution of public space through the case of Tower of David Museum of the History of Jerusalem. The second part presents four main procedures through which history museums in Israel have constructed their position as authors of "the true" image of the past. The four procedures discussed are universalized preservation practices; adaptation of artistic aesthetic values; construction of the figure of the enthusiastic amateur who serves as a mediator between historical truths, institutions, and the visiting public;

e use of fabricated exhibits in contexts determined by au-
. These procedures have been instrumental in construct-
hic image of the past that prevailed in most history muse-
as the 1970s. The authority thus constructed has often been
employed by the museum in order to extend its sphere of influence be-
yond the public space and shape the private space of individual historical
subjects. Two cases that demonstrate this extended influence are dis-
cussed in some detail: those of Bezalel museum and Yad Vashem Memo-
rial to Victims of the Holocaust. The third part of the paper describes and
analyzes a process of disruption that the monolithic image of the past has
undergone since the seventies, when a growing number of marginal
groups began attempts to represent their own past and become the inde-
pendent authors of such representations.

The Presence of the Past in the Public Space

The Tower of David Museum of the History of Jerusalem was estab-
lished in 1989 in a tower near the Jaffa gate of the ancient wall of the old
city of Jerusalem. The museum took over the site of a jail (a Turkish, then
British, Jordanian, and lately Israeli jail). It is a public institution, spon-
sored mainly by the Jerusalem municipality and its mayor, Teddy Kollek,
and its scholarly advisers are several distinguished historians at the He-
brew University. The museum's official task is to recount the history of
the city, a disputed history that as we all know has been at the heart of
many conflicts — ethnic, religious, and national — and that has come to
symbolize the Israeli-Arab conflict. The museum, however, has tried to
stay away from contemporary conflicts by advocating coexistence
among the city's (and the West's) three main religions — Islam, Christian-
ity, and Judaism — as a basis and common ground for its policies. The
purely religious conflicts have long been overshadowed, however, by the
national struggle between Jews and Arabs, in which one of the most cru-
cial issues at stake is sovereignty in and over the city of Jerusalem, and, in
turn, one of the main aspects of the struggle for sovereignty in and over
"the holy city" is precisely the representation of its history. The official
museum of the history of Jerusalem is thus both a participant in a na-
tional struggle and the author of an image of the past that aims to tran-
scend that struggle.

In its permanent exhibition the museum uses advanced technological
devices (such as holograms, dioramas, and computerized graphic design)
and displays authentic archaeological exhibits alongside fabricated exhib-

its designed specifically for this exhibition. The range of the historical data represented is wide: from the Canaanite period (about 2000 B.C.) to the end of the British Mandate in Palestine in 1948. The exhibition is organized according to the main changes in the colonial powers that ruled the city. A separate hall is dedicated to each ruling power, and a time line designates the proper place of each period and each regime along the time axis. The time line is displayed identically in each hall but with a differently highlighted section.

The exhibition concludes with the end of the British Mandate, but the time line ends with the Israeli rule of the city since 1948. One power, the Jordanian, which ruled the Eastern city of Jerusalem for nineteen crucial years, between 1948 and 1967, is oddly missing. At the very end of the exhibition course, outside the framework of the time line, there are two placards with the following inscriptions: "Jerusalem is an inseparable part of the State of Israel and its eternal capital" and "Jerusalem was divided for nineteen years. The Eastern city was annexed to the Jordanian Kingdom and West Jerusalem became the capital of Israel."

Clearly, the museum has tried not to offend the sensibilities of the three religions, but has not respected the sensibilities of the two nations that claim rights in the city. The Jordanian rule, which is definitely part of the history of the city, has been located outside the framework of the actual exhibition course, and the Palestinian claims in the city have been ignored altogether within the exhibition, since they did not constitute an autonomous Palestinian government and therefore cannot be accommodated within the structure of the exhibition. In Jerusalem, as everywhere else in Israel, Palestinians have always been designated as "inhabitants" contained within other historical narratives.

The objective point of view of the history of the city, which the museum tries to construct through a mixture of authentic and fabricated exhibits, is actually a powerful ideological device that explicitly legitimizes the Israeli claim to maintain its rule over the united city and implicitly delegitimizes all counterclaims. The Tower of David Museum of the History of Jerusalem is not only strategically sited in Jerusalem's historic space, it is also an important agent that takes part in the construction, shaping, and interpretation of this public space. But the context in which this agency takes place—the Israeli-Palestinian conflict, with its explicit power relations, including the control over means of producing and distributing images and representations of the past—is entirely missing from the museum's exhibition.

The public space is traditionally an arena of competition between various cultural agents that are involved in a struggle for cultural hegemony. An important dimension of this competition is the way a society deals with its past—how the past is sequestered from forgetfulness; exposed, gathered, formulated, and reformulated in discourse; presented and displayed in specially designated spaces. This is all the more true in a society, such as the Israeli society, that is still in a revolutionary stage, undergoing processes of crystallization. The Israeli public space is one of the important arenas in which cultural agents have inscribed the charter of rights of the People of Israel to, for, and over the Land of Israel. This is an ongoing effort that has been carried out since the beginning of the Zionist movement by means of maps, monuments, archaeological sites, and so forth. In Israeli society, the establishment and control of sites of collective memory (*lieux de mémoire*) through which the presence of the past is determined often seems to be an existential question, and it has never stopped being a burning political issue. For example, when the right-wing Likud party came to power in 1977, it launched a rapid and intensive attempt to reshape the Israeli public space. At least ten history museums dedicated to the nonsocialist first wave of Jewish immigration to Palestine at the turn of the century were established. The two right-wing underground groups, the Irgun and the Stern Gang, were documented and commemorated in three new museums. In the city of Tel Aviv all major sites in which the underground's activities took place were decorated and designated by street signs that may be considered an extension of the museum.

The history museum serves as a crossroad for practices aimed at claiming and preserving the past, a place in which different efforts to represent the past and integrate it into the daily life of the present are channeled. Most history museums in Israel are located in historical sites of various kinds, which is one element in the attempt to claim the land and reorganize the public space. Other elements include the Hebraization of foreign (mostly Arabic) names of places, sites, and landscapes, and a narrativization of the landscape along the lines of Jewish–Zionist historical and geographical topographies.

In Hanita, a famous kibbutz near the Lebanon border, the local museum magnificently integrates the indoor exhibition with the surrounding landscape. The exhibition inside the museum confers meaning on the landscape outside and relates local archaeological relics to the more contemporary histories of Zionism, regardless of their actual link to modern Jewish settlements in the area. The following sentence, which serves to

introduce "archaeological relics discovered with the renewal of Jewish settlement in Hanita in 1938" into the exhibition in the Hanita museum, is a good example of these processes: the author claims that those relics "prove a continuous cultural presence in this place." None of the archaeological exhibits is related in any way to the history of the modern Jews in the region, yet they are made part of the exhibition because they were uncovered when the Zionist pioneers [Halutzim] conquered Hanita's hills. In the same vein, when a mosaic from the Byzantine era, which could not have been properly appropriated into Jewish history, is presented in the museum's audiovisual program, it is accompanied by this question: "Could it be a relic of an ancient synagogue?"—and thus claimed through a rhetorical gesture.

"Sites of Memory" scattered throughout the public space seek to present the past as if it were rescued "as it really was" from within the site itself, as if it were enough to remove from the site some layers of dust that have been covering it for centuries. The traces of the actual work it takes to establish and organize a site of memory are erased; in their stead other traces are stamped on the site, traces of the act of discovery, the recovering of a past that was lying there, all those centuries, passively waiting to be exposed. The past is stamped within the public space and exhibited as the concealed "truth" that has been exposed.

The struggle to control the means of representing the past has always been an integral part of the Jewish national struggle for conquering the land of Israel and retelling its history. The legitimation of this project was conferred in part by the Zionist version of the history of the people and its land. Thus, to this end the past had to be objectified and inscribed onto the landscape and the public space had to reveal and articulate its own history. This combination of fabricated exhibits within the context of authentic exhibitions serves the need to spatialize the past and historicize the land.

Universalized Preservation Practices in Israel's History Museums

Since the beginning of the century, first in Palestine and later in Israel, practices of preservation, of uncovering the past and objectifying and displaying it, have been part of a national struggle for ownership of the soil, for the land, for the state. This national struggle has been transformed into a universal form of activity focusing on preservation practices; they have been presented as scholarly tools used within an enlightened culture of modernity, or as a means in the struggle against a general cultural

oblivion and the disappearance of the "authentic" world of origin. Universalized practices of preservation and uncovering locate the "past" and the "authentic" outside the present, outside its political, cultural, and social context. The vested interest to "save" and transmit the past is presented as a common struggle that transcends any "material" or mundane interest—national, ethnic, or otherwise.

Enrolling Art in the Service of Ideology

Practices of preservation, commemoration, and display are common to all museums, but their specific character and aim differ from one museum to the next and can be located within competitions and struggles among different cultural agents whose parameters are at stake. Agents invest material and symbolic resources in conflicting attempts to create, preserve, or erase, to strengthen or weaken boundaries between, for example, low and high culture—between documents and exhibits, between art and craft, and between art for art's sake and art in the service of some particular interest.[1] Often, the struggle over a particular cultural boundary is but a local expression of a more comprehensive effort to defend or undermine the autonomy of a cultural field and its immunity to the pressure of national, class, or other interests. The museum has a decisive role in maintaining the autonomy of the art field, since it functions as one of the central mechanisms of classification, rarefaction, and sanctification of the material culture.

The Bezalel museum established in Jerusalem in 1906 and the Shrine of Art that was founded in Ein Harod in 1936 are typical examples of museums conceived as art museums, although the format of their activity was similar to that of the history museum.[2] This tendency continued even after the founding of the Israeli state. The Tel Aviv Art Museum, which had been set up in 1937 but was forced to defend its activity as a museum of "pure" art for decades afterward, and the Israel Museum that was established in 1965 and bound together departments of Judaica, folklore, manuscripts, and modern art, are two more outstanding examples of the way in which the art museum was overcome by the format of the history museum.

In the first years after the establishment of the State of Israel in 1948, the Tel Aviv Art Museum had to fight for its autonomy against attacks by both the state and the military, the Tel Aviv municipality, and several Jewish organizations. In 1949, negotiations took place between the director of the museum, Dr. Haim Gamzu, and the chief education officer of

the IDF (Israel Defense Forces, Department of Planning and Photography). The army was interested in presenting an exhibition of photographs by photographers who belonged to a special military unit, and "who did the best they could to perpetuate in photographs the main events that had taken place during the year of the 'War of Independence.' " Another threat to the autonomy of the museum came about soon after, in 1951, when the leadership of Kibbutz Lohamey Ha-Ghetta'ot (a kibbutz founded by survivors of the uprising in the Warsaw ghetto), together with the Tel Aviv municipality, called upon the Tel Aviv Art Museum to organize an exhibition dedicated to the Holocaust and the Jewish revolts against the Nazi regime. In the same year, the Hebrew Society for the People's Knowledge, an organization for adult education, proposed an exhibition of Passover customs to take place in the museum. All of these requests and many more were rejected in view of the museum's proclaimed aim, that of developing an autonomous tradition of Israeli fine art.[3] The Tel Aviv Art Museum was constantly on alert to preserve its autonomy and rebuffed most of the "outside" demands that threatened to nibble away at its boundaries. The national interest, in whose name most of these demands were made, was presented by those who called on the museum to serve the common interests of the social collective. Thus these demands, articulated within the context of a radical socialist rhetoric of the period of the state's foundation, positioned the desire for a fine art tradition as a narrow-minded and treacherous desire for individual gratification rather than a socially responsible effort.

The "Amateur Enthusiast"

The figure of the single enthusiast or amateur cultural entrepreneur has been central to the processes of universalization and depoliticization of historical preservation and display practices in Israel. Many of the museums, it is customary to relate, were established by just such enthusiastic amateurs. The singular entrepreneur occupies a cultural position in which the private identification marks of the individual who inhabits it are erased. The individual is presented as the neutral and objective medium that transfers historic truths without embellishment and without interference from on high, an agent through which the inevitable has come to take place. Thus the museum founded on the vision of a single enthusiastic person establishes itself as a disinterested cultural entity whose link to the past is unmediated. This is often conceived of in terms of an individual or a group that "sacrificed" time, energy, and money for the suc-

cess of some project of historical preservation and display. This sacrifice provides a legitimating narrative for the supposed "objectivity" of the representation of the past that the group produces since it is perceived as having sequestered the past from oblivion, saved the authentic from annihilation, and so forth.

Up to the 1970s, the singular enthusiast was required to make great efforts in order that his or her personal project would be recognized as collectively important. From the middle of the 1970s, after several public agencies had recognized the ideological and economic importance of the museum as a general cultural institution, the phenomenon of the single entrepreneur was institutionalized, and the entrepreneur became the key heroic figure in creating the authentic and neutral image of the museum. The singular enthusiast's cultural image was then shaped by teachers and curriculum writers in the Ministry of Education, by tour guides of the Society for the Protection of Nature, by leaders in the youth movements, by journalists in the field of tourism and other writers dealing in particular with "the beautiful and nostalgic Land of Israel," and by members of public nonprofit historical societies.

The Fabricated Exhibit

Toward the end of the nineteenth century the traditional structure of the art museum in the West was undergoing transformation; practices of preservation and display, as well as the contents of the exhibitions and the character of the exhibits preserved, underwent a paradigmatic change. The dominant practice that characterizes the traditional museum is an act of petrification, taxidermy, or freezing, which makes possible preservation of the outward appearance of things as they appeared in the past, or at least the illusion of this appearance. The "authentic" value is an outgrowth of this practice. In contrast, the main practice in the new museum, and later, more specifically, in the history museum, is that of transforming documents into objects of display, that is, transforming representations of various types into exhibits.[4] This practice is distinguished from the previous ones, since from now on exhibits could legitimately be fabricated. An example of such a practice can be seen in the Diorama of the Holy Temple as exhibited in the Tower of David Museum, a diorama that has been "scientifically" planned according to a range of "authentic" sources. In this case the fabricated artifact aims at representing an image of the Holy Temple in the absence of the object itself or any visual representations of it. Another form of fabricated ob-

ject can be found in the many museums of the Hebrew Settlement of Palestine, in which supposedly authentic everyday objects of the period, such as shoes spattered with some very contemporary mud, are scattered throughout the display. Another prominent example is one of the two museums dedicated to the Etzel, the right-wing prestate underground movement. This museum is called Beit Gidi and was set up in Jaffa in a stone Arab house whose top floor had been destroyed in the fighting over the city in 1948. The prominent site by the water at the entrance to Jaffa was chosen in order to make the representation of battle over the city a more concrete and authentic experience. The destroyed part of the building was reconstructed in a modern style, thus emphasizing the authenticity of the older surviving part, and the building as a whole was filled with various military exhibits such as arms and weapons dating from a much later period. Not only are most of the exhibits fabricated, but the main argument is arrived at through the actual Israeli occupation of an Arab house and its restoration for the purposes of commemorating a Hebrew victory.

One may see in the collection of "fabricated exhibits" merely a broadening of the bounds of possible museum objects. But such a conception disguises the ideological manipulations that become possible as a result of crossbreeding the practices of preservation and display (which includes the transformation of documents into exhibits). Thus the sphere of museum activity came to include the discourse and practice of preservation and to adapt their central values and terms: authenticity, uniqueness, rescue from oblivion, rarity, and so forth. The crossbreeding between these two practices and the blurring of the boundaries between them made possible the emergence in its present form of the ideological institution we know as the historical museum dedicated to preserving the past and its treasures of material culture.

A Judeocentric Image of the Past

The founding of Bezalel in 1905 marked the first time since the establishment of museums in Western culture that Jews had the opportunity to articulate and display their own history in their own public space. In the Bezalel museum they were no longer represented as an "other" in the framework of others' histories. Of course, history books and essays had been written by Jews and for Jews before. But it was the first time that images of the past produced by Jews and for Jews were placed and distributed within the public space, within a geographic-social-political

space that the Jews claimed as their own. Since then, most of the muse-
ums in Israel have posited the Jewish people as the subject of the narrative
and of images of the past. They have classified (again for the first time in
the modern era) the material culture of both the land and the people, con-
sciously mixing the two, and created a new image of the past, a Judeo-
centric image of the past. Haim Attar, founder of the Shrine of Art in Ein
Harod (one of the first kibbutzim in the Valley of Izrael), formulated in-
structions for reconceiving the past that serve as an outstanding example
of the attempt to produce a history in which Jewish artists had always
existed though were often unacknowledged:

> The memory of Jewish construction that found its perfected form in the
> building of the Temple in Jerusalem and afterwards in Yabneh, Beitar,
> Safed—and afterwards in building Hanukkah candelabra and sacred
> objects in the long Exile, the holiness of synagogues built of wood, from
> the 16th and 17th centuries, that Jewish artists embellished with folk art,
> painting, carving, and skilled artistic works—and they remained
> anonymous—those who found themselves in the residences of foreigners
> and embellished treasure houses and churches with skilled artistic works,
> as far back as the time of the Inquisition in Spain and through the
> Renaissance in Italy who remained unknown as Jews.[5]

According to the remaining documentation of this exhibition, it included
photographs and drawings of synagogues from all over the world ac-
companied by various religious vessels such as candelabra and numerous
images, reproduced drawings, and paintings by well-known as well as
unknown artists whose common denominator was their Jewish faith.

In order to produce an image of a Judeocentric continuum, it was nec-
essary to reprocess the historic materials and often even to redefine con-
cepts or change their meaning. In Ein Harod, the "art world" was reor-
ganized to include the crafts (especially the fabrication of ritual objects,
Hanukkah candelabra, doorjambs, etc.) and architecture was extended to
include the building craft, so as to create a picture of a continuum of Jew-
ish architecture. Another continuum, of Jewish artists throughout the
ages, was arrived at by "discovering" the Jewish identity of various art-
ists of the past who "remained unknown as Jews."

Focusing to such an extent on the Jewish identity of Jewish artists af-
firms the otherwise largely false contention of a continuous Jewish artis-
tic tradition. Similarly, the systematic gathering of Jewish relics makes
plausible the otherwise untenable belief in a continuous Jewish material
culture. It creates the impression that artistic tradition and material cul-
ture have long awaited the Zionist movement in order to be revealed and

suitably exposed, rather than having been fabricated by the Zionist movement as part of its historiography. The terminology of "discovery" and of "forgotten Jewish relics and artists" blurs the fact that practices of collection, preservation, and discovery played an active part in creating Jewish material culture and hence in creating the Jewish people as the national subject of that culture.

Like the Shrine of Art in Ein Harod, most of the history museums in Israel have been explicitly ideological in their formulation. This attempt by one dominant group to present an image of the past as if it reflects the belief system of the society as a whole was formulated in two directions: vis-à-vis the "other from without," that is, the Palestinian; and vis-à-vis "others from within," that is, the Sephardic Jew, the Orthodox Jew, and the Israeli woman. The image constituted in relation to the Palestinian was Judeocentric; that constituted in relation to internal others was Zionist, socialist, masculinist, and emphatically Western.

The year 1905, when Bezalel was founded, was a decisive year in the conquest of the public space of Palestine and the ensuing dissemination of Zionist representations. Despite the fact that the claim of the Zionist movement to sovereignty was still in its inception, the main cultural agents of the Zionist movement functioned as already sovereign of Palestine's public space and inscribed their stamp in that space as if the image of the past had been collectively arrived at. They consciously mixed their version of the past with their interpretation of the present as an immediate continuation to a "present-past," a past that had been closed off and had not yet received the mythic formation that would later fix it as a cosmogony, a narrative of the birth and genesis of the state.

Bezalel of those years was not preoccupied with apologetics, with comparisons, or with a struggle against competing cultural agents. It exhibited an image of the past as if it were naturally given and systematically denied the plurality of coexistent narratives. It must also be stated, in all truth, that at that particular historical moment those who could compete with Zionist cultural agents, and especially the main other of Zionist discourse, that is, the Palestinian Arabs, invested little time and resources in the struggle to shape the public space and control the representations it produces.

Later, there were, of course, some attempts to produce and represent a dissenting image, an alternative to the hegemonic one. But even as late as the seventies, those attempts were marginal and so belittled that they were hardly engaged with in any significant way. The case of Jabotinsky House is a good example. Jabotinsky House was established as a memo-

rial institute for the right-wing "revisionist movement" (out of which the main component of the Likud party later evolved). It had been established before its hegemonic competitor, the Haganah Museum, was even conceived. But when the Haganah Museum was founded to commemorate the history of the mainstream Jewish armed forces of the prestate days, it did not deal with the image of the past presented in Jabotinsky House; it did not even recognize that image as a version to be denied or refuted. The subject of Jabotinsky House was totally ignored by the exhibiting subject in the dominant position.

Museum Intervention in the Private Sphere and Dictation of Patterns of Preservation and Taste

Several times in the course of the history of Israeli museums, attempts were made to transcend the boundaries of the public space and directly intervene in the private space. The pattern of these interventions has always been the same. At first, the museum endows an individual's document or artifact with its public meaning by displaying it in an exhibition and subordinating it to the museum's authority to preserve, classify, and display. Then the museum makes the transformed object accessible to the individual visitor. The museum serves as a mediator between the individual as a private person and the individual as an exemplary persona, a model of virtues and ideal behavior that is presented to the public as an ideal and that shapes patterns of taste and practices of recollection. The individual's suffering or grief, his or her victory or heroism, are expropriated from the private domain, imprinted with a public stamp, and then employed to construct a structure of identification with the individual visitor. A widespread example of this process in which personal artifacts are used to elicit identification and an anchoring of the public narrative to personal, individual lives are the books of the fallen (the names of those who have been killed in Israel's never-ending war), in memorial rooms in army bases, kibbutzim, and other sites of memory.

It seems that two opposite interests are served here: that of the individual who in making public his or her private suffering, sacrifice, or achievements enters the public sphere of commemoration and that of the official or semiofficial mechanisms of display in controlling the images of the past and their dissemination. In fact, we could claim that an economy of exchange and an implicit contract between the private individual and the public mechanisms of display takes place. The individual concedes the uniqueness of his or her private world, his or her surroundings and

memories, and agrees to limit the public exposure of this world to the museum's (or other agents') mechanism of display. He or she exchanges the private experience for a standardized version of this experience, processed and disseminated by the museum, and thus enters history. The official mechanisms, for their part, embrace supposedly unauthorized subjects and in turn earn a monopoly over the representation of the private domain, the individual's past and its interpretation.

The story of "the tank of Degania," which recently returned to the headlines after more than forty years, exposes an aspect of the exchange I am describing. A tank that led a large Syrian unit that invaded the first established Kibbutz of Degania near the Galilee Lake during the Independence War in 1948 was hit by the local defenders. After the first tank was hit, the entire unit stopped and began to withdraw, Degania was saved, and the Syrian invasion of the northern part of Israel was jeopardized. Or so the story goes. According to the official version, based on the paradigm of the few against the many, the Syrian tank that was about to enter Degania was stopped by a kibbutznik with a Molotov cocktail. There are at least two other versions of the story that absolutely contradict the perpetuated narrative. The protagonists of the alternate versions kept silent for more than forty years. They concealed their less heroic, though probably truer, versions in order not to lose their place in one of the state's founding myths.

In the Bezalel museum and in the Yad Vashem museum for the commemoration of the Holocaust victims, the attempts to oversee the individual's means of representing his or her past and the attempt to control them have been more clear-cut and more overt. Both institutes, the one for a short time at the turn of the century and the other ever since its establishment in the fifties, have explicitly affected a slippage into the individual's private sphere. In both cases, the museum tries to establish a network of dissemination of symbolic capital that is produced in the museum and is disseminated through material assets (exhibits and documents).

The Case of Bezalel

Boris Shatz, founder of the first Jewish museum in Palestine, who envisaged and realized the Bezalel "program" (a complex institution that would comprise a school, a small manufacturing and commercial plant, and a museum), conceived and even tried to implement an ideal of the "Hebrew room" and its appearance. Shatz developed a practical program for decorating the Hebrew room. The room of the modern, liberated Jew

of Eretz-Israel was supposed to be decorated with Jewish art objects produced at Bezalel. The Hebrew room constituted a part of Shatz's broader program for creating Jewish art in the Bezalel art school. The Hebrew room was intended to mix biblical and oriental motifs and to forge an integration of East and West, of the European Jewish traditions and indigenous Oriental styles. Thus Bezalel produced jewelry and religious artifacts, woven linens and rugs, and hammered copper for furnishings and decorations and numerous other objects that would constitute the unique style of the Hebrew room. Shatz wished to win recognition for the Hebrew room not only because of its "unique features" or "aesthetic quality." The goal of the manufacturing facilities and the international marketing networks that Shatz set up was rather to reach every Jewish home and mark it with an identifying stamp. That is, in Shatz's vision it was important to grant those Jewish art objects an identifying role, to distinguish the Hebrew room from every other room.

In the communication of individuals with their past, the museum as a public institution has the role and authority of a mediator, a mediator of representations of the past. The authority of the museum enables it to intervene in the private sphere. The case of Bezalel is an outstanding example of an attempt to control a demarcated public space in order to gain authority and use it as a means of intervention in the private sphere. Shatz's vision was to shape the material surroundings of the private sphere and to imprint them with a unifying, identifying set of characteristics. This was an extremely ambitious vision that nascent Israeli culture could not have sustained. Shatz tried, in fact, to subordinate the symbolic capital that had been produced in Bezalel—assets that had belonged to the field of art—to the system of national values. Very early on, he met with the opposition of a growing number of artists who aspired to work in an—at least seemingly—autonomous artistic field. Their opposition was one of the main obstacles to the realization of Shatz's project.

The Case of Yad Vashem

Despite the great difference between Bezalel and Yad Vashem, it is important to stress the similarity they share in shaping memory through display practices. Both museums were established by organs of central power. The founding of Bezalel was decided upon by the Seventh Zionist Congress in 1905. The establishment of Yad Vashem or, more exactly, the Memorial Authority for the Holocaust and War Heroism, was de-

cided by the Israeli parliament (Knesset) in 1953. The goal of the insti-
tute, as formulated in one of its publications, was

> to engrave deeply in our memory both the great destruction of European
> Jewry and the heroism of Israel in the Second World War and to
> transform this memory into great strength, that like the Holocaust and
> heroism of bygone generations, will become rooted in the consciousness
> of our people and will be woven into the tractate of our redemption.

In order to fulfill its goal, Yad Vashem museum created a mechanism of
distribution that accompanies the exhibition. Usually, in other memorial
sites dedicated to commemorate the fallen, the standardization of mourn-
ing practices takes place in the public space of the site. Yad Vashem tries
to standardize commemoration and mourning practices in the private do-
main; the museum distributes memorial cards to be hung in houses of
relatives of Holocaust victims. The card, which grants the victims "me-
morial citizenship of the State of Israel," offers individuals a common
channel of memory and mourning and guarantees the presence of the
state in a context that otherwise might remain private and intimate, but
could also conceivably become unpredictable, and even endangering, to
the social order in its irrational and unharnessed grief.

The system that distributes these exhibits is reminiscent of the way in
which Bezalel intervened in the private sphere and of Boris Shatz's vision
of the Hebrew room. Yad Vashem set for itself as a goal the "granting to
the children of the Jewish people who were destroyed and fell during the
Holocaust, memorial citizenship of the State of Israel as a sign of their
being gathered to their people." The aim was to give "the tens of thou-
sands of families in Israel the minimal consolation that they could hang
on the walls of their apartments a certificate attesting that their fathers,
mothers, brothers, sisters, sons and daughters had been gathered to their
people and that the State had granted them memorial citizenship."

Demonopolization of the Past

Since the end of the 1970s, Israeli society has witnessed a process of de-
monopolization in the production of collective memory. Many marginal
groups have tried to enter the cultural field and to actively participate in
shaping and representing the past, thus causing cracks in the previously
monolithic narrative of the past. In May 1977, with the rise of the right-
wing Likud party to power, sixty years of cultural hegemony of the Labor
Zionist movement, the main producer and distributor of the monolithic

image of the Jewish past, came to an end. Eighty museums, about 60 percent of the museums in present-day Israel, were rapidly established within the next ten years. Many of them were founded by communities or individual entrepreneurs who felt excluded from the common heritage of the Jewish people represented by school curriculums, textbooks, history museums, and other monuments scattered in the Israeli landscape. In many cases, the new founders came from marginal groups. Their cultural policy, however, was not one of protest against and subversion of the established means and modes of representation of the past, but an attempt to gain access to the existing system and use it for new and particular interest groups.

In general, four main subjects may be discerned in the act of display: the exhibiting subject, the exhibited subject, the person to whom the exhibition is addressed, and an additional subject, the other who has been excluded from the exhibition. The relation between the exhibiting subject and the exhibited subject is crucial for understanding the narrative structure of the exhibition and the criteria that dictated the practices of preservation, classification, and display. But these two subjects do not alone shape the picture of the past and its display. The potential target audience of the representation of the past has an important role to play, for it is usually a construct—hidden or overt—of the exhibition narrative. When the exhibition takes place in a context of national or ethnic struggle, as it always does in Israeli culture, another subject is involved— the other who has been excluded from the arena of exhibition and whose status as either source or object of knowledge (or both) has been denied. In the Israeli context this other may be the Arab, the Sephardic Jew, women, or, in some particularly secular or socialist contexts, the ultra-Orthodox Jew. The other is considered an unreliable witness or a subject unworthy of witnessing, and sometimes the other's presence in the representation of the past is denied altogether, for obviously the other has an alternative image of the past to offer. The processes of exclusion are usually carried out in a subtle way, through the organizing principle of the exhibition. Occasionally, though, cruder means for rewriting the past are used, as in the following example. Maurycy Gottlieb was a Polish Jewish painter who worked in Poland (1856-1879). A reproduction of his painting *Yom Kippur*, which portrays a synagogue scene during the High Holidays, is on display in the Jewish Diaspora Museum in Tel Aviv. In the original painting one can clearly see women standing in the women's gallery of the synagogue; in the reproduction on display, the female figures have been erased.[6] Someone has obviously thought that the presence of

women in representations of Jewish religious practices is improper—
dangerous, outrageous, or simply obsolete.

But what is in contention in the representation of the past is not merely
images of the past that compete with one another but also the control
over the means of representation and dissemination of this past. The
struggle is between those who currently possess these means and those
who seek a greater access to what has been denied them. The other in this
case is a competing exhibiting subject who has not been entirely excluded
from the arena of representation of the past. In certain historical circum-
stances such an act of exclusion constitutes a greater threat to majority
culture than certain forms of inclusion in the produced image; controlled
inclusion is often safer and easier to achieve and contain than exclusion.
In a case like this, the other is assimilated into the hegemonic version of
the past or is allocated a designated place in that version. From this place
the other can utter his or her version of that past with no hindrance or
threat to the dominating exhibiting subject and the images of the past he
or she produces and disseminates. As late as the mid-1970s, the Sephardic
Jew was missing from most exhibitions in Israeli museums. Then the
Ministry of Education founded the Center for Integration of the Heritage
of Eastern Jewry. The declared purpose of this institute was not to rep-
resent the living culture of Sephardic Jews but to preserve their heritage
as something that had already become part of history.[7]

The most distinct others of Israeli society, the Palestinians, are still ex-
cluded. The Palestinians' possibilities for representing either a past or a
present in the Israeli public space are extremely limited and subject to
both direct and indirect censorship.[8] The dissemination of permanent
cultural representations is hardly possible for them, due to severe legal
restrictions. Therefore, the only way open for the Palestinian community
to inscribe its representations in the public space has been to use tempo-
rary representations whose presence is ephemeral. These are not aimed
primarily at reclaiming the past as narrative but rather as an intervention
denoting a presence and suggesting a future narrative that is inclusionary
rather than exclusionary.[9] Two examples may suffice.

On March 30, 1976, violent demonstrations in many Arab villages and
towns shocked the Israeli public. The demonstrators, Israeli Palestinians,
protested against the confiscation of Arab land for public purposes by the
Israeli state. Six Arab citizens were killed in clashes with the police.
March 30 has become "Land Day" and is designated by the Israeli-Pal-
estinian community as an annual day of national solidarity. Land Day has
become an occasion on which Palestinian national and cultural identity is

reaffirmed and celebrated, invigorated through a variety of means and media in the public space of the Arab sector of the population. This display of Palestinian identity, however, is transitory; it lacks any attempt at permanently inscribing an Arabic version of the Palestinian past. Many such versions exist, of course, but they have seldom gained a permanent place in history books or structured exhibition forums.

The only Arab museum in Israel that is dedicated to Palestinian culture exhibits the work of contemporary artisans within a tradition of crafts and handwork that supposedly contains and defines it at the level of folkloric tradition. No claim is made within the displays to connect these traditions to concrete and autonomous historical narratives, to the original regional location in relation to other Arab cultures, or to their contemporary location within present-day Israel. Thus, they are displayed as aesthetic artifacts that represent a tradition of Palestinian artisanship.

Bearing in mind all the distinctions between the Israeli Palestinians and the Palestinians in the Occupied Territories, the Palestinian insurrection, the Intifada, may supply another example of the argument I have been pursuing. The uprising is on the one hand a national struggle for Palestinian self-determination and liberation from Israeli occupation. According to other political interpretations it is aimed at the destruction of the Jewish state. But since political struggle is equally also the struggle over representation, it must equally be viewed as, among other things, a most intense and violent struggle for the right and means to shape and control the Palestinian public space. Control of public space, no doubt, is not the stated purpose of the Intifada. Control of public space, however, is traditionally one of the main venues of nationalist struggle, and a colonized public space is one of the main arenas in which that struggle is enacted. Under the eyes of Israeli censorship and armed forces, Palestinians strive to influence and take control of the representations disseminated in their public space. In order to achieve this, or at least to undermine the degree of Israeli domination, Palestinians go on strike, burn tires, throw rocks, and spread graffiti on virtually every available surface—walls, doors, street columns, and the like. The Palestinians use a variety of representational means and practices in order to inscribe in space their resistance to the Israeli authorities. Here, too, representations are transitory and often ceremonial or ritualized and they make no claim upon a concrete reorganization of the past, with one interesting exception: strikes are regularly called to commemorate important events of recent Palestinian history. The Palestinian calendar is replete with anniversaries, and they are usually marked by means of temporary display in public space, through pa-

rades, school activities, and commercial strikes. No linear history is involved, however, and no coherent image of a common past is represented in this way. The permanent, public display of its history has so far remained out of reach for Palestinian society, and the streets in the West Bank and Gaza are full of substitutes for that missing history, in the form of oral history, storytelling, graffiti, placards, leaflets, and the like.

The means by which Israeli authorities deal with Palestinian art testifies to their understanding of the important role display practices and art exhibitions may play in the constitution of a national identity. From the official Israeli point of view, the Palestinians can present their art in public only when they are defined as "our" other, as an other in "our" space. In the regulations issued by the Civil Administration of the Occupied Territories, the Palestinians are prevented from displaying their art in their own space, yet they may do so across the green line, in Israel itself, under Israeli auspices. The dominating culture is willing to allow dissemination of competing images of the past only when they are subject to its own supervision and are produced and disseminated in frameworks and spaces it cautiously allocates them.

Transforming the Different into the Similar: The Politics of Cultural Assimilation

The number of museums, images, and iconographies that have emerged to stake a claim in Israel's public space since the seventies might lead one to think that this has meant that a plurality of narratives has replaced the former unity of dominant culture. I shall argue, however, that in fact what has occurred is a process of "flattening" or leveling of the various images and identities produced and represented within the museum's walls and a reduction of past images into easily consumable one-dimensional stereotypes and clichés. In many of the recently founded museums, visitors still encounter images from the prestate underground movement and illegal immigration by Jews into colonized Palestine, the tower and stockade settlements of early pioneer days, and ghetto life in the various diasporas, all of which serve to emphasize poverty, suffering, and persecution as central historical categories of Jewish tradition.

The Jewish Diaspora Museum, opened in Tel Aviv in 1979, is a perfect example for the affirmative, convenient inclusion of the other (the Sephardic Jews in this case) into the hegemonic image of the past. From the outset the museum claimed to transform the common Israeli conception of history museums based solely on authentic exhibits and their

chronological display. Here historical periodization was abandoned and replaced by a thematic organizing principle. The exhibition was divided into six sections, each section dealing with a different aspect of the life of Jewish communities in the diaspora: family life, community, faith, culture, life among the nations (persecutions, pogroms, anti–Semitism, etc.), dreams and visions of return to the land of Israel. One of the most astonishing aspects of the display is the manner in which it has uncritically integrated the familiar and offensive kitsch of supposedly Jewish or ethnic attributes into its own exhibition—every conceivable stereotype from the fur hats of Eastern European Hasidim to Yemenite embroideries to pioneer scythes and brick ovens for baking pita. The most advanced technological means such as computers, videos, and holograms are used to construct the most banal and stereotypical and supposedly authentic images that visually signify groups of people as "Jewish."

The exhibition has become less conventionally historical, perhaps, but no less ideological. All Jewish communities in the Diaspora, it is assumed, have shared the same aspects of communal life and expressed the same Jewish essence in different ways. Moreover, the course of the exhibition leads the visitor from the least to the most political aspect of Jewish life. In the political domain, the Zionist agenda is virtually the only one represented. Zionism, after all, is the successful realization of the dreams and visions of the return of the Jewish people to its land. Other dreams and other visions, and even concrete political and social movements such as the Socialist Bond (the Bund) and the Orthodox Agudat Israel that were extremely active and popular in Europe in the first half of the century, are hardly mentioned.

The multiplication of past images, which embodied a potential for challenging the hegemonic image of the past, in fact created a situation in which worn, recycled images drew their legitimacy and easy legibility from their direct association with the dominant culture. Thus, every group that set up a museum for itself and seemed to claim its unique identity turned out to be busy with a conservative attempt to appropriate for itself a position within the general hegemonic story. The Jabotinsky House dedicated to the Revisionist movement and its leader (Zeev Jabotinsky), for example, long ago abandoned any attempt to introduce the mixture of Jabotinsky's liberal and nationalist ideas, to stress their uniqueness, or to claim their validity. In 1937, when the Jabotinsky House was founded, its establishment meant much more than simply an attempt to produce an alternative historical narrative. By its very existence it posed a challenge to Labor Zionists' monopoly over the exhibit-

ing subject, thereby assuming an explicit political meaning and serving as an intervention in the political field. Today, however, despite the fact that overt nationalist ideology has dominated Israeli politics at least since 1977, during which time rightist versions of Zionist history have gained considerable legitimation, the museum continues to actively agitate for recognition of the Revisionists' part in the establishment of the state of Israel. The Revisionist museum has to be seen as having accepted the initial frameworks of the national narrative produced and distributed by its bitter enemy in local political struggle, the former hegemonic culture of Labor Zionism. The image of the past the Jabotinsky House produces does not strive to replace images produced by the once-hegemonic agents of Labor Zionism, but merely to complement them. At the same time, and precisely because its image of the past does not exclude that of the old hegemonic culture, the rightist museum pretends to be a legitimate exhibiting subject authorized to represent the Jewish collectivity as a whole.

The Museum for the Heritage of Babylonian Jewry (Jews of Iraqi origin) provides another example. One may erroneously think of its founding in 1980 in similar terms, as if its establishment too was an apparently political act, a kind of protest similar to that raised by the Sephardic protest movements of the seventies.[10] The museum was associated with Arab Jews' claim to a greater and more equal share in Israel's social and cultural life. A community that until then was quite marginal and quite naturally felt excluded from the hegemonic representations of the Jewish past decided to claim for itself its own past. But when we examine the way the founders of this museum chose to represent their history, we perceive that instead of producing their unique identity in opposition to the identity ascribed to them by the hegemonic culture, the community of Babylonian Jews represented its history through the same paradigms employed in the main museums of the hegemonic culture. By adopting both conventional display strategies and the narrative structure in which Jewish life is viewed through the trajectories of ghettoization, persecutions, and finally redemptive immigration, they have emptied their cultural act of its potential oppositional meaning. On the contrary, if the establishment of that museum had a dominant political meaning, it was that of participation in the reproduction of the dominant image of the Jewish past.

The Museum for the Heritage of Babylonian Jewry is representative of museums that have emerged and flourished in Israel since the mid-seventies, museums one may call postideological or synthesist in their impact. The initiative to found them had an apparent political motive, but their potential for political subversion has been contained by dominant

cultural ideology. Moreover, it has often succeeded in getting the direct cooperation of the minority group in conceding its unique identity and integrating it into the established version of the national narrative and its images. On the face of it, the postideological period of museums enables individuals and marginal communities to express their desire to represent themselves autonomously. The reality, however, is that official state culture determines for the marginal community the governing paradigms and neutralizes any potential for radical political change at the level of representation.

The museums that attempt to recount the histories of previously marginalized groups also include various institutes for the heritage of Oriental Jewry and the few museums devoted to the right-wing underground organizations of the Etzel (the Irgun) and the Lehi (FFI or Stern Group) and others. Parallel to the appearance of alternative voices, the dominant cultural institutions began to rewrite their previous versions of the past as monolithic. Within these more current versions, a place was allocated to various kinds of others: Bedouin Arabs, Oriental Jews, women. In most cases, these changes in official or semiofficial versions of the image of the past did not accord the other a position as an exhibiting subject; the museum's preservation practices worked to neutralize the subversive or oppositional potential of the alternative images of the past, though dominant cultural narratives have nevertheless been forced into some process of reconsideration or revision.

Conclusion

It is said that in the fullness of time, everything is doomed to oblivion. This may not necessarily be a bad thing after all, since it is cultural and epistemic amnesia or erasure that makes possible creation in the broadest sense of the word.

Innumerable improvised and institutionalized mechanisms contend with social and cultural amnesia and work to accord presence to things that are not yet or no longer present. These improvised and institutionalized mechanisms isolate within a heap of debris what seems worthy of reproduction, what is valuable as a model and an exemplar for the future. Thus they effect, through practices of preservation and remembrance, reproduction of objects that will work to convey a narrative and do so with a seemingly unique voice.

The work of preservation that expropriates the past from oblivion reproduces images of the past as well as the conditions and means of their

reproduction. This is a political project, and it often involves political struggle: "and to this battle will go forth with the sons of the fighting family as they went out to former battles."[11] The conflict taking place in the present in the field of preservation and representation of the past is over establishing one picture of history as the dominant one. It is analogous to, or at least continuous with, the former conflict that took place in the actual field (political, artistic, or literary) in the past.

Two contradictory assumptions concerning the link between past and present can be extracted from the discourse of preservation in Israeli society. On the one hand, the past is bound up with the present and dictates it: in the matter of the historic rights that the people of Israel claim over to the land of Israel, for example. On the other hand, the past is absolutely separated from the present, as exemplified by the concept of "historic truth" that is supposedly found beyond the threshold of the present and its rival ideologies, waiting to be discovered. What makes possible the coexistence of these two assumptions in the same ideological field is the attempt of the exhibiting subject to blur the traces of its interests in promoting one image of the past rather than another. As long as the exhibiting subject is in power and its position is part of the hegemonic culture, it can present its image of the past as transparent and construct a position of "an innocent visitor," an observer who is expected to slide from the representation to what is represented without noticing the crude seams that had to be stitched for the purpose of producing it.

Since the 1970s, however, at a rather slow pace, the one-dimensional image of the past that was disseminated in Israel through all possible media of representation has been fragmenting. Since the Lebanon War (in the first half of the 1980s) and through the Intifada (which began in 1987 and continues to the present), the cracks have been widening at an accelerated pace. The development of Israeli historical museums has not been able to come to terms with this erosion and thus forms an important exception to this process. For the most part, museum exhibitions change very slowly, and therefore, so it seems, over a long period they will continue to function as rear-guard producers of, and silent testimony to, the age of the monolithic image of the past.

The cracks in the hegemonic image of the past, however, are more prevalent in representations disseminated through other media, which care less for authenticity and nonreproducibility and are more temporary, more rapid and fragmentary, having no fixed and continuous presence in the public space: newspapers, electronic media, movies, photos, art, and so forth. Multiple, fragmented representations now exist together in the

same arena, covering and exposing each other, and one might say that an image of the past is being crystallized here according to the principles of antihierarchical composition. This antihierarchical composition, however, only emphasizes the breach between the signifier and the signified, between representation and represented reality. In that realm of historical and ideological discourse in which images of the past are exchanged and disseminated, the situation has recently become "anything goes." One is allowed, for example, to condemn the ideological manipulations involved in the large-scale apparatus that reproduces the memory of the Holocaust in Israeli society without having any effect on the ongoing activity of the manipulative mechanisms. One may even suggest forgetting the Holocaust altogether without having to suffer exclusion from the discourse or the condemnations that Revisionists normally encounter. One may condemn the torture of Palestinians in the Occupied Territories, but those who practice torture are oblivious and, needless to say, the tortures do not stop. One may disseminate testimonies about actions of the army and the General Security Services (GSS) in the territories, but they do not stop. One may suggest annulling the Law of Return (which guarantees immediate naturalization to Jewish immigrants) and not fear being closely followed by the GSS. One may quarrel with the mainstream Zionist version of the past, one may deconstruct it in literature and political discourse, but its hold in the political arena remains as firm as ever. One may even speak about the end of Zionism and not be condemned as wicked, or may be condemned as treacherous without this condemnation bothering anyone. One may speak about emigrating from Israel (an act that until recently was considered a shameful sin in Zionists' eyes, worthy of contempt and condemnation) and justify it in terms of personal benefits and private interests, with no apology to the national cause. One may and one may and one may. It is argued that all this critical murmur that has suddenly become permitted attests to the maturity of Israeli society—a somewhat frightening maturity that means that criticism no longer poses a threat to the social order, that a political discourse in which even the harshest provocation and the most severe critique cannot function as the seed of change and transformation has been formed. Resistance in the realm of discourse and representation has been systematically assimilated and absorbed into the dominant culture and thus forced to collude in reproducing it.

Translated by Elliott A. Green

Notes

I gratefully acknowledge the invaluable assistance of Professor Ya'akov Shavit and Dr. Adi Ophir.

1. Producing and displaying images of the past within the art museum gives Jewish history primacy over the history of art. The society and the institutions within it worked as the initiators of the museums, supported their founding, and recognized their authority, since they were conceived as a part of the Zionist vision: "Concentrating works of Jewish art—painting, sculpture, graphics, folklore—concentrating all of them here, in Israel, in the village, in the kibbutz, is one of the foundations of our movement's vision, of the fabric of our renewed life. . . . Only a man like him [Haim Attar] could have conceived and realized the idea of collecting and concentrating which is basically artistic and Zionist in content" (David Tsirkin, speaking at the thirtieth-day memorial service of Haim Attar). The museum's entrepreneurs tried to make possible the joining of Zionist ideological values and the "universal values" of the international art field: "Thanks to these great painters—and to the youngest among them who continue in the same path—our feet stepped over the threshold of domestic art and we entered the great palace of world art. . . . We must grow like a main branch, Hebrew and original, within the world art of painting and sculpture" (Haim Attar, *Mibifnim* [Tel Aviv, 1947]).

2. The fact that there were no other museums in Israel in the period when these institutes were founded determined their nature as hybrid creatures combining several different functions. Preserving material culture or establishing a repertory of relics could contribute little to the sanctification and preservation of art objects. These two art museums gathered, preserved, and canonized works of art and craft according to a system of values in which national values preceded, if not overruled, aesthetic ones. Therefore, they could not serve as preserving organs for the field of artistic production that was in the making. These museums served an ideological cause at the basis of which stood the vision of gathering the Jewish people into the land of Israel and gathering there its cultural assets.

3. In the 1960s, there was a more concrete threat to the museum's boundaries. Me'ir Dizengoff, the mayor of Tel Aviv and founder of the museum, died and requested in his will that a new building for the museum be built to fit its character as he envisioned it: a combination of departments of ethnography and Jewish folklore, the history of Tel Aviv, the history of modern Jewish settlement in Israel, drawing and sculpture and other kinds of art. The Tel Aviv Museum for Art, like other museums that were already operating when the state was established (the Shrine of Art at Ein Harod and the Bezalel museum), conceived themselves as part of the Zionist enterprise in the broad sense of the term

4. Thomas W. Gaehtgens, "Le musée historique de Versailles," in *Les lieux de mémoire*, vol. 2: *La Nation*, book 3, ed. P. Nora (Paris, 1986).

5. From the outline of Haim Attar's ideas for the Shrine of Art in Ein Harod.

6. Israeli Dafna, "Golda Meir Effect," in *Politica*, no. 27 (1989). In Hebrew.

7. Cf. Virginia Dominguez, in *Discussions in Contemporary Culture*, no. 1, ed. Hal Foster (Seattle, 1987).

8. Report on Censorship of Pictures and Texts. B'tselem: The Israeli Information Center for Human Rights in the Occupied Territories, Jerusalem, 1991.

9. Ganit Ankori indicates the establishment of several information centers and museums in the Occupied Territories, but the information gathered there is extremely partial and reflects the poverty of research on the Palestinian public space (Ganit Ankori, "Beyond the Wall," *Kav* 10 [1991]. In Hebrew). An important and reliable source for studying these temporary and disordered representations are newspaper photographs.

10. Shelomo Hasson, "From Frontier to Periphery," in *Eretz-Israel: Studies of the Land and its Antiquities*, vol. 22 (Jerusalem, 1991). In Hebrew.

11. Menachem Begin, undated letter to "the sons of the fighting family," the Archive of Jabotinsky House.

Part II

Discourses

6

The Museum as Metaphor in Nineteenth-Century France

Chantal Georgel

As a site where the products of nature, of science, and of the arts were preserved and exhibited, the museum was a central institution of the nineteenth century. In France, in particular, it embodied some of the deepest preoccupations of the revolutionary state: collective reappropriation, the reappropriation of heritage, the birthright of posterity — ceaselessly debated issues that, taken together, formed one of the leitmotivs of the Revolution.[1] If the eighteenth century in France had declared the right of the people to come into full possession of what rightfully belonged to all mankind, the nineteenth century saw the museum as the accomplishment of this idea. The museum was not just an institution, it became a symbol. The extraordinary efflorescence of museums over the course of the century attests to this phenomenon. Not a single city in France, however small, was willing to do without a museum it could call its own. In La Couture-Boussey, for example, the museum consisted of a single case of local relics displayed in the chambers of the town council.

The uses of the word *museum* during the nineteenth century, especially in the popular press, further attest to the symbolic power of the institution. Between 1806 and 1914, more than seventy newspapers, journals, and albums carried the word *musée* (museum) in their titles.[2] This fact alone suggests an interesting relationship between, on the one hand, the world of the press, with its retinue of money, publicity, and advertising — what John Grand-Carteret, in 1893, called "the century's modern forces"[3] — and, on the other hand, the museum as a privileged exhibition space.[4] The metaphor of the "printed museum" presents a particularly striking image: the museum as encyclopedic institution devoted to the education of all. This image, although it represented an ideal and in many ways unrealistic vision of the museum, carried great authority and tended to supplant other available representations. It was from this model

museum that the periodicals borrowed their purpose (to amuse, to instruct, and to moralize), their "table of contents" (an encyclopedia of useful facts), their conceptual categories, and even their layout, which was formally analogous to that of the great museum galleries.

The marriage of the museum and the press in the nineteenth century was not a coincidence. In their preambles, many editors stressed the significance they attached to the title "museum." The printed "museum" was to be a genuine museum. First of all, they argued, each reader would be able to compile a private collection of his or her own composed of reproductions of artistic or archaeological objects. Readers of the *Musée de l'histoire, de la nature et des arts* (1830) could look forward to "the advantage of possessing within a few years and at very little cost a beautiful collection of lithographs, which they might seek to acquire in vain by other means."[5] Subscribers to the *Musée des dames et des demoiselles* (1852) immediately received "a magnificent, large watercolor (facsimile) by E. Hillemacher, a true masterpiece by one of our great artists, of the sort which hangs prominently in the most distinguished salons."[6] The avowed mission of the *Musée des enfants* (1864) was to "create a rich gallery of paintings which [the children] will enjoy, and whose contemplation will produce lifelong memories both pleasurable and beneficial."[7]

Journals devoted to collecting reproductions—the *Musée des deux-mondes* (1873)[8] and the *Musée pour tous, album hebdomadaire de l'art contemporain* (1877)[9] are later examples—also laid claim to the status of museum. The *Musée chrétien* (1849),[10] for example, proposed to collect the great masterpieces of Christian art, "the art of Guido Reni, Titian, Velasquez, Murillo, Raphael . . . whose works, unfortunately, are in diaspora, but whose reunion would produce a fountain of genius!" The same goal could also inspire any journal characterizing itself as a "collection," like the *The Hunter's Museum; or, Collection of Every Species of Game, Coated or Plumed, That One Hunts with a Gun.*[11] Meanwhile, because the museum was perceived primarily as a site of display, serious competition developed among printed museums over the question of illustration: while the *Musée comique* (1851) offered "illustrations of all kinds of things,"[12] and the *Musée Philipon* (1843) prided itself on its "few words and many pictures,"[13] the *Musée parisien* (1848) went so far as to promise "only pictures."[14]

In addition to these superficial links, however, the museum and the "printed museum" were bound by more organic ties. It is clear, first of all, that the periodicity of publication was essential to achieving the stated goals of the museum journals. Journals that were published every week,

twice a month, or every month could bring their subscribers ever-re-
newed images and information, while presenting the image of a complete
collection in the making. "With this issue (no. 1)," explained the editor
of the *Musée des tailleurs, modes de Paris pour hommes, dames, et enfants*, "we
inaugurate a museum of the art of tailoring. All of the tailor's tools, each
of the discoveries that have perfected our art and advanced our knowl-
edge, every method and technology devised for achieving desired cuts
will be included in our work."[15] In principle, this approach was the same
as that of the collector, who endeavored to organize all of the elements of
an exhibition around a single idea, work, or artist. Similarly, the *Musée
archéologique* (1874) described itself as "a periodical Caylus [a well-known
eighteenth-century antiquarian], i.e. a permanent collection of ancient
objects, which continues to accrue new discoveries and rare [*inédit*] or lit-
tle known monuments."[16] The fundamentally boundless nature of the
collection was further illustrated by the original museum catalogs. The
editors of these small printed booklets left blank pages at the back that
could be filled by the curator as the collection expanded.

The periodicity of the museum-journal, and the continuous stockpil-
ing of knowledge it implied, also reflected the museum's encyclopedic
ambition—its desire to encompass all things. One of the most famous of
the "museums," the *Musée des familles*, expressed the point in its pream-
ble of 1833. "Our plan is immense," confessed Jules Janin:

> We have sought within a single publication to bring together every
> newspaper, large and small, every woodcut and copper engraving . . . to
> provide a vast and unique collection of things useful, futile, serious, silly,
> scholarly, . . . the police, the court of assizes, roads, health, pleasures,
> theaters, stables, churches, ruins, palaces, hovels, witticisms, caricatures,
> the rich, the poor, the craftsman, the flirt, the dandy, the gentleman, the
> poet, the dreamer, the novelist, the historian, who else? This entire crowd
> of minds, mores, interests, positions and needs, with its mixture of gaiety
> and sadness, of conflicting moods and opinions will find satisfaction in
> this collection, this journal, this book, this warehouse, this encyclopedia,
> this notebook, this museum.[17]

The word *museum* here concludes an almost pathetic enumeration,
summarizing better than any other the sense of universality the author set
out to evoke. As heir to the cabinet of curiosities and bearer of the ideals
of the Enlightenment and the Revolution, the museum needed to be able
to represent itself as a world in microcosm. The entrance examination of
the Royal Academy of Architecture made the point in 1778: "A museum
is an edifice containing the records and achievements of science, the lib-

eral arts and Natural history"—in short, the totality of human knowledge and practical skill. Men of the Revolution, such as Caranjeot, curator of the museum of Meaux in the year V, would make the same point later: "A library collection is not a museum, a historian's study is not a museum, a collection of drawings and paintings is not a museum: but all of these things put together we call a museum."[18] Nothing could better approximate this ideal than the museum-journal; each chapter of its table of contents corresponded to a section of the total museum—that dream of the late eighteenth century that remained a model for many throughout the nineteenth century.

Far from being typical, however, a museum like the one in Calais, founded in 1836 and consisting of fifteen sections—including "a library, weapons and novelties [curiosités], numismatics and archaeology, paintings, engravings, drawings and sculpture, physics, engineering and architecture, mineralogy, botany and medicine, comparative anatomy, ornithology, entomology, mammals, fish and reptiles, and shells"—was an exception in the nineteenth century. Nor did the Louvre that Augustin Cabat praised after a visit in 1912 as "an index of all people and all periods, an encyclopedia of all things known to man, a psychological study of all civilizations and atlas of every natural environment"[19] ever actually see the light of day. At the time of the Louvre's founding during the Revolution, natural objects became the basis of the Museum of Natural History, and works of art were divided between the Conservatoire des Arts et Métiers, for the mechanical arts, and the Musée Central des Arts (the Louvre), for the liberal arts. With few exceptions, the same segregation of information and artifacts occurred in the provincial museums, for example, those of Abbeville, Annecy, Bar le Duc, Digne, Le Hâvre, Morlaix, Saumur, and Sens.

Yet everything occurred as if the museum-journals served to safeguard a project that was sufficiently important to warrant their proliferation over the course of the century. Moreover, as if to reassert the ideal of the total museum, the museum-journal type itself spawned imitators: in addition to seventy "museum" journals, at least seventy-four periodicals called *magasins*, or "department stores," appeared between the end of the eighteenth century and 1914. As the subtitles of these publications suggest, the store was another synonym for the museum: *Magasin Charivarique: A Comical Museum and Collection of Satires and Caricatures*, Paris, 1834; *The Universal Store, a Monthly Museum of Belles-Lettres, of the Arts and Sciences*, Paris, 1860-61. This metaphor suggests still another image

of the museum, one that stressed its connection to the world of commerce and money.

The fact that the museum was free, that everyone could explore it freely and be captivated by the works and artifacts found there, from the outset linked the museum to the cultural system of the arcade,[20] whose vogue under the July Monarchy coincided with that of the museum-journals and anticipated the success of the great department stores of the Second Empire. Each of these institutions offered a spectacle of objects to the gaze of the *flâneur* of the nineteenth century. "Paris is the city most suited to the *flâneur*," wrote Jules Janin in 1846:

> It was designed, built and perfectly organized for idling [*flâner*]; the wide quays, the monuments, the boulevards, the plazas . . . the *Palais-Royal*, the largest boutique in the world, where one can purchase anything from the most beautiful diamond to the five cent pearl; the crowd, the agitation, the engravings, the ancient books, the caricatures; the right to do anything, to see everything; the libraries are open to all, as are the museums, where centuries of works of art have hoarded their wonders.[21]

Janin's description links the *magasin* or store and the museum in terms of their functions of accumulation and display, a perception echoed in a number of other registers. Both in their architecture and in their interior design, many of the first museums adopted the model of the boutique. In his *Mémoire sur la manière d'éclairer la galerie du Louvre, pour y placer le plus favorablement possible les peintures et sculptures destinées à former le Musée National de Arts* (Memoir on how to light the gallery of the Louvre for the best possible presentation of the paintings and sculptures of the National Museum of the Arts) of April 4, 1787, C. A. Guillaumot, a member of the Academy of Architecture, described how the academy visited several locations in order to study "the advantages of their interior design." Four spots were chosen: the communion chapel of the church of Saint-Mery, the salesrooms of the Hôtel Bullion on the rue Plâtrière, the gallery of M. Le Brun, an art dealer in the rue de Cléry, and, finally, the display of silk fabrics of M. Barbier, a merchant in the rue des Bourdonnais. Each of these locations was "lighted by a vast overhead cupola," producing "a most favorable effect on the exhibited objects."[22] Based on this example, the academy decided on overhead lighting for the Grande Gallerie of the Louvre.

The theoretical vocabulary of the museum was also "spontaneously" borrowed from the world of commerce. What today we call the showcase or *vitrine* provides a good example. These "mahogany tables en-

closed by glass on all four sides," or "glass cages," were called *montres* (meaning both "watches" and "to show") before 1830; the *Dictionnaire de l'Académie* of 1823 defined *montre* as "the glass cases in which watchmakers place their merchandise, so that they may be seen but not touched." Under the July Monarchy they came to be called *vitrines*, a term borrowed simultaneously from the vocabulary of interior design, commerce, the bazaar, and the department store. A constellation of signs that linked the museum and the *magasin* was taking shape. The latter served to designate the space where unexhibited objects and works were stored. A petition addressed by Goarant de Tromelin to the president of the Senate on January 16, 1868, suggests that even visitors found the distinction confusing. The petition requested that a "tag be attached to each exhibited object," so that those visitors "who rarely purchase a catalogue might examine only such marked items as interest them."[23]

The large department stores took careful note of this confusion and perpetuated it to their advantage. The Dufayel department store published a tour guide entitled *A Visit to the Grands Magasins Dufayel*. Designed for the "informed traveler, whose sojourns to Paris always include a visit to the Dufayel department store," the "visit" was modeled exactly upon that to a museum. The visitor passed from one exhibit to another, from one hall to the next: the comparative furniture exhibit, the hall of festivities, the hall of fashions, and so on.[24] The example had been furnished by the great Louvre department store, founded by Chauchard—himself a collector and the donor of an important collection of Barbizon school paintings. In its 1855 brochure, the store is presented as virtually an extension of the Louvre museum:

> This palace [the *palais du Louvre*], which symbolizes the French monarchy and has become the world's richest temple of art, was finally completed only when France attained the apogee of its industrial and commercial grandeur, and when also, beside this palace dedicated to royalty and the arts, commerce and democracy found a suitable location for this *hôtel du Louvre* [the store], itself a symbol of the flourishing of industry in France.[25]

There is little doubt that to the eyes of most visitors, untrained in the history of art, the masterpieces, art objects, and "curiosities" exhibited in the museum appeared first of all as expensive objects—"commodities" that were exceptionally expensive, to be sure, but commodities all the same. Anecdotes and caricatures that depict the visitor as exclusively interested in the price of the exhibited objects abound during this period.

According to the architect Fontaine, even the Duc de Berry, "reputed to be a connoisseur," was much concerned with the "venal price that could be attached to each painting" when he visited the Louvre on October 30, 1814.[26] The emperor Napoleon I himself never hesitated to inform his illustrious visitors that the Apollo of Belvedere was worth millions. The familiar bourgeois *amateurs* of Daumier's prints also speculated as to the price of each picture, like the "certain persons" denounced by the Goncourt brothers in their *Diary* of January 17, 1863, "who say respectfully of an expensive painting: that is a museum piece." For this state of affairs, the illustrated press, in particular the "museums" and other *magasins*, carried a heavy burden of responsibility. It was they who disseminated images of the museum, who represented visitors with whom their readers were invited to identify socially and culturally; it was they who filled their pages with reproductions of art, each captioned with a real or imagined price: the porcelain chalice [*coupe*] worth "twenty thousand francs at least," the collection of Leonardo drawings "said to have been ceded to the Louvre in 1858 by a Milanese collector for 36,000 francs," and so on.

The press, the museum, and the department store can thus be understood to have played complementary roles within a single ideological system. The association between seemingly disparate institutions that I am suggesting here is justified not so much by external similarities of vocabulary or display, or by similarities between the spatial organization of the museum and the textual organization of the journal (the visitor/reader peruses the halls of the museum just as he or she peruses the table of contents . . .); it is justified most of all, I would argue, by the strong complementarity of their functions. The museum, the department store, and the press, all born during the century of industry, were each in their own way and in complementary fashion "machines" of capitalism. While the department store offered its clients the pleasure of consuming the products of private accumulation, the press sold its readers the pleasure of accumulated information—an image of mastery that justified the title of "museum" and, indeed, represented the ideal museum. For its part, the museum allowed its visitors symbolically to possess objects that were inaccessible—objects that could neither be bought, since they were inalienable, nor fully understood, except by an elite of *amateurs* or art appreciators—and as such invested with high cultural prestige.

The image of the museum proffered in the pages of the "printed museum" was not so much that of a site of knowledge or even of power as it was simply, and more tangibly, a site of moralization. The museum

was a school of morality, a direct response to one of the major cultural goals of the century, particularly the idea of honor that flourished under the Second Empire. Among the works reproduced by the "museums,"[27] family portraits and genre scenes largely predominated. The family, the child, and religion, according to Charles Le Coeur, curator of the museum of Pau, made the museum a "latent means of moralization."[28] The best guarantors of these values were the artists themselves, whose family portraits the "museums" portrayed hanging on gallery walls (*Rubens and His Wife Isabelle Brandt* at the Munich Pinakothek, *Joseph Vernet and His Family* at the Louvre, *Lajoue and His Family* at the Versailles museum, and so on). The text accompanying these reproductions, often borrowed directly from the catalog of the museum where the work was hung, reminded the reader-visitor that each work had its own story, and that each story had a pertinent moral. "[Each] story contain[ed] a moralizing message in the poignant form of an anecdote," as the *Musée du peuple* put it in 1848.[29] The printed "museum," following the example of the institutional museum, was to be "above all a work of morality and faith, designed to instill families with respect for traditional mores, commitment to the laws of honor, and the instincts of duty and virtue."[30] Indeed, social peace was said to reign in these museums, since "peace means the reign of art . . . art [being] a universal fatherland, where the same hospitality is extended to all those who profess to belong to the republic of letters, a neutral territory in which all parties can rally together and shake each other's hands."[31]

Behind its facade of respectability, however, its image as a "gallery" of rare and unique objects bearing knowledge and meaning, we have seen that the printed museum revealed subtle and profound links between the institutional museum and what we might call "the outside world"—the world of money, where publicity was king. Over the course of the nineteenth century, control over this world of money passed increasingly to men who were ignorant of the "mysteries" of the art world, to which the museum itself was hardly likely to initiate them. But what does this interpretation of the beginnings of the museum suggest about the institution today? Of what, when they think of "art," do the thousands of visitors who form the endless lines that extend from the doors of the great museums think? Do they not think of images that have been identified as "important" in the popular press or in today's flourishing art literature, "objects" whose financial sagas make front-page news? There remains also the feeling of symbolic appropriation gained from the museum visit, and from the purchase (though not necessarily the reading) of the catalog,

which recalls the role once played by the museum-journal of the nineteenth century.

Translated by Marc Roudebush

Notes

1. See Daniel J. Sherman, *Worthy Monuments: Art Museums and the Politics of Culture in Nineteenth Century France* (Cambridge, Mass., 1989). In his introduction, Sherman defines the specificity of the French museum in very clear terms: "Not only does France have the strongest claim to have given birth to the art museum as a public institution, in the nineteenth century it both proclaimed itself inheritor and embodiment of classical civilization and occupied an acknowledged position at the center of the art world" (p. 4).

2. I have compiled my list of journals from the general periodical catalog at the Bibliothèque Nationale; the latter contains the list of copyright registrations, from which I extracted about fifty titles. I have added those I found at the Bibliothèque Historique de la Ville de Paris, and others preserved at the Bibliothèque des Arts Décoratifs.

3. See John Grand-Carteret, "Les forces modernes, la presse, les magasins et la réclame, les expositions," *XIXème siècle* (Paris, 1893), pp. 669–701.

4. See the interesting problematic developed by Philippe Hamou in *Expositions: Littérature et architecture au XIXème siècle* (Paris, 1989).

5. *Musée de l'histoire, de la nature et des arts*, no. 1, June 6, 1830 (leaflet preserved at the Bibliothèque Nationale, Z. 9527).

6. *Le Musée des dames et des demoiselles, journal indispensable aux dames et aux demoiselles*, no. 1, November 1852 (leaflet preserved at the Bibliothèque Nationale, Z. 9529).

7. *Le musée des enfants*, no. 1, 1864 (leaflet preserved at the Bibliothèque Nationale, Z. 9532).

8. *Musée des deux mondes, reproduction en couleurs de tableaux, aquarelles et pastels des meilleurs artistes*, no. 1, April 1873.

9. *Musée pour tous, album hebdomadaire de l'art contemporain*, textes par Adrien Dezany, photographies de Goupil, no. 1, February 1877.

10. *Le musée chrétien, journal des écrivains et des artistes catholiques*, no. 1, January 1849.

11. *Musée du chasseur ou collection de toutes les espèces de gibier de poil et de plume qu'on chasse au fusil, dirigé par un chasseur naturaliste et lithographié d'après nature par Victor Adam* (Paris, 1838).

12. *Musée comique, toutes sortes de choses en images*, no. 1, 1851.

13. *Musée Philipon, album de tout le monde* (Paris, 1843).

14. *Musée parisien, scènes de la Révolution de 1848*, no. 1 (Paris, February 25, 1848).

15. *Le musée des tailleurs, modes de Paris pour hommes, dames et enfants*, no. 1, October 1861.

16. *Musée archéologique, recueil illustré de monuments de l'antiquité du Moyen-Age et de la Renaissance, indicateur de l'archéologie et du collectionneur*, no. 1 (Paris, 1875).

17. *Musée des familles, lectures du soir*, no. 1 (Paris, October 1833).

18. *Le museum de Meaux*, par le Citoyen Caranjeot (Meaux, Year V).

19. Augustin Cabat, *Au musée du Louvre* (Paris, 1912).

20. The best reference is still Walter Benjamin's *Paris, capitale du XIXème siècle, le livre des passages*, introduction by Rolf Tiedemann (Paris, 1988).

21. Jules Janin, *The American in Paris; or, Heath's Picturesque Annual for 1843* (London, 1843), pp. 164–66. See also Philip Nord, *Paris Shopkeepers and the Politics of Resentment* (Princeton, N.J., 1986).

22. Guillaumot, *Mémoire sur la manière d'éclairer la galerie du Louvre, pour y placer le plus favorablement possible les peintures et sculptures destinées à former le Musée National des Arts* (Paris, Year V).

23. Archives des Musées Nationaux, file Z.2.1870

24. *Une visite au grands magasins Dufayel*, n.d. (B.N. n.2 Le Senne 2117). For a more general discussion, see also "Le grand magasin en tant qu'espace culturel," in Remy G. Saisselin, *The Bourgeois and the Bibelot* (New Brunswick, N.J., 1985).

25. See *Les chefs-d'oeuvre du Louvre, publiés par les grands magasins du Louvre* (Paris, n.d.).

26. Pierre François Léonard Fontaine, *Journal* (Paris, 1987), vol. 1, p. 1814.

27. See Chantal Georgel, "Le musée en représentation," in *Les usages de l'image au XIXème siècle* (Paris, 1992), pp. 142-53.

28. Charles Le Coeur, *Considérations sur les musées de province* (Paris, 1872), p. 17.

29. *Musée du peuple, journal des connaissances nécessaires à son bien-être et à ses besoins intellectuels*, no. 1, May 14, 1848.

30. *Le musée du Midi, recueil littéraire et religieux*, Bordeaux, no. 1, July 1853.

31. *Le musée de la littérature et des arts, lectures des familles*, no. 1, July 1852.

7

Quatremère/Benjamin/Marx: Art Museums, Aura, and Commodity Fetishism

Daniel J. Sherman

In his celebrated essay "Valéry Proust Museum," Theodor Adorno speaks of the way the modern museum can function as "a metaphor . . . for the anarchical production of commodities in fully developed bourgeois society." In the time since Adorno wrote, the metaphor has become a discourse, a pervasive critique of the museum and its practices. Adorno begins with a concise formulation of two of the crucial elements in this critique. First, museums deprive objects of the life proper to them: for Adorno, "museums are like the family sepulchres of works of art. They testify to the neutralization of culture." Second, museums, in their pervasiveness and inevitability, monopolize certain fields of vision, and thus constitute a strategy of power linked to hegemonic capitalism: "Anyone who does not have his own collection (and the great private collections are becoming rare) can, for the most part, become familiar with painting and sculpture only in museums."[1] Though this critique could in theory encompass all types of museums, Adorno speaks only of art museums, for art museums constitute the most elaborately articulated instance of decontextualization as a strategy of power. Of the various museum types, art museums have traditionally been the most wedded to a system of display that privileges the object and, disregarding evidence to the contrary, takes visual perception to be universal.[2] They have also ostentatiously cultivated their association with hegemonic culture, or, as John Berger puts it, "The majority take it as axiomatic that museums are full of holy relics which refer to a mystery that excludes them: the mystery of unaccountable wealth."[3]

The idea that museums drain life from art recurs throughout museums' history, in the writings of Saint-Simonian reformers, fin-de-siècle aesthetes, and multiculturalist curators.[4] Its origins date back to the writings of the first full-fledged critic of art museums, Antoine-Chrysostome

Quatremère de Quincy, who developed his position virtually simultaneously with the appearance of the museum itself. Following Berger and Walter Benjamin, we might be inclined to consider the discursive construction of the second charge specific to the "age of mechanical reproduction." Adorno derives the metaphorical connection between museums and capitalist political economy from Paul Valéry's short essay "Le Problème des Musées," in which Valéry writes, "Just as modern man is exhausted by the vastness of his technological possibilities, he is impoverished by the very excess of his wealth."[5] Noting that Valéry writes from the standpoint of "cultural conservatism," Adorno finds it

> all the more astounding that the aesthetic nerves which register false wealth should react so precisely to the fact of over-accumulation. When he speaks of the accumulation of excessive and therefore unusable capital, Valéry uses metaphorically an expression literally valid for the economy. Whether artists produce or rich people die, whatever happens is good for the museums. Like casinos, they cannot lose, and that is their curse. For people become hopelessly lost in the galleries, isolated in the midst of so much art.[6]

Everything here—Valéry's "modern man," Adorno's comparison of him to Proust, the reference to casinos—seems to place this critique squarely in the context of modernism. Such a discourse, in any case, clearly seems to depend on theoretical formulations fully adumbrated only in the late nineteenth century.

In fact, however, the critique of the connections between museums and money has been part of an antimuseum discourse from the beginning, for it too can be traced back to Quatremère de Quincy. Since I have argued in the past against reducing the history of museums to a single originating cause, I should make clear that my purpose is not to identify such a cause.[7] The kind of tracing back undertaken here should rather be understood as a genealogy in the Foucauldian sense, one that specifically "opposes itself to the search for origins." Genealogy, as Foucault describes it, involves the careful scrutiny of the circumstances of production of a discourse or series of discourses, in terms of historical specificity rather than of essential, metaphysical truth.[8] Foucault sees genealogy as a profoundly historical process: "The genealogist," he writes, "needs history to dispel the chimeras of the origin"; history points to the accidents, ruptures, and details that characterize every beginning.[9]

The notion of genealogy helps to make sense of the phenomenon Adorno found so astounding, the appearance of the terms of political economy in a discourse about museums. But to explain the form this dis-

course took, at a time considerably earlier than Adorno leads us to expect, we need to consider it in another framework, that offered by Frederic Jameson's political unconscious. To call a particular economy the political unconscious of Quatremère's texts suggests that these texts point to the ideological underpinnings of museums in ways all the more crucial for being routinely masked or denied. It is not simply that Quatremère anticipates certain central terms of the materialist critique that Marx developed over half a century later. Rather, a kind of dialectic existed in a discourse about museums well before Marx, a presence we can trace to the historical circumstances of the emergence of that discourse.

In Jameson's schema, interpretation involves rewriting a particular text so that it "may itself be seen as the rewriting or restructuration of a prior historical or ideological *subtext*." For the purposes of this study, and in keeping with its genealogical project, it might be preferable to conceive of the materialist subtext in Quatremère as emergent rather than prior.[10] In any case, the notion of subtext is, for reasons that will become apparent, crucial to understanding the significance of Quatremère's work for the critical discourse of museums. It may also be possible to locate what Jameson calls a "cultural revolution" within Quatremère's text. The dynamics of such a revolution manifest themselves at the formal level, to the extent that we are sensitive to the "determinate contradiction of the specific messages emitted by the varied sign systems which coexist in a given artistic process as well as in its general social formation."[11]

But the notion of a "political unconscious" also offers a means of avoiding an obvious pitfall, which would be to present Quatremère de Quincy as some kind of visionary or clairvoyant. His conception of art was both backward-looking and idealizing, and his attacks on museums join these aesthetics to a counterrevolutionary politics that largely accounts for their sweep and passion. Nonetheless, by situating his critique in a discourse of "value," and by specifying the contestatory nature of that term, Quatremère laid the groundwork for an understanding of museums' implication in the structures of a distinctly modern society, most notably the market. These are not, of course, the only terms in which the contemporary position of the museum can or ought to be critiqued. But a brief, concluding examination of some other theoretical formulations, notably those of Walter Benjamin, will suggest the enduring pertinence of Quatremère's insight for a critique of museums that, in Benjamin's terms, attempts "to set to work an engagement with history original to every new present."[12]

Quatremère de Quincy has long been recognized as both the leading art theorist of the era of the French Revolution and, in his role as perpetual secretary of the Académie des Beaux-Arts, as perhaps the most doctrinaire exponent of academic neoclassicism after 1815. As author of the 1791 *Considérations sur les arts du dessin*, he crystallized the debate over the proper relationship between the state, artists, and the public. As the official in charge of the decorative program of the Pantheon, in its newly secularized role as the national mausoleum, he had the opportunity to dispense considerable patronage; he was, in addition, an influential critic.[13] Throughout the turbulent decade of the 1790s, moreover, Quatremère displayed a consistent political engagement. Alex Potts's perceptive 1978 essay traces the connections between the writer's political attitudes and his prominent role in the construction of a historicist discourse of the arts. Potts points to the fundamental pessimism of historicism, with its "insistence that impersonal historical forces limited the scope for individual achievement in the present, and prevented any complete revival of the classic achievements of the past." In this context he finds Quatremère's political trajectory, from moderate reformism in the early 1790s to anti-Revolutionary royalism later on, a perfectly consistent response to the development of the Revolution.[14]

Quatremère's political consistency finds an echo in his views on museums. Even before the publication, nearly twenty years apart, of his two principal texts devoted to museums, Quatremère demonstrated his antipathy to the nascent institution, an antipathy so fierce that Quatremère's biographer has called it the "point de départ" of all his aesthetic doctrine after 1791.[15] In his proposal for a reform of the system of state support for the arts in *Considérations sur les arts du dessin*, Quatremère makes clear that he considers museums no substitute for free public art instruction. And though he recommends an extensive program of state art commissions, he urges that work so produced be sent not to museums but to places associated with the people and events they would commemorate.[16] These remarks, although by no means the focus of the *Considérations*, lay the conceptual groundwork for the critic's later, more sustained treatment of the subject.

The first of Quatremère's writings on museums, the *Lettres à Miranda sur le déplacement des monuments de l'Art de l'Italie*, was published over the initials "A. Q." in the summer of 1796, though the author's identity was well known, and even mentioned in the press. The seven letters express the author's opposition to the victorious French army's removal of works of art from Italy to France. The 1815 *Considérations morales sur la destina-*

tion des ouvrages de l'art, although more general, reflects his hostility to public collections founded during the Revolution. In 1815, the year of the restoration of the Bourbon dynasty, criticism of museums was likely to fall on sympathetic ears, especially when it contained veiled but obvious references to Alexandre Lenoir's Musée des Monuments Français, which housed sculpture taken from churches and other monuments of the old order. Indeed, in 1816 that museum was closed, its contents transferred to the reconsecrated royal necropolis of St. Denis. But in 1796, like the recipient of his letters, General Miranda, Quatremère was in hiding because his recent participation in a failed royalist uprising made him politically suspect. The *Lettres*, as its most recent editor, Édouard Pommier, has observed, criticize not only museums in the abstract, though the author's dislike of them is palpable, but more generally the post-Thermidorean Directory's policy of military and artistic conquest. Publishing the letters involved considerable courage, all the more so in that they appeared without any hope of influencing a policy decision that was already being carried out.[17]

Quatremère structures the *Lettres* around the view that only the entirety of the context surrounding the creation of a work of art could perform the educative functions that advocates of museums attributed to them. He calls Rome itself a museum, "immovable in its totality," and consisting of, in addition to actual monuments, "places, sites, mountains, quarries, ancient roads, the respective positions of ruined cities, geographic relationships, the connections between objects, memories, local traditions, still extant uses, parallels and comparisons that can only be carried out in the country itself" (102). Urging the states of Europe to participate in the discovery and preservation of Roman monuments, Quatremère declares that the country removing them from their "homeland" would not derive any meaningful benefit from them, while seriously harming the instruction of other nations (135). To make clear that his remarks do not apply only to antiquities, Quatremère further argues that what he calls the dismemberment of schools of painting would have equally dire consequences for artistic education. He maintains that an acquaintance with works of secondary importance is necessary for a full appreciation of masterpieces, and that external surroundings, Rome's monuments and the *campagna*, are essential to understanding works of the Italian school. "The country," he asserts, "is itself the museum" (110-12, 115).

The argument for context appears again in the *Considérations*, though in that text Quatremère adduces the examples of ancient Greeks (he had

also written against the transfer of the Elgin marbles) and, in his moving peroration, of religious art in churches. In the later text the issue of context relates to a somewhat different point, one involving the emotions that assemblages of objects arouse in viewers. But Quatremère has not completely lost sight of the education of artists, a persistent concern since the 1791 *Considérations sur les arts du dessin*, for he maintains that museums, as artificial rather than natural or historical collections, are incapable of arousing the emotion necessary for the creation of great art (50–52). The essence of his argument lies in his insistence that the greatest art is necessary art, art that is morally useful (82–85). Quatremère concedes that governments have no power to create either natural or social needs for the arts (he gives writing as an example of an art filling a social need). But he believes that governments can take steps to encourage the utility of the arts, first by proposing important public commissions, which he sees as the best way of stimulating emotion in artists, and by respecting "local, moral or accessory considerations" in the display of existing works (12–13). Museums run counter to both these objectives.

Quatremère believes that all art can provide two types of pleasure, a moral or spiritual pleasure and a sensual pleasure. Of these, only pleasure of the spirit makes works of art independent of what he calls the caprice of taste, giving them an enduring significance, and only art with a particular moral purpose can afford pleasure to the spirit (17–18). Artists who work without such a purpose in mind will likely aspire only to technical perfection, that is, to appeal to the senses. If, moreover, the public has no moral sentiment to which to respond in works of art, it will judge them solely by rational or analytical criteria, which results in what Quatremère calls a "sterile and cold" spirit of criticism (36, 40). The museum contributes to this development by depriving the public of the "accessory impressions" that make clear art's purpose, and of the "multitude of moral ideas, of intellectual harmonies" that act upon our sensibility (50–51, 43). Quatremère sees, and he uses the term explicitly, a "vicious circle," in which the lack of a context for judging art in moral terms encourages the production of work without moral purpose. Such work in turn promotes a form of judgment that is technical rather than concerned with art's utility, which encourages further such production, and so on. He calls this circle "a truly bizarre one (if it were to endure) in which the arts, artists and their works will rotate without end, for the use of a society that will never have use of them" (38).[18]

For Quatremère, the museum by its very existence signifies art's lack of utility: "Can one better proclaim the uselessness of works of art," he

asks, "than by announcing in the assemblages made of them the nullity of their purpose?" (37). He also says that "the spirit of criticism is . . . largely due to the curious system for some time prevalent in Europe" (36), which system he goes on to identify with museums and collections. Yet the notion of a "vicious circle," which follows soon after in the *Considérations*, has the effect of diverting attention from the question of origins or responsibility. Rather, the term places the museum in a continuum of institutions and practices that jointly summon Quatremère's condemnation. These practices include two closely linked to the "critical spirit" that he also denounced on its own: the public display of "morceaux d'étude," or study pieces, and the production of works for a narrow professional audience of artists, critics, and savants (32-35). For this inner circle, Quatremère contends, the technical "merit" of the work may suffice, but the public, unless it becomes inured to such practices, has a higher standard (79-80). Finally, Quatremère condemns the practice of collecting—as distinct from display—for removing works of art from their legitimate patrimony, and for shutting them away from the context that alone makes clear their purpose (38, 44).

The scope of Quatremère's critique demonstrates an acute awareness of museums' implication in larger structural transformations that the art world had long been undergoing. He does not limit his observations to either the public or the private sphere, but seems to understand that, as Habermas has argued, the creation of a public sphere depends in part on a prior privatization of certain basic economic and social activities.[19] Thus Quatremère explicitly does not condemn collections as such, but rather their banalization. He concedes that museums, in displaying works of interest only for their technique, can have a limited utility in the instruction of artists, though he reiterates his preference for site visits (45 46). It is revealing that in a work one scholar has described as "the most perfect expression of museophobia in the history of ideas"[20] the common thread in the practices and institutions condemned is *not* a system of display but rather a system of value. This is a system of private commercial exchange transferred, in Quatremère's view abusively, to the public sphere. Here we need to examine Quatremère's use of the word *prix*, which in French can mean either value in the absolute sense or price in the contingent sense. For Quatremère, the *prix* or value of a work resides in its "rapports utiles," or useful relations, both to a particular purpose and to the moral ideas informing that purpose. Any kind of preservation that transforms art into an "object of luxury or curiosity" deprives it of these vital relationships (17).

But Quatremère also uses *prix* in another sense, one involving commerce. At the beginning of the *Considérations* he writes:

> In the first rank of these destructive opinions we must place one that
> tends to treat works of art as useful only to the extent that they can be
> objects of value [*objets de prix*]. From the fact that certain pieces, by the
> reputation and rare talent of their creators, have also become rare objects,
> and consequently very costly, some speculators have thought that the
> objective in encouraging artists ought to be to obtain from them
> productions that have commercial value. A misunderstanding as serious in
> itself as ridiculous in its object. The commercial value of a work of art is
> purely accidental to it. To esteem it for this reason is to degrade it, and
> consequently to remove from it the value that one supposedly attaches to
> it. (15-16)

Art should not be confused with the products of industry, Quatremère maintains, and he calls the production of art without larger utility "materialism." Here, if anywhere, lies the origin of the "curious system" of which museums form the linchpin, for the production of work without a moral purpose, like a vase or a piece of furniture, reduces artists to the pursuit of mere mechanical perfection (16, 22-24).

We can measure the importance of this theme by tracing it back to the *Lettres*. Quatremère devotes most of the seventh and last of them to refuting the idea that the removal of monuments from Italy could be commercially advantageous to the country or countries acquiring them. He initially dismisses this argument, except for a precedent from Cicero that he finds spurious, as unworthy even of discussion. He has already declared in the second letter that "the shamefully mercantile profit that a city acquiring [antiquities] believes it would make would be a profit lost for the arts" (96). Now he asks, "What could be more contrary to the true spirit and to the enlightened love of the arts than these fiscal theories, which find in the monuments of popular instruction only objects of commerce, and who discover in masterpieces of taste and genius nothing more than indirect taxes on foreign curiosity!" (132-34). But after this moral response he also offers a practical one. Since, as he has previously argued, the dispersal of works of art from their original context leads ineluctably to a decline in artistic instruction and eventually in the quality of the works produced, any commercial profit could only be temporary. "What," he asks, in apparent anticipation of the vicious circle, "would be the point of a monopoly over a trade without outlets and of products without consumers?" (136-37).

Throughout both the *Lettres* and the *Considérations*, images of commerce signify the deepest level of Quatremère's disapproval. "Do you believe," he asks in the fifth letter to Miranda, "that the nation that appropriates to its supposed benefit some of these models of beauty, like so many lots of merchandise, would find a great profit in importing them?" (118). Speaking in the *Considérations* of destroying the value of a coherent ensemble of objects by dispersing or taking them out of context, he sighs, "How little is required to destroy this charm, and to convert a monument of painting into a picture shop!" (57). He also describes works that interest or please only specialists as "a currency that has value only among savants" (55). In decrying even the thought of selling artistic booty for profit, Quatremère asks sarcastically, "Who knows if we won't end up converting [works of art] into mortgages, and draw banknotes on antique sculpture?" (*Lettres*, 136–37).

Yet, just as he does not condemn museums outright, Quatremère also, if less frequently, and exclusively in the *Lettres*, uses both the term and the notion of commerce in a positive sense. At the beginning of the first letter, he calls his agreement with Miranda to consider philosophical and political subjects in their correspondence a "commercial agreement [*traité de commerce*]," and goes on to say, "such is the nature of the commerce of thought that he who gives the most is not he who is the least enriched" (87). Admittedly, such a usage might be seen as constructing a kind of counterdiscourse of commerce, one ironically opposed to the values of commerce itself. But when Quatremère refers, without details, to a "commerce" that could enrich all parts of Europe without harming the Italian patrimony—he seems to be thinking of sculptural casts, but he never provides the promised elaboration—the term seems free of subversive connotations (98, 139).[21] We may here be confronting the signs of the "determinate contradiction" that point to Jameson's "cultural revolution." To understand this contradiction, we must have recourse to Marx.

The circulation of casts does not trouble Quatremère because it does not constitute an exchange, a transaction in which money signifies a value form separate from an object's use value, which means simply its utility in daily life. Casts of one country's objects, that is, have value only insofar as they can be useful in instructing another country's artists.[22] What Quatremère objects to in the institutions and practices he attacks in the *Considérations* is precisely their implication in a commercial transaction. In a sense he goes even further than Marx, for whom it is self-evident that an exchange cannot be effected unless an object has use value for

the party acquiring it.[23] For Quatremère, a work of art either has use value, that is to say, a moral purpose in society, or it has *only* exchange value, as an "objet de prix," which is to say it is useless. Yet it seems to me that this is essentially a semantic distinction, that in claiming that works without purpose have no utility, Quatremère is simply making in another way Marx's observation that "the character of having value, when once impressed upon products, obtains fixity only by reason of their acting and re-acting upon each other as quantities of value."[24] For Quatremère, any number of transactions, actual or implicit, can rob art of use value: production for sale, removal from their original context, or installation in a museum, which, we will recall, he likens to a picture shop.

At this point an objection may arise. The pointers to a Jamesonian subtext in Quatremère de Quincy are so numerous, the signs of a "determinate contradiction" so obvious, that one may wonder whether they constitute a "political unconscious" in any useful sense of the term. But if one looks more closely at the kinds of debates that the creation of the Louvre provoked, the singularity of Quatremère's views, and of their subtext, becomes apparent. As Pommier observes, Quatremère's distinction between "natural" museums such as the city of Rome and artificially created institutions "goes much farther than the political contestation in which the press had engaged."[25] The press and, one might add, those involved in the creation of the Louvre. In 1793 the artist and dealer Jean-Baptiste-Pierre Lebrun launched a bitter public polemic against the minister of the interior, Roland, who had refused to appoint him to the commission responsible for organizing the Louvre as a museum. Lebrun accused the minister of political cronyism, claiming that he had considerably more expertise in handling and assessing paintings than the artists Roland had appointed. Pommier makes clear that this debate touched on vital issues concerning the management of the museum, but it also contains a revealing discussion of the relationship between the museum and the marketplace.[26]

In the reply he sent to the press, Roland dismissed Lebrun not only as the husband of an émigrée, the painter Élisabeth Vigée-Lebrun, and hence politically suspect, but also, and more significantly, as a dealer (*marchand*). "The position that the dealer Lebrun was asking of me," Roland wrote, "might well have been only a great opportunity for him to advance his own interests, and the journeys he was offering to undertake [to look for potential acquisitions for the museum] would perhaps have contributed more to his shop and his pocketbook than to our museums."[27] In their report a month later to Roland's successor as minister,

Garat, the commissioners of the museum repeated Roland's argument in even stronger terms. Defending their own expertise, they denounced the knowledge of dealers like Lebrun as fatally contaminated by the marketplace. "Any degree of speculation in a matter of this kind could only be harmful to the Republic," they wrote. "Artists are incapable of such a cast of mind, everything removes them from it; can one say as much of dealers?"[28]

For those in charge of the early Louvre, simply keeping from their ranks anyone (other than artists themselves) involved in the art market, as well as such measures, discussed but not implemented until somewhat later, as banning the works of living artists from the museum, could sufficiently insulate the museum from the taint of the marketplace.[29] For Quatremère, as we have seen, and notwithstanding the occasional ambiguities of his usage, such a taint inhered in the very organization of the museum. He was not even concerned with such developments as the apparently unproblematic entry of the museum commission into the art market a few months after the Lebrun affair, the result of the Convention's appropriation of 100,000 francs as an acquisition fund for the Louvre. (Lebrun was one of the dealers who profited, in a transaction for which his ally Jacques-Louis David served as intermediary.)[30] In Quatremère's writings, commerce, far from being a notion assimilable to a controlling discourse such as that of artists' "disinterest," lurks as a subtext: pervasive, contradictory, and dangerous.

"The categories of bourgeois economy," Marx asserts " . . . are forms of thought expressing with social validity the conditions of a definite, historically determined mode of production, viz., the production of commodities."[31] Whatever contradictions we may discern in Quatremère's use of the term "commerce" may plausibly be attributed to the flux in those categories at the time he was writing. Nor does such an attribution imply or rest on a reductionist Marxist interpretation of the French Revolution as a "bourgeois revolution." For if one understands "modes of production" in the broadest sense, as existing in the realm of culture, politics, and discourse as well as in the economy, it would be difficult to contest a characterization of the 1790s in France in Jameson's terms. For Jameson, "cultural revolution" is "that moment in which the coexistence of various modes of production becomes visibly antagonistic, their contradictions moving to the very center of political, social, and historical life."[32]

Listen, moreover, to the passionate denunciation of "receptacles of factitious ruins" with which Quatremère concludes the first part of the *Considérations*:

> To displace all these monuments, to gather up in this way the
> decomposed fragments, to put the debris in a methodical order, and to
> make of such a gathering a practical course in modern chronology: this is,
> for a practical reason, to constitute ourselves as a dead nation; it is to
> attend our own funeral while we are alive; it is to kill Art to write its
> history; but it is not its history, it is an epitaph. (47–48)

The emphasis on the replacement of something living with something
inert recalls Marx's celebrated notion of commodity fetishism, which he
defines as "a definite social relation between men, that assumes, in their
eyes [of those exchanging commodities], the fantastic form of a relation
between things."[33] Quatremère sees that, although museums ostensibly,
and ostentatiously, withdraw art objects from commercial circulation,
the fetishization they perform has the same effect as commodification.
By both reproducing and implicitly endorsing the decontextualizing
strategies of the marketplace, museums rob art of life. Quatremère's con-
ception of the object in a museum thus neatly fits Adorno's theorization
of the commodity: "on the one hand, an alienated object in which use-
value perishes, and on the other, an alien survivor that outlives its own
immediacy."[34]

That something like a notion of commodity fetishism should surface in
the first sustained critique of museums is remarkable enough, but Qua-
tremère goes further. To the argument—still used in some quarters
today[35]—that "absolute beauty" can be appreciated without context,
Quatremère, while admitting that such a thing may exist, both in nature
and in art, asserts that absolute beauty "produces no passions, has no en-
thusiasts, warms no hearts" (53). Only the feelings surrounding it can do
that, even if they are based in illusions fostered by religion. This is, I
would suggest, effectively to deny that works of art embody any kind of
transcendence as objects.[36] To the extent that museums mobilize a notion
of transcendence to mask their links to the market and to commodity
fetishism, Quatremère leaves them no outlet. He is no harder on muse-
ums than on himself, for he writes more sweepingly and more bitterly in
Considérations than he had twenty years before. It is as though in the ab-
sence of the particular target of his earlier polemic, he realizes that the
phenomena he deplores, deeply rooted in modern society, cannot easily
be eradicated.

We know that museums have aroused opposition from the beginning
in part because of the political, social, and cultural forces that mediate
their fundamental relationships. But Quatremère's analysis goes beyond
the mediations to focus on the relationships themselves, which we may

call ideological in that they provide the basic principle by which museums operate. That principle, the treatment of individual objects as bearers of meaning, Quatremère saw as indissoluble from a more general process of what Marx would call commodification. What makes Quatremère so radical, his ideas so enduring, is the sense in his work not of inevitability but of connectedness, of the way in which museums tacitly ratify, even while ostensibly standing apart from, the ideology of the marketplace. His work strips away the discourse of museums and exposes it precisely as discourse, as what Raymonde Moulin has called a strategy of "ideological compensation" for museums' fundamental implication in the marketplace.[37]

We may feel that museums today face a quite different set of issues, involving as they do the problematic—if not always problematized—status of "original" objects in the face of reproduction of various kinds and in various media.[38] Yet if we compare Quatremère, as a kind of pre-Marxist reworking a materialist subtext, with those who have brought a Marxist framework to bear on modern critical theory, the continuing power of Quatremère's work cannot be doubted. This essay began by projecting backward from an insight of Adorno; I noted in passing the applicability to Quatremère of something like Habermas's conception of the public sphere. Some reflections on parallels between Quatremère and Adorno's colleague and contemporary Walter Benjamin will, then, bring us full circle. For Benjamin reminds us that "for a dialectical historian, these works [works of art, but we may expand the insight to texts] incorporate both their pre-history and their after history—an after-history in virtue of which their pre-history, too, can be seen to undergo constant change."[39]

At first glance Benjamin and Quatremère seem to work within quite distinct discursive spaces. Most of Benjamin's work on culture is concerned with the "age of mechanical reproduction," and particularly with the media most characteristic of that age, photography and film. His discussion in a number of essays of the decline of the "aura" of works of art obviously signals an interest in issues of originality and the status of the object. For Quatremère, on the other hand, the question of the "originality" of the work of art matters less than the issue of art's utility in society. Benjamin, moreover, makes only a few cryptic references to museums, in the generic guise of "public collections"; he was more interested in collecting as a practice than in museums as institutions.[40] Yet a closer examination yields a number of striking similarities, not least in relation to the concept of aura.

Benjamin identifies two forms of valuation for art: cult or ritual value and exhibition value. "The unique value of the 'authentic' work of art," he writes, "has its basis in ritual, the location of its original use value." When the technology of reproduction reduces the authority, and hence the cult value, of original works of art, the emphasis shifts to exhibition value, which finds its justification in a discourse of artistic autonomy of the sort that Quatremère decries.[41] Although Benjamin locates this shift in what he calls the age of mechanical reproduction, he sees both as part of a larger process: "The simultaneous contemplation of paintings by a large public, such as developed in the nineteenth century, is an early symptom of the crisis of painting, a crisis which was by no means occasioned exclusively by photography but rather in a relatively independent manner by the appeal of art works to the masses."[42] Quatremère would agree, though he views the phenomenon in somewhat different terms. For him, the problem lies in robbing art of the utility that ritual, broadly construed to include civic as well as religious functions, provided it. For Benjamin, on the other hand, mechanical reproduction makes possible a shift in perception, so that the public no longer looks for an original but for reproducibility.[43] Quatremère regarded this development as a serious loss; Benjamin finds it full of revolutionary possibility.

Beyond this difference in attitude, however, Benjamin and Quatremère offer remarkably similar explanations of the developments they describe; for both, commodification plays a vital role. One of the reasons Benjamin rejects the traditional discourse of the history of culture, here art history, is that "the disintegration of culture into commodities to be possessed by mankind is unthinkable for it." Benjamin continues: "The concept of culture as the embodiment of entities that are considered independently, if not of the production process in which they arose, then of that in which they continue to survive, is fetishistic. Culture appears reified."[44] Thus a materialist position, which Benjamin explicitly contrasts to "cultural history," goes hand in hand with a rejection of the standard art historical discourse, the emergence of which Quatremère surveyed with grave misgivings. Like Quatremère before him, Benjamin opposes the divorce the traditional critical discourse attempts to effect between art and its conditions of production and reception.

The essay "The Work of Art in the Age of Mechanical Reproduction" contains what is perhaps Benjamin's most celebrated insight into the relationship between art and society: "That which withers in the age of mechanical reproduction is the aura of the work of art."[45] Such an assertion appears entirely foreign to Quatremère de Quincy, until one examines its

terms more closely. "The age of mechanical reproduction," first of all: Benjamin does not date this precisely, but his references to lithography and photography indicate that it begins sometime in the early nineteenth century. Yet in terms of the conceptual work they perform, the museum and reproduction in a very real sense belong to the same age. It is no coincidence that the birth of the Louvre and other museums during the French Revolution also saw a burgeoning of what Malraux would later call the "musée imaginaire," a bound compendium of reproductions of works contained in actual institutions.[46] Although Quatremère does not deal specifically with reproduction, such an enterprise clearly falls into the category of fetishizing activities, the "kill[ing] Art to write its history," that he deplored.

"Aura," too, in many ways echoes the ideas of Quatremère. A number of scholars have drawn a connection between the notion of aura and Benjamin's conviction that art can only be understood as a term in a continuing process of production, perception, and reception. Perception itself he sees as conditioned by modes of production.[47] Aura, in this context, he defines as "the associations which, at home in the *mémoire involontaire*, tend to cluster around the object of a perception"; it involves the possibility of an empathetic response to an object.[48] The decline of aura, then, as the critic Andrew Benjamin puts it, consists of nothing less than "a decline in the capacity to experience."[49] The idea of involuntary associations recalls Quatremère's "accessory impressions," those "moral ideas and intellectual harmonies" that give life to the experience of art. Quatremère, moreover, often contrasts the genuine experience of art with the coldness of critical judgment that characterizes a culture in which exhibition value predominates over social and moral utility.[50]

Walter Benjamin does not take a consistent position on the decline of aura; his response to it varies from the vaguely regretful tenor of "On Some Motifs in Baudelaire," cited in the previous paragraph, to the much more positive tone of the "Work of Art" essay, in which the decline of aura releases revolutionary potential.[51] Indeed, writing to Benjamin in 1936 about the latter essay, Adorno finds it "disquieting . . . that you now casually transfer the concept of magical aura to the 'autonomous work of art' and flatly assign to the latter a counter-revolutionary function."[52] Adorno insists on the existence of dialectic within autonomous works of art, and argues that high as well as popular art can come "close to the state of freedom, of something that can be consciously produced and made." Believing that Benjamin has excessively romanticized the proletariat and mass culture in the essay, he proposes as a remedy

"*more* dialectics," at the site of artistic production of all kinds.[53] In a sense, however, the dialectical element of Benjamin's argument resides in the central observation of the decline of aura, an insight that does not change despite Benjamin's shifting view of it. The force of this insight emerges more clearly when read through Quatremère de Quincy.

In an earlier letter to Benjamin, Adorno calls for a more rigorous historicization of "the *specific* commodity character of the 19th century, in other words, the industrial production of commodities." The inescapable astringency of Quatremère's subtext, at the moment of the emergence of the modern commodity form, offers precisely this element of historical specificity. In his more nostalgic mode, Benjamin writes that "experience of the aura rests on the transposition of a response common in human relationships to the relationship between the inanimate or natural object and man."[54] Andrew Benjamin has observed that such a conception of aura encompasses an ethical dimension;[55] in this respect it bears some resemblance to Quatremère's moralism. Yet this formulation also strikingly evokes Marx's description of commodity fetishism. It suggests, as opposed to the magic of art's original ritual setting, an aura characteristic of a period of preindustrial capitalism, one in which art has already lost some of its use value but has not yet become completely commodified. Quatremère, after all, situates the processes he describes in a long period of decline; he knows that, as Adorno observes, "commodities and alienation have existed since the beginning of capitalism—i.e. the age of manufactures, which is also that of baroque art; while the 'unity' of the modern age has since then lain precisely in the commodity character."[56] For Quatremère, more clearly than for Benjamin, the aura attached to art in the eighteenth century already represents a decline. But Benjamin and Quatremère coincide in their views of the decline of aura in the modern age: both figure commodification as its vital motor.

It remains true that Benjamin has little to say about museums as such; two sentences from "Unpacking My Library" more or less sum it up: "But one thing should be noted: the phenomenon of collecting loses its meaning as it loses its personal owner. Even though public collections may be less objectionable socially and more useful academically than private collections, the objects get their due only in the latter."[57] This succinctness has a parallel in Quatremère's ultimate, damning epithet, "receptacles of factitious ruins," and has the same effect as the latter's sustained polemic. Both simply refuse to consider the possibility, still less the implications, of the production of a substitute aura by, for, and within museum spaces, and thus foreclose further theorization. In much the

same way, Adorno comments flatly, "Art treasures are hoarded in them [museums], and their market value leaves no room for the pleasure of looking at them."[58] But a suggestion of how one might proceed along the theoretical lines already sketched out, of how such a theorization of museums' recent development might look, can be found in the work of the late Belgian artist and activist Marcel Broodthaers.

Broodthaers attempted to engage the current spectrum of museum practices, and their connection to the marketplace, in part by interrogating the museum's past. In a series of "museum fictions" beginning in 1968 and consisting of nonexhibitions, parodic exhibitions, and written statements in a variety of forms, he exposed the ordering knowledge produced by museums as a strategy of power. Broodthaers was particularly concerned with the way in which museums institutionalize a discourse justifying art's isolation from society; like Quatremère and Benjamin, he saw commodification as intimately connected to that development.[59] The last of these museum fictions, at Documenta 5 in 1972, began as the Musée d'Art Moderne, Département des Aigles, Section d'Art Moderne. As Douglas Crimp describes it, Broodthaers "painted a black square on the floor of the Neue Galerie and inscribed within it, in white script and in three languages, 'Private Property.' The square was protected by stanchions supporting chains on all four sides. The words 'musée/museum' were written on the window, readable from outside."[60] What Broodthaers produced was, in effect, a modernist rendition of Quatremère's nightmare, an institution that "protects" art by depriving it of life, flaunting its public role while consecrating a system of value based entirely on private exchange. Broodthaers's work is of course more complicated than that, but, like so much else, as a discourse it begins with Quatremère.

Notes

An early, briefer version of this essay was delivered at the Symposium on the Formation of National Collections of Art and Archaeology organized by the Center for Advanced Study in the Visual Arts, National Gallery of Art, and held at the National Gallery in Washington, D.C., in October 1991. I am grateful for the comments of other participants in the symposium, particularly Irene Biermann, Andrew McClellan, Philip Fisher, and Carol Duncan. I would also like to thank my research assistant, David Harvey, and, for their comments and suggestions, Deborah Harter, Irit Rogoff, Victor Burgin, Richard Wolin, and the graduate students in my Rice University seminar on cultural history.

1. Adorno, "Valéry Proust Museum," in his *Prisms*, trans. Samuel and Sherry Weber (Cambridge, Mass., 1981), pp. 175–77.

2. The class nature of this assumption has emerged empirically through visitor surveys going back twenty-five years, but recognition of their implications has been far from uni-

versal. See Pierre Bourdieu and Alain Darbel, *L'amour de l'art: Les musées d'art européens et leur public*, 2nd ed. (Paris, 1969); Philip Wright, "The Quality of Visitors' Experiences in Art Museums," in *The New Museology*, ed. Peter Vergo (London, 1989), p. 121; Nick Merriman, "Museum Visiting as a Cultural Phenomenon," in Vergo, ed., *The New Museology*, passim.

3. John Berger, *Ways of Seeing* (London, 1972), p. 24. See also Danielle Rice, "On the Ethics of Museum Education," *Museum News*, June 1987, pp. 13-19, especially p. 16; and Merriman, "Museum Visiting," p. 165.

4. *Aux artistes: Du passé et de l'avenir des beaux-arts* (Paris, 1830); Robert de la Sizeranne, "Les prisons de l'art," in his *Les questions esthétiques contemporaines* (Paris, 1904); Eilean Hooper-Greanhill, "Counting Visitors or Visitors Who Count?" in *The Museum Time-Machine: Putting Cultures on Display*, ed. Robert Lumley (London, 1988), p. 226. For other fin-de-siècle critiques, see my *Worthy Monuments: Art Museums and the Politics of Culture in Nineteenth-Century France* (Cambridge, Mass., pp. 83-84.

5. Adorno, "Valéry Proust Museum," p. 177; Benjamin, "The Work of Art in the Age of Mechanical Reproduction," in his *Illuminations*, trans. Harry Zohn (New York, 1968), pp. 217-57; Valéry, "Le problème des musées," in his *Pièces sur l'art* (Paris, 1934), p. 97. Valéry's original French reads, "L'homme moderne, comme il est exténué par l'énormité de ses moyens techniques, est appauvri par l'excès même de ses richesses." I am grateful to Deborah Harter for assistance with the translation.

6. Adorno, "Valéry Proust Museum," p. 177.

7. Daniel J. Sherman, "The Bourgeoisie, Cultural Appropriation, and the Art Museum in Nineteenth-Century France," *Radical History Review*, no. 38 (Spring 1987): pp. 38-39.

8. Michel Foucault, "Nietzsche, Genealogy, History," in his *Language, Counter-Memory, Practice: Selected Essays and Interviews*, trans. Donald F. Bouchard and Sherry Simon (Ithaca, N.Y., 1977), pp. 140-44, citation from p. 140; cf. also Patricia O'Brien, "Michel Foucault's History of Culture," in *The New Cultural History*, ed. Lynn Hunt (Berkeley, Calif., 1989), p. 37. On series, see Foucault, *The Archaeology of Knowledge and the Discourse on Language*, trans. A. M. Sheridan Smith (New York, 1972), pp. 7-8.

9. Foucault, "Nietzsche, Genealogy, History," p. 144.

10. Fredric Jameson, *The Political Unconscious: Narrative as a Socially Symbolic Act* (Ithaca, N.Y., 1981), p. 81. The slight modification I propose coincides with the observation with which Jameson concludes the quoted sentence: "it being always understood that the 'subtext' is not immediately present as such, not some common-sense external reality, nor even the conventional narratives of history manuals, but rather must itself must always be (re-)constructed after the fact."

11. Ibid., pp. 95, 98-99, long citation from pp. 98-99.

12. Benjamin, "Eduard Fuchs, Collector and Historian," in his *One-Way Street and Other Writings*, trans. Edmund Jephcott and Kingsley Shorter (London, 1979), p. 352.

13. The most comprehensive treatment of Quatremère is still the critical study by R. Schneider, *Quatremère de Quincy et son intervention dans les arts (1788-1830)* (Paris, 1910). But see also *Aux armes et aux arts! Les arts de la Révolution 1789-1799*, ed. Philippe Bordes and Régis Michel (Paris, 1988), especially the essays by Michel on the Salons (Quatremère as a critic), Bordes on art and politics, Udolpho Van de Sandt on competitions, Daniel Rabreau on architecture (Quatremère and the Pantheon), and Édouard Pommier on art theory. Pommier's *L'art de la liberté: Doctrines et débats de la Révolution française* (Paris, 1991) also contains extensive discussions of Quatremère's theoretical writings; some of these discussions will be cited later in this essay.

14. A. D. Potts, "Political Attitudes and the Rise of Historicism in Art Theory," *Art History* 1 (1978): pp. 191, 200-202; citation from p. 191.

15. Schneider, *Quatremère de Quincy*, p. 179. For the *Lettres*, I have used the edition edited by Édouard Pommier (Paris, 1989); for the *Considérations*, Quatremère de Quincy, *Considérations morales sur la destination des ouvrages de l'art, suivi de lettres sur l'enlèvement des ouvrages de l'art antique à Athènes et à Rome*, Corps des Oeuvres de Philosophie en Langue Française (Paris, 1989). References to these works will be by page number only and will be incorporated into the text. All translations are my own.

16. Pommier, *L'art de la liberté*, pp. 71-72, 76-77.

17. E. Pommier, "La Révolution et le destin des oeuvres d'art," introduction to Quatremère de Quincy, *Lettres à Miranda sur le déplacement des monuments de l'art de l'Italie* (Paris, 1989), pp. 18, 58-59. For an insightful analysis of the *Lettres* that places them in the context of Quatremère's architectural theory, see Sylvia Lavin, *Quatremère de Quincy and the Invention of a Modern Language of Architecture* (Cambridge, Mass., 1992), pp. 148-57.

18. Annie Becq calls attention to this passage in "Artistes et marché," in *La carmagnole des muses: L'homme de lettres et l'artiste dans la Révolution*, cd. Jean-Claude Bonnet (Paris, 1988), p. 90. This essay owes much to Becq's suggestion of a relationship between Quatremère's ideas and those of Marx, though she neither mentions Marx by name nor elaborates on the relationship.

19. Jürgen Habermas, *The Structural Transformation of the Public Sphere: An Inquiry into a Category of Bourgeois Society*, trans. Thomas Burger and Frederick Lawrence (Cambridge, Mass., 1989), pp. 14-31.

20. Schneider, *Quatremère de Quincy*, p. 188.

21. Pommier points to another positive usage of the terminology of political economy in Quatremère: when, specifically citing Adam Smith in the third letter to Miranda, he speaks of the potential benefits of a "division of labor" in archaeology. Pommier calls Quatremère "le premier à transposer ainsi les principes de l'organisation de la production dans le domaine de la recherche" (*L'art de la liberté*, p. 426).

22. Karl Marx, *Capital: A Critique of Political Economy*, vol. 1, *The Process of Capitalist Production*, trans. Samuel Moore and Edward Aveling (New York, 1967), pp. 35-36, 90; for an analogy to the circulation of casts, see his discussion of barter, pp. 87-88.

23. Marx, *Capital*, vol. 1, p. 85.

24. Ibid., p. 75.

25. Pommier, *L'art de la liberté*, p. 424.

26. Alexandre Tuetey and Jean Guiffrey, eds., *La commission du muséum et la création du Musée du Louvre (1792-1793)*, Archives de l'art français, n.s. 3 (Paris, 1909), doc. 24, pp. 56-57; cf. Pommier, *L'art de la liberté*, pp. 112-13.

27. Tuetey and Guiffrey, *Archives*, doc. 25, p. 59.

28. Ibid., doc. 45, pp. 91-92. Rather than the simple "marchand," the commission used the even more pejorative "brocanteur," meaning a dealer in antiques, or more generally in secondhand goods.

29. On the issue of works by living artists, see Tuetey and Guiffrey, *Archives*, doc. 67, p. 125.

30. Tuetey and Guiffrey, *Archives*, docs. 95, 118-20, pp. 191-94, 233-35.

31. Ibid., p. 76.

32. Jameson, *The Political Unconscious*, p. 95.

33. Marx, *Capital*, vol. 1, p. 72.

34. Theodor Adorno, "Letters to Walter Benjamin," in Ernst Bloch, George Lukács, Bertolt Brecht, et al., *Aesthetics and Politics*, translation editor Ronald Taylor (London, 1980), p. 113.

35. See my discussion of this issue in "Art History and Art Politics: The Museum According to Orsay," *Oxford Art Journal* 13, no. 2 (Summer 1990): pp. 55-67, especially p. 55 and n. 9.

36. Discussing the emphasis Quatremère places on the original context of works of art, Sylvia Lavin asserts that "an important buttress for Quatremère's argument was the transcendence historically associated with the Republic of Letters" (*Quatremère de Quincy*, p. 155). This kind of transcendence, however, was indissolubly associated with the ideal purpose that artists and works of art carried out in harmony with their original environment. I believe it is misleading to suggest, as Lavin does in a subsequent gloss, that for Quatremère the individual "work of art" had "transcendent value" (*ibid.*, p. 156).

37. R. Moulin, "Champ artistique et société industrielle capitaliste," in *Science et conscience de la société: Mélanges en l'honneur de Raymond Aron*, 2 vols. (Paris, 1971), 2:194.

38. For an illuminating discussion of this issue, see Alan Morton, "Tomorrow's Yesterdays: Science Museums and the Future," in Lumley, ed., *The Museum Time-Machine*, pp. 128-43.

39. Benjamin, "Eduard Fuchs," p. 351.

40. Benjamin writes on collecting in "Unpacking My Library," in *Illuminations*, pp. 59-67, and in "Eduard Fuchs." On public collections, see *Illuminations*, p. 67, a passage repeated in basically the same form in "Eduard Fuchs," p. 383. From these texts, as well as from some passages in the *Passagen-Werk*, Douglas Crimp has constructed a cogent presentation of Benjamin's position on collecting and its applicability to museums: "This Is Not a Museum of Art," in Marge Goldwater et al., *Marcel Broodthaers* (Minneapolis and New York, 1989), pp. 71-75.

41. Benjamin, "Work of Art," pp. 223-25; citation from p. 224. See also Joel Snyder, "Benjamin on Reproducibility and Aura: A Reading of 'The Work of Art in the Age of Its Technical Reproducibility,' " in *Benjamin: Philosophy, History, Aesthetics*, ed. Gary Smith (Chicago, 1989), pp. 168-69.

42. Benjamin, "Work of Art," p. 234.

43. Ibid., p. 223; cf. Snyder, "Benjamin on Reproducibility," p. 169: "[Benjamin] takes it as a fact that the evolving mass perception is one that is fundamentally opposed to the individual and irreproducible."

44. Benjamin, "Eduard Fuchs," p. 360.

45. Benjamin, "Work of Art," p. 221.

46. In February 1793 an engraver named Pierre Laurent requested and received permission to publish a series of engravings encompassing the entire collection of the Louvre; though this was far from the first such project, the Revolutionary discourse in which it was inscribed lent it particular urgency. See Tuetey and Guiffrey, *Archives*, documents 42, 54, 55, pp. 84-85, 104-6, and, for another example, Pommier, *L'art de la liberté*, pp. 53-54.

47. Snyder, "Benjamin on Reproducibility," pp. 164-66; Jennifer Todd, "Production, Reception, Criticism: Walter Benjamin and the Problem of Meaning in Art," in Smith, ed., *Benjamin*, p. 108.

48. Benjamin, "On Some Motifs in Baudelaire," in *Illuminations*, pp. 186-88; citation from p. 186.

49. Andrew Benjamin, *Art, Mimesis, and the Avant-Garde: Aspects of a Philosophy of Difference* (London and New York, 1991), p. 148.

50. Cf. *Considérations morales*, pp. 36, 40, 50-51.

51. A. Benjamin, *Art, Mimesis*, p. 146.

52. Adorno, "Letters to Walter Benjamin," p. 121. I am grateful to Richard Wolin for pointing out the relevance of this text, and in general for his expert observations on this issue.

53. Ibid., pp. 122-24.

54. Ibid., p. 114; Benjamin, "On Some Motifs in Baudelaire," p. 188.

55. A. Benjamin, *Art, Mimesis*, p. 147.

56. Adorno, "Letters to Walter Benjamin," p. 114.

57. *Illuminations*, p. 67; cf. note 37 above.

58. Adorno, "Valéry Proust Museum," p. 175.

59. Crimp, "This Is Not a Museum of Art," p. 80.

60. Ibid., p. 90. Broodthaers himself commented on the irony of this installation appearing in the museumlike space of Documenta.

8

The Struggle against the Museum; or, The Display of Art in Totalitarian Space

Boris Groys

Toward the end of the nineteenth century, the museum assumed its definitive form as a place set apart for pure aesthetic contemplation and opposed to the external world of social praxis. Needless to say, this division of life space into two heterogeneous zones consistent with the classical opposition of *vita contemplativa* to *vita activa* proved intolerable to the various totalitarian utopias erected in the twentieth century. In their various forms, the ideologies of the new age strove to erase the boundary between the museum and the surrounding world in order to lend the museum a social function and integrate it into its milieu while at the same time striving to conceive of the entire space of life as the object of aesthetic experience. Totalitarianism represents but another such attempt to create a single, total visual space within which to efface the boundary separating art from life, the museum from practical life, contemplation from action. In revolutionary Russia in particular, the museum and its relation to reality became the object of a fierce polemic and underwent several radical transformations. The fledgling Soviet state furthermore set out to redefine the museum's institutional place within culture. If in the West the success of antimuseum artistic ideologies continued, in the final analysis, to be measured by the institutionalization and representation of those ideologies in the context of that very same traditional museum, in Russia the museum itself early on became a pawn in ideological struggles. This factor makes the Russian experience at once peculiar and revelatory of what might have ensued, on a global scale, from a victorious—rather than merely successful—artistic avant-garde.

In the aftermath of the October Revolution the institutional fate of museums in Russia was defined for the most part by two conditions: the vast imperial and private art collections acquired by the Soviet government in the process of requisitioning the "heritage" of the old regime;

144

and the ideological struggle against the museum and museum art conducted by the Russian avant-garde, whose artists and theoreticians gained considerable influence on cultural policy in the first years after the Revolution. The corresponding polemic over the cultural heritage of the past and the possibility—or impossibility—of using it to construct the new society shaped the image and social role of the museum in Soviet society up to the very recent past, when Soviet communism itself came to look more like a museum exhibit than like the society of the future. Hence the perpetual discussions in recent years of what to do with the monuments of "real socialism," whose mass is far too great to house in any museum.

The antimuseum polemic forms an organic element of all the avant-garde movements of the beginning of this century, but it assumed perhaps its sharpest form in postrevolutionary Russia. In the wake of the Revolution the entire cultural hierarchy of the past was destroyed, since the new regime undertook a complete restructuring of both the social and the cultural life of the country. Hastily requisitioned from the former ruling classes, the artistic heritage of the past had been transformed into a single chaotic mass that was now supposed to be reorganized on the basis of completely new social and aesthetic criteria.

In all this the museum as such was inevitably associated with the way of life and psychology of the vanquished classes. One topos of Soviet avant-garde criticism at the time was the conviction that the very institution of the museum was connected with *vita contemplativa*, understood as a purely consumerist attitude toward life deserving no place in a society in which he who does not work does not eat. Thus, the entire concept of the museum was associated with both the ruling and the middle classes, for whom both edification and pleasure were entirely divorced from the need to produce. From this point of view, the museum was unsuited from the outset to a dictatorship of the proletariat, since it contradicted that class's essential quality of being constantly engaged in the process of production, of embodying in itself the *vita activa* in pure form. For a proletarian to go to a museum to gaze on the beautiful meant that his labors toward the aesthetic transformation of life itself had failed. The avant-garde aesthetic understood the museum-as-temple-of-beauty exclusively as compensation for an absence of beauty in life itself.

From the very beginning, this radical point of view failed to satisfy the Soviet authorities, if only because it failed to explain what was to be done with the mass of artworks they had inherited. For this reason they themselves situated art within the system of proletarian education: indeed, in

order to construct the beautiful in life itself the proletariat first needed some ideal of beauty to embody. It was inevitable that this ideal be discovered in the artistic heritage of the past, though that heritage first had to be sorted out so that museums ended up only with works edifying to the proletariat, and it had to be purged of everything that might hinder that education. In the end this new socialist museum turned out to be significantly different from the traditional museum of the nineteenth century, which had been oriented toward the idea of historical representation. The goal of this newly conceived museum became not to present objects and artifacts that might be considered original, characteristic, and specific in the historical development of art; rather, it was to present only those elements that appeared useful from a didactic point of view. This new museum was oriented not toward the heterogeneity of historical artistic styles or the representation of the historically original in art, but toward homogeneity, the establishment of common ground, and the elucidation of what is identical in all of world culture.

Avant-garde objections to this project usually boiled down to the belief that the new proletarian ideal of beauty must not be a mere heir to old ideals, that the aesthetic of the past should not be dragged into the society of the future. This objection, however, reveals a peculiarity fundamental to this entire polemic, albeit one insufficiently recognized by the participants themselves: the demand for a new aesthetic to match a new society signifies a persistence in viewing that new society from within the culture of the traditional museum. According to this perspective, the art of the future must be as distinct from the art of the past as the various epochs of that past, taken in the context of their traditional museum representation, may be distinguished from one another by purely formal, stylistic characteristics. For all its struggle against the museum, then, avant-garde criticism turns out to regard art history from the museum's own customary perspective and through its traditional categories of representation. On the other hand, the party's attitude toward art, which presented itself as a defense of the museum from the "nihilistic" attacks mounted on it by the avant-garde, was in fact premised on an interpretation of the museum that made a radical break with received tradition. In this interpretation the museum ceased to be a place for pure contemplation opposed to practical life, and instead acquired a specific utilitarian goal assigned to it from without: the preservation of the museum under conditions of party control entailed a fundamental transformation of its traditional identity.

The aim of the avant-garde had been to liquidate the schism that divided the single space of "life" into a museum space of pure, nonutilitar-

ian contemplation and the real space of utilitarian praxis beyond the do-main of "art." The longed-for result was a unified, all-encompassing space of life in which everyday praxis would coincide with art. But the avant-garde persisted in thinking of this new totality of life as something stylistically opposed to tradition, which is to say that it continued to see it in a museum perspective. Communist ideology also embraced the goal of integrating all of culture into a social praxis subordinate to a single plan. To the communist leadership, however, this implied not the liqui-dation of old culture but requisitioning it on the level of ideology, just as it had already been requisitioned physically from the former ruling classes. In this sense the aesthetic of Stalinist socialist realism represents the culmination of the avant-garde project for creating a total space in which life and art coincide. The remainder of this essay will examine, in-sofar as its own space permits, various phases of the execution of this project.

Kasimir Malevich's brief essay "On the Museum" provides a good ex-ample of what the Russian avant-garde expected from the Soviet govern-ment.[1] Malevich begins by noting that "the centre of political life has moved to Russia. Here has been formed the breast against which the en-tire power of the old-established states smashed itself. . . . A similar cen-tre must be formed for art and creativity." Malevich predicated this cen-ter on a refusal to preserve the museum art of the past. Having posed a series of rhetorical questions—"Do we need Rubens or the Cheops Pyr-amid? Is the depraved Venus necessary to the pilot in the heights of our new comprehension? Do we need old copies of clay towns, supported on the crutches of Greek columns?" and so on—Malevich draws the conclu-sion that "contemporary life needs nothing other than what belongs to it; and only that which grows on its shoulders belongs to it."

In making these claims Malevich by no means envisions some purely symbolic and stylistic gesture repudiating the past on the level of art it-self, such as one might see in the early manifestos of the Russian futurists. He has in mind the actual physical destruction of the art of the past, at a time, moreover, when artistic treasures faced the very real threat of de-struction from the civil war and economic chaos gripping the country. The essence of Malevich's essay lies in its call to the authorities not to hinder the ruin of old artistic treasures, which would clear the path to-ward forging a new aesthetic. In particular, Malevich writes:

Life knows what it is doing, and if it is striving to destroy one must not

interfere, since by hindering we are blocking the path to a new conception of life that is born within us. In burning a corpse we obtain one gramme of powder: accordingly thousands of graveyards could be accumulated on a single chemist's shelf. We can make a concession to the conservatives by offering that they burn all past epochs, since they are dead, and set up one pharmacy. . . . One could feel more sorry about a screw breaking off than about the destruction of St. Basil Cathedral.

The position Malevich assumes here was shared by many other theorists of the Russian avant-garde. One characteristic example would be Viktor Shklovsky's reminder that even in the past works of art often had been destroyed without the slightest remorse.[2]

Of course it would be wrong to see some form of modern barbarism in this antimuseum position of the Russian avant-garde. Efforts to preserve monuments of the past were closely tied to the secularization of European culture. But for one who believes in, say, the ontological reality of Platonic ideas or a transcendental God, the preservation of artistic monuments cannot help but appear an extremely unreliable surrogate for divine memory. A secularized historical transcendence, one of whose forms is the preservation of things in museums, creates only the illusion of cultural immortality: its material nature signifies both its extreme vulnerability to all sorts of accidents, its dependence on too many external factors, and, in the final analysis, its condemnation to inevitable ruin in some more distant future. For Malevich, just as for the early Christians, such ruin is neither radical nor final, since he believes in "life," which in his writings comes to represent something of an equivalent to God. The destruction of any one work of art is continuously compensated for by life itself producing ever more of them anew. For Malevich, in contrast to the church or modern industrial society,[3] life is subconscious and does not express itself in any specific, finished forms, for life itself is infinite and has no precise goal. Malevich thus defines art as nonobjective, which is to say capable in principle of assuming any form provided that form is "viable." To affix this or that form as something atemporal, or to preserve a form artificially in a museum, is tantamount for Malevich to preserving a corpse—that is, at once impossible and pointless.

At the same time Malevich's own suprematism does take a definite form. For him it arises as the result of a sui generis operation of removing all remnants of traditional representation from the field of the painting, leaving in their place the famous *Black Square* as a sign of pure nonobjectivity. Life thus opens itself up to Malevich via the removal of traditional culture, much as "truth" disclosed itself to the ideologues of the Enlight-

enment via the removal of all possible traditional prejudice. In this one can discern the basic method of at least the Russian artistic avant-garde: creativity is here no longer understood as the addition of something to the sum of what already exists, but on the contrary as the deletion of something from that sum. Thus, for Malevich destruction coincides with creativity. He cares little for museums and the monuments of past culture precisely because the act of destroying them is at the same time the act of creating the new. Thus, proposing that the art of the past be consigned to a bonfire, Malevich further writes: "The aim will be the same, even if people will examine the powder from Rubens and all his art—a mass of ideas will arise in people, and will be often more alive than actual representation (and take up less room)." Malevich here conceives the burning of museum art as a kind of conceptualist act, the documentation of which—specifically, the handful of ashes left behind—turns out to have an artistic value at least equivalent to that of the past art incinerated in the process.

At the same time, closer analysis of Malevich's statement reveals that for him the space of the museum retains its importance even after it has been purged of its artistic contents. The operations Malevich proposes for destroying the artistic tradition can also be understood as an effort to introduce into the museum space objects from the realm of nonart along the lines of his black square or handful of ashes. The belief that these objects will appear in the museum's space spontaneously, as the automatic result of destroying what had been there before, recalls a circus magic act. Incidentally, the perception of the work of art as a mere "thing" signifying nothing rather than as a sign of some extra-artistic reality, which is characteristic not only of Malevich but also of such Russian constructivists as Tatlin and Rodchenko, recalls nothing so much as the modern experience of those antiquities collected in museums in isolation from their ordinary semiotic function—that is, of those very corpses no longer signifying any life whatsoever. Only the prior isolation of art in museums can bring one to see them as containing "physical things" deprived of the representative role art plays in the church, in the court, and in state institutions. In a certain sense it thus becomes plausible to speak of the art of Malevich and the Russian constructivists, with its insistence on its own material nature and thingness, as museum art par excellence.

The implication of such contradictions within a utopian concept of art by no means escaped the attention of contemporary criticism. Thus, one of the leading critics of the Russian avant-garde, N. Tarabukin, asserts that

although "left art" had rejected traditional forms of representation, it continued to create nonutilitarian objects whose proper place could only be in a museum. In particular, Tarabukin writes in his well-known "From the Palette to the Machine":

> Everything created by the "left" wing of contemporary art will find its vindication nowhere else but within the museum's walls, and the whole revolutionary tempest will find its peace in the silence of that cemetery. And "art historians," those indefatigable grave robbers, for their part have the task of composing the explanatory texts for these mortuary crypts.[4]

For Tarabukin the only possible way out of these contradictions lies in a complete break with museum tradition, which had oriented art toward the creation of intentionally nonutilitarian things, and in a turn on the part of artists toward production itself. Neither does Tarabukin believe that the artist can or should play some specific role in the production process. It is not the artist's mission to add a dollop of beauty to industrial products. Artists must instead recognize the beauty of things made exclusively according to principles of function and technique. One can even declare the engineer or worker who has made such a thing an "artist," provided the thing is well made. Tarabukin's notion of a "well-made thing" includes the demand that this thing contain nothing extraneous to technology or dictated exclusively by traditional criteria of "artfulness." As a result, in fact, industrial production itself becomes for Tarabukin a specific artistic style; in other words, Tarabukin perceives production itself in the perspective of that very same museum whose destruction he clamors for so energetically.

That Tarabukin indeed aestheticizes production in this manner can be seen unambiguously from the way in which he describes the very process of production as "nonobjective": "The goal of the activity of those engaged in production is production itself, which is nothing but a means for manufacturing products. In this light nonobjectivism is a phenomenon characteristic of our times which reveals the essence of contemporary culture."[5] Thus, if Tarabukin demands the liquidation of the museum and the rejection of nonutilitarian art, he at the same time interprets the production process as having no definite goal, and consequently as nonutilitarian and nonobjective. In traditional society production satisfied the demands of the ruling classes, who for their part led the contemplative life, and one could say that in such a society production had some sort of goal external to itself. But in the socialist society of the future ev-

eryone will be involved equally in the production process, which as a result becomes ateleological, unproductive, and nonobjective, since everything that it produces it itself immediately reconsumes. Hence the possibility Tarabukin senses for regarding the whole of this new, purely industrial society as a work of art corresponding to nothing less than the traditional Kantian definition of art as "purposiveness without purpose."

As Tarabukin's metaphors indicate, the avant-garde aesthetic regards the struggle against the museum as but a form of the struggle against death in the name of edified life. It sees this struggle as directed against the liquidation of all spaces associated with death rather than life, such as the cemetery and the museum. At the same time it assumes that the things housed in museums were themselves once forcefully wrenched from life itself and placed in the museum, that is, were killed by "the ruling classes." Death thus turns out to be only a violent end that is always preceded by life. One need only eliminate the space of death, in this instance the museum, in order for there to open up beyond it the totality of life without death. Of course this demand is problematic, since the division of life into two spaces, those of death and life, is characteristic of any culture and it is therefore impossible to travel backward through history to reach the space of life alone, or even, if one prefers, that of death. But it is even more characteristic that in avant-garde theory life itself, together with its quality of nonobjectivity, acquires a certain resemblance to death, since from the start the living "here and now" is regarded as but one specific style among a series of dead styles. In such a conception of art the artist ceases to be the active producer of new things. Rather, the artist becomes, in Tarabukin's word, a "propagandist" who points toward reality itself as an aesthetic phenomenon:[6] the real museum is here supplanted by a kind of mental museum of all possible historical forms of culture. Thus the oft-noted fact that the Russian cult of production played first and foremost a propagandistic, rather than properly productive, role cannot be explained simply by the backward state of Soviet industry at the time. More than anything it was the very ideology of productivism as formulated by Tarabukin that demanded from the artist not active production (which would have been from its point of view only an awkward substitute for the real production process), but mere propaganda aimed at opening eyes to an already-formed production aesthetic.

The European museum came into being as a collection of artifacts testifying to the physical life of past centuries: it was a depository for things extracted, whether by time itself or through some literal application of force, from their usual utilitarian or religious use. Thus did the museum

guarantee the "authenticity" of its objects. When, later on, art began to be produced from the outset for the museum there arose a threat to this authenticity: instead of the corpses of previously living things, museums began to receive things that had been conceived and created as nothing but corpses. Another way of putting it is that together with historical consciousness there arose the possibility of artificially producing the historically new. Avant-garde theory responded to this threat by calling for the liquidation of the museum itself, or, in other words, for the artificial re-creation of the situation preceding the historical consciousness that had given rise to the museum. This project for artificially resurrecting an original, "natural" order of things, however, could only be realized through repressive measures and propaganda aimed at generating a new totality in which historical representation, particularly that of the museum, would no longer be possible.

Actually, the avant-garde itself was not entirely suited to engendering such a totality, inhibited as it was by its purely negative posture toward the museum art of the past. A genuine triumph over the "museum" perspective could be achieved not simply by destroying the museum, which would leave in its wake a void capable of being filled with new representations, but instead by integrating the museum into the totality of production or the social process. In the Stalin period the ideology and practice of socialist realism brought about this very kind of integration by radically utilitarizing museum art instead of aestheticizing utilitarian reality.

The artists and theoreticians of the Russian avant-garde were themselves well aware of the internal contradiction arising between, on the one hand, the demand for a rejection of the museum and historicism in favor of an immediately experienced reality, and, on the other, the specific, historically innovative nature of their own works, which acquired significance only within the museum system of representations. Thus Kandinsky asserts that one should not draw distinctions between new and old devices in art; one should only submit oneself to the "inner necessity" of their application.[7] Tatlin similarly declares that the artist's way lies "neither toward the new, nor toward the old, but toward the necessary."

The same may be said of Tarabukin, for whom contemporary art reveals nothing but the "productive," and therefore the nonobjective, nature of art as such. As he puts it, "Even the hallowed da Vinci . . . is a non-objectivist, since his work on color, texture, and more generally on the entire technical process of construction and composition of pictorial

elements—no matter how figurally representative those elements may be—is non-objective."[8] Thus by definition museum art has a "productive" component of its own. Moreover, it is precisely the explicit nature of art that forces us to look more closely at this component, that "organizes our perception of reality." Art understood as a part of the production process acquires the function of pointing toward that same process, or, what amounts to the same thing, contributes to the construction of socialism. Moreover, Leonardo da Vinci, if properly interpreted, turns out to be in a position to do this no worse than, say, that of Tatlin—even much better, since he lacks Tatlin's avant-garde negativism toward old and worn means of organizing reality, which from a purely "productive," utilitarian point of view there is no justification for rejecting.

In contrast to the traditional historicism manifested in standard museum exhibits, the Marxist aesthetic sees the art of past centuries as more than the simple succession of internally homogeneous styles. On the contrary, it perceives each artistic period as bearing the mark of a deep schism because it is produced by a society internally divided by class conflict. Traditional Marxist theory usually treats the dominant forms of culture as the culture of the ruling classes. Such was the opinion of G. Plekhanov, who laid the bases for Russian Marxist aesthetics well before the Revolution. One particularly influential movement in Soviet Russia of the 1920s that drew on Plekhanov's ideas was the sociological school of V. Friche, for which every distinct artistic style represented an equally distinct social group. Thus, for Friche, for example, "linear painting" represented the consciousness of the industrial bourgeoisie, while "coloristic painting," especially impressionism, represented that of the financial bourgeoisie.[9] This sociological school of art criticism also defined the manner in which exhibits were organized and hung in the 1920s, devoting them to such themes as "the art of the wealthy land- and serf-owning class" or "the art of the imperialist era."

This symbolic surrender of the riches of the past to the "class enemy," however, ultimately led to the downfall of the sociological school and together with it of the Russian avant-garde, to which in the minds of party theoreticians it enjoyed close ideological ties. What the party in fact wanted was for all that vast wealth that the Soviet state had gratuitously requisitioned from its former owners—the imperial family, the aristocracy, merchants, the church—to be requisitioned symbolically as well, that is to say, for it to be understood as the original property of those oppressed classes whose interests the Soviet state saw itself as represent-

ing. But in order for this to happen, the art of the past had to be understood as having originally expressed the interests and feelings of the folk (or, what amounts to the same thing, of previously oppressed classes) and only later having been illegitimately appropriated by the ruling classes. The formula "dominant art forms equal art of the ruling classes" no longer suited this purpose and had to be replaced by a new formula, "dominant cultural forms equal folk culture usurped by the ruling classes." This substitution took place gradually during the 1930s and marked the encroachment of socialist realism in its initial Stalinist version. Socialist realism was once and for all declared the sole method for all Soviet art in 1934, but its fundamental tenets were laid down earlier.

For the most part, the artistic theory and practice of the Stalin period operate out of a handful of quotations from Lenin that formulate the so-called theory of two cultures in one. Moreover, under Stalinism this theory comes to acquire a significantly broader meaning than it has in Lenin's own writings. Thus, though in many articles and speeches Lenin does in fact call for a new socialist culture to be erected on the ruins of its bourgeois predecessor, he nonetheless continues to adhere to the traditional notion that the old culture was precisely bourgeois in character. In one of the drafts for his resolution on the "Proletarian-Culture Organizations" Lenin writes, "not the invention of a new proletarian culture, but the development of the best models, traditions and results of the existing culture, from the point of view of the Marxist world outlook and the conditions of life and struggle of the proletariat in the period of its dictatorship."[10] And in another draft:

> Marxism has won its historic significance as the ideology of the revolutionary proletariat because, far from rejecting the most valuable achievements of the bourgeois epoch, it has, on the contrary, assimilated and refashioned everything of value in the more than two thousand years of the development of human thought and culture. Only further work on this basis and in this direction . . . can be recognized as the development of a genuine proletarian culture.[11]

In a still earlier article devoted to the nationalities question, however, Lenin already writes of the socialist components of past culture: "We take from each national culture only its democratic and socialist elements; we take them only and absolutely in opposition to the bourgeois culture and bourgeois nationalism of each culture." It was precisely from this article that the theoreticians of socialist realism derived their doctrine of two cultures in one, usually in the course of citing the following passage:

The elements of democratic and socialist culture are present . . . in every
national culture, since in every culture there are toiling and exploited
masses, whose conditions of life inevitably give rise to the ideology of
democracy and socialism. But every nation also possesses a bourgeois
culture . . . in the form, not merely of "elements," but of the dominant
culture.[12]

To such an understanding of tradition the rejection of all past culture in
order to create a completely new proletarian culture can only mean the
denigration of an already existing tradition of geniunely socialist culture,
to which Marxism itself belongs. In a certain sense such a project could
even be seen as undermining the influence and cultural legitimacy of the
Communist Party, whose intellectual roots go back to a previous histor-
ical period. Of course there immediately arises the question of how and
by what criteria one is to divide one culture into two. Most immediately,
the issue of creating culture is here replaced by that of interpreting the
cultural heritage. If socialist art of the future is to rely on preexisting
models of socialist art, then the delineation of these models within the
larger mass of past art becomes of central significance to artistic produc-
tion itself.

It for Lenin any national tradition contains only relatively few elements
of protosocialist culture, then during the 1920s and especially during the
Stalin period virtually all world culture gradually comes to be seen as
"folk," and therefore progressive, in nature. This shift in the interpreta-
tion of the artistic heritage found rapid reflection in the character of mu-
seum exhibits. If, for example, in the early 1920s A. Fedorov-Davydov,
one of the founding theoreticians of Soviet museum administration, was
still able to boast that both permanent displays and large exhibitions had
been organized according to sociological criteria, before long the socio-
logical method had been subjected to harsh criticism and was open to se-
rious accusations like the following: "The role of the folk as the chief cre-
ator of artistic values was negated [by the sociological method], and all
the achievements of the past were given away to the dominant exploiting
classes."[13] Stalinist criticism thus considered the high art of ancient
Greece, the Renaissance, and nineteenth-century Russian realist painting
to be the expressions of a somewhat ahistorical "spirit of the people."
The duty of Soviet art criticism and museum administration was there-
fore not to reject but to reintegrate the artistic heritage of the past in such
a way as to "render explicit its folk character" and in the same manner
also to "expropriate it from the former expropriators" on the level of cul-
tural discourse. As a result, practically all the art of the past turns out to

be essentially tautological: from the perspective of official Soviet art history it all expresses "age-old folk dreams of a better, socialist life." At the same time, it expresses criticism of the class structure of society in its day, so that it turns out also to be a teleological foreshadowing of Soviet socialist realism. From this point on, efforts to negate the significance of the artistic heritage thus come to be viewed almost as a form of political sabotage. Characterizing those members of the avant-garde who had gone over to the Soviet side, O. Beskin, a well-known critic of the time, writes, "In other words what has been offered to the proletariat is that it deprive itself of the mightiest weapon for use in its construction and battle, the perfected weapon of the ideologically saturated artistic image."[14] Realism now comes to be recognized as the chief positive quality in the art of the past.

In the context of socialist realist theory of the Stalin era, the very term "realism" denotes not so much the mimesis of an external reality—mimesis of that sort was usually vilified as "naturalism"—as it does a preparedness to reify an artistic ideal within reality itself. One might say that here tradition itself is reinterpreted in an avant-garde spirit to mean not the "passive" depiction of reality but the expression of an active bent toward reality's transformation. An earlier polemic between Trotsky and some avant-garde critics is characteristic in this regard. The critics had condemned art's passive reflection of life in favor of the active restructuring of life by artistic means. Pointing out that the reflection of life is a necessary element in its transformation, Trotsky writes, "Art, it is said, is not a mirror, but a hammer: it does not reflect, it shapes. But at present even the handling of a hammer is taught with the help of a mirror. . . . If one cannot get along without a mirror, even in shaving oneself, how can one reconstruct oneself or one's life, without seeing oneself in the mirror of literature?"[15] For the sake of the higher goal of building the ideal society of the future, Trotsky here renders the entire artistic tradition utilitarian; what is rejected as a result is the division of art, constitutive for modernity, into elite, high, "pure," museum forms on the one hand and low, commercial, and utilitarian forms on the other. It was the liquidation of this boundary that was responsible for creating in fact that single total space of coincidence between art and life toward which the avant-garde had striven but had failed to reach.

In essence the Stalinist aesthetic preserved the same goal of overcoming the division between art and life. However, it undertook to solve the problem not by destroying the museum but by a sort of equalization of museum exhibits and their surrounding milieu, accomplished by physi-

cally filling the milieu with art indistinguishable from that in museums. It is this strategy of equalizing what is in museums with what lies outside them that creates the very specific aesthetic atmosphere found in totalitarian societies of the Stalinist type. To the aesthetics of the Stalin era, art has value only insofar as it satisfies the Leninist theory of reflection, according to which art must reflect life "as it truly is." But from the viewpoint of Marxism-Leninism this true knowledge of life can in turn be attained only through an apperception of the hidden dialectic of social development, and this only dialectical materialism can reveal. This apperception discloses the world in the form not of its present appearance but of what it must become in the future: Soviet art's blueprints for a new world have authenticity because behind them stands an authentic political force capable of realizing the projects Soviet artists propose. Thus, in one of his notorious instructive speeches A. A. Zhdanov declares, "Soviet literature must know how . . . to peer into our future. That future will not be a utopia, because the groundwork for our future is already today being laid by systematic and conscientious work. . . . Writers must not bring up the rear of events, they should march in the front ranks of the people, pointing out the path along which it will develop."[16] Art is thus subordinated to the truth about the world, which a victorious ideology transmits to it over the heads of any historical artistic styles or languages, even if this truth was partly anticipated in them. Socialist realist art at once depicts reality and creates it, since it is part of a social force that simultaneously creates both reality and its representation (namely, the Communist Party). With their control over both reality and its artistic representation, the communist authorities find themselves capable of making art autoreferential and thus fulfilling the avant-garde's dream of bringing about the complete identity of signifier and signified. Thus the distance between these two elements of the sign, itself a sign of the unstable relationship between a concept and its representation in reality, collapses, and there emerges a cultural system displaying both internal cohesion and a corollary power to signify. In this type of art, contemplation and praxis also coincide, which in turn completely erases the boundary between the museum and the surrounding world.

Against this continuous backdrop of life as art, the avant-garde begins to look like a museum corpse, fit only to be cast out and destroyed, because it sees itself only as a critique of representation, a destruction of tradition, a negation of the possibility of any active knowledge of reality. As a form of pure negativity, the avant-garde here falls into the trap of its own theoretical concepts. It became easy for theoreticians of socialist re-

alism to demand the exclusion of the avant-garde from the artistic tradition preserved in museums because they could always cite its own self-definition as a purely destructive activity lacking all independent artistic value and aiming only to liquidate tradition so as to clear the board for reality itself. As a result, the struggle against the avant-garde came to be seen exclusively as an effort to rescue the artistic heritage for the sake of its practical integration into everyday life. Needless to say, this notion of the artistic tradition excluded works by avant-garde artists themselves, since those works negated their own worth. This is why Soviet museums removed from their collections or refused to accept both avant-garde art and religious art of the past, which was also seen as something purely formalistic, negative, and fictive.

In practice the instrumentalization of the artistic tradition meant that the entire space of Soviet life gradually became filled with an enormous number of posters, monuments, frescoes, mosaics, and so forth that were all modeled after museum art. On the other hand, depictions of Soviet life intended for exhibitions and museums gradually began to reproduce this very same Soviet visual milieu already saturated with art. Moreover, they did so in the very forms in which that mass art had been cast, for it is precisely a saturation with the signs of Sovietness that distinguishes Soviet from non-Soviet life space: the "artistic transformation of life" turns out to involve filling the space of life with artistic wares. Paintings intended for museums were in turn reproduced in the form of posters, illustrations for mass periodicals, propaganda displays for the workplace, and so forth. The art of the past that made it into the official canon was also drawn into this process of gradual duplication. As a result, the boundary between the space of real life and that of museum exhibits was gradually erased on the visual level as well. Under this Soviet aesthetic, artistic production continually reflects and reproduces itself, thus engendering a total space of visual experience. The art of the avant-garde conceived of itself as a contrast to the art of the past and was therefore comprehensible only to those already familiar with the artistic tradition. Socialist realism, however, advances its own aesthetic as the criterion for understanding the art of the past. Its central prerequisite is declared to be the coincidence of "ideological high-mindedness" with "artistic excellence," which in practice means erasing the boundary between poster and painting, between museum space and nonmuseum space, between reality and its representation, between history and the present.[17]

Ever since the Stalin era this congruence of museum and nonmuseum space in the Soviet Union has had not only ideological but also institutional and economic guarantees.[18] The purchasing policies of Soviet museums have always been under the nearly complete sway of the Union of Soviet Artists. This is perhaps the most basic difference between Soviet and Western museums. Curators and museum employees in the Soviet Union play insignificant roles, since they have no right to select from the general mass of artworks those that merit inclusion in the museum, which is the chief prerogative and source of prestige for curators in the West. Soviet museums automatically buy artworks from those artists who have made their career within the official artists' union. The artists' union is a powerful organization that controls not only the production of artworks but also the entire process involving the organization of exhibits, art criticism, state purchasing policies, and even the tiniest aspects of the lives of Soviet artists and all those in the USSR who have any relation to art. Moreover, the ruling bureaucrats of the artists' union are drawn chiefly from among those artists who enjoy close and direct ties with the party elite. As a result, the hierarchical position of artists within the Soviet bureaucracy is much higher than that of the museum employees who buy their works or the critics who evaluate them.

Correspondingly, success in the nitty-gritty political battles waged among factions inside the artists' union is a much more important factor in a given artist's career than recognition by museum curators. Individual exhibitions are an extreme rarity in the Soviet Union, and in the usual sense of the word there is no artistic market whatsoever. The basic form in which art reaches the public is that of collective exhibitions organized by assorted commissions within the artists' union and devoted to specific themes (such as episodes in Soviet history) or produced in conjunction with particular political events. More often than not, these paintings have themes like the glorification of the Soviet Army, industrial and agricultural success stories, or portraiture of the political leaders. As a result, the viewer witnesses yet another erasure of boundaries, this time thematic, between the visual propaganda constantly before him in the streets and what he sees at exhibits or in the museums that acquire their paintings from such exhibitions (if only because it is the same artists who fill the orders for mass propaganda, through the same channels of political influence). There arises a kind of artistic utopia in which it is the artist and not the museum who obtains power over the representation of history.

It is interesting to note that the institutional priority of the artist over the museum was one of the very first demands formulated by members

of the Russian avant-garde. One can thus read in a fairly early decree issued by the Department of Fine Arts of the Narkompros (People's Commissariat for Enlightenment, forerunner of the Ministry of Culture) that:

> Since artists are the creative force in the realm of art, it is their duty to direct the artistic education of the country as a whole. Museum administrators, regardless of whatever close association they may have with artistic circles, are prevented by their professional background from being sufficiently competent in questions of artistic creativity and education. That long-standing anachronism, by which museums are filled with works of art selected by museum administrators, must be abolished. The business of acquiring works of contemporary art is the exclusive competence of artists themselves.[19]

Thus not the museum curator but the artist becomes the state official who decides which art, specifically, is representative and worthy of preservation. This demand, which in principle even now defines the hierarchical structure of Soviet art institutions, at the same time signifies a refusal to regard present art in the context of the art of the past, whose agent is that very museum curator. On the contrary, under such a system the museum wholly subordinates itself to the demands and tastes of the present.

As a result, the perception of visual material within this space of complete coincidence between museum and nonmuseum is effectively neutralized. The eye of the Soviet citizen generally fails to register art as a specific phenomenon, since he encounters the same thing everywhere he goes. His entire field of vision is taken up by tautological, monotonous, visually nondescript art stamped out of clichéd molds. This saturation of the whole visual field with monotonous objects is intentionally *not* aimed at a traditional perception of the museum sort, which expects to have its attention heightened by originality and extraordinariness. On the contrary, this constant production of identical objects aims at excluding the possibility that anything original could arise, or that there could appear some space set apart from all other space. In a certain sense one could say that in its own way the role of totalitarian socialist realism is purely negative, too: I have in mind that process by which the world comes to be filled with tautological art in order to exclude the possibility of anything else. Under such conditions art becomes just as incapable of representing life as it is of opposing itself to life, for art and life are essentially indistinguishable. Hence, incidentally, the difficulty we sense in our own day of placing the art of socialist realism in museums in the aftermath of its dominance. To return a socialist realist painting to the museum would be

tantamount to placing an Andy Warhol Campbell's soup can back on the supermarket shelf. The fact of the matter is that at a certain historical moment this painting itself filled the space of reality; to place it back in a historically organized museum exhibit would be to strip it instantly of all that aggressive posture toward life that is its essence.

The project for creating a single, total space of aesthetic experience—a space of the coincidence of art and life—that was begun by the Russian avant-garde and then culminated in Stalinist socialist realism did not succeed. It failed in particular because it led to the massive overproduction of art having value neither for the museum nor, consequently, for the market. In this respect Soviet art shared in the fate of all other sectors of a Soviet economy based on the negation of the "bourgeois" consumer and the unlimited dominance of the "proletarian" producer. Having effectively eliminated the museum as the primary consumer of artworks, and having wholly subordinated it to the artist as a producer of art who shapes life itself, Soviet ideology stripped art of both its relation to the art consumer and its role as mediator between the present and the historical immortality of the museum. In the end Soviet art did in fact coincide with life, having transformed itself into a potentially infinite process of serial (re)production devoted to generating an equally endless devaluation of the artistic and market worth of every individual work of art— and in the final analysis of art in general.

Translated by Thomas Seifrid

Notes

1. K. Malevich, "On the Museum," in his *Essays on Art* (New York, 1971), pp. 68–72.

2. Specifically, Shklovsky writes that "all great architects were destroyers. . . . The monks who erased Vergil's poetry from parchments in order to write their chronicles and draw their illuminations were right" (V. Shklovsky, *Gamburgskii schet* [Moscow, 1990], p. 93).

3. About the relationship of art to church and industry see K. Malevich, "God Is Not Cast Down," in *Essays on Art*.

4. "Tout ce qui est créé par l'aile 'gauche' de l'art contemporain ne trouvera sa justification que dans les murs de musée, et toute la tempête révolutionnaire trouvera son apaisement dans la silence de ce cimetière. Et les 'historiens de l'art,' ces infatigables détrousseurs de cadavres, ont à leur tour le travail de composer des textes explicatifs pour ces cryptes mortuaires" (N. Taraboukine, *Le dernier tableau* [Paris, 1980], p. 48).

5. "Le but de l'activité de celui qui travaille dans la production, c'est la production elle-même, qui n'est qu'un moyen de fabrication de produits. . . . Sous ce rapport, le non-objectivisme est un phénomène caractéristique de notre temps qui révèle l'essence de la culture contemporaine" (Ibid., p. 63).

6. Ibid., p. 58.

7. Thus Kandinsky speaks of the "complete and unbounded freedom of the artist in the selecting of means" in V. Kandinsky, *O dukhovnom v iskusstve* (New York, 1967).

8. "Léonard canonisé . . . est un non-objectif, car son travail sur le coloris, la texture et d'une manière générale, tout le processus technique de construction et de mise en forme des éléments picturaux, même s'ils sont représentatifs-figuratifs, est non-objectif" (p. 70).

9. V. Friche, *Sotsiologiia iskusstva* (Leningrad, 1930), pp. 89 ff.

10. V. I. Lenin, *On Culture and Cultural Revolution* (Moscow, 1970), p. 150.

11. Ibid., p. 148.

12. Ibid., pp. 43-44.

13. A. K. Lebedev and K. A. Sitnik, *Khudozhestvennye muzei SSSR k XX godovshchine Oktiabria* (Moscow, 1937), p. 708.

14. Osip Beskin, *Formalizm v zhivopisi* (Moscow, 1933), p. 59.

15. Leon Trotsky, *Literature and Revolution* (New York, 1957), p. 137.

16. Quoted in V. Zimenko, "Sotsialisticheskii realizm kak otrazhenie zhizni sotsialisticheskogo obshchestva," *Iskusstvo*, no. 1, 1951. It is characteristic that the journal considers the remarks Zhdanov addresses to writers as instructive for artists as well.

17. On the general relationship between the Russian avant-garde and socialist realism see B. Groys, *Gesamtkunstwerk Stalin* (Munich, 1988), translated as *The Total Art of Stalinism: Avant-Garde, Aesthetic Dictatorship, and Beyond* (Princeton, N.J., 1992).

18. [This essay was written prior to the breakup of the Soviet Union in December 1991. In consultation with the translator, we have chosen to retain the original tense usage as a sign of a historical continuity still extant at the time of writing. — Eds.]

19. Quoted from "Postanovleniia IZO (Narkomprosa) po voprosu o printsipakh muzeevedeniia, priniatogo kollegiei Otdela v zasedanii ot 7 fevr. 1919 g.," in *Sovetskoe iskusstvo za 15 let. Materialy i dokumentatsiia* (Moscow-Leningrad, 1933), p. 84.

9

"Degenerate Art" and Documenta I: Modernism Ostracized and Disarmed

Walter Grasskamp

Documenta has been called the most important and most spectacular of international art events. With each succeeding Documenta, the enterprise assumes greater and greater significance as an arbiter of contemporary art styles and markets. Thus what began in the 1950s as an experiment within a particular local context has turned out to be a successful series that can claim, at the end of each installment, that it is to be continued. This could not have been foreseen at the outset. In 1955, the first Documenta had no index number. Hopes for continuity may have existed but were hardly justifiable in a ruined postwar town that, after long prospering in the middle of the German Reich, found itself cast by history into a provincial borderland.

The plans for the original Documenta were dictated more or less by coincidence. Kassel's opportunity to be the setting for the *Bundesgartenschau*, a regular national garden festival that always takes place in a different city, gave birth to the idea of organizing an exhibition of modern art. This parallel event was planned for a large tent on the grounds in front of the ruins of the oldest original museum building, the Museum Fridericianum. The painter and designer Arnold Bode adopted the idea from Hermann Mattern, his colleague at the local academy of arts and crafts, and gave it a decisive twist: inspired by the Picasso exhibition in the ruins of the Palazzo Reale in Milan, he promoted the idea of provisionally rebuilding the Museum Fridericianum to host a temporary collection of twentieth-century art during the garden festival.

In contrast to today, the first Documenta was thus a retrospective enterprise, focusing on the first fifty years of the twentieth century. Documenta II, which followed in 1959 in the originally intended rhythm of every four years, concentrated on art since the end of World War II, and by 1964 Documenta III had brought the focus up to the present and con-

centrated only on contemporary art. That proved to be a successful formula for making an institution out of a temporary event. Documenta III was a triumph for the original organizers: Bode, who was mainly responsible for the modernistic and exemplary mise-en-scène, and Werner Haftmann, head of an advisory committee of art historians. Haftmann proclaimed abstract art to be a world language, a thesis very optimistic about the international role of art and very appropriate to the predominance of abstract art in the exhibition.

In the course of the preparations for the fourth Documenta, to be held in 1968, the discussions of what was to be regarded as modern art led to a major conflict and ended with a shake-up of the advisory committee and the resignations of longtime members, among them Werner Haftmann. Arnold Bode, the local political force for the continuity of the Documenta, lost influence as well, but kept in touch with the new preparatory team, in which the Dutchman Jean Leering was primus inter pares. Pop art and other trends current in the sixties were included, though somewhat late, in the show, which changed to Arabic index numbers and posed as Documenta 4. This modest modernization could not prevent criticism from the other side, however, and the press conference and opening festival were disturbed by artists and students who saw it as entirely insufficient.

Documenta 5, in 1972, was directed by Harald Szeemann, who coined the slogan "Individual Mythologies" and directed a team of specialized colleagues who installed a department of conceptual art as well as departments of film, trivial emblems, and museums by artists. Szeemann, then thirty-nine, proved that the Documenta was able to meet the demands of presenting both topical art and thematic exhibitions, and gave birth to a new model of mediating art: the mediator as hero, sender, and addressee of inspiration at the same time. Highly respected by the artists, he was the object of mounting public criticism, all the more so when it turned out that a financial deficit had to be made up after the end of the exhibition. The amount of the shortfall appears ridiculous today, but seriously threatened Szeemann's career at the time, so that the outstanding role of Documenta 5 and of Szeemann's inspiration were only recognized a couple of years later.

The Documentas that followed in 1977 (Documenta 6), 1982 (Documenta 7), 1987 (Documenta 8), and 1992 (Documenta 9) were directed by Manfred Schneckenburger, Rudi Fuchs, and Jan Hoet, and are so close to contemporary experience that further description of them may be unnecessary. In any case, the following essay concentrates on the first Doc-

umenta, reconstructing and discussing it as an incomplete, even inadequate answer to another German exhibition of some national and international importance, the campaign against "degenerate art" in 1937. The main topic leads into some particularly German details of history and art history, but even provincial details are important in the analysis of this paradigmatic controversy over modernism, as represented in the medium of the exhibition. This essay was written in 1987 and was first published on the occasion of the fiftieth anniversary of the exhibition Degenerate Art.

Counterexhibition

In the copious literature on the history of the Documenta, a theme of central importance has long been left out of consideration.[1] It is the question of the relationship of the Documenta to another exhibition of modern art on German soil, one of equal if not greater importance: the exhibition Degenerate Art, which opened in 1937, eighteen years before the first Documenta and exactly fifty years before the eighth. The first Documenta, in 1955, measured even by its own claims, is to be understood as an answer to the trauma that resulted from that original antimodernist smear campaign and that remains associated with it today. The significance of the first Documenta is in no way diminished if one understands it as an important stage in the history of the reception of the Degenerate Art exhibition.

As if they wished to revise that smear campaign into a regrettable deviation, the founders of the Documenta returned to international modernism with vehemence and enthusiasm. But they neglected to answer conclusively and concisely with their Documenta the questions that the Degenerate Art exhibition had raised. This omission can perhaps be understood in retrospect, but not unconditionally condoned. The Degenerate Art exhibition did not stage just any idiotic, senseless, or barbaric attack on modern art. It was rather a suggestive and refined attempt to discredit modern art at the level of its means and problems: an attack that was surely conclusive for many viewers and that did not fully lose its effect even after the liberation from national socialism. It could not have been staged with merely a superficial understanding of the problems, debates, and purposes of modernism. The work of opposing it and the ideology it propagated is not accomplished by declaring oneself unreservedly in favor of the modernism that was pilloried there. It is rather a matter of accounting at the same time for modernism's dubiousness, dis-

sonance, and aggressive arrogance, which the National Socialists were so cleverly able to turn against it. The first Documentas did not fulfill this historical task, and thus they remained in the long shadow of that smear campaign even when they tried to put themselves in the right light.

Seven focal points can be isolated in the polemic with which the Degenerate Art exhibition and the National Socialist cultural politics took aim at modern art. They stand in the center of this essay, which concentrates on whether and how the Documenta faced these tendencies. It is thereby drawn into the context of other contemporary documents that expand the range of the interpretation. The point of departure and the center of the essay are the first three exhibits encountered by visitors to the first Documenta in 1955, of which only the third was a work of art. From the photo panels in the lobby of the Fridericianum to the photo panels on the back wall of the entry hall and up to the first sculpture in the stairwell, this constellation proves to be a "dialectical image" in Walter Benjamin's sense. The basic attitude of the organizers of the first Documenta can perhaps be read more clearly from it than from a traversal of the works.[2] Most of the following reflections are taken up by the theme of *liaisons dangereuses*, the dangerous liaisons of the avant-garde. These are set up as a response to the minimal attention this theme found in the conception of the first Documentas, which avoided dealing with it altogether until it became the central theme of the fifth.

Liaisons dangereuses

In 1947, the painter Werner Heldt gave a speech opening an exhibition of French painting at the Gerd Rosen Gallery in West Berlin. In it he related the following: "In the year 1937, when the great iconoclasm set in with the exhibition of so-called 'Degenerate Art,' Werner Gilles told me that some of his pictures had been hung there, next to some drawings by a lunatic. Under them was written 'What is the difference!?' "[3] Indeed, what is the difference between modern art and the works of lunatics? Has any theory of modern art been able to answer this question since then? Werner Heldt could not, and did not even try. To the contrary, reflection on the question led him to emphasize not the differences between the two zones of creativity, but what they had in common:

> This question, once posed out of narrow-mindedness, arrogance and malice . . . is still posed today for the same reasons. What is the difference between the "sculptures by lunatics" and the aspirations of the art of our time? In 1929 I came upon Prinzhorn's book *Bildnerei der*

Geisteskranken [Imagery by lunatics]. Monstrosities could be seen there: witches, spirits, demons, grotesque and gruesome apparitions and dreams. Such things were familiar to me from dreams and earliest childhood memories. I saw something related in the works of artists of all times: Bosch, Seghers, Meryon, Gaudi, van Gogh, Henri Rousseau, Odilon Redon, Munch, Ensor, Kubin. What was it? It was the hallucinatory look! Life as a dream; it was the presentiment of a powerful realm full of magic, populated with angels and demons, forming the eternal underworld of our human realm.

These reflections of Werner Heldt are the document of a nearly touching helplessness in the face of a modernism, in which he himself—especially as one ostracized—was entangled. As if under a spell, he lost his train of thought and answered not the question of the difference, but rather that of the affinity of modernism and madness. He nevertheless maintained a position of abhorrence and incomprehension in the face of insanity, which was not dissimilar to that abhorrence and anxiety by which the critics of modern art were moved. As if for comfort and reassurance, he subsequently argued that artists *of all time* had operated in this border-land, though he then listed a series of colleagues who, with two exceptions, all stood on the threshold or on this side of the threshold of mod ernism. He entirely lost sight of what was specifically modern in his mode of questioning when he sought to recast as universally human, and presented as universally dreamlike, that which was only a product of his own universalizing. For just as representations of angels and demons have their own history, the relationship between art and madness is also the result of a historical development, whose specifically modern culmi-nation Heldt here denies. If even an active participant and well-meaning observer of modernism such as Werner Heldt neither understood nor wished to understand this relationship, then how much less can be ex-pected from an opponent of modernism? Only a historical reflection, not a universally human one, can serve to lead out of this dilemma.

Individuality and Disability

In 1921 the book *Ein Geisteskranker als Kunstler* (A lunatic as artist) ap-peared, dedicated by Walter Morgenthaler to the sanitorium patient Adolf Wölfli, and in 1922 Hans Prinzhorn's *Bildnerei der Geisteskranken: Ein Beitrag zur Psychologie und Psychopathologie der Gestaltung* (Imagery by lu-natics: A contribution to the psychology and psychopathology of Cre-ation) appeared. The effect these two pathbreaking works had on artists exceeded their effect on psychologists. It did not happen by chance. Even

before 1914 the student Max Ernst had been gathering relevant practical knowledge in the collection of sculptures and pictures in the Bonn University Nerve Clinic and had gained further inspiration from criminological lectures, whose case studies are as a rule not suited for sensitive listeners.[4] The terrain was already prepared before the publication of Prinzhorn's book, which then—exported single-handedly to Paris by Max Ernst—greatly affected French surrealism.[5] The search by artists for new sources of inspiration, a specific feature of modernism, was decisive for an erosion of the delineations between categories of artistic activity.[6] The previously clear-cut and fixed boundary between art and a creativity singled out as insanity became obscured only in this context.

If the nineteenth century had still problematized the boundary between individualism and deviant behavior via the concept of genius—as in Cesare Lombroso's *Genio e Follia* (Genius and madness), which appeared in 1864—then for the artists of the twentieth century, precisely that protective mantle of the concept of genius was at stake when they began aggressively to aestheticize the products and experiences of the insane and to integrate them into their work. They thereby offered to National Socialist disparagement a vulnerable target that was profitably aimed at. The development of these tendencies to disparagement can be traced from Lombroso's book through Wilhelm Lang-Eichbaum's work *Genie, Irrsinn und Ruhm* (Genius, insanity and fame), which appeared first in 1928 and later with variously stressed revisions, on up to Paul Schultze-Naumberg's *Kunst und Rasse* (Art and race). It is an oversimplification to consider this development as the exclusive result of "narrow-mindedness, arrogance and malice," as Werner Heldt does, and Heldt was not the last to make things so easy for himself.

Risky Sources

The art of lunatics was not the only source that modern artists attempted to tap and to make grist for their mills. Two further sources were discovered in the search for the origin of an art that had run off the social rails. Both were already unacceptable for the bourgeoisie, and therefore all the more so for the National Socialists. One source was the art of the people previously disdained as primitive, who had been the victims of European colonialism and whose idols had thus entered the European field of vision. The other source was children's drawings, which, likewise, in spite of every idealization of childhood produced up to then by the bourgeoi-

sie, were not taken seriously but were considered as transitional stages of a slowly educated rationality.[7]

The field of both these inspirational resources had been opened up in Germany by the anthology edited in 1912 by Wassily Kandinsky and Franz Marc, *Der Blaue Reiter* (The blue rider).[8] Next to examples from folklore, motifs of a haphazard exoticism, and artworks from different epochs, children's drawings and reproductions of primitive art assumed a prominent place in the pictorial and argumentative economy of its programmatic text.

One would be wrong to assume in both cases that artists who acknowledged these two victims of modernism, the colonized tribes of Africa and institutionalized lunatics, were expressing their solidarity with the fate of their elected kin. Anything but that. Rather, the artists resolved entirely selfishly the dilemma of inspiration that modernism had gotten them into, and procured their remedies by helping themselves in children's rooms, in the curiosity cabinets of the clinics, and in the ethnological museums, the colonial boutiques of art. Whatever may have moved artists to search for the source and the origin of art, whatever may have spurred them to the adventure of tapping into even risky sources, the risk of the effect of such a primitivized modernism was certainly not clear to them in the extent to which national socialism then avenged it. With the recourse to children's drawings and to the art of lunatics and primitive peoples, they involuntarily and for the sake of an already lost cause offered three pivotal points of defamation to the Degenerate Art exhibition and the antimodernist propaganda. In an analysis of this defamation, George Bussman has contested the long-standing view that demonizes the Degenerate Art exhibition as a singular event.[9] Rather, it focused reservations and anxieties about modernism that had for a long time characterized bourgeois reactions to modern art, which may once have been more civil but were in no way more conciliatory. If the reservations and anxieties survived the smear campaign and have continued to appear up to the present, it is not only because this exhibition provided the most suggestive articulation of them, but also precisely because the anxiety about modern art was not a specifically National Socialist syndrome. Rather, it was simply a spectacular parade ground for their propaganda.

Modernism Disarmed

It thus comes as no surprise that two of the three risky sources of modern

art were not rehabilitated at Documenta I, but merely left out. It did show the modern art of the twentieth century in a historical perspective, but without the accompanying history. Neither in the actual exhibition nor in the catalog can one discern even the trace of an engagement with the risky sources of modern art. Rather, the first Documenta transformed a modernism that had arisen out of difficult conflicts and disruptions into a timelessly valid contemporary art. It willfully overvalued the possibility that a pure art exhibition would be able to convey and mediate the context and historical contours of modern art. If the organizers of the Degenerate Art exhibition had provided the pieces on display with polemical commentaries, then the organizers of the Documenta renounced any commentary on the exhibits, even any that could have counteracted the memory of the discrediting of modernism. They relied on the autonomy of the works of art, as if these could assert and legitimate themselves on their own. Nonetheless, in two prominent places of the first Documenta, one can discern the effort to counter the discrediting that was still conceivable and possible in the context of *liaisons dangereuses*. The exhibition received the visitor with large walls of images, on which poster-sized photographs were supposed to ensure the proper consensus on the exhibition. First, the visitor encountered a collection of historical artworks from different cultures and periods. In the only reproduction of this poster wall that I know of (fig. 9.1), which I came across accidentally in an old advertisement for Documenta II, not all of the poster photographs can be recognized, and it is even less possible to identify them.[10] A contemporary press release summarizes: "It was a fine idea to cover the side walls of the lobby with a colorful jumble of large photos of archaic, early Christian and exotic-primitive artistic forms, and thus from the beginning to recall that all these things have left their traces behind in the art of the last fifty years."[11] In the depiction of the apparently double wall of images, we must rely on this informant, but we need not follow his interpretation. For the lowest common denominator of such a compilation of artworks consists rather in placing reduced or stylized forms from all times and cultures in contrast to an artistic taste that the visitor to the first Documenta was assumed to have. Thus the German public had to be suspected of considering true art to be the amalgam of naturalism and classicism that national socialism had for twelve years stamped on official art, in order to turn it *against modernism*. Indeed, this seems to have been a continuing prejudice up to the present. The photo panel opposed this unhistorical universalization of a specific artistic taste with another universalization that was equally false, to the extent that it gathered together

Fig. 9.1. Entrance hall of the Museum Fridericianum during Documenta I: poster wall with works of African and pre-Columbian as well as European art of the Middle Ages and early advanced civilizations

archaic and primitive as well as medieval and exotic sculptures so that the purpose of the collection could not be overlooked. The National Socialist suggestion of a *continuity of classicism* was countered with the assertion of a *continuity of the archaic*.

Just as some fifty years earlier in the anthology *Der Blaue Reiter*, things proceeded according to a principle of eclecticism to which every work from every time and culture was suited, if it supported the thesis that the formal discoveries of modernism *were not new*, but rather had always already existed. Such a strategy of legitimation fits with an image of a reduction of modernism. What was specifically new in it was dehistoricized and embedded in a universal, unhistorical, and encroaching continuity, which attempted to anticipate the possible resistance to modernism with the claim that modernism had always already existed. This respectable turn of modernism into a false continuity is comparable to a book that appeared in 1952, *5000 Jahre moderner Kunst oder: Das Bilderbuch des Königs Salomo. Kunst der Gegenwart und Kunst der Vergangenheit in Gegenüberstellungen* (5000 years of modern art; or, The picture book of King Salomo. Art of the past and present in comparison).[12] Already on the title page it displays an idol from the Cyclades as a justification of an abstract

sculpture by Brancusi and thereby signals not only the tenor of the book, but also a strategy of legitimation that the photo wall of Documenta I endorses.

This strategy of legitimation was current up through Documenta III. In 1964, although by that time with originals, such a preface was still supposed to channel visitors through a passage of historical artworks in order to prepare them for the reception of modern art as eternally valid, a plan that apparently collapsed for financial reasons.[13] Nevertheless, according to Jean Leering, it was still a matter of controversial discussion in advance of Documenta 4, and was finally discarded after the resignation of its supporters from the organization committee. In its place, Bazon Bock's *Besucherschule* (Visitor's school) became an integral component of the exhibition at the fourth, fifth, and sixth Documentas.

Naturally, there can be no doubt that modern art has been enriched by such sources. Spectacular archaeological discoveries from early advanced civilizations occurred, after all, in precisely the period in which modern art was taking shape. The excavations on Crete with their noteworthy ceramic discoveries were as unlikely to escape the attention of artists as the Cycladian idols and the diggings in Mesopotamia and Egypt. Lyonel Feininger's wall paintings for a party of the Berlin Secession in 1912 provide evidence of direct borrowings from Minoan art.[14] And thus, in fact, in addition to the three risky sources of modernism a fourth is to be seriously put forward: archaeological discoveries. Rolf Wedewer has recently renewed a discussion of the relationship between ancient Egyptian and modern sculpture.[15] Yet it remains noteworthy how differently the various sources on the photo wall of the first Documenta were treated. Two were simply suppressed, while the third, tribal art, was domesticated in an amalgam of forms and configurations in which the medieval and the primitive, the archaic and the exotic were intermingled. The explosive discovery, indeed the downright boom of primitive art in Europe, which can be precisely dated, was transformed here into an uninterrupted continuity of archaic forms and disarmed by the presence of European examples. The reaction of Documenta I to three of the decisive attacks of the Degenerate Art exhibition was thus defensive and aloof.

Suit of the Time

The second wall of photos found on the back side of the entrance hall also succumbed to this tendency to inhibition. Without responding to the preceding emphasis on the individuality of the artist as a disability, the first

Documenta answered the discrediting of the artist by presenting the problem as harmless. To that end, it made use of the long-defunct model of stylization, although with the aid of modern media. For the artists of the twentieth century—and importantly among them, those previously ostracized—it set up a photo wall as a memorial, on which enlarged photographic portraits personalized a historical problem of modernism (fig. 9.2). The poster-sized photographic portraits as expressions of outstanding individuality were opposed to the National Socialist claim that it was a disability; the heroic portraits of the great solitary artists were opposed to the National Socialist discrediting of their works.

As if the photographic portraits were supposed to provide evidence that extraordinary persons like the artists of modernity were in fact recognizably humans—newsreels in the cinemas were already beginning to take an interest in apes who painted—the Documenta enthroned the artists of modernism instead of rehabilitating the previously attacked modernism in its entirety. That would have also meant providing a conclusive historical explanation and aesthetic reasons for its relationship to insanity and to primitive art forms, however unpopular they may have turned out to be. Instead the artist encountered us as a hero and thus in a worn-out garment, even if photography lends it the glow of a modern restoration.

The catalog of the first Documenta proves that the strategy of enthroning modernism instead of rehabilitating it was no accident and is not being overinterpreted here. In it there is a small but prominent appendix in which sixteen photographs carry out once again the heroization of the artist. Presented in suits and ties, the futurists as well as Max Beckmann confront the reader in a bourgeois setting that is supposed to counteract any doubts as to the respectability of this artistic existence. It is, moreover, the same attire as that in which the founders of the Documenta present themselves as respectable citizens. Even in the studio shots, in which sweaters and flannel shirts dominate, we encounter staid, serious people whose working conditions are in no way inferior to the orderly surroundings of a tidy cabinet shop. Only the photo of Max Ernst radiates a certain disturbing disorder, but is characterized as a movie still, and Ernst Ludwig Kirchner, the *peintre maudit*, is excused for his unconventional appearance by the fact that he is portrayed during a studio party.[16]

If one accepts what John Berger has written about the meaning of suits in early photographs by August Sander, it sharpens one's view of the supporting role of these respectable articles of clothing, which played such an unmistakable role in the construction of an image for Documenta.[17] What is relevant is not that those artists wore suits, but rather

Fig. 9.2. Back of the entrance hall of the Fridericianum during Documenta I, seen from the staircase: poster wall with photographs of Max Beckmann, Paul Klee, Piet Mondrian, and Oskar Kokoschka and a reproduction of the painting *Eine Künstlergruppe* (A group of artists) by Ernst Ludwig Kirchner.

the question of why this fact was ascribed such a demonstrative signifi-
cance in 1955.

The tendency to interpret the suit as an index of bourgeois respectabil-
ity, even in the case of the artist, had already begun shortly after the war.
In one of the first issues of the journal *Das Kunstwerk*, Alfred Döblin an-
alyzed eight photographs of persons ostensibly unknown to him and
identified them as a bank director, a public prosecutor, a village school-
teacher, a retired tax officer, and a composer from a good family. The
men dressed up in suits and ties are identified by the captions as Max Lie-
bermann, Max Beckmann, Heinrich Zille, Max Slevogt, and Paul Klee.
The only one of them portrayed without suit and tie and with a shirt
open at the collar is characterized as a "partisan" and "fanatic," as a "vi-
olent youth" who would "blow up trains." It was Oskar Kokoschka.
Döblin identified Lovis Corinth as a "robber," not least by inference
from the "white tie and ordinary collar" he wore in his portrait.[18]

This suit of the time, with whose help the one-time author of the pref-
ace to August Sander's *Antlitz der Zeit* (Face of the time) provided re-
spectable vitas for modern artists, stands here as in Documenta I in con-
trast to the white smocks in which National Socialist propaganda
preferred to present its favorite artists in studio shots. But it is also steno-
graphic shorthand for a great coalition of the bourgeoisie reestablished
beyond all parties and everything past. By making one forget the uni-
forms that in the intervening period had stamped the image of Germany,
the civilian "uniform" of the suit creates a continuity between the First
Republic and the Second. For the contemporaries of the first Documenta,
the connection must have been readable, or at least detectable. If one
looks through the photographs that show notables and politicians at the
openings of the first Documentas, this article of clothing is just as prev-
alent as in the self-presentation of the organizers of the Documenta.

But it was more than accommodation when they also extolled it in the
portraits of the artists. One can discern in it a discreet reaction to *uni-
formed national socialism's antibourgeois resentment*, as it had been reflected in
the Degenerate Art exhibition. There many of the exhibits were affixed
with the *price* for which they had most recently been sold. For the con-
temporaries of the exhibition, the so-called *Volksgenossen*, modern art
was thus unmistakably branded as an object of speculation, a luxury
good, the plaything of an irresponsible and wasteful bourgeoisie. The
Documenta answered this attack on the role of the bourgeoisie in up-
holding culture with a discreet but marked *revaluation of the image of bour-*

geois appearance, in which, unfortunately, very differently motivated antibourgeois attitudes of the avant-garde dropped out.

Heroes of the Void

It is historically easy to reconstruct and respect the caution and considerateness with which the organizers of the first Documenta attempted to oblige a public that was still suspected of having a hostile disposition toward modernism. But their concessions came at the cost of presenting modernism only in a conveniently filtered and partial way, and its fragmentary character could be passed over but not made up for by a public success and a glossy setting. The rehabilitation of modernism, even of its antibourgeois affronts, would have been entirely possible within the intellectual horizon of this period if it had only incorporated the experiences and discussions of the 1920s and 1930s and not just the art of those years. If, that is, one poses the question of why artists glimpsed in insanity both an inspiration and an analogy to their own activity, then the answer that imposes itself is that it was artists who vicariously paid the price for the central problem of modernism's worldview. Modernism eventually annulled nearly all traditional values without at the same time giving a new, popular, and comprehensive orientation. In the new historical vacuum of which many modern artists had become aware by reading Nietzsche, an art had to be established that was free to decide for itself *what* it wanted to represent, and *how*. The latitude of extreme freedom was also one of an extremely imperiled individuality. The absence of a task as the mark of autonomous art, and especially of modern art, provoked the search for the *origin* of art. If art no longer had fixed aims, then only the paths to its sources remained open. As the extreme embodiment of an individuality labeled as asocial, the lunatic offered an affinity. The existential directness with which he transposed his onerous fate into barely legible yet fascinating forms must have aroused the envy of artists. For even they had little more than their constantly threatened individuality to make into a theme for art, and in so doing, they exploited day and night both their perceptions and their dreams.

National socialism undertook to replace the lost foundations of meaning in a society completely modernized in the sphere of production with a premodern, agrarian image of an imaginary present. To accomplish this, it *had* to discredit the works of artists on whom had dawned, only a few years before, the great gap of modernism and the absence of foundations of meaning for what was nevertheless a strenuous and wearying

technical everyday world. National socialism, which represented the attempt to superimpose an antimodern ideology over a modern everyday world, profitably seized on the self-proclaimed affinity of artists to the insane as an indication that every other attempt to accommodate oneself to modernism was condemned to this failure. Thus artists were pilloried along with lunatics, and thus the Documenta could have presented them as heroes—not as heroes of the bourgeois class, but as exemplary sufferers, as vicarious explorers of the modern void of meaning.

Discreet Response

The Jewish contribution was so tightly linked to German modernism that it seemed only to confirm the National Socialists in their anti–Semitic interpretation of modernism. Documenta I engaged this contribution cautiously as well. In Dr. Erich Lewinski, the head of the Kassel regional court, the founding society of the Documenta had a vice chairman who demonstrated his readiness to take part in the rebuilding of the cultural politics of the Federal Republic, although along with his own people, many intellectuals and artists had been killed or expelled; they had given German modernism an unmistakable stamp of "Jewish internationalism" and had thus become victims of nationalism. The gaps in the exhibition appeared all the more clearly. Missing were important and renowned German-Jewish artists whose contributions to the art of the twentieth century—the terrain of the first Documenta—would not have precluded their inclusion, which in particular cases would have been imperative: Jankel Adler, Felix Nussbaum, Gert Wollheim, and, above all, Ludwig Meidner and Otto Freundlich. Naturally, Freundlich's sculpture, which had been reproduced on the title page of the guidebook to the Degenerate Art exhibition, was absent. But precisely why the first Documenta thought it could dispense with a work by Freundlich is not something that everyone will be able to reconstruct.

Depoliticization

The antisocialist and anticommunist tendencies that had been unmistakably stamped as "antibolshevik" by the Degenerate Art exhibition remained entirely uncontradicted. In the year 1955, a year before the Communist Party was banned in the Federal Republic and two years after Adenauer's triumphant electoral victory over the Social Democrats, the exclusion of nearly all the politically engaged art of the Weimar Republic

was certainly not surprising, but is nonetheless noteworthy in our context. Aside from Dix, none of the artists who stood for these tendencies in the Weimar Republic was represented: not Grosz, not John Heartfield. Only Grieshaber and Hofer were included as representatives of a younger, politically engaged generation. The exclusion corresponded to a principled depoliticization of the Documenta. National socialism had forced the art it protected as well as that it discredited into a political context. The countermeasure of the Documenta consisted in relieving art of any political context and then understanding this as a liberation.

But it thereby deprived modern art of every historical context that could not be limited to the purely art historical. Such a decision can be understood as an attitude for which Wolfgang Fritz Haug later coined the contentious term "helpless antifascism."[19] The first Documenta made its essential political contribution precisely through its depoliticization of art. The equation of the National Socialist with the Stalinist persecution of art seemed to give it the right to exclude even the socialist art that was not discredited by Stalinism.

Die Kniende (The kneeler)

The only issue on which Documenta I took a decisive stand in relation to the Degenerate Art exhibition was in its acknowledgment of the formal freedom of modern art. As an expression of radical subjectivity, formal freedom had inevitably been a provocation for the National Socialist mentality, which wanted to replace subjective freedom with unconditional obedience and the renunciation of independent thought. As the representative of the entire tradition of subjectivity, modern art was pilloried for its excess, with the purpose of stigmatizing subjectivity in general, even in its deliberately unmentioned liberal and moderate modes. To that extent, the pure form of modern art took on an eminently political signification, independent of its political content or narrative motives. Pure form was interpreted not only as an aesthetic but also as a social deviation—a specifically modern novelty in the history of iconoclasm.

This tendency of National Socialist propaganda was the only one explicitly taken up and contradicted by the early Documentas: by defending the form of modern art, they challenged the Degenerate Art exhibition. Yet their counterargument was poorly defined. By arranging the archaic and primitive works of the photo wall to be seen before the actual exhibition, what they affirmed in modern art was precisely not its radically

subjective character. Rather, they relativized subjectivity by recourse to what seemed formally similar works from cultures and societies that knew nothing of this radicalization of subjectivity, or of subjectivity as even the smallest latitude for freedom and judgment. Such, in any case, is the thesis of a book from which four illustrations were nonetheless taken for the poster wall, Werner Schmalenbach's *Die Kunst Afrikas* (The art of Africa), published in Basel in 1953. Moreover, the unconditional acknowledgment of modern art was an acknowledgment of a specific modern art, whose criteria for the selections for the first Documenta can easily be reconstructed. In spite of such political and artistic gaps, the acknowledgment of the formal freedom of modern art was not unpolitical. It could not be unpolitical after national socialism had made a political issue out of formal freedom, nor should it have been unpolitical. In this regard, however, the Documenta remained once again discreet, although in a monumental way. If, that is, one followed the path further through the propylaea of Documenta I, past the display of the archaic and the portrait wall of the heroes of the bourgeoisie, the next thing one encountered was a sculpture placed in the stairwell as a *monument to German discontinuity* — which many contemporaries must have been able to reconstruct. The visitor saw, as the first artwork displayed in the course of the exhibition, Wilhelm Lehmbruck's *Kneeler.* Hardly any other work by a twentieth century German artist was as qualified as this one to open a counterexhibition to Degenerate Art.

The sculpture dates from 1911, eight years before Lehmbruck committed suicide. It was shown that year in Paris at the Salon d'Automne, a year later at the legendary Cologne Separatist Exhibition, and in 1913 at the Armory Show in New York — all important stages of the international avant-garde. With it, Lehmbruck became internationally reputed, and above all his *Kneeler* stood out as a singular representative of German expressionist sculpture.[70]

It could be said to have maintained this singular significance after his death, when the *Kneeler* became a point around which bourgeois and National Socialist iconoclasm crystallized. In 1927 a bronze cast of the sculpture was displayed in Duisberg. The smear campaign by local and regional groups and newspapers began at once, and already deployed the repertoire of attacks and arguments that the National Socialists were able to make good use of ten years later, when they in turn granted a prominent place to a *Kneeler* in the arrangement of the Degenerate Art exhibition (fig. 9.3). Thus the *Kneeler* was not only probably the first autonomous modern outdoor sculpture on German soil, but also the first to be

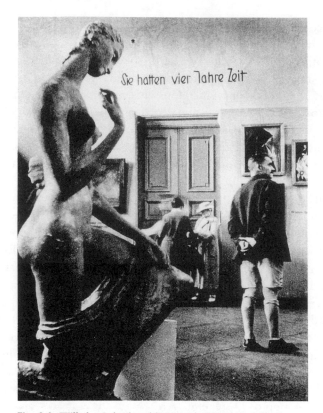

Fig. 9.3. Wilhelm Lehmbruck's *Kniende* (Kneeler) at the Degenerate Art exhibition, Munich, 1937.

upset and damaged.[21] Previously it had visited nearly every national and international exhibition at which the early fame of German modernism manifested itself, and therefore embodied the tragedy of this swiftly arrested awakening more concisely than any other work. By putting this work at the entrance to their exhibition (fig. 9.4), the organizers of Documenta I did a kind of memorial justice to their historical and political task, even if only in memoriam and *pars pro toto*.

Revoking Abstraction

The reduction of modernism summarized here was not maliciously intended, and perhaps not even intentional. The persecutions unleashed by the National Socialists had left its strategists weak in the knees, and so they reacted with caution. They presented modernism in a cleansed ver-

Fig. 9.4. Wilhelm Lehmbruck's *Kniende* (Kneeler) in the stairwell at Documenta I, Kassel, 1955.

sion, so to speak, that counted on the labels "especially valuable" and "children allowed." Perhaps at that time nothing else was possible. But the price paid for this popular version of modernism appears too high in retrospect. The modernism of Documenta I appeared mutilated, as if someone wanted to make a children's book out of a pornographic novel at the price of renouncing its most characteristic passages.

There is a further indication of this fear of telling the people the whole truth. It stems from the context of the Documenta and confirms the suspicion that the disavowal of the central achievements of modern art nei-

ther can nor should be attributed in any way to the personal arbitrariness of the founders of the Documenta. It is a question of the famous comparisons of photographs and modern artworks with which the journal *Magnum* accompanied the second Documenta.[22] In these comparisons, analogies between real, recognizable scenarios and abstract, nonrepresentational artworks were set up with remarkable suggestiveness and admirable care (fig. 9.5). The purpose of the comparison amounted to the visually suggestive thesis that abstract, nonrepresentational art is a sort of modern realism—a thesis then fashionable in many variations. It brought this comparison of images into proximity with the reduced modernity of the Documenta, and accounted for the absence of traditional realist painters, since abstract art now substituted a genuinely contemporary conception of realism for an obsolete notion of realism. Such a comparison cleverly snatched away the argument from a viewer who wanted to hold onto traditional notions of realism.

That may have been well intended, and it was certainly well done, but it represented nothing less than the complete negation of everything that abstract art had ever been, namely, anything but realistic, expressly because such pictures were not only painted but also in part theorized by their authors, not least by Kandinsky. Even in thus "revoking abstraction," which is brought home to the visual habits of everyday life, the principle of the Documenta dominates: to propagate modernism on hostile ground in Germany at the cost of rendering harmless its central motives and achievements—a form of *preservation through abandonment*.

All in all, in retrospect one must not only attest to the understandable caution of the Documenta's organizers, who did not want simply to blurt things out. One must also express the suspicion that they wanted to make modernism, which was radical, abyssal, dissonant, difficult, and abject, into an opportunity for a set of unfounded postures, and that for the sake of such gratification they neatly removed and cast aside the indigestible portions of the original problematic.

Individual Mythologies

The Documentas that followed did not undo the reduction of modernism. Documenta I, as the first postwar synopsis of modernism, was thus able to establish its image of modernism as the authoritative model in the Federal Republic. Its uninvestigated influence may have reached as far as the purchasing policies of the museums and the exhibition policies of the art societies; it took the latter nearly twenty years to complete and revise,

Fig. 9.5. Facing pages from "Documenta der Kunst—Documenta des Lebens," *Magnum*, no. 24 (June 1959): *left*, Wassily Kandinsky, watercolor, 1925; *right*, *Honest John*, U.S. Army rocket.

gradually, unspectacularly, and fragmentarily, the full image of modernism.[23]

It was therefore not until Documenta 5, in 1972, that a radical break was made in this tradition of false continuities, in order to take up the buried continuities. No wonder it was reproached as degenerate art. Its section "Imagery by Lunatics" exhibited no one less than the same Adolf Wölfli who had been the subject of the first publication that had maneuvered artists onto that fateful track at the beginning of the symbiosis of art and madness. At the same time, its director, Harald Szeemann, with the catchphrase "Individual Mythologies," provided the category under which many, if not most, of the previously disparate modernists could be classified. If Werner Haftmann and Willi Baumeister had never managed to refute the *respectable* version of antimodernism, Hans Sedlmayer's malicious book *Verlust der Mitte* (The loss of the center), then this phrase offered language in which to rally a promising counterstrike to what had seemed up to then to justify Sedlmayer's thesis of decline. Only a few formulations in modern art studies have succeeded in conceptualizing its object, modern art, so appropriately.

Aside from Kandinsky's distinction between the Great Real and the Great Abstract (atypically liberal for an artist), one could mention Benjamin H. D. Buchloh's addendum of the Great Trivial, which is to be taken seriously, even if it was perhaps not entirely intended to be. Meant for Polke, it still awaited its application to pop art and photorealism, and all the more to the so-called Neue Wilden or "new vehemence" painters of the 1980s. Such categorical classifications have a much greater importance for the understanding of modern art than all the stylizations of modernism that have come into contemporary discourse as "isms." Of the categorical classifications, that of "Individual Mythologies" possesses the highest rank and the greatest range. It gathers with dignity what was defamed and stigmatized, and maintains, in the paradox of its formulation, an incomparable proximity to its object. For most of modern art, its ostracized part, it provides a comprehensive concept, as if all at once the magnetic field within which all the individual bits had previously seemed to organize themselves so bizarrely and willfully were indicated. The concept reached well beyond the artists displayed under it; above all, it reached back into the history of modern art and finally gave it in general a recognizable shape, to the extent that its primitivist tendencies appear as a paradox of modernism, without distilling a different myth of the twentieth century.

With Documenta 5, the repressed exhibition of Degenerate Art found its long-overdue answer.

Downgraded Design

If one understands the Degenerate Art exhibition and the polemic against modern art as a parade ground of National Socialist propaganda, then one of the fateful consequences of this attack is that it only applied to art. That would be fateful for modern design, which was no less ruthlessly persecuted and expatriated by the National Socialists, but which, since there was no "degenerate design" exhibition, enjoyed no demonstrative rehabilitation. The first Documenta failed spectacularly here. Within the framework of its postwar synopsis, its neglect of design and the applied arts ignored a central impulse of modernism, which it should have excluded all the less from its panorama of the twentieth century because its first three decades were molded by the typical modern opening of art to previously lost and newly emergent possibilities of application. Artists engaged in such work were shown at the first Documenta only with their "autonomous" works (Baumeister, Marcks, Schlemmer, Schwitters), but most, especially the constructivists, were considered neither artists nor designers. Bode detracted unnecessarily from his reputation as a grandiose designer of exhibitions by withholding from the visitors such design artists as El Lissitsky, whose early experiments in exhibition must have inspired him.

Leaving out design in this case was fateful, for it colluded with a general devaluation of design, even if it did not shape it initially. Unfortunately, the exhibitions of the Recklinghausen Ruhr festivals also gave up in the 1950s the task of integrating art and design, just as opportunities to challenge the Documenta over the long term with differently conceived exhibitions were in general thrown away early on. After the first attempts in this direction, the exhibitions Mensch und Form unserer Zeit (Human and form in our time) in 1952 and Schönheit aus der Hand, Schönheit aus der Maschine (Beauty by hand, beauty by machine) in 1958, both noteworthy though nearly forgotten today, the cultural politics of the trade unions and the Socialist Party, which entirely lacked a conception in any case, succumbed to the discreet charm of the bourgeoisie and rushed to catch up in the field of art exhibitions rather than steering in the other direction.

The Documenta's omissions were avenged nowhere more spectacularly than in its own showplace, the Fridericianum, which was rebuilt at

the end of the 1970s with nothing but a backdoor servants' entrance for designers. Today the building bears in many of its details the anonymous signature of a "modern" style now discredited as "airport design," which clearly inscribes the low status of the applied arts on the scene of a portentously "autonomous" art.

But the relationship of the Documenta to architecture and design remained above all the Achilles heel of its conception, for the gap opened when the first Documenta, voluntarily or not, refuted "Degenerate Art" by taking over its reduction of modern art to the "autonomous" was never closed. In 1955, it showed nothing beyond art except a small photo documentary, Architecture from 1905 to 1955. In 1964, what was then the Kassel Industrial Arts School contributed parallel exhibitions in its own spaces, one entitled Industrial Design and the Other Graphics, which Bode may well have considered as trial balloons for correcting the Documenta's conception, although his announced plan to make architecture the center of the fourth Documenta went unrealized.[24] The fifth Documenta showed the shadow world of design in trivial iconography together with a small section called Utopia and Planning; at the sixth, the Utopian Design section was rather a fragmentary view of art and technology. The seventh pathetically elevated the initial concept of autonomous art, and the eighth finally supplemented art with current show design in the framework of its thesis of the intermingling of the arts. At no Documenta was the basic concept revised; as a whole, it failed to rehabilitate the excommunicated modernists who had stood for the early *social* (and often, however dimly, socialist-inspired) "total artwork of modernism," whether in the tradition of the *Werkbund* or the *Bauhaus*, the schools of industrial arts or an art understood operatively.

In the context of this development, the image of modern art had changed so decisively that even the form of the "pure" art exhibition had been sporadically sacrificed. Unaffected, the Documenta returned to this conception of exhibition, which had been the model for premodernism. That recourse was unfortunately *not* conservative; rather, the Documenta failed at its own task of conservation: the necessity of saving modernism from being forgotten. The model of reception offered by Documenta I for the reconstruction of modern art had the character of a well-meaning falsification of modernism that attempted to oblige popular reservations by endeavoring to round off the corners and edges of the problematic modernists. It turned modernism into just another "ism," one merely declaimed rather than legitimated and preserved in its full range. It thereby participated early on in an inconspicuous transformation of mod-

ernism into an "ism," which encouraged the emergence of a postmodernism that to a considerable degree is also just another "ism."

This reduction of modernism took place *not* as a revision, which would have presupposed the presentation of the rejected aspects of modernism, at least in the spheres of its discussion and legitimation. Since that did not take place and everyone relied on the flashy setting, one must consider the first Documenta as the scene of an *abortive appropriation* of modernism. Thus, in Germany and more precisely in Kassel, the ratification of postmodernism at the eighth Documenta looked especially peculiar, for the Documenta had never succeeded in becoming the recuperative forum for all of modernism, which had been arrested early, destroyed, then only appreciated in highly fragmented form, and therefore really continued to serve as only a prospectus to itself.

The Leveling of Photography

What was true of design also applied to photography. As a typical genre of modernism, it was not allowed to appear on the same level as painting and sculpture, but was put into the service of mediating them. Just like design, it had to divert attention from its own historicity and its specific artistic devices onto the artwork it presented. Thus a photo panel stood at the beginning of Documenta I, but photography did not itself appear in the exhibition as a new art form of modernism. It was not until the fifth Documenta that it could enter the Fridericianum as an art form, though, in contrast to design, it was fully rehabilitated at the sixth Documenta in 1977.

If Documenta I did not respect photography as art, it did make demonstrative use of it. To many observers of the photo panel in the lobby and the photographs of artists, it must have been clear at once which original vilification the photo walls were supposed to respond to. Since 1928, Paul Schultze-Naumberg's pamphlet *Art and Race* had offered a comparison of physiognomic and bodily deformities with modern portraits and representations of nudes, a confrontation of modern artworks and instinctively repulsive deformations that is still shocking today (fig. 9.6). It functions so suggestively only because photography constitutes the technical and medial *tertium comparationis* of the comparison. By putting photographs of paintings next to photographs of the sick, reproduced in each case in the same dimensions and classified, the fact that image and reality were being confused could be concealed. This leveling by photography helped to repress the typically modern claim of painting to create a por-

Fig. 9.6. Facing pages from Paul Schultze-Naumberg's *Kunst und Rasse* (Art and race), third expanded edition, 1938: comparison of works by, among others, Modigliani and Schmidt-Rottluf with photographs showing "physical and mental handicaps."

tion of its own reality according to autonomous laws, by bringing paintings and illnesses down to the same level of reality as a photodocument. That was 1928 — the same year that Paul Valéry in "La Conquête de l'Ubiquité" discussed the reproducibility of artworks through modern media for the first time, and eight years before André Malraux read Walter Benjamin's essay on the same subject and incorporated it into the conception of his *musée imaginaire* — and was thus not only a perfidious attack, but also an astonishing anticipation. In Schultze-Naumberg's confrontations, the caricature of the imaginary museum appears *avant la lettre*. He successfully factored into the comparison of image and reality the same effect that Malraux hoped for in the immanent art comparison, pointing up stylistic features that should be promoted by photographic leveling independently of material, size, dimension, and handling of the works. What Malraux wanted to use for the study of style, Schultze-Naumberg used for the general denunciation of the stylization in which modern painting had found its subject matter after photography had badly shaken its mimetic relation to reality. This historically confounded relation between modern painting and photography was suppressed by Schultze-Naumberg, in order to make photography deal a deadly blow to modern painting. Its seeming authenticity downgraded the painting into a corpus delecti, and its leveling was completed as an intellectual act of violence for which photography created a delusive surface of plausibility and vividness.

The photo wall of the first Documenta was directed against such a transmogrification of the modern concept of the image. It posited the thesis of the autonomy of art in opposition to Schultze Naumberg's flagrant use of photographic leveling to infringe the boundary between image and reality. The works of the photo panel stood for the claim that art arises from art and can only be compared and related to it. In opposition to his denunciation, it posited the *universality of stylization*, a corroboration of the basic thesis of Malraux's imaginary museum, itself indebted to another photographic leveling: *the effacing of cultural differences* that the museum had already prepared in advance. The photography of the imaginary museum denied the boundaries between art, ethnology, and archaeology still valid in the essence of the real museum, in order to equate photographically the objects dispersed there *as artworks*. Photography, which remained banned as an art from Documenta I, nevertheless authoritatively stamped its artistic concept, underneath the threshold of perception, but in a complex grip. The One Hundred Day Museum, as it was only called later, was ideologically based on the artistic concept of the

imaginary museum, itself indebted to the visual leveling of photography, its indifferent, unhistorical, and dull *exaggeration of the similar*. Photography cemented this notion at the cost of not participating in the autonomy of art.

In contrast, on the occasion of Documenta II, the series of images in the journal *Magnum* represented a relapse into Schultze-Naumberg's strategy, although with reversed premises. If Schultze-Naumberg had polemically played reality against the stylization of art, then in the *Magnum* images, abstraction was rehabilitated by the citation of reality. But even the rehabilitation functioned only through the suppression of the difference between image and reality. An abstract painting by Wols, held at the right distance from a cloud emanating from the explosion of an atomic bomb, looks just like an abstract *image* of a mushroom cloud (fig. 9.7). One can make the connection in a flash, but only by means of the photographic comparison: the abstract painting can look like the representation of an atomic bomb's emanation because its character as an image is masked and the autonomous artistic concept is subverted. Nearly all the comparisons of this seductive series use such artistic devices of photography in order to create similarities wherever differences prevail (fig. 9.8). Only when photographed with a telephoto lens is the image of a city so abstractly and ornamentally foreshortened that it can be offered as the legitimation of an abstract painting. Only by means of photographic cropping can a section of a painting be made comparable to a portion of reality. This series, even if it champions modern painting, shares the central weakness of Schultze-Naumberg's comparison; it attacks him only with his own weapons.

Translated by Michael Shae

Fig. 9.7. Facing pages from "Documenta der Kunst—Documenta des Lebens," *Magnum*, no. 24 (June 1959): *left*, photograph of a mushroom cloud; *right*, Wols, oil, 1946.

Fig. 9.8. Facing pages from "Documenta der Kunst—Documenta des Lebens," *Magnum*, no. 24 (June 1959): *left*, photograph; *right*, Wols, *Composition No. 10*, gouache.

Notes

This essay was originally published, without the introduction, in Walter Grasskamp, *Die unbewältigte Moderne: Kunst und Öffentlichkeit* (Unmastered modernism: Art and the public) (Munich, 1989), pp. 77-119.

1. The following are the most significant publications concerning Documenta and its history: Dieter Westecker, ed., *documenta-Dokumente 1955-1968: Vier internationale Ausstellungen moderner Kunst; Texte und Fotografien* (Kassel, 1972); Walter Grasskamp, ed., "Mythos documenta: Ein Bilderbuch zur Kunstgeschichte," *Kunstforum International* 49 (Cologne, 1982); Manfred Schneckenburger, ed., *documenta: Idee und Institution. Tendenzen, Konzepte, Materialien* (Munich, 1983); Volker Rattemeyer, ed., *documenta: trendmaker im internationalen Kunstbetrieb?* (Kassel o.J., 1984); Harald Kimpel, "Künstliche Beatmung von Begriffsleichen: Zur Situation der neueren documenta-Geschichtsschreibung," in *Informationen* (Kassel, 1985), pp. 14-15; Manfred Schneckenburger, "Ein deutsches Ausstellungswunder und die deutsche Kunst," in *1945-1985: Kunst in der Bundesrepublik Deutschland*, exhibition catalog, Nationalgalerie Berlin (West), 1985, pp. 683-87; Walter Grasskamp, "Hans Haacke— Sommer 1959," in his *Der vergessliche Engel: Künstlerportraits für Fortgeschrittene* (Munich, 1986), pp. 157-75; Harald Kimpel, Aggregatzustände des Musentempels, "Die Dauerauseinandersetzung der documenta mit dem Museum," in *Anstösse*, Zeitschrift der Ev. Akademie Hofgeismar 4 (1987): pp. 146-56; Volker Rattemeyer and Renate Petzinger, "Pars pro toto: Die Geschichte der documenta am Beispiel des Treppenhauses des Fridericianums," *Kunstforum* 90 (1987): pp. 334-57; Eberhard Roters, "Ausstellungen, die Epoche machten," in *Stationen der Moderne: Die bedeutenden Kunstausstellungen des 20. Jahrhunderts in Deutschland*. Katalog Berlinische Galerie (1988): pp. 15-24; Uwe M. Schneede, "Autonomie und Eingriff—Ausstellungen als Politikum. Sieben Fälle," in *Stationen der Moderne*, pp. 34-42; Kurt Winkler, "II. documenta '59—Kunst nach 1945, Kassel 1959," in *Stationen der Moderne*, pp. 426-73.

2. A contemporary reconstruction of Documenta I can be found in my article in *Die Kunst der Ausstellungen. Eine Dokumentation dreissig exemplarischer Kunstausstellungen dieses Jahrhunderts* (Frankfurt [Main]/Leipzig, 1991), pp. 116-25.

3. Werner Heldt, opening speech in Galerie Gerd Rosen, cited in Wieland Schmied, *Werner Heldt* (Cologne, 1976), p. 90.

4. Compare Eduard Trier's "Was Max Ernst studiert hat" with Klemens Dieckhöfer's "Max Ernst und seine Begegnung mit Medizin und Psychologie," both in *Max Ernst in Cologne: Die rheinische Kunstszene bis 1922*, ed. Wulf Herzogenrath (Cologne, 1980).

5. Wulf Herzogenrath, "Max Ernst in Cologne—d'Adamax und die Dilettanten," in Herzogenrath, ed., *Max Ernst in Cologne*, 8-16, p. 14.

6. See Walter Grasskamp, "Sigmar Polke—Erleuchtung in der Dunkelkammer," in my *Der vergessliche Engel*, pp. 75-85.

7. Ingeborg Weber-Kellermann, *Die Kindheit: Eine Kulturgeschichte* (Frankfurt/Main, 1979); *Die gesellschaftliche Wirklichkeit der Kinder in der bildenden Kunst*, exhibition catalog, Neuen Gesellschaft für Bildende Kunst (Berlin, 1979). It would seem that the influence of Julius Langbehn's *Rembrandt als Erzieher* (1890) antimodernist attitude toward children and childhood on the modern reception of children's drawings in relation to modern art has yet to be charted.

8. Wassily Kandinsky and Franz Marc, eds., *Der Blaue Reiter. Dokumentarische Neuausgabe von Klaus Lankheit* (Munich, 1984).

9. Georg Bussmann, " 'Entartete Kunst'—Blick auf einen nützlichen Mythos," in *Deutsche Kunst im 20. Jahrhundert: Malerei und Plastik 1905-1985*, ed. Joachimides et al. (Munich, 1985), pp. 105-13.

10. *Information 1, II. documenta '59*. Eight-page brochure accompanying the *Magnum Zeitschrift*. The photograph is also to be found in the Göppinger Plastics brochure on inte-

rior decoration materials in the "Documenta" (Kassel, 1955), Göppinger Galerie publs., vol. 1 (Frankfurt/Main 1955). Sources for these photographs and wall posters: Werner Schmalenbach, *Die Kunst Afrikas* (Basel, 1953), 4 illustrations, and André Malraux, *Psychologie der Kunst: Die künstlerische Gestaltung* (Baden-Baden, 1949), 1 illustration. Additional recognizable illustrations show medieval sculpture, probably a royal devotional image from a choir stall as well as an Etruscan, probably Greek-Archaic, sculpture. Other illustrations could be Sumerian-Assyrian sculptures and reliefs as well as a monument from the Easter Islands.

11. Johann Frerking, "Documenta," in *Hannoversche Presse*, July 23, 1955.

12. Ludwig Goldscheider, *5000 Jahre Moderner Kunst oder: Das Bilderbuch des Königs Salomo: Kunst der Gegenwart und Kunst der Vergangenzeit in Gegenüberstellungen* (London, 1952). An earlier version of this book was published by Phaidon in Vienna under the title *Timeless Art* in 1934.

13. Personal communication with Harald Kimpel.

14. Illustrated in *Lyonel Feininger, Karikaturen, Comic strips, Illustrationen*, exhibition catalog, Museum für Kunst und Gewerbe (Hamburg, 1981), p. 39.

15. *Ägyptische und moderne Skulptur: Aufbruch und Dauer.* Ausstellungskatalog Museum Morsbroich (Leverkusen, 1986).

16. *Katalog der documenta I* (Munich, 1955). In the catalog of the 1980 Munich Kirchner retrospective this photo appears with the caption "Ernst Ludwig Kirchner at 'In den Lärchen' House looking at dancing peasant figures around 1919-1920." Similarly, the caption for the Max Ernst photo is unclear. The film by Hans Richter quoted as *Not For Sale* should probably be his film *Dreams That Money Can Buy*.

17. John Berger, "Der Anzug und die Photographie," in his *Das Leben der Bilder oder die Kunst des Sehens* (Berlin, 1981), pp. 27-34.

18. Alfred Döblin: "Fotos ohne Unterschrift," in *Das Kunstwerk* 1, no. 12 (1946/47): pp. 24-33. I would like to thank Günter Drebusch in Witten for this information.

19. Wolfgang Fritz Haug, *Der hilflose Antifaschismus* (Frankfurt/Main, 1967).

20. Eduard Trier, *Wilhelm Lehmbruck: Die Kniende* (Stuttgart, 1966); *Wilhelm Lehmbruck: Katalog der Sammlung des Wilhelm-Lehmbruck-Museums der Stadt Duisburg* (Recklinghausen, 1981); Reinhold Hohl, "Wilhelm Lehmbruck: Ein deutsches Schutzgebiet," in Joachimides et al., *Deutsche Kunst*, pp. 434-35.

21. Siegfried Salzmann, *Hinweg mit der "Knienden": Ein Beitrag zur Geschichte des Kunstskandals* (Duisburg, 1981).

22. "Documenta der Kunst—Documenta des Lebens: Die moderne Kunst ist realistisch," *Magnum. Die Zeitschrift für das moderne Leben*, no. 24, (June 1959): pp. 6-48.

23. Compare the author's essay "Rekonstruktion und Revision: Die Kunstvereine nach 1945," in Grasskamp, *Die unbewältige Moderne*, pp. 120-32.

24. Overall, Bode pleaded for including applied arts from the very beginning. An earlier concept of Documenta I under his guidance had sections called "Industrial (Design) Reform" and "Homes" (documenta-archiv, Kassel).

Part III

Spectacles

10

The Times and Spaces of History: Representation, Assyria, and the British Museum

Frederick N. Bohrer

> History is the subject of a structure whose site is not homogeneous, empty time, but time filled by the presence of the now.
>
> Walter Benjamin, *Theses on the Philosophy of History*

> Its past was a souvenir.
>
> Wallace Stevens, "Of Modern Poetry"

The student of exoticism must necessarily be a connoisseur of discontinuity. That is, he or she must be concerned with the varieties of an inchoate elsewhere, an array whose only real common denominator is the lack of a common denominator. Whether it is termed the exotic or the Other or the primitive, it can hardly be a purely neutral or objective statement to define something merely as being not like us, rather than describing what it *is* like. This commonality of absence, a negative, dialectical contrast with the civilized West, is the trace of the perpetual connection in exoticism between defining the subject and judging it, for by our constructions of the Other we implicitly define and judge ourselves. Indeed, the recent reawakening of interest in artistic exoticism[1] may well be related to the current broader questioning of traditional modes for the analysis of representation and the search for epistemological alternatives.

In its own way, this essay is a study in exoticism, but in the larger sense broached above. I will be concerned with exoticism not only as a class of objects, but also as a process of representation. Specifically, I want to consider briefly some aspects of the institutional and representational fortunes of a notable class of exotic objects, a collection of ancient Assyrian artifacts established at the British Museum in the years around 1850. I will focus on the varied construals of the artifacts, as well as the social and institutional loci under which their representation took place. To begin,

though, we must first anchor this analysis among some related theoretical issues, for to establish this as a case study in artistic exoticism will require an explicit orientation in art historical method, the analysis of museums, and the nature of exoticism itself.

In contemporary art historiography, a common device for treating disparate things is the trope of "dialogue." The term almost invariably denotes artistic influence or confluence.[2] We might conventionally invoke such a dialogue, and thus purport to measure museum objects' influences, in considering the variety of maxims and motifs in Western art related to that of the ancient Near East.[3]

The notion of "dialogue" provides a framework that lends full integrity to both parties, viewer and thing viewed. Yet, in a broader view, surely the relation between museum object and viewer suggests not a dialogue of equal volition so much as an interrogation—a forced, often tendentious meeting in which certain priorities clearly dominate.[4] For the mute, passive object lies under the active, controlling gaze of the viewer, and under the ideological protocols of the institution arranging the viewing. Moreover, both display and viewer are themselves constructs. Both displayer and viewer are tied to specific constituencies and function within them. A full analysis of any artistic "dialogue" or "influence" must then delve as well into issues of class and politics, here, notably, of agencies and audiences of reception and circulation. Where do such groups derive their power? How do they define and maintain themselves?

While such a conception may be relatively widely applicable, it becomes paramount in the treatment of exoticism, wherein the distance is greatest between contexts of production and reception, and artifacts are thus most vulnerable to recontextualization. Moreover, these priorities of presentation are important not only in themselves, but also as a precedent to further circulation. For the museum serves not only as a site of presentation but also as a dominant threshold of re-presentation—as practiced in painting and sculpture as well as a host of other media, such as panoramas, book and magazine illustrations, film, and theatrical representation.

From this standpoint, antiquity clearly emerges as another field of exoticism, another re-presentation in the modern West of a site of cultural difference. Moreover, Assyrian and other nonclassical antiquities (the term is as exemplary as exoticism itself, a commonality defined only by lack) embody particularly the tenets of the exotic. For the more strongly

we cling to the Greco-Roman tradition as that of our distant forebears, the more we delimit other antique cultures as foreign.[5]

The crux of this connection between antiquity and exoticism is that, from the standpoint of the beholder, geographical and temporal distance might be taken as virtually interchangeable. An image of an ancient Celtic rite could be deemed exotic in nineteenth-century Britain as easily as one of contemporary Africa. While rarely considered analytically, such an equation of modes of distance is hardly novel in artistic evaluation. The aesthetic "grand tour" on which we are led by art museums of the survey type has long been organized to span both a historical and a geographical range of production.[6]

Both temporal and spatial distance present challenges to the sufficiency of physical presence on which our concept of visual communication depends. "Presence" here might be taken as a genre of the linguistic/epistemological theme of which literary deconstruction is a critique. Presence is the very basis of the visual dialogue I have mentioned. The museum's very assembly ostensibly offers just what presence pretends, namely, as Christopher Norris describes it, "a God's eye view that would finally transcend all mere relativities of time and place."[7]

But the construal of *visual* presence deserves attention in its own right. More specifically, temporal and spatial distance are forms of absence, for which the presentness of the artifact itself must compensate. Yet such immediacy is no guarantee of lucidity. Museums have their own integral unities, their own strategies of presence. Among those in the nineteenth century in which antiquities played a major part, the differences are striking. Today, one might think of the natural history museum or the "museum of mankind," in whose synecdochic scope an artifact serves as a cloudy threshold on a foreign culture, a part of a whole.[8] Yet the didactic, often evolutionary, schema stressed in ethnography museums evolved rather later in the nineteenth century, after the abrupt arrival of the Assyrian objects.[9] By contrast, a system geared toward aesthetic valorization was well established throughout the nineteenth century: the largely metonymic and substitutive realm of art museums, in which objects took roles in a Western system of values.

How the museum organizes its artifacts, the strategy of presence it adopts, is a clue to the kind of distance it seeks to bridge. This, in turn, is related to the expectations of its perceived audience. Temporal and spatial distancing are related but distinct processes in nineteenth-century exoticism. While few Western travelers in Oriental lands questioned their geographical coordinates and distance from the West, many reveled in col-

lapsing history in their new locales, as if they were on vacation from the temporal determinacy of Western Europe.

Thus Lucie Duff-Gordon's impression of Egypt in the 1860s was of an intricately layered field of historical referents. "This country," she wrote, "is a palimpsest, in which the Bible is written over Herodotus, and the Koran over that. In the towns the Koran is most visible, in the country Herodotus."[10] In the preceding decade, which also saw the enshrinement of Assyrian artifacts in major museum installations in London and Paris, Théophile Gautier used antiquities to identify contemporaneous inhabit-ants of the land, asserting that "Les Fellahs et les Cophtes n'ont pas varié depuis Möise; tels on les voit sur les fresques des palais ou des tombeaux d'Aménoteph, de Toutmès et de Sesourtasen, tels ils sont encore aujourd-'hui [The Fellahs and Copts have not changed since the time of Moses; such as you see them on the frescoes of the palaces or tombs of Amen-hotep, Thutmose and Sesostris, such are they today]."[11] In both cases, while spatial distance from the contemporary West is clear, the temporal description is marked by a more radical collapse of scale. East may never meet West, but in exoticist locales the present is invariably mingled and interdependent with the past.

Thus, extensions in time and space are anything but strictly homolo-gous. Schematically put, the modern Western conception of time pre-sents a linear, directed, hierarchical system of extent that is largely inter-nalized. By contrast, spatial extension is a homogeneous, omnidirectional system in which measurements are far easier to represent, compare, and communicate to a wider audience.[12] It is surely symptomatic of this differ-ence, among other factors, that contemporary art history devotes much more study to the spatially than to the temporally exotic.

Awareness of such varieties of distance and display offers a matrix for relating different representations and interpretations. Such an approach is particularly appropriate for an institution such as the British Museum. As a repository of recognized artworks as well as antiquarian and ethno-graphic artifacts, from both past and contemporary cultures, it supported a vast, confused array of modes of display. Moreover, Assyrian artifacts ap-peared virtually sui generis compared to other antiquities, and thus could be especially prone to migrate among evaluative possibilities. As we move from taxonomy to narrative, in the constitution of Assyria as it negotiated a complex series of material and ideological thresholds, we shall glimpse not only a series of positions in the interpretation of Assyria, but also something of the institutional, ideological, and even contingent forces that shaped them.

The first material remains of any consequence to be extracted from Me-
sopotamia were the products of the discoveries of a Frenchman and an
Englishman, Paul–Émile Botta and Austen Henry Layard, in the 1840s.[13]
Both men were affiliated, in different ways, with their governments' for-
eign services and drew support from national sources. Moreover, both
were directed from early on by the officials of central national museums,
the Louvre and the British Museum. By the end of 1847, both museums
had begun to display the artifacts thus acquired.

The very decision to display the objects is the start of their reception,
and it says much about institutional priorities at the time. While the his-
tory of the Louvre installation and its public reception was complicated
by the vast political and cultural changes ushered in by the revolution of
1848, the English situation was strikingly coherent.

The British Museum in the 1840s was an Enlightenment institution in
a post-Enlightenment world. It had been developed in the later eigh-
teenth century as a center for the increase and diffusion of knowledge.
Through unstinting governmental support and a series of remarkable
acquisitions—among them the library of John Cotton, William Hamil-
ton's antique vase collection, and the Elgin marbles—it had acquired, by
the early nineteenth century, nearly unparalleled prestige in Europe and
the world.[14]

But the social consensus that had made the British Museum a uniquely
successful institution was dissolving in social and political conflict.
Among the characteristic changes of the 1830s and 1840s was the rise to
political prominence of burgeoning middle- and lower-class constituen-
cies. Especially notable here is the passage of the Voting Rights Act of
1832, which enfranchised groups geographically and culturally distant
from the British Museum's traditional sphere of influence. The museum
was legally beholden to Parliament for its funding and its policies, and
the new Parliamentarians were anything but pleased with this dominant
cultural institution. The sum of their critique was that the museum
served as a private lounging place for the rich and was practically impen-
etrable to the newly enfranchised public.[15] Indeed, gaining admission to
the British Museum was a complex, inconvenient, and intimidating pro-
cedure, after which one would be led on a curt summary tour through
masses of unlabeled objects.[16] The requirements for admission and tours
were progressively loosened, though this did not fully alleviate the situ-
ation or change the essential attitude of the museum's administrators.

Thus, on the day after Christmas (Boxing Day) of 1846, as widely re-
ported in the press, nearly 20,000 "well-dressed mechanics" (as the

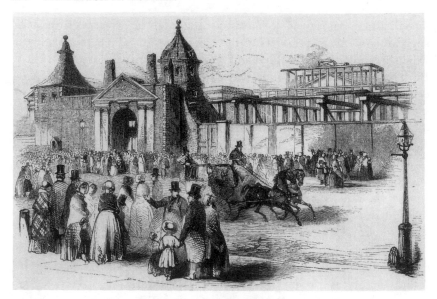

Fig. 10.1. "The British Museum on a British Holiday," *Howitt's Journal*, January 16, 1847. Courtesy of the Trustees of the British Museum.

Times described them) turned out on this rare day of leisure to view the collections.[17] The vast majority were turned away. There was still a quota for tours to the general public. This incident was seized upon and fixed in print by one of the many magazines that had sprung up to serve and construe the lower classes. *Howitt's Journal* was founded by two writers of inspirational and instructional material for the working classes, William and Mary Howitt.[18] The key piece in their first issue was an acerbic tirade by W. J. Fox, a renowned orator who had migrated from the Unitarian movement to the Radical drive for secular education and working-class rights. Fox seized upon this incident as exemplary:

> Our rulers do not know the people. They only regard the masses as a
> half-washed swinish multitude. They fear to trust them and do so very
> much to make them not trust-worthy. They anticipate a multiplication of
> statues with noses broken off, pictures with eyes scratched out and unique
> vases smashed to atoms.[19]

Characteristically, much of Fox's protest was codified in visual form. It was accompanied by an engraving (fig. 10.1) showing large crowds of family groups waiting in line at the gate of the British Museum (then in the process of being transformed into the vast structure it presently inhabits). The static, lower-class family groups contrast with the mobile,

well-to-do single man who surveys the scene from the back of a private coach. Here, then, is part of a continuing collision of constituencies and debate on the proprietary nature of the museum's activities. It also sets the stage for the entry of Layard's objects into the collection, which began about three months later.

Having glimpsed the museum from outside, let us continue the story by following the Assyrian finds into the building. The privileged threshold of representation that was the British Museum actually served as site and sum of a variety of practical and intellectual filters through which objects were displayed. Overall, the treatment of the Assyrian objects appears to have been the beneficiary (or victim) of several not completely compatible claims to importance, significant but not precisely compelling by the museum's standards. For the Assyrian objects were recommended as an antiquarian concern in addition to as a national prize. They were something between a proper object of study, a trophy, and a curiosity.

To Stratford Canning, the British ambassador in Constantinople, who had supported Layard's initial excavations and first recommended him to the British Museum, the works were a way to outdo the slightly earlier French success. As he wrote to Sir Robert Peel, "M. Botta's success at Nineveh has induced me to adventure in the same lottery, and my ticket has turned up a prize . . . there is much reason to hope that Montague House [the British Museum] will beat the Louvre hollow."[20] Henry Creswicke Rawlinson, one of the decipherers of the mysterious cuneiform writing on the objects, who vouched on scholarly grounds for the worth of the Assyrian objects to the British Museum, seconded Canning's national interests.[21]

Yet while the museum was clearly open to enshrining these achievements, no apparent preparations for permanently housing the Assyrian artifacts themselves had been made before the arrival of the first cache.[22] The British Museum first presented them to visitors only in the one space of vast scope and tiny dimension whose title was no more specific than that of the department that managed the finds: the gallery described in the British Museum *Synopsis* (the basic visitor's guidebook) only as the Antiquities Gallery. In fact, in 1850, parliamentary commissioners did not recognize this as a gallery at all; it was seen as merely a decorated corridor.[23] Compared to the galleries devoted solely to such variously determinate collections as those of Greek vases, the Elgin marbles, or antiquities from Phigaleia, the Assyrian artifacts had odd company indeed. The Antiquities Gallery was filled helter-skelter mostly with bits of

Greek and Roman sculpture from miscellaneous collections.[24] It also contained an assemblage of "British antiquities" consisting mostly of supposed Roman and Norman remains discovered throughout Great Britain and donated by sundry clergymen, members of Parliament, and aristocrats.[25] The Assyrian artifacts chosen for this display were the ones that could be most easily explicated. The *Synopsis* describes the Assyrian objects displayed as reliefs, mainly scenes of military attack or hunting or courtly life, and thus artifacts in which mimetic and narrative values appeared to dominate. The *Synopsis* mentions also that the reliefs were part of a palace decoration scheme in which a continuing band of a cuneiform inscription was just as important—which only highlights the fact that such inscriptions were nowhere actually displayed.

By the middle of 1849, after more than a year of continual enrichment of the Assyrian collections, a larger and somewhat more homogeneous arrangement evolved in the form of the Nimrud Room, actually an empty area of the basement, traversed only by a temporary wooden staircase entered just beyond the Antiquities Gallery. Layard's finds thus came to stand, though just barely, beyond the transition from the eclectic milieu of the Antiquities Gallery into the more determinate and rarefied realm of the specified antiquities collections. Still, the interpretive treatment of these works in the *Synopsis* was hardly changed from the earlier summary presentation.[26] The works were still essentially a curiosity in the British Museum, if not actually a burden.

In 1853, when the Assyrian collections were installed in rooms specifically designed for them, they bore a more obvious interpretive relation to the other antiquities collections. Still, the solution ultimately found for them reconciled public prominence and official resignation about housing the objects. Indeed, one of the most prominent of the trustees, William Hamilton, actually deemed the objects "a parcel of rubbish" and wished them "at the bottom of the sea."[27] Similar testimony can be adduced for the even more influential, and irregular, Richard Westmacott, who as "sculpture adviser" was the only nontrustee allowed in trustees' meetings.[28] The impetus for presenting the objects in more coherent surroundings came not from the museum's officers or trustees, but from the independent managing architect of the new building, Sydney Smirke.[29]

Smirke had noted as early as 1849 that "the present arrangement of the Nineveh sculptures is temporary and its space insufficient."[30] He proposed a location that seemed logical, namely, a large area of unused space between two wings otherwise occupied by antiquities—by the Elgin marbles, the very paradigms of classical antiquity, and Charles Fellows's

recent Lycian finds, which did much to extend and complicate notions of Greek production and quality.[31] But while the proposal made sense to the architect, it met strong protests from Edward Hawkins, the keeper of antiquities, "as interfering with the chronological arrangement of the Greek Sculpture."[32]

The trustees steered a middle course. The plan for the objects and the request for funds were presented to Parliament with an uncharacteristically ingratiating passage that explains their position:

> They [the trustees] would not have proposed this addition to the other estimates of the year, were it not for the peculiar circumstances attending the discovery and acquisition of the Assyrian sculptures, and the natural anxiety of the public to have the means of convenient access to them at as early a period as it can be provided.[33]

The remarkable quickness and volume of these discoveries were part of the "peculiar circumstances," but the only factor actually described here, public interest, was the decisive one in this temporary suspension of the museum's own interpretive standards. While the passage uses public interest to justify the funds, in the period of Layard's finds the public is more often mentioned in the museum's own records in connection with calling the police. Great confusion and lack of order during an influx of Crystal Palace visitors necessitated one such call to the constabulary, while another was based on the purely imagined threat of a meeting of "physical force" Chartists in 1848.[34]

If this public interest did not cause a complete break in the ideology of presentation of the British Museum, it may at least have served to assimilate Assyria further into its antiquities collections. By the end of the following year, Hawkins had submitted a report recommending how to provide for an adequate Assyrian gallery "and for the scientific arrangement of all Museum sculpture."[35] By this time, the public's "natural anxiety" had only grown further, with the arrival, in October 1850, of the great winged bull and lion, colossal animal sculptures that are still the very emblems of Assyria to the broad public. In light of the available accommodations as well as the public interest, they were placed in the most accessible spot possible: the museum's main entrance hall, directly by the south entrance. Yet, true to the trustees' feeling about public viewers, they directed that the objects were "to be there protected by a sufficient fence."[36]

Yet, however imperious, diffident, or monolithic the British Museum may have appeared, it was indeed yoked to public opinion. Its required

yearly reports to Parliament took careful note of the numbers of public visitors. Layard described museum officials in early 1850 as "delighted at the crammed houses which the new entertainment brought them," while his Uncle Benjamin wrote Layard that his work had brought more people "than any ten previous contributors."[37] A respectful letter to Hawkins's assistant, Samuel Birch, in mid-1852 again singles out the Assyrian display as one of unique interest to numerous spectators: "May I beg the favour of your kind permission to visit the Museum today. Two invalid relatives, not often in town, wish to view the Nineveh sculptures and would be thankful to escape the bustle of an open day."[38]

Yet if the British Museum temporarily suspended ideological requirements like "scientific arrangement" on behalf of the demands of publicity, its dominant system of evaluation remained fundamentally unchanged. The modest but extraordinary actions of the museum are acknowledgments of the great interests that lay elsewhere. While it is remarkable to find such responsiveness at all within the British Museum, it is quite as striking to note that on the "home ground" of these interests, in organs of popular culture, Assyria and its artifacts could be virtually transformed.

The most significant popular testimony is that of the great English organ of middle-class cultural record: the *Illustrated London News*. Renowned for its policy of subordinating verbal to visual, the *Illustrated London News* had emerged by 1850 as the best-selling weekly periodical in England.[39] While it took pride in transmitting news of cultural events and providing engravings of works of art, the journal also relied upon a consistent strategy of presence, a formula that governed choice of style as well as subject matter in visual (and textual) material. Most basic is the effect of transforming painting, sculpture, metalwork, and so on into line drawings, itself a complex filter in which some visual aspects (e.g., color, scale, texture) are diminished and others (linearity, shading, subject matter) intensified. In another sense, there is the effect of a "display of displays," as a few objects were selected from their home displays for the mixed jumble of the *Illustrated London News*'s fine-art pages.

The illustrations themselves were related to the journal's perception of its audience. The *Illustrated London News*'s very first notice of the Assyrian objects, in June 1847, stated that "when we consider that this description may have to meet the eyes of many who may never have the opportunity of seeing the originals, we are satisfied that no other apology will be requisite for so far extending this paper."[40] Given the controversy between the British Museum and its public, this amounts to tacit admission

that the *Illustrated London News* coverage marks for its lower- to middle-class readership not a supplement or transfer so much as a fundamental origin of information.

Even more directly, another notice deplored "the impediments thrown in the way of our artists by the British Museum."[41] By late 1848, when this passage appeared, the museum's trustees had decided to publish a folio of Layard's finds.[42] In this war over the ownership of appearance, both parties, the British Museum and the *Illustrated London News*, had a claim to represent the public, but with different conceptions of the public, these were different representations, with different objects. Thus the very identity of Assyria could be fractured as it circulated.

In contrast to the exclusion of Assyrian script in the Antiquities Gallery, the *Illustrated London News* reproduced a cuneiform slab that was among Layard's finds (with an erasure dutifully noted) in addition to figural reliefs.[43] A text accompanying the engraving explains that "it will thus meet the eye of many who may not be able to obtain a correct copy of the original without difficulty."[44] Indeed, the difficulty of actually reaching such objects was even more directly alleviated by the journal in other cases.

The *Illustrated London News*'s view of the Nineveh Gallery, opened in 1853, depicted the room as open to the viewer and sparsely peopled by middle-class viewers: a welcoming place, free of bustle (fig. 10.2).[45] Even more remarkable is the same journal's treatment of the colossal winged animals (fig. 10.3). The objects appear to the reader precisely as they appear to the figures in the engraving, without intermediary, and certainly without an intervening and obscuring fence. This recasting of a display also has proprietary and antiauthoritarian overtones, as it amounts to removing the shield imposed by the museum for the sake of the public viewer. It also amounts to removing an ideological shield, such as that imposed by stalwarts of traditional artistic evaluation, to the effect that such artifacts were not to be considered as art but rather mere curiosity.[46] The artifacts were generally presented within the Fine Arts section of the *Illustrated London News*, and the ideal viewers here certainly seem no less respectful than they would be before the Elgin marbles.

What the *Illustrated London News* presents in its view of these viewers and their object, as in all of its coverage, is a picture of presence: a satisfying communication that seems to allow the viewer/reader proximity to what is actually distant. Paradoxically, this proximity can only be achieved by actual refashioning of the display milieu, not by mere illustration. Yet the textual accompaniments in the journal never directly

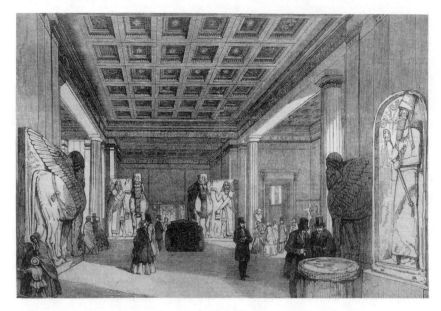

Fig. 10.2. "The Nineveh Room, at the British Museum," *Illustrated London News*, February 12, 1853.

mention this change. To the contrary, the textual portion of the *Illustrated London News*'s coverage claims its own importance directly from the importance of the developments at the British Museum. To do otherwise would surely threaten the illusion of presence, the realistic claim on which the coverage is based.

Thus while the appearance of the installation must be changed just so it can be available to different groups, so too is it essential to withhold or defer this information. While strategies of presence may vary, their objects must be deemed identical. Yet if even the most seemingly factual and straightforward coverage involves considerable embellishment and transformation, how much more evident were ideological and cultural distinctions among constituencies in what were more overtly interpretive and appropriated settings.

The British Museum's own interpretive classification of the Assyrian artifacts, its way of presenting them to the world, appears most directly in its ultimate installation. From 1853 on, the Assyrian artifacts inhabited one section of a series of three long, narrow galleries along the western section of the ground floor. The Assyrian galleries were distinguished from one another by the geographical provenance of their contents.

NIMROUD SCULPTURES JUST RECEIVED AT THE BRITISH MUSEUM.

Fig. 10.3. "Human-Headed and Eagle-Winged Bull" and "Human-Headed and Winged Lion," *Illustrated London News*, October 26, 1850.

Thus, two were identified with Nimrud, the principal object of Layard's first excavation campaign, and one with Kouyunjik, a central mound of ancient Nineveh located about twenty miles up the Tigris from Nimrud, the focus of Layard's second campaign.

Yet while the Assyrian displays were differentiated geographically from one another, when the museum finally arranged the Assyrian collections according to Hawkins's "scientific" principles, the overall controlling presentational scheme was temporal. In the west wing of the British Museum one could walk laterally through four different displays. Starting at the central courtyard, they were the Egyptian, Assyrian, Phigaleian, and Elgin galleries. This scheme presents a distinct chronological progression, from the most distant past to classical antiquity (exemplified in both the Phigaleian frieze and the Elgin marbles). Dating mostly from the ninth to the seventh centuries B.C., the Assyrian works were a relatively recent product compared to the majority of Egyptian artifacts.[47] Further, as the vast majority of the Assyrian artifacts displayed in the antiquities galleries consisted of reliefs, they might have appeared similar to the low-relief work of the classical Greek Phigaleian gallery (containing works from the temple of Apollo at Bassae, related to the style of the Parthenon), and thus ushered in the classical works while offering a contrast to their refinement.

Through the control of temporal organization, Assyria found a place at the British Museum between two different sorts of objects, the unquestioned aesthetic paragons of classical Greece and the curious artifacts of ancient Egypt. The question of whether the Assyrian collection could be compared aesthetically with the Greek or Egyptian, whether it was art or artifacts, could be decided either way.[48] Indeed, like artifacts and installations, texts too were open to different construals, leading similarly to different constructions.

Joseph Bonomi was a sort of antiquarian irregular, known for his expertise about Egypt and Palestine.[49] Nonetheless, as a trusted antiquarian gatekeeper, he wrote a long account of the British Museum's first large Assyrian cache that appeared in the *Illustrated London News* as well as a central publication of traditional antiquarianism, *Athenaeum*.[50] The most space in the account, essentially the same in both publications, is devoted to a description of the subject matter of the reliefs that dominated the shipment. Yet Bonomi's lengthy discussion of the date of the artifacts, virtually inevitable in *Athenaeum*'s coverage, is completely cut from the version in the rival journal. The *Illustrated London News* piece, on the other hand, highlights the objects themselves and the seeming narrative

of many of the subjects,[51] even including actual illustrations of five of the objects. *Athenaeum*'s inability to make the works visually available perfectly reinforces Bonomi's stated opinion that the objects "can in no way be available for their beauty as works of art." This passage too is deleted from the *Illustrated London News* version, which does not directly argue otherwise, but makes the objects available more directly to the viewer within a less precise context that might be deemed more personal as easily as more aesthetic.

In these differing construals, the distinction between personal and categorical is complemented by that between spatial and temporal. Rationalized temporal classification could not have been less important in the illustrated journal's presentation of the Assyrian antiquities. Temporal specificity was drastically reduced, even radically collapsed, in its pages. The Assyrian reliefs could be found among a vast array of objects, ancient and modern, while the textual coverage was largely descriptive and narrative. The explicit distance between reader and artifact on which the *Illustrated London News* dwelt was geographical, that more commonly negotiated form of exoticist distance. Indeed, a separate article detailed the complex procedure through which the artifacts were transferred to London from distant Nineveh, and periodic reminders of the progress of shipments dotted subsequent issues of the magazine.[52]

Moreover, this remarkable recasting of the very form of distance, from temporal to spatial, was hardly confined to the *Illustrated London News*. It was shared widely in popular representations of Assyria, and was a foundation of their success. If *Athenaeum* or the British Museum relied upon the temporal as part of the discourse of a recondite elite, Layard, the *Illustrated London News*, and others stressed the spatial to integrate Assyria with more common and less erudite realms of experience and entertainment.

Layard's own *Nineveh and Its Remains* was the single most important publication in publicizing the Assyrian artifacts.[53] Among the most popular works in the entire history of archaeology, it was an extraordinary best-seller from the moment of its publication in early 1849. Yet this work is even more attuned to "presentism" in the representation of Assyria than the illustrated journal. The majority of the book describes the contemporary state of the Mesopotamian lands and their inhabitants. Even when Layard presents the excavation itself, he spends as much time on the site and its procedures, customs, and quirks as on the products of the dig. The same complex process of transport that the *Illustrated London News* details was also of great interest to Layard. It is the subject of both

Fig. 10.4. "Procession of the Bull Beneath the Mound of Nimroud," frontispiece to Austen Henry Layard, *Nineveh and Its Remains*, vol. 2 (New York: George Putnam, 1850).

of the elaborate frontispiece engravings of the two-volume original (fig. 10.4).[54]

Further, the same mode of envisioning, again privileging spatial over temporal distance, characterizes more exclusively visual forms of the commodification of Layard's discoveries. The discovery of Assyria activated what Richard Altick has called "the strongest impact the progress of archaeological discovery made upon the [English nineteenth century] entertainment world."[55] An Assyrian panorama enjoyed an especially long run in Robert Burford's Leicester Panopticon.[56]

The popular success of the representation of Assyria in England depended directly upon its adaptability to existing norms of visual commodification, dominated by purveyors of spectacle and entertainment. Yet the farther Assyria strayed from the British Museum's controlled spaces, the more diffused it became in a very different cultural atmosphere, the more it became subject to other predispositions of the audience. Among the British Museum's trustees' greatest fears was that the finds would become more entertainment than instruction.[57] Whereas Layard's book at least had learned overtones,[58] the world of the panoramas was resolutely commercial, sensational, and quite distinct from the museum.

A panorama similar to Burford's that can be better documented today

is that presented in 1851 by Frederick Cooper, an artist who had been sent by the British Museum to assist Layard in producing quick and accurate sketches of his discoveries. Cooper was not all Layard had hoped for and was soon back in London, exploiting his brief acquaintance.[59] In Cooper's panorama the objects that Layard discovered took up a remarkably small portion of the whole, only five of the thirty-seven scenes into which it was divided. Much more was made of the excavation site itself, the nearby village of Mosul, the customs, costumes, and dwellings of the Arab inhabitants, and even Layard himself and those he oversaw. A contemporary review notes, with characteristic understatement, that "the sombre and gloomy character of the excavations is judiciously relieved by episodes from the wild and picturesque life of the desert."[60] The temporal fruits of excavation were thus subsumed in (seemingly preferable) contemporary and only spatially distant sights. This position marks the very edge of the popular diffusion of the British Museum's new objects, an arrangement in which the inconvenient objects themselves begin to disappear, pretext for an incidental but more wondrous setting. Yet this position only marks a logical extension of the *Illustrated London News*'s coverage and the related aesthetic evaluation of the Assyrian works. As objects become dehistoricized images, they come to compete with other images for the interested momentary glance.

Notably, the most successful absorption of Assyrian artifacts into contemporary cultural representation was one with claims to both contemporaneity and historical commitment: the 1853 presentation of a full-scale dramatic production by the impresario Charles Kean based on Lord Byron's *Sardanapalus*. The play was performed nearly a hundred times in a two-year run. Its unique claim to fame and success was its remarkable costume and set designs painstakingly based on Assyrian artifacts in the British Museum (fig. 10.5).[61]

For all the trumpeted novelty offered by the spectacle, the production also depended on a certain traditionalism connected with the name of Byron, then emerging as a renowned, and past, literary master. Uniqueness and difference could only be marked and controlled in a strict system of sameness. As Kean acknowledged:

> Until the present moment, it has been impossible to render Lord Byron's Tragedy of "Sardanapalus" upon the Stage with proper dramatic effect, because, until now, we have known nothing of Assyrian architecture and costume. It is also worthy of remark that, interesting as the rescued bas-reliefs which have furnished such information are, they could not find

Fig. 10.5. "Scene from the Tragedy of 'Sardanapalus,' at the Princess' Theatre—The Hall of Nimrod," *Illustrated London News*, June 18, 1853.

dramatic illustration but for the existence of the only Tragedy that has reference to the period of which they treat.[62]

Kean's originality lay in bringing together two disparate bodies of work to reinforce one another without confusing the identity of either. The Assyrian objects themselves here take a central place. They appear, moreover, as historical artifacts, their distant past bridged by the more recent one represented by Byron. The effect was among the most extraordinary ever accorded to Assyrian artifacts.

The *Times* noted that, Pygmalion-like, "the Layard monuments of the British Museum have started into life," and that viewers "completely live with the descendents of Nimrod, and walk out of the theater looking forward to the invasion of Julius Caesar as something in the remote future."[63] Even more telling were the adulatory words of *Lloyd's Weekly Newspaper*, one of the *Illustrated London News*'s most successful competitors.[64] *Lloyd's* said:

That one performance gave us a better insight into the manners and habits of the Assyrians, than a whole lifetime has enabled us to acquire of

the French. It was a grand lesson of animated geography; and the more curious, as being the animated geography of a nation that is dead.[65]

These accolades are as grand as can be imagined, a testimony to the machineries of presence in Kean's grand theatrical apparatus: a transcendence of geographical, cultural, and especially temporal distance, the more extraordinary for being vastly farther away than France.

Kean sought Layard's (willingly proffered) approval for the "authenticity" of his Assyrian settings. While such testimony was particularly important to ratify the claim to have bridged the temporal distance to Assyria, it also points to the acceptance of Layard (and, as some might have thought, through him the British Museum) as authority. More than Cooper's panorama, Kean's production is visually consequent to the initial act of domestication arranged through Layard and the British Museum and promulgated through the *Illustrated London News*. Still, Kean, Cooper, and even the *Illustrated London News* share an aestheticizing approach at odds with the classicizing/antiquarian orientation of the British Museum.

Kean's presentation is closest to the British Museum's, but only as a contrast to it. The very hallmark of its success was a hallucinatory presence, a dramatic unity completely inadmissible by antiquarian standards. *Lloyd's* "insight" is as much the product of adjusting the presentation to the norms of nineteenth-century theater, harnessing the unknown for the known. Objects, it would seem, can be acculturated in the same manner as people: through the creation of a hybrid of differing cultural norms, a dynamic and never perfectly determinate mixture of sameness and difference, presence and distance. Yet, as throughout exoticism, the Western portion of the mixture is dominant, as Layard becomes as prominent as his finds are for Cooper, or as Kean uses them to illustrate Byron, or as the British Museum only grudgingly admits the Assyrian works much prominence at all.

The emulation and commodification of the British Museum's Assyrian objects took many further forms, from jewelry to sculpture, painting to book design, architecture to metalwork,[66] but the audiences and cultural constituencies behind them fit the same sort of structure I have sketched here. On the one hand, the Assyrian collection may have benefited the British Museum by reaching a larger and different public, helping to valorize it to this new constituency. On the other hand, as the museum

served as Britain's great treasure house of culture, the objects themselves could be seen to share some of the aura of the other canonical objects and significant artifacts housed therein.

Yet the relation was not merely reciprocal or equally beneficial. We might deem the British Museum to be a privileged point of introduction in the overall British reception of Assyria. This privilege is chronological as well as intellectual. That is, the artifacts needed to pass through the British Museum on their way into the larger world for reasons of physical as well as ideological efficacy. The British Museum was a sort of keystone to a series of systems of evaluation, display, and circulation. Looked at this way, a study in the reception of Assyria is a matter of tracking a sign through the inflection of its signifiers. In this light, rather surprisingly, the most remarkable feature of the British Museum is its openness, for Assyria was located at the crux of a number of oppositions, even contradictions, contained in the museum's rambling structure of governance and presentation.

The Assyrian objects stood at a transition between antiquities and artworks, in a display of both temporal and spatial distinctions. The objects emerged in a period of the museum's own transition, and were beneficiaries of it. They could hardly have been housed had not the museum been undergoing physical expansion, and their special treatment was a result of their being of interest to both more traditional and newer audiences. Indeed, the objects not only participated in bringing the museum's collection to a larger audience, they also offered something to quell its upstart critics.

Most notable of all is the formative diffidence of the museum's directors: the trustees, the primary officers, and their sculpture adviser. Neither Parliamentarians nor the activist Smirke were effectively thwarted, despite noted distaste for the Assyrian objects. Just as their meager funding of Layard provided his original motive for seeking fortune with fame among the wider populace,[67] so more generally the directors' withdrawal from the wider public sphere set the stage for the popular manifestations that emerged to satisfy the public's interest. Whether grudging or not, this inaction was, in a sense, benevolent. In this context, the most decisive feature of Westmacott's character was not his artistic taste, but his distaste for addressing the public.[68]

The Assyrian representations in Layard's book, in the *Illustrated London News*, and by Cooper and Kean are thus substitutions. In a way, these representational phenomena could be deemed separate from, and secondary to, the original discovery and display. Yet the two clusters of events

have much in common and belong to a single larger system. For all, even the British Museum's display, are attempts to constitute the presence of Assyria for people who are certainly not Assyrians. Hence, as in all ex-oticism, all share a discontinuity, as the distant Other is bent (if not broken) into a present sameness.

Temporal and spatial emphasis offer different possibilities for the construction of this presence. Which of these forms of distance one chooses for an organizing principle says as much about oneself and one's intended audience as it does about the object of study. For its recherché temporality and emphasis on the artifacts themselves, Kean's construal is most comparable to that of the British Museum. Its considerable success testifies to a basic perceptual and social solidarity in mid-nineteenth-century England.

The more radically disjunct representations of Layard and, especially, Cooper offer a similar conclusion. For despite their recasting of presentation from time to space, subsumption of object in context, and greater concentration on entertainment per se, they offered no fundamental threat to the primacy of the British Museum. They were clearly shaped (perhaps constrained) by a design to carry the discoveries beyond the museum's traditional audience. Their very success, Cooper's almost to the edge of comprehensibility, actually confirmed the primacy of the museum. Just as the museum's police actions show, its directors had far less to fear from the public than they thought.

The *Illustrated London News*'s coverage also suggests a more general conclusion about the nature of popularity and promulgation in mid-nineteenth-century England. The popular interest in Assyria was especially an interest in the works as visual objects. The *Illustrated London News*'s coverage was thus of a fundamentally different sort from that of the purely textual *Athenaeum*. Similarly, the immensely popular one volume abridgment of Layard's book had both vastly less text and even more illustrations than the original work. Theorists from Aristotle to Lessing have considered time the province of linguistic arts while space belonged to the visual arts. In accordance with this linkage, the turn from temporal to spatial can also be cast as a turn from verbal to visual. In this latter mode, too, the museum functioned as an essential threshold over which historical knowledge and associations (through which adding the works to the British Museum's collections was first justified) confronted contemporary appearances.

Still, one should not minimize the differences in appearance between actual Assyrian objects and *Illustrated London News* engravings. Indeed,

the anonymous popular engravings are not even all consistent with each other in scale, extent of detailing, attention to textures, and similar matters. To note such differences, such discontinuities, even in such an ostensibly straightforward and unmediated publication as the *Illustrated London News*, much less throughout the range we have surveyed, underlines how provisional was any individual acquaintance with the objects and how rich and varied a range of references could be supported. Ultimately, the force of social and ideological conflict, of the broad range of questioners, interests, and claims to ownership, meant that even what was in the British Museum, and even more so its significance, could be open to conflict.

Notes

I am grateful to Judith Lisansky, Roger Benjamin, and Daniel Sherman for commenting on earlier drafts of this article. Some material is adapted from my doctoral dissertation, which was partly funded by a Kress Fellowship from the Center for Advanced Study in the Visual Arts of the National Gallery of Art, Washington, D.C.

1. Three important paradigms of the range and interpretation of exoticism are Edward Said, *Orientalism* (New York, 1979); Henri Baudet, *Paradise on Earth* (Middletown, Conn., 1988); *Exotische Welten, Europäische Phantasien*, exhibition catalog, Staatsgalerie, Stuttgart (Stuttgart, 1987). On visual images, see also Linda Nochlin, "The Imaginary Orient," *Art in America*, May 1983, pp. 118-25, reprinted in *The Politics of Vision: Essays in Nineteenth Century Art and Society* (New York, 1989), pp. 33-59.

2. A brief sampler of the variety of dialogues: William Rubin, *Picasso and Braque: Pioneering Cubism*, exhibition catalog, Museum of Modern Art (New York, 1989), pp. 11, 15-30, and passim; Lothar Lang, "Dialog mit Picasso: Zu einem Zyklus von Renato Guttuso," *Bildende Kunst* 6 (1975): pp. 262-66; M. W. Martin, "The Ballet 'Parade': A Dialogue Between Cubism and Futurism," *Art Quarterly* 1 (1978): pp. 85-111; Reinhold Hohl, *The Silent Dialogue: The Still Life in the Twentieth Century*, exhibition catalog, Galerie Beyeler, Basel (Basel, 1979) (on "the creative dialogue between artists and objects"); "Den globale dialog: primitiv og moderne kunst," *Louisiana Revy* 26 (1986, special issue).

3. The only book-length study of this topic well exemplifies the method: Hannelore Künzl, *Der Einfluss des alten Orients auf die europäische Kunst besonders im 19. und 20 Jh.* (Cologne, 1973).

4. On the disarming function implicit in the art historical invocation of dialogue in Orientalism, see Çeylan Tawardos, "Foreign Bodies: Art History and the Discourse of 19th Century Orientalist Art," *Third Text* 3/4 (Spring/Summer 1988): p. 58. I am grateful to Carol Duncan for this reference.

5. Frank M. Turner, *The Greek Heritage in Victorian Britain* (New Haven, Conn., 1981). Cf. Martin Bernal's treatment of English "hellenomania" in *Black Athena* (New Brunswick, N.J., 1987), especially pp. 318-26.

6. Carol Duncan and Alan Wallach, "The Universal Survey Museum," *Art History* 3 (1980): pp. 448-69.

7. Christopher Norris, *Derrida* (Cambridge, Mass., 1987), p. 70. As presence is associated with speech and privileged over writing, it might be compared with the common art historical privileging of viewing the original over gaining visual information through reproductions.

8. On synecdochic and metonymic as categories of museum display, see Stephen Bann, *The Clothing of Clio* (Cambridge, Mass., 1984), pp. 77-92. Cf. Dean MacCannell's related treatment, *The Tourist* (New York, 1989), pp. 78-80.

9. On this later development, see David K. van Keuren, "Museums and Ideology: Augustus Pitt-Rivers, Anthropological Museums, and Social Change in Later Victorian Britain," *Victorian Studies* 28 (1984): pp. 171-89; and Kenneth Hudson, *Museums of Influence* (Cambridge, 1987), pp. 31-34. On display ramifications, see Arthur Danto, "Art and Artifact," in *Art/Artifact* (New York, 1988), pp. 18-32; this entire Center for African Art catalog is an exemplary treatment of the range of exhibition contexts of non-Western art.

10. Lucie Duff Gordon, *Letters from Egypt* (London, 1983), 67-68.

11. Théophile Gautier, "Gérôme: Tableaux, Études et Croquis de Voyage," *L'Artiste* ser. 6 vol. 3 (1856): p. 34.

12. The classic elaboration of modern space and time is the "Transcendental Aesthetic" portion of Kant's *Critique of Pure Reason*. On the differences of experience allowed by the two, see especially sections I.6. and I.8.

13. In the vast literature on Layard, see especially, in addition to Layard's own works, Gordon Waterfield, *Layard of Nineveh* (New York, 1963); H. W. F. Saggs, introduction to A. H. Layard, *Nineveh and Its Remains* (New York, 1970), pp. 1-64. The most detailed biographical information on Botta is Charles Levavasseur, "Notice sur Paul-Émile Botta," in P. E. Botta, *Relation d'un Voyage Dans L'Yémen . . .* (Paris, 1880), pp. 1-34. On his archaeological activities, see P. E. Botta, *M. Botta's Letters on the Discoveries at Nineveh . . .* (London, 1850); Adrien de Longpérier, *Notice des Antiquitiés Assyriennes . . . du Musée du Louvre* (Paris, 1854), pp. 5-14. More integrated narratives are Seton Lloyd, *Foundations in the Dust* (London, 1980); Julian Reade, *Assyrian Sculpture* (London, 1983), pp. 5-12.

14. On the British Museum's antiquities collections, see especially Edward Miller, *That Noble Cabinet: A History of the British Museum* (London, 1973), pp. 191-223.

15. Cf. the testimony of the radical William Cobbett. "Of what use, in the wide world, was this British Museum? . . . Why should tradesmen and farmers be called upon to pay for the support of a place which was intended only for the amusement of the curious and the rich, and not for the benefit or for the instruction of the poor?" (*Hansard Parliamentary Debates*, ser. 3, vol. 16 [1833], col. 1003; quoted in Richard D. Altick, *The Shows of London* [Cambridge, Mass., 1978], pp. 443-44.)

16. On the British Museum and its audience, see Altick, *Shows*, pp. 439-46. See also Kenneth Hudson, *A Social History of Museums* (Atlantic Highlands, N.J., 1975), pp. 8-10. Two chief primary sources are *Report from the Select Committee on the Condition, Management, and Affairs of the British Museum* (London, 1835) (pars. 1320-30 excerpted in Altick, *Shows*, p. 444); and *Select Committee on National Monuments and Works of Art*, Parliamentary Papers, House of Commons, 1841, vol. 6, pars. 2869-3004 (examination of Sir Henry Ellis, principal librarian of the British Museum).

17. "The British Museum," *Times* (London), December 29, 1846, p. 5. The *Times* notes that "crowds during the day assembled in the street murmuring at the injustice of exclusion on this, perhaps the only holyday in the year."

18. *Howitt's Journal* 1 (1847): p. 28, editorial box.

19. W. J. Fox, "The British Museum Closed," *Howitt's Journal* 1 (1847): pp. 29-31. Fox trefers to the smashing of the Portland vase by a public visitor in 1845; see Altick, *Shows*, p. 449.

20. Stanley Lane-Poole, *The Life of the Right Honourable Stratford Canning*, 2 vols., (London and New York, 1888; reprinted New York, 1976), vol. 2, p. 149 (page references are to reprint edition).

21. "It pains me grievously to see the French monopolize the field, for the fruits of Botta's labours . . . are not things to pass away in a day but will constitute a nation's glory in future ages." Quoted in Saggs's introduction to Layard, *Nineveh*, p. 42.

22. The earliest traces are British Museum Archives (cited hereafter as BMA), Committee, February 24, 1849, 7730. The reference numbers here and in subsequent citations are those used by the British Museum Archives.

23. *Report of the Commissioners Appointed to Inquire into the Constitution and Management of the British Museum*, Parliamentary Papers, House of Commons, 1850, vol. 24, pars. 8142-43.

24. This itemization is derived from *Synopsis of the Contents of the British Museum*, 53rd ed. (London, 1848) (cited hereafter as *BM Synopsis*). This guide is the first to describe the placement of the Assyrian artifacts in the British Museum.

25. In a way parallel to the Assyrian collection, though a bit later and on a smaller scale, the British antiquities collection also found its way into a separate display venue. On the decision to set out this separate collection, hastened, as ever, by the prodding of a parliamentary commission, see Miller, *That Noble Cabinet*, pp. 209-13. Cf. T. Kendrick, "The British Museum and British Antiquities," *Antiquity* 3 (1954): pp. 132-43.

26. *BM Synopsis*, 55th ed., 1850, 112-14.

27. Miller, *That Noble Cabinet*, p. 192.

28. For Westmacott's testimony, see note 48. A typical example of his influence is described in the museum's minutes, in response to a letter from Charles Fellows asking whether portions of the display of the Xanthian frieze he had discovered for the museum would be improved as he advised. "The Trustees conferred with Sir Richard Westmacott. The Secretary was directed to acquaint Sir Fellows that with the information before them the Trustees have no intention of altering the arrangement of that frieze" (BMA, Comm., January 30, 1847, 7151).

29. Smirke called the attention of the Royal Institute of British Architects to Layard's discoveries soon after their arrival, and later delivered a paper on the Assyrian finds to the group (letter from Smirke to Joseph Scoles, RIBA Archives, June 28, 1847). Cf. "Some Remarks on . . . the Assyrian Sculptures," *RIBA Proceedings*, ser. 1, no. 10, March 18, 1850.

30. BMA, Subcommittee, November 29, 1849, p. 467.

31. On Fellows, see BMA, Comm., November 28, 1846, 7082-83; Comm., January 30, 1847, 7151; General Meeting (hereafter GM), June 12, 1847, 1953; *Report of the Commissioners*, pars. 43-44.

32. BMA, Subcomm., January 12, 1850, 471-73.

33. Ibid.

34. BMA, Comm., July 12, 1851, 8252-53; GM, April 5, 1848, 2013; Comm., April 15, 1848, 7496.

35. BMA, Comm., September 20, 1851, 8294.

36. BMA, Comm., October 8, 1850, 8067.

37. Austen H. Layard, *Autobiography*, 2 vols. (London, 1903), vol. 2, p. 191; Waterfield, *Layard of Nineveh*, p. 195.

38. British Museum Department of Western Asiatic Antiquities, Correspondence I.1, no. 161.

39. Richard D. Altick, *The English Common Reader* (Chicago, 1963), pp. 343-44, 394.

40. *Illustrated London News*, June 26, 1847, p. 412. Cited hereafter as *ILN*.

41. *ILN*, December 16, 1848, pp. 373-74.

42. BMA, Comm., January 8, 1848, 7411-14; February 12, 1848, 7427; April 15, 2848, 7503; May 6, 7514.

43. *ILN*, March 31, 1849, p. 213.

44. The implicit hope that disseminating such information beyond traditional and upper-class locales would lead others to make contributions to deciphering and understanding As-

syria was realized, a few decades later, in the person of George Smith. Smith, a bank-note engraver, had taught himself to read cuneiform and ultimately discovered a crucial passage in the Epic of Gilgamesh. On Smith, see Lloyd, *Foundations in the Dust*, pp. 146-47.

45. *ILN*, March 26, 1853, p. 225.

46. See my "Assyria as Art: A Perspective on the Early Reception of Ancient Near Eastern Artifacts," *Culture and History* 4 (1989): pp. 7-34.

47. The 1848 *BM Synopsis* lists most of the major objects in the central display area (the Egyptian Saloon) as ranging from the twelfth to the twenty-sixth dynasties, a span of over 1,300 years that reached back beyond 1900 B.C. For Assyrian dating, see *BM Synopsis*, 60th ed., 1853, pp. 103-5; *BM Synopsis*, 61st ed., 1854, pp. 95-103.

48. Compare Richard Westmacott, "I think it impossible that any artist can look at the Nineveh Marbles as works for study, for such they certainly are not; they are works of prescriptive art, like works of Egyptian art" (*Minutes of . . . the Select Committee on the National Gallery*, Parliamentary Papers, House of Commons, 1852-53, vol. 31, par. 9053), with Layard in a letter of 1846: "[The Assyrians'] knowledge of the arts is surprising and greatly superior to that of any contemporary nation. . . . The [colossal winged] lions lastly discovered, for instance, are admirably drawn, and the muscles, bones, and veins quite true to nature, and portrayed with great spirit" (Layard, *Autobiography*, vol. 2, pp. 166-67).

49. On Bonomi's place in Robert Hay's Egyptian expedition, see Selwyn Tillet, *Egypt Itself* (London, 1980), passim. Other aspects of Bonomi's career are touched upon by Michael Darby in the exhibition catalog *The Islamic Perspective* (London, 1983), pp. 30-31, 39. See also Joseph Bonomi, *Nineveh and Its Palaces* (London, 1852).

50. *Athenaeum* (London), June 19, 1847, pp. 650 51; *Athenaeum*, July 3, 1847, pp. 706-7; *ILN*, June 26, 1847, pp. 409-10, 412. Though the dates are garbled, Bonomi admits his authorship in British Library (cited hereafter as BL) Add. MS. 38,510, ff. 199-200.

51. "Nine of the Rilievi apparently relate to the actions of the same King, certain of the subjects seeming to follow naturally and consecutively."

52. E.g., *ILN*, July 27, 1850, p. 71; December 21, 1850, p. 484; December 28, 1850, p. 505; February 28, 1852, p. 184.

53. Austen Henry Layard, *Nineveh and Its Remains*, 2 vols., (London, 1849). On the remarkable success and publishing context of this book, see Frederick N. Bohrer, "The Printed Orient: The Production of A. H. Layard's Earliest Works," *Culture and History* (forthcoming).

54. The other frontispiece depicts the raising of the bull from the excavation site. The artist of these images was George Scharf, later director of the National Portrait Gallery. Scharf was presumably chosen because he had previously accompanied Charles Fellows in an archaeological excavation to Asia Minor and produced plates for a publication related to the trip. Yet at the time Scharf's main livelihood came from illustrating a variety of books for John Murray. He was thus as much beholden to Murray, the publisher, to produce works that would be commercially appropriate as he was to Layard to produce images that were true.

55. Altick, *Shows*, p. 182.

56. Burford even contacted Layard (who apparently never responded) to ask for panoramic drawings. BL Add. MS. 38,979, ff. 316 18.

57. See the cautionary words of John Ward, one of the first trustees of the British Museum, quoted in Miller, *That Noble Cabinet*, p. 62. Cf. Harold Rosenberg's comment on the modern art museum: "In the direction it [the museum] has taken nothing awaits it but transformation into a low rating mass medium" ("The Museum Today," in his *The Dedefinition of Art* [New York, 1972], p. 242).

58. The tone of the narrative bears comparison to Layard's early contributions to scholarly journals, such as "A Description of the Province of Khúzistán," *Journal of the Royal Geographic Society* 16 (1846): pp. 1-105.

59. "Mr. Cooper, the artist, ought never to have left the Strand" (letter from A. H. Layard, Mosul, July 7, 1850, British Museum Department of Western Asiatic Antiquities, Correspondence I.1, no. 3154.

60. One of many breathless reviews in the exhibit catalog, *Diorama of Nineveh. Painted by Frederick Charles Cooper* (London, 1851), inside front cover. Quoted from *The Wesleyan Times*.

61. George Gordon, Lord Byron, *Sardanapalus . . . Adapted for Representation by Charles Kean* (New York, n.d.). Cf. Martin Meisel, *Realizations* (Princeton, N.J., 1983), pp. 181-83.

62. Kean, preface to Lord Byron, *Sardanapalus*, pp. 5-6.

63. *Times* (London), June 14, 1853, p. 7.

64. Altick, *Common Reader*, p. 394, puts it third in total circulation, behind only *Illustrated London News* and *News of the World*. In 1851, the magazine claimed a circulation around 150,000 copies (*Lloyd's Weekly Newspaper*, May 11, 1851, p. 6). Altick's more reliable figures put it at about one-third of that number.

65. Quoted in Inge Krengel-Strudthoff, "Archäologie auf der Bühne—das wiedererstandene Ninive: Charles Keans Ausstattung zu *Sardanapalus* von Lord Byron," *Kleine Schriften der Gesellschaft für Theatergeschichte* 31 (1981): p. 19.

66. I will consider this range of production in a forthcoming study.

67. Samuel Birch, assistant keeper of antiquities at the British Museum, who genuinely supported Layard's finds, offered the rationale that "English authorities are influenced more from without than within" (Waterfield, *Layard of Nineveh*, p. 180).

68. Thus, when someone at "the Sunday papers" asked Westmacott for an explanation for his own addition to the British Museum, the pedimental sculpture that adorns the main entrance, he did not respond directly but turned for help to the museum's principal librarian (i.e., executive director), explaining, "I have a horror of appearing in print." BL Add. MS. 38,626, ff. 198-201.

11

From Ruins to Debris: The Feminization of Fascism in German-History Museums

Irit Rogoff

> Today many German women are beggars and prostitutes. Like their
> houses, they need repairing. . . . All these people look alike now, but
> there is an emptiness in their eyes that doesn't come just from hunger
> and bombing. It is from years of fear and automaton obedience. Twelve
> years of special fear detracts from the personality. These people never
> thought for themselves. We have never had a real revolution in
> Germany. Look how they obey their conquerors now.
> "And the German Women . . . ?" *Vogue*, March 1946

The voice is that of a benevolent American conqueror observing, a year
after the end of the Second World War, those who have been vanquished
and whose culture lies in ruins.[1] It is refracted through a prism of gender
and representation as befits the editorial concerns of *Vogue*, the most em-
inent of all fashion magazines and a century-long arbiter of taste and
style. The writer conflates several issues to do with women, survival,
aesthetics, and sexuality into an odd, style-conscious ethnography:

> The German doctor was slim and gnarled, about thirty-eight years old.
> She was quite sexless in her neat and rusty black. She kept clutching her
> hands together as she talked, hands with skin as reddened as her long
> nose. She was one of the two hundred and sixty doctors permitted to
> practice in Frankfurt. . . . This doctor was one of the many people I
> questioned about German women as I travelled from one shattered town
> to another. I found myself obsessed with curiosity about these thick-
> waisted females who are bringing up the New German race. They have
> been accustomed to Nazi lovers; now they give themselves eagerly to
> American men.[2]

The absurdities of coded fashion dicta—the slim as opposed to the
thick-waisted, the long unpowdered red nose, the unfashionable black
costume, the concept of women who spent the war years delivering

themselves up to lovers rather than enduring death, destruction, bombings, and food shortages—may be part of a particular cautionary discourse of fashion. But the attempt to perceive a historical moment and a national narrative through the conditions of women's lives and through the images and representations of women is of great interest.

In positing these women as victims who in their state of ruination are somehow denied their pleasures as women, the author denies them their historical specificities and any possibility of agency. Thus, not only is a particular historical discourse gendered female, but that gendering also serves to position the discourse, in this case through the gaze of the conqueror, which requires a subordinated subject and allows for no greater historical complexity than a ruined femininity that stands as a metaphor for a nation in ruins. To readers who will retort by saying that of course a women's fashion magazine would discuss world historical issues in terms of gender and representation, I would offer Kaja Silverman's astute observation that "the history of Western fashion poses a serious challenge both to the automatic equation of spectacular display with female subjectivity and with the assumption that exhibitionism always implies woman's subjugation to a controlling male gaze."[3] While Silverman is discussing issues of spectatorship and I am discussing the implications of gendering historical narratives through display strategies, the underlying questions concerning the inscription of female subjectivities into cultural/ historical narratives continue to be central to any investigation that posits gender as a tool of analysis.

My preoccupation with the subject discussed in this essay dates to a recent visit to the City Museum of Osnabrück, where a new wing to be devoted to the history of the town was being installed. In wandering around I noticed, right next to the simulated reenactment of some Nazi horror, a glamorous 1930s plaster mannequin of the lingerie shop window variety, with crimped blond hair and delicately arched eyebrows over radiant blue eyes, wearing a 1930s corset (fig. 11.1). Why, I wondered, were we being shown an item of women's underwear?—in order to make the experience of the period more concrete? What was the relation between this fetishized object without arms or legs and the representation of history? Could one, in fact, do gendered readings of the *display* modes of past culture? My characterization of the mannequin as a fetishized object is founded on the extreme separation between the figure and the narrative that dominates the display that surrounds her. In Freudian psychoanalysis the fetish object is the part that stands for the whole. Freud says that the fetish is a substitute for the penis and adds that "it is

Fig. 11.1. Plaster lingerie mannequin from the 1930s. City
history section, City Museum, Osnabrück. Photograph by I.
Rogoff.

not the substitute for any chance penis, but for a particular and quite spe-
cial penis that had been particularly important in early childhood but had
later been lost."[4] Fetishized objects understood within the structures of
culture come to stand for a complex whole that is not available. Thus the
fetishized nature of some of these images of femininity within historical
displays can be related to the extent to which coherent and continuous
historical narratives are not available and thus have to be grasped at
through certain economies of symbolic exchange.

 Representations of women as well as the gendering of particular dis-
courses serve to facilitate, codify, and stage the reconstruction of partic-
ular historical episodes. The discussion I would like to pursue in this

context deals with historically convenient narratives and historically convenient victims, viewed critically through the terms of gender-specific analysis. It is an attempt to formulate questions regarding the links between historical display and the very concept of victimization, of how it is constructed, gendered, and represented and of what narrative purposes it serves within the specific contexts of museum displays. I need to start off with a series of disclaimers. This is not a paper about the documentation and representation of National Socialist fascism. While it focuses on a particular set of circumstances, it does so in order to try to articulate a broader theoretical problem central to the contemporary moment in feminist debates, namely, how we can read cultural processes and procedures as gendered entities. While the particular episodic and fragmentary examples I am looking at are specific to Germany, they also reveal a certain model—an extreme one to be sure—of rewriting the relations between historical legacies and contemporary ideologies through gendered systems of representation.

Since the end of the Second World War, West German cultural discourses have been dominated by the tensions inherent in the construction and reconstruction of successive and conflicting narratives of German history. The present moment is characterized by the contradictory mode in which local historical narratives are framed by wider theoretical developments. On the one hand we find the *Historikerstreit*, the German historical debate that dominated the latter part of the 1980s, in which the neoconservative historians in Germany have sought to relativize the fascist era by stressing those aspects in which other countries have undergone so-called "comparable experiences"—that is, totalitarianism and genocide.[5] Instead of bracketing nazism out of German historical continuity, as does the school of historical thought and method that looks at German history as following in a *Sonderweg*, a unique path, the neoconservative historians in Germany have sought to relativize it by stressing the respects in which other countries have undergone comparable experiences.

The opposing argument, that of the proponents of the *Sonderweg* who have emerged from the post-1968 neo-Marxist schools of history, refuses notions of historical relativization and insists on looking at the Nazi state's activities as institutional continuities sited within a specific development of German history. The contemporary and historical political implications of this debate are immense; the responses that the West German philosopher Jürgen Habermas has made to neoconservative historians, charging them with attempting to construct a usable past within

present-day conservative politics, have illuminated their full complexity.[6] As West German economic prosperity continued within the relatively smooth waters of strife-free labor relations and, until recently, limited awareness of increasing racial exploitation and stratification, as West German cultural practices such as contemporary visual art gained critical cachet and market clout, so the revisions of historical narratives emerged with greater strength to frame and envelop these developments with comfort and ease. It is important to mention in this context that the *Historikerstreit* has not been an esoteric debate among scholars but a full-fledged political campaign persistently carried out by both factions within the national press and media between 1985 and 1990. More recently, the processes of German reconciliation and reunification gave rise to another dimension of these historical contestations that has lain dormant within the folds of cold war politics and East/West divisions — namely, who can claim a greater right to the national heritage, to the defeat of fascism and resistance to totalitarianism.

At another level, the wider theoretical one, we inhabit the moment of posthistory, that moment in late bourgeois development in which historical movement seems to be arrested despite many accelerated processes.[7] German reunification, with all of its embattled animosities, claims, and counterclaims, is a clear manifestation of this posthistorical moment in that it is playing out a series of scenarios originating in the immediate aftermath of the Second World War and the period of National Socialist fascism. The claims of both German nations to forms of postwar corrective ideology, be it capitalist parliamentary or state socialist, are still determined by the era that immediately preceded them. The discourses that attempt a criminalization (or decriminalization) of German Democratic Republic communism seem to be motivated by the need to establish a parallel to the period of denazification that the Federal Republic of Germany went through after the war.

During the 1980s the so-called debate on German history seemed to focus on ever more conscious attempts to engage in historical rewrites that would serve as legitimating narratives for the increasingly conservative political climate of the Federal Republic. Thus, the neoconservative historians of the early 1980s challenged the continuing inclusionary legacies of the left liberal historians of the 1970s while poststructuralist theorists negated the concept of history as a coherent and continuous factual body and posited concepts of textuality, discursive formations, and issues of representation in its stead.

Of late, many of these debates seem increasingly to serve as a mode of internal intellectual tinkering within the confines of the dominant historical paradigms. My sense is of a well-worn dance floor on which the balletic movements of historiography unfold, repeating ritual movements in varied configurations. Fascism is cast as the index for Western horror, and nazism is recognized as its most abominable manifestation. This moral yardstick, then, is the animating center of the historical debates, and it would be inconceivable to refute either the historical horror or the contemporary political necessity of maintaining it as a navigational reference point. But there are also dangers within these necessary processes, for fascism can also be a convenient myth that produces a totalizing discourse founded on binary oppositions of good and evil and recounted through monolithic narratives that accommodate such binaries. Even the more finely attenuated social histories generated through the school of *Alltagsgeschichte* have worked primarily to expand the cast of characters operating within these binaries; thus the histories of peasants and workers, of women, of Slavs, of Jews, of regional people and every form of affiliated otherness are documented and harnessed to a series of ordering paradigms. The narrative structures are in place and other bodies of information, alternative factualities, are set into them. At best, a certain metahistorical narrative is challenged; at worst, an endless proliferation of recuperated facts accumulates.

But what of the historical episodes for which no historical narrative structure exists? What of the inconceivable, the unspeakable, the denied and the repressed, the strategies of representation that intend one thing but actually achieve something completely different? How are we going to set about formulating narrative structures that will somehow allow us to articulate that which is outside the languages of historical knowledge? Where can we begin to locate the possibilities for alternative narratives?

For me, working as so many of us do on the centrality of sexual and cultural difference to the construction of both narratives and representations, it is the attempt to formulate gender as a category and tool of analysis that has begun the work of illuminating the concealed potential structures that might be available to us. Recently, I encountered an aspect of the inconceivable and unspeakable in the process of being articulated when I chanced on a screening of Helke Sander's new film *Befreier und Befreite* (the title has been badly translated as "Liberators Take Liberties" rather than "Liberators and Liberated").[8] It is a long and complex documentary film whose subject is the mass rapes that took place during the first months of the so-called Allied liberation of fascist Germany. The ev-

idence assembled shows that the German army raped women on the eastern front during the later part of the war and that most of the Allied forces, with the apparent exception of the British, raped during those first months in conquered Germany. But nothing even remotely comparable to the mass rape activity of the Red Army when it entered Germany had taken place.

Since statistics are not available and the subject remains taboo, Sander and her team of researchers and statisticians worked for a decade assembling the poor documentary resources and interviewing victims. Their findings led to a cautious estimate that around 2 million women were raped in the six months between December 1944 and the summer of 1945, primarily in areas occupied by the Red Army although by no means exclusively so. Although the Nazi regime had collapsed by the spring of 1945 and Nazi legislation forbidding abortion was no longer applicable, the immediate postwar situation during the months of early Allied occupation was so chaotic that it seems impossible to discern what access women who had been raped had to abortions. Many women, it seems, were so ill-nourished and exhausted that they only noticed their pregnancy too late to have an abortion, while others had no access to appropriate medical care. Perhaps as many as a hundred thousand children were born in the aftermath of this tidal wave of rape, and a large number were given up for adoption since in many cases the women's husbands or other relatives would not accept them into what survived of the family.

The incidents and the surviving documentation of them are as brutal and as horrifying a story as one could encounter. What is equally astounding, however, is the silence that surrounded them for forty-five years. Watching these women, now in their sixties, seventies, and eighties, struggling on camera to formulate in words an experience for which no structures of articulation seem to have existed is at least as significant as being informed of the facts themselves. As one of the Russian intellectuals interviewed in the film states, this was a sexual genocide, a mass rape in which it was not the women themselves who were raped but the womenfolk of the German soldiers, a conquest by proxy that was written through women's bodies onto the military and political terrain.

One of the women interviewed, an elderly doctor with a white bun and a flowered shawl, made my mind leap back to the red-nosed, unfashionably clad doctor in the 1946 *Vogue* article. The woman in the film spoke of withstanding her male colleagues' disapproval and defying the Nazi laws still in effect in order to provide "gynecological cleansing procedures" to women who had been raped in Freudenstadt, where Moroc-

can Free French troops raped large numbers of women in retaliation for war crimes committed by a German battalion originating in this city. She spoke of treating some six hundred women within a period of ten days. Suddenly I began to speculate about the woman in the article who had been "one of the only 250 doctors allowed [by Allied forces] to practice in Frankfurt." Who and what had she defied to be considered sufficiently untainted to work as a doctor in 1946? What could it have been like to be one of very few women doctors and to function in some form of opposition? From a nervous and unfashionable apparition she is transformed into a field of possibilities for defiance, resistance, and, perhaps, humane impulses.

The women in Helke Sander's film spoke of their efforts to deform themselves and present an unattractive facade to the occupying soldiers, of their not understanding that these rapes had nothing to do with sexual desire. They spoke of their husbands' and fathers' anger at them for not having resisted their attackers more aggressively, of the doctors' unwillingness to help, of the years of angry silence in their homes after their husbands returned, of their inability to conceive of themselves as war victims or casualties and to lobby for some form of benefits for themselves and their children. They spoke of a generation of denial of sexual identity and of the repatriarchalization of the domestic sphere in the postwar period. They spoke quietly and calmly, without embarrassment, anger, or horror, and most of all they spoke with a sense of wonder that this was actually and finally a subject of discussion. We left the cinema as perplexed as we were horrified: How could all of this have somehow been written out of historical narratives? Where were the structures of historical analysis that would unearth and thematize the gendered and sexual dimension of military, political, and social history in their own terms, perhaps as a counterdiscourse to whatever terms dominate official understanding founded in policy and legislation? The silences and absences were not born of timidity. These were strong and capable women who had survived fascism and war, who had worked and brought up children and kept families together. Their silence was not necessarily a product of denial and the wish to forget but of the absence of a legitimate discourse into which their experiences could be placed.

Obviously, a double process of victimization has taken place here: these women were victimized by the soldiers who brutally and repeatedly raped them and then by the social structures that denied them help and recognition. The second level of victimization occurred through the totalizing historical narratives that denied them the possibility of articu-

lating their experiences as part of a collective national moment of apoc-
alyptic trauma and change. That these linked victimizations have taken
place is neither accidental nor simply a matter of inhibition, but is the
combined effect of the inconvenience of these narratives within a set of
postwar political trajectories and of the total absence of discourses of the
sexual economy of warfare and liberation.

It is here—in the concealed and potentially possible narrative structures
of historical discourses and in the implications of their suppression and
articulation—that I would locate the urgency and the resonance at this
particular moment. Gayatri Spivak has described her own quest to un-
derstand "in what ways, in what contexts, under what kinds of race and
class situations, gender is used as what kind of signifier to cover over
what kinds of things."[9] If contemporary museum displays of the period
of fascism are characterized by a disproportionately high representation
of the lives of women, domestic economies, and the culture of survival,
if the display modes themselves are operating in resistance to solid, co-
herent, and continuous narrative structures of history and substituting
bits and pieces of historical debris in their place, what form of historical
rewriting is actually taking place? Furthermore, if feminine as victim is
serving as a metaphor and structure of identification for the entire nation
as victim, what form of alternative historical narrative is being con-
structed here? It is therefore gender as a covert signifying practice that is
the concern I will briefly attempt to sketch out here.

To begin with, I would like to locate my argument within the broader
critical discussion that has been converging on the "museum" as a cul-
tural concept and as the site of cultural narration. The subject of the emer-
gent field within which the present discussion is operating is the attempt
to view the concept of "museum" as a twentieth-century critical dis-
course, a theorization of the cultural practices of collecting, classifying,
displaying, entertaining, and legitimating *various* histories through *se-
lected* objects within *staged* environments. The intent of this form of anal-
ysis would be to shift away from chronicling the museum as an institu-
tion and toward a mapping of twentieth-century critical theories of
culture converging on the museum as a site of the production of knowl-
edge and cultural sensibilities. Thus, by focusing on a series of texts that
represent some of the main tenets of Western critical thought in this cen-
tury, we are able to chart the emergence of a "museum discourse" in
which concrete histories are interrogated via concepts of habit, fiction,
desire, and consciousness. While mapping out this field may seem like a
digression, it is ultimately important for a process of denaturalization of

what I find to be deeply gendered displays of German history under National Socialist fascism. If we understand the tools and processes by which concepts such as the "museum" become self-legitimating, we stand a better chance of recognizing the means by which categories of gender are manipulated within historical narratives.

The museum, as a complex amalgam of ideological intentions operating through strategies of pleasure and gratification, is equally the site of the production of cultural identities. Through numerous and varied practices, cultural exclusions are reproduced and cultural "otherness" is constituted. In mapping the contemporary field, we are careful to distinguish between such problems as the extremely limited representation of work by women artists and the problematics of a determining masculinist code for artistic production, innovation, and quality. Equally, we distinguish between the display of other people's cultures and the consequent construction of their identities within a Western cultural discourse and the problematics of displaying cultural appropriation, such as "primitivism," within dominant cultural practices. Thus, the history in which this discourse is located is not so much the history of specific institutions as the history of twentieth-century critical preoccupations and problematics as they converge on the concepts of museums and museumification as mediating both cultural fantasies and power relations.

Museums are ostensibly utopian sites (I am using Foucault's formulation of both utopian and heterotopian sites)[10] — sites with no real places, supposedly representing society itself in perfected form. In the process of being transformed from collections of scholarly research to the sites of public spectacle they are today, these utopian fictions have somehow become emblematic of modern solidarity. Over the past twenty years a broad range of critical analyses have converged on the museum, unmasking the structures, rituals, and procedures by which the relations between objects, bodies of knowledge, and processes of ideological persuasion are enacted. The critical analysis of the museum as the site of actively disseminated hegemonic culture has taken place within several overall categories focusing, as we set forth in our introduction to this book, on issues of classification and ordering, on the links between collecting and ideology, on the ability of modes of representation to manage cultural consciousness,[11] and on a recognition of the absences and exclusions that museums practice.

These, then, are the main categories in which *critical* analysis has taken place. In my own work on museums and the politics of display I am interested in shifting away from the concept of museum as utopia, a site in

which society is represented in ideal form, to what Foucault termed "heterotopias"—countersites in which all the other real sites that can be found in culture are simultaneously represented, contested, and inverted. Thus, I am interested in examining the relations between the museum and Adorno's "Museal" (describing objects to which the viewer no longer has a vital relationship and that are in the process of dying)[12] and seeing how strategies of display actually make the museum the funerary site of uncomfortable or inconvenient historical narratives. This form of analysis has something in common with certain contemporary art practices that serve as interventions into the culture at unexpected moments and places and that refocus our cultural gaze on sites conveniently evacuated of their historical meanings by what Denis Adams refers to in his body of recent work as "the architecture of amnesia."[13] Furthermore, my work has been influenced by my concern over the acceleration, within North American and European cultures, of a certain museumification, a manipulation through strategies of display of historical periods and historical processes. I would like to understand how Adorno's theory of the "museal" works in relation to historical narratives as well as to objects of aesthetic edification. The following brief account of both historical artifacts and strategies of display, then, attempts to examine the manipulation of gender categories in reconstituting a mode of representation for National Socialist fascism in German museums of history.

The documentation and representation of National Socialist fascism has been an issue of constant debate within German and international museum circles over the past decade.[14] As the tendency toward more specific and detailed documentation has grown, so have discussions concerning the need to formulate a display strategy that signals to the viewer a critical attitude. Much of the discussion has focused on the fears expressed by many German scholars and museum workers that in constructing extensive displays of the period of German fascism one is constantly running the risk, however minimal, of nostalgically reproducing the culture of the period. At the same time, loss of personal memory and its effect on the collective historical memory has been equally feared. While this is specific to Germany, it also reveals a certain model—an extreme one, to be sure—of rewriting the relations between historical legacies and contemporary ideologies through gendered systems of representation.

As a consequence of these discussions, increasingly inventive and complex display solutions that aim at acquainting viewers with germane facts

about life in the period between 1933 and 1945—without glorifying its theatrical bombast and its public rituals of national might and glory—are being formulated. Many of these display modes have been influenced by the work of the *Alltagsgeschichte* school of historians, in which the emphasis is on the secular and mundane rituals of everyday life rather than on the events of acknowledged importance in the historical narratives of the state and its institutions being enacted at the centers of power. Thus, displays often focus on the domestic sphere, on the life of civilians at home during the war, on issues of commerce, nutrition, and the culture of survival. A very particular process of feminization has taken place through the selection of the issues that are being foregrounded and the objects used to represent them. By feminization I mean both a disproportionately large representation of women in the domestic and private sphere as well as a system of representation that operates through binary oppositions of strong and weak signs. While I may oppose binary systems at the critical level as a narrow and limited set of ordering principles, the need to be responsible and conscious readers or viewers requires us to recognize the degree to which such oppositions dominate cultural formations.

The original aesthetic of the fascist era was on the whole coherent, unified, monumental, seamless, idealized, and bombastic. Musclebound male bodies had impenetrable surfaces, and classical, composed, and deeroticized female bodies were subservient to the task of historical continuity, of continuing the links with the original Aryan culture of Hellas (fig. 11.2). These were bodies of total integrity in which no disruption occurred at any level, either in the smooth sealed surfaces or in the distinct cultural classifications. These were also bodies marshaled in public displays of staged power framed by architecture, a kind of Taylorism in the service of a spectacular economy of staged power.[15] As a system of representation, these manifestations were founded in a universalized binary opposition of power and simplicity: heroic power and aloof tradition versus the simple, sentimental formulas of supposedly cozy, harmonious domestic lives. Such a system of representation aimed at transcending the struggles of class and gender, outlawing racial otherness, and substituting an internal play with regional otherness as a form of acceptable exoticism within the sanctioned paradigm of the European and the Aryan.

The contemporary museum displays of fascism have done everything within their power to counter the original system of signification. The

Fig. 11.2. Arno Breker's "Victory," 1941. Photograph
courtesy of Düsseldorfer Kunsthalle, reprinted from
their catalog *1937, Die Axt Hat Geblüht* (1987).

first of the cases I want to examine is a permanent exhibition in Berlin
entitled Topography of Terror, the remains of the former Prinz Albrecht
Palais, an eighteenth-century palace that became the infamous Gestapo
headquarters in Berlin (fig. 11.3). Sponsored by the Berlin Senate, ad-
ministered by the Berliner Festspiele, and opened to the public as a mu-
seum in 1988, the site is an excavation of the subterranean remains of the
building, which was leveled by Allied bombings of the city. In its man-
ifest anxiety not to reconstruct or even allude to the former glories of the
historic site and therefore to its continuing historical location, it perfectly
exemplifies my perception of the move from ruins to debris.

Fig. 11.3. Two views of the partially ruined dungeons of former Gestapo headquarters in Berlin, now the exhibition space. Topography of Terror. Photograph by I. Rogoff.

A curatorial and political decision was made to leave the site in a largely destroyed state; all that remains under broken cement rafters, twisted steel girders, and demolished brick walls is the state police basements with their instruments of torture.[16] The sole addition to these dank chambers echoing with associations of both tortured and torturers is an installation of sober historical documentation in a makeshift room above the basements. At the time of the public inauguration of the museum in 1988, its location near the soon-to-be-torn-down Berlin Wall served to enhance its message of discomfiture.

It is clear from the documentation that the decision to leave the site in this state reflects an inherent unease with any possibility of reconstructing it. To leave it in the form of debris, which does not allude to the structure that existed above except through historical legend and sober, distancing documentation, seemed an honorable solution. The historical display fragments the original narrative and replaces the original animating forces with distant representations. Another aspect of this display strategy comes into effect inadvertently, however. It elicits from the viewer, who physically shares in the experience of ruination and whose imagination, fed both by the documentation and by numerous postwar filmic

representations of Nazi torture taking place in dank basements, a set of empathetic and participatory responses. A structure of identification is set up, enhanced by the pathos and devastation of the physical site, in which the viewer identifies with the victims of the regime. Thus, the entry into the historical narrative is made at the point of a collective victimization by an oddly absent, oddly distanced tyrannical force. But who were these victims of Gestapo torture ? They were primarily those opposed to the regime, those designated as intolerable to its aims, and those characterized by it as vile, dangerous, and unworthy of the right to exist. Ordinary citizens who obeyed the laws did not on the whole suffer torture at the hands of the state police. What they did suffer was the losses and deprivations of a horrific war, and it is the conflation of these two modes of suffering and the leveling of the concept of victimization that some of the other exhibition strategies bring to mind.

In another one of these displays—the section devoted to the period between 1933 and 1945 in the mammoth Berlin, Berlin exhibition at the Martin Gropius Bau in 1987, one of several dozen exhibitions that celebrated the city's 750th anniversary—another form of counterdiscursive fragmentation was utilized.[17] Foregrounding the pathetic, defiled, and fragmentary relics of the era are extensive displays of, for example, burned and crumpled identity papers, bundles of the yellow stars that Jews were forced to wear for identification, several moth eaten suits of concentration camp inmates, and some pathetic secret toys (figs. 11.4, 11.5, 11.6). In this form of display, the master narrative of the period is not only fragmented but also domesticated through the use of objects of everyday use. In this particular display, the tendency to make these everyday objects speak of historical dissolution brings to mind an odd precedence: similar means were used by the National Socialist regime to set up hostile ideologies as binary opposites.

Soon after the 1937 cycle of famous exhibitions—of Degenerate Art, Great German Art, Peoples Folk Craft Traditions—another exhibition was staged, ironically entitled The Soviet Paradise.[18] In its displays of the pathetic clutter of impoverished everyday life under the Soviet regime were included shabby suits of clothing hung on the walls of simulated shack dwellings (fig. 11.7). These degraded objects of everyday life and their haphazard arrangement in the display alluded to debasement, incoherence, and lack of both ideological and moral integrity.[19] It is curious to see how the contemporary displays repeat the strategies of this little-known and long-forgotten exhibition. Throughout Berlin, Berlin, as in the earlier historical exhibitions, the concept of "clutter" serves to em-

Fig. 11.4. Berlin, Berlin exhibition: identity papers. Photograph by I. Rogoff.

Fig. 11.5. Berlin, Berlin exhibition: yellow stars worn by Berlin Jews. Photograph by I. Rogoff.

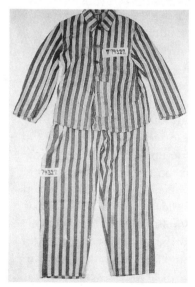

Fig. 11.6. Berlin, Berlin exhibition: striped suit worn by an inmate at Sachsenhausen. Photograph by I. Rogoff.

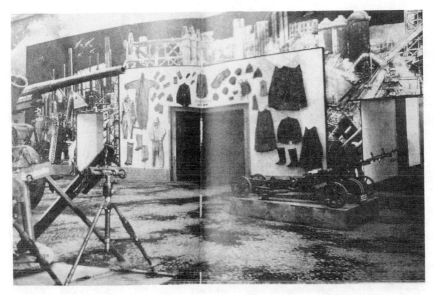

Fig. 11.7. Photograph (by Max Krajewski, 1937) of the Soviet Paradise exhibition, reproduced in the catalog *Inszenierung der Macht*, Neue Berliner Kunstverein, 1987.

body a particular narrative strategy through modes of display. Capitalizing on the earlier Nazi condemnation of clutter as a representation of ignominious dissolution and glorified by the historical discourses of *Alltagsgeschichte*, which afford the everyday a role in the heroic resistance to the master narratives of dominant culture, this aesthetic is here reversed. In addition, one is surprised by the predominance of images of women and family life, by the degree to which the years of military struggle are represented through images of women engaged in the culture of survival—raising children, queuing for food, sifting through the rubble of bombed buildings.

The display at the Osnabrück City Museum with which I began is a clear example of the combination of a display strategy that utilizes "clutter" as a counterdiscourse to official and public representations of fascism and populates this counterdiscourse in the form of an exhibition with images of women in the private sphere (fig. 11.8), thereby creating a link between the display and a domestication of history. The extensive use of glass vitrines in which almost all of the objects are grouped through supposedly eccentric and subjective choices—like the bric-a-brac in any bourgeois home of the 1930s—serves to accentuate the aura of the domestic and the arbitrary.

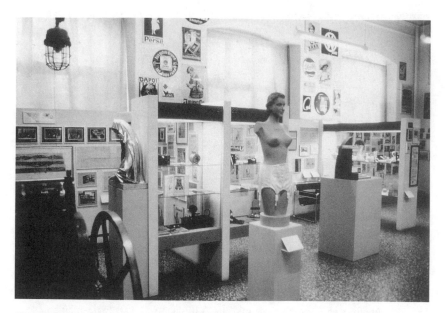

Fig. 11.8. The display of objects, artifacts, and photographs from the period under National Socialism, 1933-1945, in the city history section, City Museum, Osnabrück. Photograph by I. Rogoff.

A close look within some of these glass cases reveals that certain principles of gendered binaries are at work within the groupings (fig. 11.9). Here the objects on display are all props of a masculine culture of warfare: daggers, medals, citations, busts of heroes, and so on. They are set up in relation to a seemingly out of place erotic statuette of the nude Psyche with Cupid. Returning to my original concern with the structure of the fetish, I would argue that this statuette, its incongruous placement accentuating its own status as a fetishized object, stands for an absent articulating context for these other objects. Freud, in his theorization of the fetish, talks about the male child's emerging castration anxiety and then says, "In later life a grown man may perhaps experience a similar panic when the cry goes up that throne and altar are in danger, and similar illogical consequences will ensue."[20] The remarkable juxtaposition of war memorabilia—both instruments of aggression and significations of honor and loyalty—and this erotic image of unbounded female sexuality is a concrete visualization in historical terms of the binaries of public sacrifice and private gratification. In contemporary terms, however, as a strategy of representation it works to signal absence rather than gratifi-

Fig. 11.9. The display of objects, artifacts, and photographs from the period under National Socialism, 1933-1945, in the city history section, City Museum, Osnabrück. Photograph by I. Rogoff.

cation. The encompassing whole of historical narratives of war and battle and ceremony cannot and must not be recuperated. Some other context or frame must be provided to contain these relics, and that context is suggested by the nude Psyche, the statuette's mythological status somehow transcending its historical specificity while providing a base for the narrative in a continuing and enduring drama of human nature. In the absence of the placating powers of a coherent historical narrative, such gendered binaries as are displayed in this glass cabinet can be related to one another and serve an explicatory function when they are viewed through the structures of the fetish. In the context of the overall dynamics between objects and historical narratives in the exhibition, we can view this arrangement of objects as serving to encode a relation between strong and weak signs within systems of representation gendered masculine and feminine.

My use of the concept of "feminization" in constructing this argument is problematic and perhaps unclear. I would like to clarify it through expansion. At one level, I am indeed deploying the term "feminization" to mean the images of women and the domestic sphere that seem to dom-

inate the displays everywhere. Beyond that, however, I am most concerned with a principle of representation that rests on certain theoretical formulations of femininity in relation to some other structure or some other ordering principle. Thus it is femininity and therefore feminization *viewed and manipulated* as a discursive position and as the weak term in a binary opposition of masculine/feminine that interests me here. Furthermore, my use of feminization in this argument rests on its being perceived within this cultural strategy of "the feminine" as a sign of a lack or an absence. It is through these structures of meaning that I can point to certain display strategies as being profoundly gendered. It is their existence within a set of binary opposites, their ability to hint at a lack or an absence, that constructs their functioning as gendered.

The opening in 1989 of the Deutsches Historisches Museum, a new museum of history then in temporary headquarters in West Berlin, lent another dimension to these questions. The opening exhibition, displaying some of the museum's recent purchases and focusing on the war years of 1941 to 1945, was held in the basement of the museum's quarters.[21] The already dank basement created a dungeonlike atmosphere in which distant rumbles of taped "war sounds" were heard, while the displays concentrated on images of civilians, primarily women and children behind the lines, and on the domestic sphere as viewed through humble household implements. Viewers were constituted as victims, along with the historical population on display, as victims of the period of German fascism. It is a model of victimization in which both categories—gender and the private sphere—come together as counterdiscourses to the public, aggressive, and domineering mode of National Socialist fascism and its world of signification.

The historical display of the period of National Socialist fascism eschews aesthetics in favor of material factuality and focuses on the small, humble, burned and crumpled remains of simple, everyday lives. Inverting the system of representation from the original masculine aesthetic to one that I would characterize as "feminized," emphasizing the realities of women's lives (*civilian* lives), and focusing on the remains as *debris* rather than *ruins* and on the protagonists as *victims* rather than *vanquished* rewrites the entire relation of the nation to its fascist heritage. Furthermore, the dramatic and pathetic strategies of display construct the contemporary viewer as an equally victimized heir to this national legacy. The consequence is imprisonment of the entire project within a binary structure in which the original rhetoric and aesthetic continue to determine the present through a process of negative differentiation.

Fig. 11.10. Berlin, Berlin exhibition: chess game camouflaged in cigarette case.
Photograph by I. Rogoff.

The neo-Marxist materialist critiques of culture launched in the late 1960s and the impact of the school of *Alltagsgeschichte* have obviously had a great deal of influence on the visual display of culture in their insistence on a much wider representation for classes, genders, and regions privileged by such narratives. The impact of the *Alltagsgeschichte* school of history in its recuperation of the dismissed and undervalued histories and narratives of the disempowered and the disenfranchised has led not only to the selection of such humble objects for display but also to their being invested with properties of resistance. One object in the Berlin, Berlin exhibition seems to encapsulate these shifts and the meanings invested in them: a small metal cigarette box taken into the concentration camp at Sachsenhausen, apparently through the auspices of the Danish Red Cross (fig. 11.10). Secreted behind the cigarette pack is a miniature chess game made of paper. The object has an internal subversive content in that it contains a forbidden, smuggled game and simultaneously serves as an emblem of historical resistance in the context of the contemporary museum display. In this display, we are not shown any official or public images of the camp at Sachsenhausen; we see it represented through the inmate's striped suit, the cigarette box, identity tags, and so forth. These humble objects function to counter the official and the public narratives

on the one hand, and to anchor the viewer through simulacra of supposedly "personal" memories on the other. They are the components of Walter Benjamin's "construction of an alarm clock that awakens the kitsch of the past century in 'recollection.' "[22]

Similarly, the extensive and thorough feminist project of recuperating and exhibiting the ignored histories of women and of their representation within modern German history has also had a considerable if less acknowledged influence. The combined impact of the strategies of *Alltagsgeschichte* and of feminist historical recuperations does not, however, completely explain the shift in the gender basis of the entire nature of the display. Images of women dominate everywhere, ranging from mobilized youth to ideal mother to civilian struggling for survival and continuity of life among the ruins. Victorious or defeated armies and the mobilized and intrusive nature of public life under what is now called "the terror" are strangely absent. Display strategies include basements and dungeons, reconstructed shelters and interrogation cells, wailing sirens and bombings on audio tracks. Everywhere, the main protagonists are women, and dotted here and there are oddly eroticized and fetishized images such as the armless, legless, corseted mannequin with which we began.

Fetishized and gendered feminine, these displays become, to rephrase Donna Haraway's term, technologies of (not reinforced but of) suppressed and rejected meanings. By investing the narratives with properties of the erotic and the domestic, of victimization and domination, fetishized objects gendered feminine can allow for an alternative narrative of mastery and control over a repressed though unmasterable past. The historical realities of women's lives throughout the period have once again been subjugated to the structures, policies, and narratives of the state.

Every one of the studies on the lives of women under fascism and during the war that I have consulted tells us that they were oppressed by the state.[23] To be sure, they were both oppressed and denied many of the progressive reforms that had been legislated during the Weimar period. But Claudia Koonz, one of the historians who tell of the oppression of women, also says that "for all the official misogyny, the Nazi years did not affect long-term trends very strongly. Women's entry into the job market and the decline in family size continued apace without a major break."[24] She details how wartime economies allowed women to move into clerical work and resulted in a rise in wages and notes that the Nazi government leisure programs allowed for trips to Italy and theater outings for their members, experiences that would not previously have been available to working-class women. As Homi Bhabha claims, "the state

of emergency is also always a state of emergence,"[25] and it is impossible to conceive of women working for years in the public sphere, even at a low level, achieving a certain measure of competence and autonomy through the wretched struggles of daily survival, and filling dual and triple roles within families without some form of change taking place, some form of negotiation between an official ideology of repression and the development of a more confident realization of possibilities. In 1973 Edgar Reitz made a film entitled *Die Reise Nach Wien* (The trip to Vienna) from a script he wrote with Alexander Kluge that seems to have so embarrassed everyone as to have quickly disappeared from view.[26] In it he tells the story of two high-spirited young women in a small village during the war. There are restrictions on food, their husbands and all the other men—except for a few unattractive old codgers and prissy bureaucrats—are away at the front, there are no pretty clothes, no amusements, and daily life is overwhelmed by endless authoritarian restrictions. Our heroines are bored, listless, and disgruntled, and they launch a series of tiny acts of resistance: they slaughter the family pig against all orders and make use of every part of its anatomy, they take down the curtains and make spectacular outfits from them, and finally they embark on a covert trip to Vienna, where, dressed in their new finery, they seduce an enlisted man and a high-ranking officer. The film is fairly realistic about the risks the women are taking and does not claim for them any heroic acts of resistance beyond the gratification of everyday desire for amusement and flirtation. Reitz in 1973 did not yet have at his disposal a filmic language other than romantic adventure comedy through which to tell of his heroines' exploits, and the result was that his film was dismissed as a piece of irreverent froth. It did, however, alert us to the degree to which women's lives can never really be chronicled exclusively in relation to official ideology and policy, for they have always included a high degree of nonspectacular negotiation and resistance at the margins.

Had tremendous changes not taken place in women's perceptions of themselves during these years, how else could we explain the vehemence and ferocity of the postwar backlash against women's independence during the years of so-called normalization of the economic miracle, a backlash that has marked the lives of women in each of the countries that took part in the war?[27] Furthermore, we now know that many women in West Germany did not accept their evacuation from the public sphere and founded civil resistance movements such as the anti-rearmament peace movement and the Mothers' Union against Nuclear Power.

How then are we to understand the correlation between political and historical strategies that insist on keeping women in a state of permanent victimhood and are unable to accommodate their resistance into overall historical narratives and a display strategy that works for an overall "feminization" of the experience of fascism?

In both avant-garde films and literature we have in recent years seen the production of sexualized and eroticized representations of European fascism and a focus on the links between our social fascination with evil and the emergent psychoanalytically influenced perception of the unconscious as the repression of desire. Simultaneously, numerous historical analyses put forward over the past decade have focused on the relation between gender and the representation of fascism in Europe in the 1930s and 1940s. Such analyses identified both the production of images and texts within fascist culture and their reception and reproduction by contemporary culture as functioning within paradigms of stereotyped masculinity. Klaus Theweleit expounded in *Male Fantasies* a social and psychoanalytical reading of actions, images, and texts of the period immediately preceding German nazism that argues that the protofascist discourse is "masculinized" in idiom and pits itself against an opposite political and ideological discourse (either "socialism" or "humanism") that is characterized as "feminine." Saul Friedänder in *Reflections of Nazism — Of Death and Kitsch* extended this argument in his close reading of contemporary European representations of fascism, in which stereotypes of virility, strength, and fetishized desire are at work in the re-reading and reproduction of fascist culture. Within both fascist discourses and revised contemporary representations of them, the issue of masculine purity and its privileging over the organic, the fluid, and the dissolute, which are used to characterize the feminine, plays a central role.

In "Woman — Territory of Desire" Theweleit writes:

> [The] mutability of these processes [of bodied differentiation — between solid and liquid, rational and irrational, etc.] has increased in the course of history with the accelerating of processes of social transition. Femininity in particular has retained a special malleability under patriarchy, for women have never been able to be identified directly with dominant historical processes, such as those that gave rise to bourgeois society, because they have never been the direct agents of those processes; in some way or other they have always remained objects and raw materials, pieces of nature awaiting socialization. This has enabled men to see and use them collectively as part of the earth's *inorganic body* — the terrain of men's own production. Behind every frontier that is opened up the sum total of all female bodies appear; oceans of animated flesh and virginal

skin, streams of hair, seas of eyes—an infinite, untrodden territory of
desire which at every stage of historical deterritorialization, men in search
of materials for (abstract) utopias have inundated with their desires.[28]

Fetishized and gendered displays of the period of National Socialist fas-
cism are about a deterritorialization and reterritorialization of a national
unconscious, played out through a range of psychic responses to dis-
played objects. As Ludmilla Jordanova argues, Freud's work on the fe-
tish, which focused on the endowment of objects with sexual signifi-
cance, can be extended to a broad range of psychic responses to displayed
objects. The aspect of fetish that is about mastery and control over ob-
jects and over people, the one that is played out over the exotic and col-
onized "other," functions as a strategy for dismissing social relations
within the material world.[29] Instead, a tragic, pathetic, passive, and en-
during *human drama* is invoked, enacted through the supposedly timeless
and ahistorical arena of women's lives and written via the representation
of women's bodies and fetishized parts of female anatomy. Museum dis-
plays, in their profound anxiety not to replicate the original seductive
spectacle, have produced an equally dangerous gendered fiction that is
rendering viewers politically neutered through humane empathy and his-
torical mastery.

Notes

Numerous conversations and discussion forums have helped me formulate these ideas.
Conversations with Griselda Pollock, Silke Wenk, Catherine Curtius-Hoffmann, Sigrid
Weigel, Hayden White, and Vivian Sohbchek were crucial in untangling the complexities of
using the term "feminization" in relation to historical narrative. Equally, the opportunity to
present these materials at the history of consciousness faculty seminar at the University of
California at Santa Cruz, to the third International Feminist Art History Conference in
Hamburg, to the graduate students of the Departments of Art History and German Studies
at Stanford, and to the Deutsche Akademische Austansch Dienst/University of California
Colloquium on German Studies at Lake Arrowhead provided extremely helpful opportu-
nities for discussion.

1. Evelyn Clark Emmet, "And the German Women . . . ? Like their buildings, they're
badly in need of repairs," *Vogue*, March 1946. An editor's note says, "One of *Vogue*'s edi-
tors, Evelyn Clark Emmet, went to the European theatre on a three month tour of duty as
a Red Cross correspondent. This report on German women was made especially for
Vogue." The tone of the article is extremely condescending and punitive toward German
women, who are viewed as one homogeneous category, and it echoes the semi-official sen-
timents expressed in the interviews with officers of the American occupying forces that it is
quoting. The aim of the article seems to be to reassure American women of how advan-
taged and progressive their position is compared to that of desolate German women en-
slaved through their obedience to men and to fascism. I am grateful to Stephanie Ellis, a
graduate student in the art department at the University of California at Davis, for bringing
this report to my attention.

2. Ibid., p. 156.

3. Kaja Silverman, "Fragments of a Fashionable Discourse," in *Studies in Entertainment*, ed. Tania Modleski (Bloomington, Ind., 1986), p. 139.

4. Freud, *The Standard Edition of the Complete Psychological Works of Sigmund Freud*, trans. James Strachey (London, 1952), vol. 12, p. 152.

5. A documentary source to these debates is *Historikerstreit*, Serie Piper Aktuell (Munich, 1987).

6. Charles Maier, *The Unmasterable Past* (Cambridge, Mass., 1989) and the *New German Critique* special issue on the "Historikerstreit," Summer 1988.

7. Dietmar Kamper, "The Transformation of Bodies by the Imagination: On the Arrogance of the Mind Towards Time," in *Binational—German/American Art of the late 80s* (Dusseldorf and Boston, 1988), p. 50.

8. *Befreier und Befreite* directed by Helke Sander, Bremer Institut für Film und Fernsehen, 1992. The film is accompanied by a book of the same title by Sander and Barbara Jahr, (Munich, 1992). The bulk of the research on which the film is based is documented in this volume.

9. Gayatri Spivak interviewed by Walter Adamson in *Discourses: Conversations in Postmodern Art and Culture*, ed. Russell Ferguson et al. (Cambridge, Mass., 1991), p. 107.

10. Michel Foucault, "Of Other Spaces," *Diacritics* 16, no. 1 (1986).

11. This work is based on Hans Magnus Enzensberger's 1967 *The Consciousness Industry* and has been explored in detail in the work of the artist Hans Haacke, "Museums: Managers of Consciousness," in Brian Wallis, ed., *Hans Haacke: Unfinished Business* (New York and Cambridge, Mass., 1986), p. 60, and the work of Marcel Broodthaers, available in English in Marge Goldwater et al., *Marcel Broodthaers* (Minneapolis, 1989) and a special issue of *October* (no. 42) on Marcel Broodthaers edited by B. H. D. Buchloh.

12. Theodor Adorno, "The Valéry Proust Museum," in his *Prisms* (Cambridge, 1975), pp. 175-85.

13. See the "Fallen Angels" project in Graz's Styrian Autumn Festival 1988, in *Denis Adams: The Architecture of Amnesia* (New York, 1991).

14. Protokol der Anhörung zum Forum für Geschichte und Gegenwart, Senator für Kulturelle Angelegenheiten (Berlin, 1984).

15. The most interesting discussion of this phenomenon is the catalog of the Berlin curatorial collective Neue Berliner Kunst Verein, *Inszenierung der Macht* (Berlin, 1987).

16. For documentation of the site and the decisions concerning it, see *Zum Umgang mit dem Gestapo-Gelande*, Gutachten der Akademie der Kunste (Berlin, 1988).

17. *Berlin, Berlin: Die Ausstellung zur Geschichte der Stadt*, Berliner Festspiele GMBH (Berlin, 1987).

18. Inszenierung der Macht: Austellung "Das Sovjet-Paradies" in *Inszenierung der Macht*, pp. 51-63. Nine days after the exhibition was inaugurated by Goebbels on May 18, 1942, it was sabotaged by a resistance group of Jews and communists. As a result of explosions, part of the exhibition burned down. The photographs here were taken at the time of the opening by the photographer Max Krajewski and were discovered in 1986 during the demolition of a building on Berlin's Potsdamer Strasse.

19. "Das Sovietische Paradies," a photo essay, in *Inszenierung der Macht*.

20. Freud, *Standard Edition* 12:153.

21. *1.9.39: Ein Versuch uber den Umgang mit Erinnerung an den Zweiten Weltkrieg*, exhibition catalog, Deutsches Historisches Museum, Berlin, 1989.

22. Walter Benjamin, " 'H' File," *Passagen-Werk*, quoted in Douglas Crimp, "This Is Not a Museum of Art," in *Marcel Broodthaers* (Minneapolis, 1989), pp. 72-73.

23. Claudia Koonz, *Mothers in the Fatherland* (New York, 1987); Rita Thalmann, ed., *Femmes et Fascismes* (Paris, 1986); Christine Witrock, *Weiblichkeit Mythen: Das Frauenbild im Fascismus und seine vorlaufer in der Frauenbewegung der 20er Jahre* (Frankfurt, 1983).

24. Koonz, *Mothers in the Fatherland*, p. 198.

25. Homi K. Bhabha, "Remembering Fanon: Self, Psyche and the Colonial Condition," in *Remaking History*, ed. P. Mariani and B. Kruger (Seattle, 1989), p. 134.

26. *Die Reise nach Wien*, script by Edgar Reitz and Alexander Kluge, directed by Edgar Reitz, Production Reitz/WDR, Cologne, 1973.

27. For the most cogent discussion of the redomestication of German culture viewed through representations of women in mass media culture and in public sphere activity, see *Perlonzeit: Wie die Frauen ihre Wirtschaftswunder Erlebten* (Berlin, 1985).

28. Klaus Theweleit, *Male Fantasies*, vol. 1 (Minneapolis, 1987), p. 294.

29. Jordanova constructs an extremely interesting use of the fetish in relation to dominant epistemic structures and filtered through museum display strategies. Her discussion focuses primarily on the relation to "other culture" as designated in the work of James Clifford and Donna Haraway and differentiates between the aspect of the fetish that is about mastery and control and the aspect that is about designating things as possessing magic. See Ludmilla Jordanova, "Objects of Knowledge: A Historical Perspective on Museums," in *The New Museology*, ed. Peter Vergo (London, 1989), pp. 38–39.

12

A New Center:
The National Museum of
Women in the Arts

Anne Higonnet

It was an institution whose time seemed to have come—a museum for art by women.[1] It was going to mean recognition for women's achievements, a celebration of their history, a retort to centuries of ignorance and dismissal; it was going to redress the inequities that women still face in the art world. But even before the museum opened in 1987, while it was still being planned, in the early 1980s, the controversy began. Were women being hailed or condemned by a sex-segregated institution? Had too many compromises been made to fund the museum? Was its collection aesthetically adequate? The answers have streamed on and on, combative and impassioned. Meanwhile, the National Museum of Women in the Arts (NMWA) garnered what may be the most considerable constituency, in terms of both numbers and dedication, of any American museum its size.

Each group had its arguments. But these arguments were, ultimately, less about the museum itself than about the ideology that subtends it. The real issue was the economic and political institutionalization of feminism. As the cultural manifestation of that phenomenon, the NMWA unsettled both the right and the left of the American political spectrum. In the eyes of the right, the museum brought together what should never be mixed: politics and culture. From a leftist point of view, the NMWA did not mix politics and culture enough. Neither of these positions was new.

What was new was a middle ground the museum represented, a position that denied any conflict between its gender convictions and its political beliefs, happily navigating the shoals of commodity marketing and corporate financing. For its constituents, at once moderately feminist and politically centrist, the institutional embodiment of their beliefs posed no dilemma. The very existence of the NMWA signaled their accession to

mainstream political status. A cultural institution like a museum varnishes established authority to a high gloss.

Caught in a crossfire, the NMWA has been forced to defend itself. Its political position remained liminal, secured without being secure, empowered but not powerful. The gender component of the NMWA's program had not become as neutral a factor as its founders had hoped. Moreover, the NMWA has exacerbated its situation by making the charged issue of gender impossible for anyone interested in museums to ignore. The NMWA gave institutional weight to an interpretation of women's situation in the history of art in a way that could not be dismissed. All of a sudden, the NMWA's interpretation existed as a building two blocks from the White House in Washington, D.C.; as a permanent collection of more than five hundred works and a schedule of temporary exhibitions; as a library; as a staff; and as money—as the $19 million investment of individuals, corporations, and foundations toward the NMWA's $30 million fund-raising goal.

"There is no such thing as women's art," said museum founder Wilhelmina Holladay. "Art is art, but there is art by women that is not recognized yet."[2] Holladay characterized the foundation of the museum as a "feminist act," but added: "We're doing it for women, so the adjective is suitable. But we've tried very hard to not talk about the inequities. We've decided that putting the accent on the achievements of women, on the positive, makes a better statement."[3] The NMWA officially maintained that art had been ignored in the past if it happened to be by women, that women's art was unfairly represented, and that the museum could begin to redress that inequity by exhibiting women's work under its institutional aegis. Avoiding all polemic, Holladay explained her position as a narrative, told in her own voice. Her story had a beginning: her first purchase of a woman's painting, made with her husband Wallace; and an end: the establishment of the museum. Along the way we met artist heroines like Clara Peeters and Maria Sibylla Merian and an art historian villain, H. W. Janson.

The NMWA agenda assumed that women's art means women's painting, supplemented by sculpture, drawings, and prints. Holladay said: "The museum can't help but succeed, at least to some extent, in heightening the awareness that women have painted great paintings."[4] The NMWA encoded its attitude in its catalog, a lavish book made possible by Philip Morris and the National Endowment for the Arts. Each "great" woman artist received a monographic two-page spread, complete with an image of the artist as well as images of her work. Artists

whom the museum apparently considered less "great," like Native American ceramicists, were grouped several to a page. The NMWA's aesthetic standards remained undaunted by the fact that artists in their collection deemed "greatest" by traditional standards were rarely represented by a work deemed major according to those same standards, but rather by a print, a drawing, or a sketch. One major concession to artistic diversity had been a change in the museum's name, which initially was the National Museum of Women's Art.

The NMWA position immediately aroused controversy. Those more conservative than NMWA leaders objected to art being awarded museum status only because women made it. This argument itself developed two variants: if women's art were of "museum quality," ultraconservatives argued, it would already be in museums,[5] while the NMWA "sets a new low in abandoning even the pretense of adhering to an aesthetic standard";[6] those who maintained this position claimed that women already receive " 'equal' — which is to say preferential — consideration" in the art world,[7] and that "art should be separate from sociology."[8] A more nuanced position described the NMWA as an unfortunate but necessary temporary measure. The museum would enable the passage of a genderless artistic excellence to its rightful reward in an objective and open marketplace of culture, and "then this museum would become obsolete."[9] From those more radical than the NMWA leadership came the objection that separate is not equal. Some feminists found separate status intrinsically demeaning, a kind of "ghettoization,"[10] and demanded recognition for women's art in existing institutions on the grounds that women's art could already be favorably compared with men's art if the observer were unbiased.[11] Another sort of feminist criticized the NMWA's quality criteria for not being separate enough. Since, according to this opinion, the NMWA patterned its definition of art on First World white bourgeois men's terms, which deny the inescapable difference of women's art in a gendered culture, it ignored the realities of women's artistic production.[12]

All these reactions received unpredictably extensive media coverage. Mainstream journals like the *New York Times*, the *Washington Post*, *Time*, and *Newsweek* devoted prominent columns to the most basic gender issues of art's history. In 1987 alone, 260 press items came to the attention of the NMWA public relations office.[13] Arguments both for and against the NMWA publicized discrimination against women's art more widely than it had ever been publicized before. Even admirable (and perhaps more consistent) advocacy groups like the Guerrilla Girls and the Wom-

en's Caucus for Art could not command an audience as important in sheer size. Among the statistics thus broadcast were the 236 to 20 male to female ratio in the twentieth-century wing of the Metropolitan Museum of Art in New York and the thirty-three cents American women artists earn to the male artist's dollar (compared with the fifty-nine cents women earn overall to the male dollar).[14]

Of course gender issues were brought to popular attention because the NMWA bids for a museum's valorizing power. The bid itself was banal; hundreds of museums in America, both art museums and museums of special-interest groups, deploy institutional prestige to further the claims of their constituency. The NMWA's bid distinguished itself by the strength of its response, a strength measured both in terms of publicity and in terms of member, donor, foundation, and corporate support.

Wilhelmina Holladay orchestrated that success. She and her husband conceived of the museum, gave it their private art collection, found the site, and administered the renovation of the building. Holladay personally conducted the campaign to fund the museum. She is recognized as a gifted fund-raiser, but her gift more truly lies in her choice of a project at the confluence of contemporary gender, museum, and marketing histories and her deft exploitation of that confluence.

The NMWA became a reality in so short a time because it reaped the profits of more than a century's accumulated ideological investment. Most obviously, the NMWA benefits from the cultural aura of the art museum. Less obviously but more specifically, it benefits from the transformation of the museum into a marketplace for cultural commodities. And least obviously but most fundamentally, it benefits from consumer culture's association of art and femininity.

Nowhere did Holladay's feminine artistic values, magnified into NMWA policies, seem more immediately and negatively apparent than in her amateur administration. In the early phases of her project, Holladay gave priority to fund-raising over the considerations of scholarship and design that are deemed professional by others in the museum field. Again, objections came from both right and left. Any woman who raises funds aggressively risks offending delicate gender sensibilities. Nice ladies don't grab money. But while critics ambivalently noted Holladay's freedom from feminine diffidence, they also wondered whether the NMWA's residual feminine tone undercut the dignity of both museums and career women.[15]

Everyone in this debate used the words *amateur* and *professional* as if we all knew exactly what they meant. *Amateur*, of course, is supposed to

mean incompetent and feminine; *professional* means competent, paid, objective, full-time, and, in the best of all possible worlds, blind to gender. In practice, however, these two weapon-words stake out desired but very insecure positions. When the museum as we know it came into being, in the nineteenth century, *amateur* designated someone who loved art, and who knew it expertly, without necessarily making a living from it. Many of the past century's canniest, most innovative collectors (e.g., Lord Hertford, creator of the Wallace Collection) and even museum directors and curators (e.g., Belle Greene at the Morgan Library) could be called amateurs. Only recently has expertise in the arts been inextricably linked to an income and to an official career. Those who now earn their incomes primarily from museum jobs understandably wish to assert that their dependence actually guarantees their superior performance. Meanwhile, women who benefit from husbands' incomes but not from much formal training understandably wish to defend an older idea about the arts that offers them an end run into cultural power.

By 1988, the NMWA had a professional director, Anne-Imelda Radice, who oversaw a full-time staff of sixteen and eighty volunteer docents. But only in 1988 did the NMWA hire its first curator, Helaine Posner. As of that year, the museum still had no curator for any field other than contemporary art. One of the earliest allies of the NMWA was the Junior League, a politically conservative volunteer organization, which gave the museum a $90,000 grant to train volunteers. Holladay said, "I think people work better for love rather than money. If you get paid, well, that's an added bonus, but it's not necessary."[16] The NMWA, however, quickly pointed out that Dr. David Scott, a professional museum consultant who had been involved in many museum projects, including the Louvre pyramid, was "instrumental" in planning the renovation of its building. The museum also asserted that several art historians and foundation counselors played a part in policy decisions. Scott, however, said in 1986 that he had not been consulted for a year,[17] while art historian Ann Sutherland Harris stated in 1987 that she was consulted only "sporadically."[18]

In 1987, Holladay answered charges of amateur curatorial policy and general inattention to staffing with her perceived need to concentrate primarily on the museum's finances. "I will do anything in my power to educate, but I will not let it become political. If we don't become a controversial issue, the business community will continue to support us. At the moment my major concern is raising the money to refurbish the building."[19]

Fig. 12.1. Entrance hall, National Museum of Women in the
Arts. Photograph by Gary Fleming, courtesy of the National
Museum of Women in the Arts.

While no one has faulted Holladay for her pragmatic prudence, some
commentators have taken issue with the choices made in the $8 million
redecoration of the $5 million building, a former Masonic temple (and
therefore at one time exclusively male). Describing the grandiose
ground-floor entrance hall (fig. 12.1), its pink and white marble, three
crystal chandeliers, and gold-leaf ceiling, an *Oakland Tribune* correspon-
dent contrasted it with the space allocated to galleries: "The entering vis-
itor, blinded by the glare of new marble, looks in vain for any sign of art
in the immense first floor lobby . . . and must search out the galleries

tucked away in a portion of the third floor." This writer went on to characterize the hall as "restored in the fussiest manner imaginable" in a "color scheme reminiscent of a discredited 'feminine' taste."[20] The hall has also been compared to Schrafft's,[21] its style called "Early Neiman Marcus."[22]

Indeed, the entire ground floor is devoted to consumption. Only the information desk, right near the door, mars the vast empty lobby that occupies almost the entire floor and extends up marble stairways toward empty mezzanine balconies. The Martin Marietta Hall, a space characterized by an NMWA brochure as "noncommercial," is "available" for a "contribution" of $7,500 an evening. The galleries, too, can be rented, for up to $3,500; accessory docents cost $50 apiece. In order to facilitate catering services, the NMWA spent $1 million to purchase the basement of the building next door so that it could install a fully equipped kitchen. Directly behind the information desk, visible almost from the museum entrance, is the gift shop.

The hall is both cause and consequence of corporate financing. The Martin Marietta corporation contributed $1.5 million toward its renovation. Lascaris Design Group donated the marble. Trane provided the climate control system, American Standard the plumbing, and Du Pont the carpet, while Ridgeways committed itself to stage catered events there at least once a week. Fifty-nine other corporations and foundations have supported the NMWA with contributions in kind. Fifty-four foundations have awarded grants to the museum, and 128 corporations, foundations, and organizations each gave $5,000 or more.

In its allocation of space for the purpose of generating income, the NMWA is hardly different from, for instance, the new wing of the Boston Museum of Fine Arts, whose public spaces are entirely devoted to eating, buying, and blockbuster exhibitions. What startles in the case of the NMWA is the planning of the entire museum from its very inception on the basis of financial imperatives, and the couching of those imperatives in a mode perceived as "feminine." But the NMWA only marks another step in a long association of women with the consumption of cultural commodities, an association understood and encouraged by art museums across the country.

We cannot accept the NMWA as an advocate of women's art that is forced into ancillary financial activities in order to support a primary function; we must instead understand the variety of the museum's activities as the organic logic of its historical situation. The ostensible distinc-

tion made by the NMWA between a cultural mission and a commercial substructure is not, ultimately, a distinction at all.

From its earliest days, advertising has deftly exploited a specious comparison between women's production of art and their consumption of commodities. The first advertisements to incorporate images took the form of fashion plates. These popular prints fostered a femininity dependent on the consumption of goods identified as the elements of an art, the art of fashion. Among the most frequent fashion-plate motifs, as early as the 1840s, are women sketching, painting, visiting museums, and looking into art shop vitrines. This strategy fulfilled two linked functions: it modified the commodity's commercial taint with the sanctity of aesthetic status, and, thereby, minimized women's subjection to the economic imperatives of a consumer culture by valorizing their consumption of commodities as a creative activity.

Though the intended consequence of this identification of feminine consumption with art has been the sale of items whose connection to art is tenuous at best, the premises of the argument have developed a lucrative life of their own. Art institutions—museums chief among them— have adopted the association of purchasable femininity with art to create a specialized market for themselves. Art institutions control this market all the more easily because advertising's association of women with art has always included images of women as passive spectators of art, or even as semi-animate art objects.

Hence the museum's ability to draw on a feminine constituency for many purposes. Museum attendance figures are not usually broken down by sex, but both the Boston Museum of Fine Arts and the Musée d'Orsay in Paris guess that somewhat over half of their visitors are women. Virtually all of the American art museum's educational and fund-raising staff are women—unpaid women. The Boston area, with three major museums of different sorts, provides a telling case. The Museum of Fine Arts builds its gallery instruction around the skills of its eighty volunteer docents; all eighty are women. At least as active and committed to the museum is the Ladies Committee, a group of seventy volunteer women who carry out much of the museum's fund-raising. The Harvard Art Museums also conduct a volunteer docent program, highly competitive because of the university's intellectual prestige: one out of two applicants must be turned down; of the thirty current docents, one is a man and twenty-nine are women. The Isabella Stewart Gardner Museum pays its part-time docents, who compete in training programs; out of twelve current docents, three are men and nine are women. These women volunteers

take their work seriously. Many docent programs screen applicants rigorously, train their members for several months, and require extensive time commitments. The Ladies Committee members serve full-time, four-year terms. The Toledo Art Museum "aide program" requires a full-time, ten-year commitment. The NMWA's use of volunteer labor, as well as the femininity of its fund-raising, thus has roots—and counterparts—in general museum practice.

As museums sought to develop their feminine constituency, they have transformed themselves in the image of their own promotional campaigns, further cementing their alliance with the values of a consumer culture. Like other museums, notably the Metropolitan Museum of Art in New York, the NMWA hosts functions called costume exhibits, which merge fund-raising with the marketing of high-fashion women's clothing. According to an article entitled "In the Glow of Givenchy" covering one of these "gala" events, "there were as many Givenchy dresses on the guests as there were in the exhibition." Some 660 people attended; tickets cost $150, and $100,000 was raised for the museum.[23] The museum holds an annual benefit ball, benefit weekends, and a nationwide array of breakfasts, luncheons, teas, and other events. Most recently, the NMWA has begun planning an "Art in Bloom" program patterned on the Boston Museum of Fine Arts model, pioneered by the Ladies Committee some thirty years ago. Prominent political, social, and entertainment personalities contribute a key element to the fund-raising occasion. Barbara Bush, then wife of the vice president, cut the ribbon at the NMWA's inaugural ceremony. Nancy Reagan, then first lady, was the titular head of three of the museum's annual balls. Museums cannot now survive without such events.

The NMWA carries the association of feminine production with a feminine consumer identity to a new level by offering women the most prestigious and self-enhancing artistic commodity of all—an entire museum. Wilhelmina Holladay's personal social stake in the establishment of the museum is by now conventional, having precedents in innumerable museums—the Frick, for example. She denied that she enjoys NMWA publicity personally: "Don't write about me. Write about the museum. It isn't an ego trip for Wally and me. We have no ambitions, social or political."[24] Yet she has made herself indispensable to a very visible public cause and seems unlikely to relinquish her role. "I have to do it myself," she says. "People want to talk to me."[25] In 1987 she was named Washingtonian of the Year by *Washingtonian* magazine.

Public relations benefits for corporate donors are also familiar. AT&T has been commemorated for its $100,000 donation of the library reading room; United Technologies was duly and visibly acknowledged for the $500,000 that underwrote the inaugural exhibition, American Women Artists, 1830–1930. If corporations have been unusually generous, it is because, as Wilhelmina Holladay said, "I speak their language. And I'm not sure museum people always do."[26] Gordon Bowman, director of United Technologies' art program, agreed: "Billie Holladay is sensible as well as enthusiastic. Corporations *like* people to be sensible."[27]

Holladay obviously also used her social prominence and her Washington diplomatic contacts for fund-raising purposes. Museum support committees were formed by ambassadors' wives, supposedly because they would represent the interests of foreign women artists. Some very wealthy women are among the NMWA's board members and supporters; 481 members each contributed $5,000 or more. Three anonymous donors gave $1.5 million each to help the museum buy its building. On the museum's advisory board in 1988 was Mrs. Adnan Khashoggi, wife of a man reputed to be among the richest in the world. Said Caroline Hunt Schoellkopf, the richest woman in America, a founding member of the NMWA, and a member of its Texas committee: "I had faith in Billie. With her dedication and dynamism, I knew the project would be a success."[28]

But the NMWA offered something to more modest women on a scale and with a success never before imagined. As of 1988 the NMWA had more than 83,000 base-level members, who had contributed an average of twenty-five dollars each.[29] (The Corcoran Gallery, a museum of comparable size, has 3,500 members.) "My financial contribution is small, but it is the support of one more woman,"[30] wrote one supporter. Holladay had worked toward a grass-roots organization by establishing state committees. NMWA fund-raising brochures appealed to the individual woman, sometimes on a professional basis, sometimes in more traditionally feminine ways. And the appeal worked. In answer to NMWA mailings, one woman wrote from Alexandria, Virginia: "I received your letters and actually read them. They are, although printed by the hundreds, I am sure, personal and caring, and they show your dedication to the Museum."[31]

Holladay appeared in person at innumerable fund-raising efforts, frequently organized by the wives of state governors or by corporation executives. She gave the NMWA a face and a personality. The NMWA's current needs were listed in its newsletter as a "wish list" that included

items as small as a twenty-dollar book. In response, the museum received an average of three hundred letters a week, about half of them notes from women expressing gratitude for the existence of the institution. "I think our National Museum of Women in the Arts is a magnificent achievement, as well as it is a beginning," wrote the same Alexandria member.

In a sense, the NMWA's success was a pure marketing phenomenon. Indeed, for several years members were investing in a museum that was primarily a marketing scheme rather than a public collection of objects, a staff, or a building; 55,000 people joined before the museum opened. To achieve its objectives, the NMWA commissioned a direct-mail campaign from the public relations firm Craver, Mathews, Smith and Company. The campaign targeted women on feminist mailing lists (supporters of women's causes), women members of professional arts organizations, women on museum gift-shop catalog lists, women members of cultural organizations (such as supporters of public television), and women on upscale mail-order clothing catalog lists. The museum had 8,000 members when it hired Craver, Matthews, Smith. In one eighteen-month period in 1987 and 1988, mailings elicited 29,000 new memberships.

But in another sense, the NMWA puts museum marketing to a new purpose. It takes women's passive consumption of art and channels it toward a revision of women's production. Once again women have been induced to buy into art, but this time the proffered commodity is the celebration of their own past and an institutional protection of at least some aspects of their current or future artistic projects. The rationale for the Martin Marietta Hall is that it will generate income that will guarantee the museum's independence and give it the freedom to allocate funds as it wishes. The hall, in effect, is an endowment like those that many museums, foundations, and universities have; rarely in any of these cases is the source of the money questioned. The gift shop is similarly conceived. Obviously, it produces profits, but it also serves as a rare provider of current publications on many kinds of women's art. Within five minutes after I entered the gift shop I heard a woman from Memphis exclaim to her companion that she "didn't learn about a single of these women artists in my college art course, even though the teacher was a woman."

The NMWA emphasized the dual function of the museum as a place of display and a place of learning, drawing attention to the size of their library: four thousand books and six thousand files on individual women artists. The rhetoric of NMWA brochures spoke of redemption and participation:

Make art history—join the National Museum of Women in the Arts! This first-of-its-kind institution celebrates the artistic achievements of women. . . . Join us and help expand the horizons of art.

We continue to need your help urgently—as much as we did when our museum was still a dream you and I had. . . . You and I know The National Museum of Women in the Arts is not "just a museum." We're an *inspiration* to women everywhere who are struggling to gain recognition.

One of the museum's stated purposes, often reiterated by Wilhelmina Holladay, was to inspire future generations of women with the knowledge that women, too, had always made art, a knowledge that no mainstream art museum then cared to instill. Indicators of a new attitude, according to Holladay, would be an increase in the prices of women's painting and the inclusion of more women's work in mainstream museums. Holladay felt the NMWA had already helped these changes begin; around the time of NMWA's inauguration, she cited the steep price fetched by a Vallayer-Coster painting,[32] in addition to the National Gallery's 1987 shows of both Morisot's and O'Keeffe's work. The connection between these occurrences and the NMWA may have been tenuous, but it is certainly true that just the year after the museum opened, the Janson art history textbook Holladay had so publicly condemned for its sexism suddenly incorporated twenty-five women artists into its roster.

The NMWA purported to be a new kind of museum, one that not only displayed work by artists invisible elsewhere, but also could alter the practices of other museums. The problem was that the NMWA itself was not as innovative as it claimed to be, but at the same time it raised the specter of issues so radical that no museum could address them and survive intact.

In its marketing, staffing, and fund-raising practices, the NMWA diverged from other mainstream art museums only in that it was more effective. The gender issue that seemed on the surface to be the cause of the NMWA controversy exposed class and cultural issues in which gender functions as a prominent but not exclusive component. The NMWA attracted so much attention because it threatened to lay bare the assumptions on which most art museums operate. The art museum democratically asserts high art as a common cultural heritage, and such is the mediatized prestige of high art that we are lulled into credulity. In fact, the art museum is an upper middle class institution supported by corporate funding and women's volunteer labor that genuinely intends to use

its power in an attempt to share its benefits—but to what end? The propagation of its own values.

Founded, funded, and sustained in a matrix of cultural power, the NMWA unwittingly challenged its own terms. Against its will, the NMWA warned that it is not possible now for gender to be an entirely neutral political issue, however cautious and apolitical its vehicle might try to be. Hoping to institutionalize a moderate feminism, the NMWA has found itself either criticized or praised not only for its stance on gender, but also for assumptions it had never considered.

And yet, gender politics today takes more than one form. For cultural critics, the NMWA's contradictions demand theoretical and absolute resolutions. But for close to 84,000 women, those same contradictions offer an immediately functional mode of self-representation. Precisely because it is paradoxical, because it says one thing and does another, the NMWA provides a way for women to deal with their dilemmas by not dealing with them. The NMWA reveals the existence of a considerable group of women for whom consumer culture and corporate finance are avenues, not impediments, to self-expression. To these women the NMWA has given a place and a voice. They believe that cultural change can come from the center, from within as well as from without.

It would be easy to ask whether the ends justify the means, or even whether, in this case, the means have become an end in themselves. Are the women who support the NMWA being exploited by the very power, financial and social, they hope will change their cultural status? Which raises another, less easy, question: What real alternative currently exists? Is any transformation of the art museum significant enough to affect women throughout America possible without financial and social support on the NMWA scale? Did the NMWA members choose, after all, the most viable option available to them? The NMWA represents feminism at its most opportunistic, compromising, and—materially—effective. It makes painfully apparent a discrepancy between feminist ideals and the concrete possibilities for acting on them.

Notes

My thanks to Brian Wallis for his cogent critique and to Daniel Sherman and Irit Rogoff, who invited me to give a talk at the Harvard Center for European Studies conference on "The Institutions of Culture: The Museum" in 1988. My research was carried out with the help of Rosemary Amatetti, Elizabeth Gilbert, Susan Taylor, the NMWA staff, the education and development offices of the Boston Museum of Fine Arts, the Isabella Stewart Gardner Museum, the Harvard Art Museums, and the Toledo Art Museum, and above all with the invaluable assistance of Deborah Cohen, to whom this essay is dedicated.

1. What was once a talk has become an essay whose references to time, facts, and figures remain those of 1988.

2. "Personal Statement" issued by the NMWA, p. 1.

3. Quoted in Laura Cottingham, "Women Artists: A Question of Difference," *Art & Auction*, March 1987, p. 122.

4. Quoted in Cottingham, "Women Artists," p. 122.

5. Artist Grace Hartigan says: "I have always been exhibited with men *and* women, and I certainly don't think I would be interested at this point in my life in being exhibited in a separate museum. It's a tough life—for men and women—but women who are doing important things are being shown all over the place. What this museum may do is promote the cause of mediocre women artists" (quoted in Sara Day, "A Museum for Women," *Art News* 85, no. 6 [Summer 1986]: p. 155)

6. Hilton Kramer, "The New Women's Museum in Washington," *New Criterion*, June 1987, p. 1.

7. Kramer, "The New Women's Museum," p. 1. Kramer included in his art world: practicing artists, art critics, historians, editors, consultants, curators and "other positions of power and influence." Similarly, Robert Hughes wrote for *Time* in 1987: "About half the substructure of power in the art world, from museum curators and dealers to critics and corporate art advisers, is female. No talented woman has real difficulty getting her work into a serious gallery. . . . Who would waste ten minutes on these sub-Sargent portraits, these mincing imitations of Childe Hassam, these genre scenes crawling with dimpled rosy brats, if they had *not* been painted by American women?" ("How to Start an Art Museum," *Time* 80, no. 6 [Auguest 10, 1987]: p. 48).

8. Gallery owner Mary Boone, quoted in Richard Maschal, "Women in the Arts," *Charlotte Observer*, October 18, 1984, p. 4B.

9. Cathleen McGuigan, "A Museum of One's Own," *Newsweek*, April 13, 1987, p. 76. McGuigan added: "Perhaps in another generation women's art will be in the mainstream where it belongs, hanging next to work by male artists." Art historian Barbara Rose wrote: "For women to achieve equality the emphasis must be on *quality*, not gender. And please, could we leave the pots and quilts to the craft museum where they belong?" ("Women Artists: Pro and Con," *Vogue*, April 1987, pp. 150–52).

10. Linda Nochlin, quoted in Day, "A Museum for Women," p. 115.

11. Linda Nochlin, author of the landmark article "Why Have There Been No Great Women Artists?" in Day, "A Museum for Women," p. 115: "I am for such an idea only if it is a feminist project and constitutes the intent to change the position of women artists rather than affirm it by ghettoization. Mrs. Holladay is using the goodwill of the women's movement for a project that is totally apart from the goals and spirit of progressive feminism. This museum, instead of being for the people and run by competent professionals, without hindrance, is a social battlefield and pleasuring ground for the socially prominent."

12. Artist Miriam Shapiro and art historian Robert Rosenblum (possibly for different reasons) felt the museum would more fully represent women's cultural past if crafts were included in the museum as well as fine arts (Day, "A Museum for Women," p. 115). The Washington Project for the Arts mounted a counterexhibition to the NMWA's first show, *American Women Artists, 1830–1930*. Said a contributing artist, Ida Applebroog: "We're being intentionally provocative, showing just the kind of work Mrs. Holladay doesn't want in her museum. It's a confrontation in terms of social, political and sexual issues" (quoted in Grace Glueck, "A New Showcase for Art by Women," *New York Times*, April 1, 1987, p. C23).

13. NMWA 1987 press report.

14. Other statistics: At the Whitney Museum of American Art, four out of fifty-one monographic shows held between 1980 and 1986 were of women's work. At the Guggen-

heim Museum, two out of fifty-two shows were women's. At New York's Museum of Modern Art between 1981 and 1987, women were 12 percent of the exhibited artists; at the Los Angeles County Museum of Art between 1977 and 1987, 4.2 percent. The National Gallery in Washington, D.C., owns 2,807 paintings, 60 of them by women. Although 38 percent of American artists are women, 95 to 98 percent of the works in museums are by men.

15. Art historian Ann Sutherland Harris has been quoted as saying: "I'm afraid the museum will have a credibility problem unless it hires someone with real training in 19th and 20th century art. It's a little like running a Holocaust museum and refusing to hire Jews" (Glueck, "A New Showcase," p. C23). Miriam Shapiro said at the same time: "Frankly, I'm ambivalent. I support such a museum because we need one to repair the historical omission of women's place in cultural history. But in this there doesn't seem to be a concise acquisition position and exhibition program. Also, it needs a staff of the highest quality and an active, rotating board of professional advisors. It seems to me the code word here is Junior League" (quoted in Glueck, "A New Showcase," p. C23).

16. Quoted in Sarah Booth Conroy, "The Founding Force of Wilhelmina Holladay," *Washington Post*, February 15, 1987, p. G16.

17. Day, "A Museum for Women," p. 111.

18. Glueck, "A New Showcase," p. C23.

19. Quoted in Day, "A Museum for Women," p. 117.

20. Diane Ketcham, "New National Women's Museum Makes Up for Years of Neglect," *Oakland Tribune*, July 7, 1987.

21. McGuigan, "A Museum of One's Own," p. 76.

22. John Loughery, "Mrs. Holladay and the Guerrilla Girls," *Arts Magazine*, no. 62 (October 1987): p. 61.

23. Sarah Booth Conroy, "In the Glow of Givenchy," *Washington Post*, February 23, 1983, pp. B1, B3.

24. Quoted in Conroy, "The Founding Force," p. G1.

25. Quoted in Conroy, "The Founding Force," p. G18.

26. Quoted in Conroy, "The Founding Force," p. G18.

27. Quoted in Dena Kaye, "The Feminine Eye," *Town and Country*, May 1987, p. 144.

28. Quoted in Kaye, "The Feminine Eye," pp. 142, 144.

29. November 1982: $1.5 million raised. April 1984: $8 million. October 1984: 700 members enrolled. August 1985: 12,000 members; $9 million. Fall 1985: 16,000 members. February 1986: $10 million. Summer 1986: 27,000 members. November 1986: $13 million. February 1987: 55,000 members; $15 million. April 3, 1987: 55,000 members. April 7, 1987: 60,000 members, $16 million.

30. Letter to the museum, courtesy NMWA.

31. Courtesy of the NMWA.

32. Anne Schwartz, "A Woman's Place," *Americana* 15, no. 1 (March-April 1987): p. 81.

13

Selling Nations:
International Exhibitions and Cultural
Diplomacy

Brian Wallis

In September 1990, bus shelters throughout New York City displayed backlit color posters featuring a detail from an extraordinary self-portrait of Frida Kahlo posing with several monkeys. The huge, eye-catching posters offered the following intriguing promise: "Manhattan Will Be More Exotic This Fall!" What would make Manhattan more exotic, the advertisement suggested, was the "mystery and wonder of Mexico," which could be found at the Metropolitan Museum of Art, the Museum of Modern Art, the IBM Gallery, and other cultural institutions. The bus-stop ads were part of a $10 million campaign by Grey Advertising to promote Mexico; the campaign was, in turn, part of a national cultural festival.[1] And as with most such national cultural festivals, Mexico's art was the central attraction. Indeed, the final line of the poster provided the official name of the celebration: Mexico: A Work of Art.

Of all the ways to constitute a nation, this one—the nation as a work of art—is perhaps the most audacious. Though clearly a copywriter's invention, the naming of a country as a work of art is a bold sleight of hand in that it alludes at once to the invented nature of nationality and to the role of culture in defining the nation to natives and foreigners alike. Since the publication of Edward Said's pathbreaking *Orientalism* in 1978, we have become increasingly aware of the manufactured nature of national identity and the extent to which that identity is constructed through cultural representations. But to use multicomponent cultural festivals as a form of cultural diplomacy or, to put it more crudely, public relations is the latest development in a long history of propagandistic deployments of art exhibitions. The festival concept only signals a more aggressive assertion of nationalism and a greater inclination to manipulate the manifold powers of the culture industry.

Visual representations are a key element in symbolizing and sustaining national communal bonds. Such representations are not just reactive (that is, depictions of an existing state of being), they are also purposefully creative and they can generate new social and political formations. Through the engineered overproduction of certain types of images or the censorship or suppression of others, and through controlling the way images are viewed or by determining which are preserved, cultural representations can also be used to produce a certain view of a nation's history. Production and distribution of the emblems of nationalism are by no means controlled exclusively by the ruling class; on the contrary, national icons derive their power precisely from the fact that they are universally available. In either case, however, the point is that national culture does not exist apart from its social construction; there is no national essence, no distinctive Americanness or Mexicanness, apart from that determined by specific political circumstances.

Cultural festivals such as the Mexico extravaganza are among the means by which nations seek to construct their national identity for foreign audiences, notably the American audience. Mexico: A Work of Art, sponsored by the Friends of the Arts of Mexico and underwritten by Televisa, Mexico's largest television network, is one of the most extensive national cultural festivals ever staged. It consisted of more than 150 exhibitions, performances, and cultural events throughout the United States, all explicating for Americans the culture of Mexico. The festival culminated in the gargantuan traveling exhibition Mexico: Splendors of Thirty Centuries, first presented at the Metropolitan Museum of Art in October 1990 and also shown at the San Antonio Museum of Art and the Los Angeles County Museum of Art. This exhibition, which according to Met director Philippe de Montebello comprised "more sheer tonnage" than any other show ever mounted at the museum, attempted to survey three thousand years of Mexican history with just over four hundred objects and a seven-hundred-page catalog.

In its quest for overwhelming scale and encyclopedic scope, the Mexico festival resembles two other recent national extravaganzas—Turkey: The Continuing Magnificence (1987-88) and Festival of Indonesia (1990-92). Typically, cultural festivals dovetail art exhibitions with lectures, films, plays, and public performances of national entertainments. In addition, they often include public relations appearances by national leaders, power receptions, business seminars, and department store tie-ins. In other words, in many different ways they function as huge public relations gambits, designed to "sell" the nation's image in the United States.

Although one could profitably study such cultural festivals in their entirety, here I would like to focus exclusively on the art exhibitions upon which they center, and to examine the highly effective ways in which the discourse of nationality proffered through the art objects is articulated. Such exhibitions are different from other "treasure" shows not only in size and complexity but also in their specifically political motivations. Their unabashed purpose is to transform negative stereotypes into positive ones and, in the process, to improve the political and economic standing of their country. These exhibitions are intricate, multilayered engines of global diplomacy, which, when staged properly, are almost indiscernible as self-promotions.

In an era when global extension and international flows of capital and information, along with the disintegrative forces of separatism, have made "the nation" seem like a threatened species, national cultural festivals are a very particular sign of the repackaging of the imagery of that political entity. The art exhibitions these festivals embrace, in particular, demonstrate the drive to reassert nationalism as a sort of decoy. Given the simulated nature of such representations of nationalism, we must ask how the nation is being reconstructed through culture. Whose version of the national culture is being shown? What is not shown? And why?

By and large, national festival exhibitions have eclipsed the spectacular blockbusters of the mid-1970s to mid-1980s as national promotional vehicles. Such shows as The Treasures of King Tutankhamen (1976-79), Irish Gold: Treasures of Early Irish Art (1978), Five Thousand Years of Korean Art (1979), Treasures of the Kremlin (1979), and Treasures of Ancient Nigeria (1980) also focused on national artifacts and were intended in part for diplomatic effect, but the good public relations they generated primarily benefitted their multinational corporate sponsors.[2] Among the additional consequences of those shows — obviously serving various interests — were the promotion of tourism, the populist expansion of the role of the museum, and the development of international business and political connections. These blockbusters were spectacular, to be sure, but as narrowly focused individual exhibitions, they lacked both the educational appeal of the multifaceted approach and, despite wide coverage, they fell short of the sustained promotion of national culture offered by festivals.

One of the prototypes for the broad-range cultural festivals with a nationalist agenda was the 1985-86 Festival of India (which followed an earlier Festival of India held in England in 1982). That $15 million event included over a hundred exhibitions, dances, and performances in thirty-

eight museums, in ninety cities and in thirty-seven states, as the organizers proudly and repeatedly boasted. But the Festival of India is probably best remembered today for its widely advertised promotions at Bloomingdale's, which drew the department store into the culture industry through the sale of "official" and "indigenous" Indian products. The Festival of India centered, of course, on an art exhibition, in this case, India! Art and Culture: 1300-1900, a show at the Metropolitan Museum that included more than 350 objects spanning five centuries.

From the Metropolitan Museum's point of view, the expansiveness of this exhibition was itself innovative. "To take the whole gigantic subcontinent, covering all media over five centuries, including tribal and rural art, courtly and religious art, Buddhist temple art, Muslim and Hindu art, all the way through," said Philippe de Montebello, "that had never been done before."[3] But what the Met's ebullient director saw as expansive and comprehensive was in another light a drastically condensed and edited national history geared toward a particular purpose.

"It's cultural diplomacy," said Ted M. G. Tanen, executive director of the Indo-U.S. Subcommission on Education and Culture and the principal organizer of the Festival of India. "India has been woefully neglected in this country and we hope that as a result of this festival, there will be many more opportunities and more people taking advantage of a better climate for exchange."[4] In other words, the festival's purpose was to increase the visibility of India's past in order to structure beneficial political and business relations for India's future.

Elaborating on this point, Tanen, who now heads his own firm, Tanen Associates, which specializes in producing national cultural festivals, recently cited two reasons for such an event: "It should make a broad spectrum of Americans aware of the many facets of another country's culture, and it should initiate and develop exchange programs that will ensure continued binational dialogue long after the festival is done."[5] The concept of the festival, as opposed to the one-shot blockbuster, says Tanen, is to maximize impact: "Concentrating a number of events around the exhibition . . . will increase the impact and provide an opportunity to include a great many others."[6] Tanen is quite candid about why countries are interested in having festivals: "A country may wish to have a more positive image in the United States, or it may wish to encourage tourism and to build up new markets for its products."[7]

Surprisingly, not all such exhibitions are "authored" by the national governments involved. "Each festival is organized differently," says Joan Sands, a public relations executive who specializes in international exhi-

bitions. "Britain Salutes was set up by a businessman to show off the strength of British investment; the Festival of India was organized by the government, primarily through its embassy; and the Festival of Indonesia was organized by a cultural foundation to promote the culture of Indonesia."[8] Regardless of who the initiators or sponsors may be, these festivals are generally put together by Americans: American organizers, American advertisers, and American curators.

In the case of the Mexico exhibition, this meant bilateral cooperation between the Mexican and American organizers. The exhibition was initiated in 1987, well before plans for the current U.S.-Mexico trade talks and even before the election of President Carlos Salinas. But from the start, the show's prime mover, Emilio Azcarraga, Jr., probably the wealthiest man in Mexico and the principal shareholder in Televisa, Mexico's largest television and entertainment conglomerate, wanted to establish closer ties with the United States. Often criticized for his "Americanization" of Mexican mass culture, Azcarraga has also been a major patron of contemporary Mexican art.[9] When Salinas was elected president, he immediately recognized the usefulness of the Mexico festival and, as Philippe de Montebello notes in the exhibition catalog, welcomed the American curators and organizers, becoming "one of [the project's] most enthusiastic supporters."[10]

Artworks have different meanings in different contexts. In order to use cultural artifacts for public relations purposes, it is necessary to select and juxtapose artworks in such a way that they focus and enhance the national image for foreign consumption. Turkey attempted just such a retooling in the sumptuous and well-publicized exhibition The Age of Sultan Suleyman the Magnificent, shown in Washington, D.C., Chicago, and New York as part of the festival Turkey: The Continuing Magnificence in 1987-88.

When planning for the Suleyman exhibition began in 1978, the initial discussions between National Gallery director J. Carter Brown and Turkish ambassador Sukru Elekdag came close on the heels of two other diplomatic blockbusters, Egypt's Treasures of Tutankhamen and East Germany's Splendors of Dresden. But because of the very sensitive nature of diplomatic relations between the United States and Turkey, the curatorial negotiations required the involvement of the State Department, the U.S. Information Agency, the White House, and the president of the Metropolitan Museum, William Macomber, who was a former ambassador to Turkey.

As the Turkish minister of culture and tourism (that title says it all!) stated, the purpose of the exhibition was "to enable those people who cannot visit Turkey to see our culture and our resources."[11] From the start, Turkey's motive went far beyond merely promoting tourism. Since 1980, when its military dictators were ousted, Turkey had been trying to reestablish its national image, both internally and externally. In particular, it sought to be taken seriously by the United States as a Western — even European — trade partner. At the time of the exhibition, however, many critics argued that the military still ruled the country and that the elections for the post of prime minister were primarily demonstrations to convince the West that Turkey was moving toward democracy.

Turkey was also desperate for sustained, and even increased, foreign aid. Congress, however, was reluctant to support further aid to Turkey without strict conditions. For instance, there was — and still is — strong congressional opposition to Turkey's continued occupation of Northern Cyprus and its continuing conflict with Greece over the issue. Further, many in Congress wanted an official commemoration of the genocide of Armenians during World War I. And, finally, there were continuing serious allegations of broad human rights abuses in Turkey, particularly in relation to the oppression of the outlawed Kurdish nationalist movement. (Later, this situation was not aided by the fact that, while the exhibition was at the Metropolitan Museum in 1987, the *New York Times* reported that Americas Watch had again cited Turkey for "gross human rights violations" in relation to existing prison conditions, treatment of political prisoners, and treatment of Kurdish people.)[12]

In 1985, the government of Turkey enlisted the aid of Gray & Company, a prominent Washington public relations firm with close ties to the Reagan administration (they staged Ronald Reagan's second inauguration, and Robert Gray himself had a hand in writing Reagan's inaugural address). For $600,000 a year, Gray & Company's mission was to "improve and increase knowledge of the Republic of Turkey in the United States."[13] Ambassador Elekdag bristled at a reporter's suggestion that Gray was reinventing his country's image, saying, "I am the one doing the job. They [Gray] assist me in giving me advice, feeding me information."[14] But from all accounts it seems clear that it was Gray who came up with the plan for a yearlong festival of exhibitions, performances, lectures, and seminars with the common theme Turkey: The Continuing Magnificence. In selecting this title, Gray & Company sought to eradicate negative stereotypes that Americans might apply to Turkish people and to replace them with very specific alternatives, drawn from an epoch

of the Turkish past venerated in the West: the renaissance of the arts dur-
ing the reign of the Ottoman emperor Suleyman I (1520–1566).

In the exhibition itself, extraordinary examples of goldsmithing, cal-
ligraphy, metalwork, miniatures, tile work, carpets, maps, and tapestries
filled the rooms; many of the items came directly from the Topkapi Pal-
ace and had never been loaned before. But while the wall texts constantly
stressed the range and boldness of the sultan's conquests—during his
reign the Ottoman Empire doubled in size—the objects on view pre-
sented a rather homogeneous aspect. The exhibition focused only on the
rarefied and elitist art of Suleyman's court. One of the threads running
through the catalogs and wall texts was the sultan's "generous patron-
age." But this was never public patronage of a sort to reach beyond the
palace. These objects were made exclusively for the pleasure of the sultan
and were not even seen by the public until the dissolution of the empire in
1924.[15]

It was apparent, in fact, in the selection of objects that Turkey's con-
struction of nationalism was bound up with ideologies of imperialism.
Prominently displayed maps, illuminated scenes of battles and conquests,
ceremonial armor, and the bellicose language of the wall texts reiterated
the importance of the Ottoman expansionism to the development of cul-
ture. An updated commercial twist was present in the marketing of re-
productions of Turkish art objects and other souvenirs. Everywhere one
turned were the most conventional signs of Turkishness: Bloomingdale's
served Turkish coffee and cakes; the National Gallery provided Turkish
cigarettes; and the Met used custom-made plates with Suleyman's mono-
gram for its extravagant opening.

This stereotyping of Turkish images pointed to a central paradox,
common in national exhibitions: in order to establish their status within
the international community, individual nations are compelled to drama-
tize conventionalized versions of their national images, asserting past
glories and amplifying stereotypical differences. As we know from the
writings of Edward Said and others, Orientalism is a political fiction, a
mythic idea of the East based on Western projections of fear. Orientalism
is a deformed representation sustained through the misappropriation of
the signs of foreignness, often entailing suppressions and exclusions. In
the case of the Turkish festival, a country that had been subjected to Ori-
entalist characterizations in the late nineteenth century by British colo-
nialists was now forced to adopt what might be called a "self-Oriental-
izing" mode. Instead of an outside oppressor imposing on Turkey a
stereotypical identity, the nation was itself proposing in the exhibition to

remake its national image into that stereotype—a representation American audiences presumably anticipated.

Of course, when they are successful, such exhibitions are characterized by a seeming absence of politics. Each of these exceedingly tasteful, well-endowed presentations of some of the country's finest artifacts sets out, then, not only to map the art history of that country, but also to compose a national allegory, to invent a fictive or at least enhanced past. This process is similar to that noted by British historian Benedict Anderson in his study of nationalism: "If nation-states are widely conceded to be 'new' and 'historical,' the nations to which they give political expression always loom out of an immemorial past, and, still more important, glide into a limitless future."[16] Thus, Indonesia, a republic founded in 1945, can suddenly boast a three-thousand-year history.[17] Or, on the other hand, the boundaries of the modern country can be swelled to fill the expanse of a far earlier empire, as in the Suleyman exhibition, in which the contemporary Turkish republic took credit for cultural achievements throughout the vast sixteenth-century Ottoman Empire. "The nation" is in either instance perceived as an empty and elastic container into which can be fit any variety of art objects.

National festival exhibitions are inevitably caught up in the tension of trying to reconcile a static "essence" of the nation with an actual history of dynamic change.[18] In the case of Splendors of Mexico this essentialist approach serves as a sort of absurdly schematized simplification of the country's extremely volatile history. In his catalog essay, Mexican poet and 1990 Nobel Prize winner Octavio Paz claims that the overriding characteristic of his country is "a will that tends again and again toward synthesis."[19] Paz insists that Mexicans have always been able to assimilate any invasion and that "the process (rupture-reintegration-rupture-reintegration) can be taken as a leitmotif of the history of Mexico."[20] In fact, so completely is Paz convinced of the inevitability of Mexico's destiny to be conquered that he even sees the Spanish Conquest as a growth experience ("the fall of Mesoamerican culture was inevitable") that "would have been impossible without the collaboration of the native populations."[21] Paz's image of a passive nation naturally inclined toward acceptance of—rather than resistance to—occupation and domination facilitates an attitude of national self-loathing. But, of course, such justifications for brutal conquest have quite a different meaning for the sponsors, both governmental and corporate, of the Mexico festival.

Wittingly or not, the selection of objects for the Mexico show reiterated this general theme of conquest and assimilation. The exhibition pro-

ceeded in a seamless continuity from the semimythic pre-Columbian past (symbolized by the mammoth stone head that greeted the viewer at the entrance), through the Spanish Conquest and up to the present (or at least as close to the present as Rufino Tamayo, at the time of the opening the only living artist included). This undifferentiated historical progression was evident from a glance at the show's floor plan: each successive historical epoch was allocated a virtually identical block of space. The "transition" (as Paz calls it) from Aztec rule to Spanish was scarcely explained: in one room a massive stone jaguar's head from an Aztec temple, in the next a Spanish cross and a bleeding Christ. A wall label mentioned the intervening events: "In the early post-Conquest period, idealistic missionaries not only taught Indian artists new principles, forms, and styles but also encouraged them to use traditional methods in the service of the new religion."

The theme of the triumph of Christian religion over the pagan religions of the native Mexicans was repeated throughout the show in a variety of guises. Prominently displayed was the nearly life-size eighteenth-century polychromed sculpture of *Saint James the Moor-Killer*, and Luis Juarez's painting *The Archangel Michael Conquering Satan* (ca. 1605-1615) was not far away. Though they are Christian parables, these dramatic images clearly were meant as metaphors of and legitimations for the Conquest. In a similar way, the exhibition hammered home another theme: the right of the powerful to accumulate wealth and property. This theme emerged most forcefully in the rooms that documented eighteenth- and nineteenth-century art in Mexico. There, most of the paintings reflected the rise of the Mexican bourgeoisie through extravagant still-life displays of fruits and flowers and vainglorious portraits of newly endowed landowners seated before their endless properties.

Without a critical take on these very themes—domination and capitalist accumulation—one cannot understand the wrenching political upheavals and revolutionary movements that also typify Mexico's culture. The persistent skeleton motif in the fantastic prints of José Guadalupe Posada (1852-1913) or in the unexpectedly surreal paintings of Francisco Goitia (1886-1969) is not simply a quaint or folkish invocation of Day of the Dead festivals, as the catalog suggests, but a deliberate commentary on specific political circumstances. Goitia's *Landscape of Zacatecas II* (ca. 1914), for instance, is a rather haunting picture of two skeletons hanging from a tree, painted shortly after the initial Mexican Revolution of 1910-1913. Oddly, the catalog reproduces Goitia's statement about the painting—"There is a great deal of sadness in this country and I have tried

to sum up a certain phase of it" — without suggesting what, in specific historical terms, the revolutionary Goitia might have been referring to.[22]

This supersession of the aesthetic over the political reached its apogee in the section dealing with the Mexican muralists, principally Diego Rivera, David Alfaro Siqueiros, and José Clemente Orozco. No attempt was made in this section (selected by Met curator of twentieth-century art William Lieberman) to signal, either through sketches or site photographs, the importance or significance of the Mexican mural movement. Rather, these artists were represented by fairly conventional easel paintings, many borrowed from the already overexposed selection owned by the Museum of Modern Art (MOMA). Thus, we were given a rather uncharacteristically romanticized and traditionalist 1931 fresco panel by Rivera, *Agrarian Leader Zapata* (which was actually commissioned by MOMA), and a smallish Siqueiros duco-on-wood panel, *Echo of a Scream* (1937), that has been reproduced and exhibited so often that it now seems only kitschy. Such works hardly express the central and forceful role that art played in Mexican culture after 1910.

Indeed, in his introductory essay, Paz pointedly downplays the political element in this work, saying, "Can we see the work of Rivera and Siqueiros except through the distorting glass of ideology? This is a difficult question to answer for a contemporary of Hitler and Stalin. My answer is an unequivocal *yes!* For we see their painting, not their moral and political aberrations."[23] And as if to further deny the centrality of a political interpretation to these particular works, the organizers removed or redacted several key phrases of critic Dore Ashton's catalog essay on twentieth-century Mexican art. In what became a minor controversy, newspapers in the United States and Mexico recounted Ashton's charges that her text had been censored by the Friend of the Arts of Mexico. As George Black reported in the *Los Angeles Times*, Ashton's "reference to art works being in the possession of 'rich but largely uncultured patrons' was excised; the 'odious intervention' of the United States in Mexico became the 'immense intervention.' "[24]

In most developing countries today, the government-imposed ideal of a homogeneous nationalism is being strongly challenged by a wide range of racial, ethnic, and religious factions. Yet national cultural festivals mask the contemporary situations in the countries, especially the factionalism, by papering it over with catchphrases like the Indonesian national motto, Unity in Diversity.[25] As it happens, resistance to unity is especially strong in Indonesia, a country distinguished by more than three hundred distinct ethnic groups scattered among its thirteen thousand is-

lands stretching from the tip of Southeast Asia to the west coast of Australia. Because of its great national diversity, there were strong objections in Indonesia when the organizers of the Festival of Indonesia revealed that they would focus their two principal art exhibitions rather narrowly on classical Indonesian sculpture and on the elite court arts. A principal objection was that these two approaches totally ignored the culture of the Indonesian Muslims — although Muslims account for 90 percent of Indonesia's population. Finally, an ethnographic exhibition, Beyond the Java Sea, was added.[26]

Even with three full-scale exhibitions, in addition to nearly a hundred other events, the Festival of Indonesia failed to address many contemporary issues — political, environmental, and cultural. The massive festival sought to give renewed prominence to "the world's largest invisible country," but at the same time hoped to extinguish America's most prevalent image of Indonesia: the cold war client-state that was ruled by the dictator Sukarno until he was forcibly ousted in the CIA-staged coup of 1965.[27] Memories of this heinous regime are revived by the policies of the current Indonesian government and its continued human rights abuses in the disputed province of East Timor and in the province of Aceh on Sumatra. Adding to the dissension are environmentalists' protests against widespread destruction of the Indonesian rain forests, AFL-CIO objections about appalling labor practices in Indonesia, and official censorship of contemporary artists even as the government uses historic art to promote nationalism.[28]

In order to bring such realities to the euphoric nationalism of the Indonesia festival, one sponsor, the Ford Foundation, gave a $100,000 grant to the Social Science Research Council for an independent series of lectures and panels that would reflect a range of opinions on Indonesia. As Toby Volkman, a staff associate at the council, told the *Wall Street Journal*, "[We] felt that the thrust of the festival was an Indonesia government attempt to present Indonesia in a very favorable, uncritical light. Our role as scholars is to be more critical."[29] Among the council projects were a conference at Cornell University entitled "The Role of the Indonesian-Chinese in Indonesian Life," a workshop on East Timor, a feminist conference on women in Indonesia in Seattle, and a panel on deforestation in Indonesia at the New York Botanical Garden.

Ted Tanen, who helped organize the Indonesia festival, claims that he encouraged the sponsor of the exhibition, the Nutsantara Jaya Foundation, to deal forthrightly with all the issues, including human rights and the environment. He argues that scholarly debates such as the Cornell

conference are insider events and can have little effect on the promotional aspects of the festival. "To try to avoid controversy," Tanen says, "only creates more."[30] But Mochtar Kusuma-Atmadga, Indonesia's former minister of foreign affairs and the chairman of the Nutsantara Jaya Foundation, demurs. "We thought the festival was an occasion to create understanding and friendship, not to create conflict," he says. "This is about art, not politics."[31]

What the Indonesia exhibitions attempted to portray is a highly cultured society in which the spirit of art is constantly present, even in everyday life. This is especially evident in the rather small exhibition The Sculpture of Indonesia, which opened at the National Gallery, was shown at the Metropolitan Museum, and closed at the Asian Art Museum in San Francisco (September 1991 to January 1992). In this show, stylistic traits were reintroduced as spiritual ones. Thus, much was made of what the wall labels referred to as "Indonesian grace." Although this particular trait has long been cherished among Indonesians, its invocation as a national characteristic has a hollow ring at this particular moment, since the widespread Indonesian student protests of 1989 were united in opposition to what they called their government's "violent society."[32]

Grace was clearly evident in the many, surprisingly small, figures of Buddha and the youthful bodhisattva Manjusri, with their elegant detail and sinuous curves. Still, even among the objects at hand, the effort to apply this standard comprehensively had its comic moments. At one point in the installation at the Met, a wall label extolling the "calmer, gentler spirit" of the Indonesians was placed next to a sculpture of Vishnu as Narasimha, ripping the heart out of the demon-king Hiranyakasipu.

In Sculpture of Indonesia, the image of an ancient nation of romantically overgrown ruins was invoked by the large-scale color photographs of unpopulated architectural ruins that punctuated the exhibition and provided an element of lush fantasy. The seductive lure of faraway cultural monuments is presumably calculated to stimulate tourism, the principal "industry" in many nonindustrialized countries. In Indonesia, for example, tourism accounted for approximately $1.9 billion in income in 1990, making it the fourth-largest foreign-exchange earner for the country.[33] And, in an effort to increase that income further, the government of Indonesia proclaimed 1991 Visit Indonesia Year, a sort of globetrotter's counterpart to the Festival of Indonesia. Unfortunately, Visit Indonesia Year, another huge effort, consisting of more than 250 tourist-related events throughout the archipelago, was kicked off at the same time as the Gulf War. Tourist travel abruptly halted and occupation rates in Indone-

sian hotels took a nosedive (rates for February 1991 were less than half of the 60 to 90 percent capacity of the year before). What was perhaps worse in the long run, Visit Indonesia Year generated resistance from a number of Indonesian political factions worried about the "negative impact" the anticipated tourist boom would have on the fragile balance of Indonesian society. But tourism director general Joop Ave insisted ominously that "income-generation, patronage of the arts and increased demand for locally manufactured goods and handicrafts will outweigh any misgivings among locals about their exposure to outsiders."[34]

Tourism is just one aspect of the many-sided business relations that national cultural festivals are meant to enhance. Symbolically, these festivals signal that a country is ready to play ball economically with the United States and that it is vying for preference as a trading partner. And virtually all of these national festivals have been directed at the United States. All of the countries that have had festivals in the United States recently have shared an economic profile. They all have huge international debts (mainly to the United States); cheap, docile labor markets (attractive to U.S. businesses); and valuable exports managed by U.S. multinational corporations (principally oil). All of them have recently privatized state industries (with encouragement from the United States and the International Monetary Fund). But national cultural festivals are more than a bargaining chip in debt renegotiations, trade agreements, or money transfers. Indeed, festivals mark a specific moment in the realignment of international political and economic power relations.

Culture, and the sophistication that presumably goes along with appreciating it, now plays an important role in global financial thinking as well as in the perception of businesses and business partners. In this respect, national cultural festivals participate in what one critic has called "an unprecedented collapse of what had once been distinguishable cultural and economic spheres."[35] Along with multi-million-dollar van Gogh purchases and corporate takeovers of publishing houses and entertainment conglomerates, these huge culture fests are symptomatic of the trend toward using the aura of culture to attract capital.

Circumstances have changed dramatically from just a decade ago, when corporate sponsorship of art was a relatively benign and little-used business tool. Now cultural funding is an important component in the advertising and promotional efforts of many capital enterprises, just as it is for many nations. But because of their greater size and diversity, national culture festivals require more substantial and diversified funding than the one-shot corporate-backed blockbuster.[36] Though one might

expect, therefore, heavy patronage from the initiating country, this is not always the case; indeed, the lists of donors are surprisingly multinational, reflecting wholly new partnerships and alliances. Instead, what one finds is what cultural critic Shifra Goldman has called a "global alignment of power elites from nations of the First and Third Worlds whose objective is the control of resources and cultural configurations across national boundaries."[37]

This global power sharing among the elites of various countries was the principal message in the corporate advertising campaign developed by Philip Morris for the Suleyman exhibition in 1987.[38] The print ad featured artworks from the Suleyman show and sought to justify the imperialism of the Ottoman Turks because "they created an art that harmonized opposites . . . [and] in doing so, they made of themselves and their art a bridge between East and West, a bridge that serves the modern world." Before the reader could even imagine how this bridge serves the modern world, the sponsor supplied the answer: "In our business as in yours, we need to be reminded that the art of innovation knows no boundaries, including the seemingly impossible, and that one of the noblest works of art is a bridge between cultures."

No one agrees with that sentiment more than Ted Tanen, who is already planning for future national festivals. The countries that could benefit from such events, Tanen says, share certain characteristics: they are "important geographically, militarily, economically, and culturally [but] are little known in the United States."[39] So clear are the requirements that Tanen is already making up his list of future prospects: Brazil, Egypt, Nigeria, Iran, Canada, Thailand, Morocco, and Vietnam.[40] But what the ex-Foreign Service officer does not say is that such festivals could be as advantageous to U.S. diplomatic policy as they are to that of the host country. Not surprisingly, perhaps, given the multiple interests everywhere in evidence in such supposedly nationalistic promotions, these are just the sort of reformed economic partners George Bush had in mind for his new world order.

Spectacularizing the nationalist myth, national cultural festivals present an opportunity for nations to circulate their treasures in a move toward future business developments. And if they do, what harm does this pose? Undeniably, the exhibitions present rare and exciting works of art that only the most ambitious traveler would otherwise get to see; they also provide encapsulated, easily digestible vignettes of a foreign nation's culture and, in the process, they presumably foster international understanding. But consider what they do not say. At a time when Americans

are asking hard questions about our own national heritage, these exhibitions scarcely broach the complicated issues raised by any contemporary, multicultural society or touch on the contradictions or conflicts in the histories of the countries they represent.

And in terms of the museum's role, these shows are far from the disinterested scholarship most museums claim to provide. Though scrupulously researched and painstakingly displayed, nationalist exhibitions are, in the end, a blatant, self-admitted form of propaganda. Yet museums, strapped for cash now more than ever, are reluctant to resist the allure of these well-endowed crowd pleasers, even when they verge on exploitation of the museum's intellectual resources and professional integrity. Today, nations enfranchise museums, just as they do department stores. Finally, rather than expanding our understanding, these shows narrow our view of a country to a benign, if exotic, fairy tale.

Notes

This essay is a revised and expanded text of a talk given at a conference on "The Institutions of Culture: The Museum" at the Harvard University Center for European Studies in March 1988. A slightly different version was published in the "Art and National Identity" issue of *Art in America* (September 1991, pp. 84–91)

1. Bernice Kanner, "The Art of Tourism," *New York*, November 26, 1990, pp. 16–18. See also Kim Foltz, "Mexico Features Its Culture in New Tourism Campaign," *New York Times*, November 7, 1990, p. D19. Ironically, advertising does not usually play a big role in cultural festivals simply because it costs too much. The Mexico campaign is considered an exception. Generally, the festival itself is structured as a form of advertising, in lieu of paid promotion. The principal reason for exceptions is corporate involvement, in which case corporate sponsors do their own advertising.

2. On the diplomatic uses of these earlier exhibitions, see Judith Huggins Balfe, "Artworks as Symbols in International Politics," *International Journal of Politics, Culture and Society* 1, no. 2 (Winter 1987): pp. 5–27.

3. Quoted in Leslie Bennetts, "Cultural Riches of India at the Met," *New York Times*, September 10, 1985, p. C17.

4. Quoted in Bennetts, "Cultural Riches," p. C17.

5. Ted M. G. Tanen, "Festivals and Diplomacy," in *Exhibiting Cultures: The Poetics and Politics of Museum Display*, ed. Ivan Karp and Steven D. Lavine (Washington, D.C., 1991), p. 371.

6. Ibid., p. 370.

7. Ibid., p. 368.

8. Joan Sands, conversation with the author, March 13, 1991.

9. On the background of the Mexican show, see Shifra M. Goldman, "Metropolitan Splendors," *New Art Examiner* 18, no. 8 (April 1991): pp. 16–19. Also useful are Mark Stevens, "South of the Border," *Vanity Fair*, October 1990, pp. 156–62; and George Black, "Mexico's Past, as Edited for U.S. Display," *Los Angeles Times*, October 9, 1990, p. B7.

10. Philippe de Montebello, "Director's Foreword," in Octavio Paz et al., *Mexico: Splendors of Thirty Centuries* (Boston, 1990), p. vii.

11. *New York Times*, August 29, 1983.

12. Elizabeth Neuffer, "Rights Group Reports Continued Abuses of Liberty in Turkey," *New York Times*, November 29, 1987, p. 21.

13. Barbara Gamarekian, "Turkey Focuses on Its Image," *Washington Post*, January 20, 1987, p. A18.

14. Ibid.

15. On the exhibition, see the fine catalog: Esin Atil, *The Age of Sultan Suleyman the Magnificent* (Washington, D.C., 1987).

16. Benedict Anderson, *Imagined Communities: Reflections on the Origin and Spread of Nationalism* (London, 1983), p. 19.

17. Ibid.: "The late President Sukarno always spoke with complete sincerity of the 350 years of colonialism that his 'Indonesia' had endured, although the very concept 'Indonesia' is a twentieth-century invention, and most of today's Indonesia was only conquered by the Dutch between 1850 and 1910."

18. In *Orientalism*, Edward Said argues that the colonialist discourse is established as a tension between static "visions" of domination and the unstable "narratives" imposed by real historical events. "Narrative," says Said, "asserts the power of men to be born, develop, and die, the tendency of institutions and actualities to change, the likelihood that modernity and contemporaneity will finally overtake 'classical' civilizations; above all, it asserts that the domination of reality by vision is no more than a will to power, a will to truth and interpretation, and not an objective condition of history." (Said, *Orientalism* [New York, 1979], p. 240.)

19. Paz, "Will for Form," in Octavio Paz et al., *Mexico: Splendors*, p. 4.

20. Ibid.

21. Ibid., p. 22.

22. A useful compilation of the work of J. G. Posada is provided in Julian Rothenstein, ed., *Posada: Messenger of Mortality* (Mount Kisco, N.Y., 1989). Also useful for alternative readings of twentieth-century Mexican art and culture is Erika Billeter, ed., *Images of Mexico: The Contribution of Mexico to 20th-Century Art* (Dallas, 1987).

23. Paz, "Will for Form," p. 34.

24. Black, "Mexico's Past, as Edited."

25. Paul Michael Taylor uses this motto to open his essay in Taylor and Lorraine V. Aragon, *Beyond the Java Sea: Art of Indonesia's Outer Islands* (Washington, D.C., 1991).

26. Tanen, interview with the author, April 4, 1991.

27. For recent revelations on the CIA's role in the overthrow of Sukarno, see "Talk of the Town," *New Yorker*, July 2, 1990, pp. 21-22.

28. For a report on the censorship of the satirical playwright Nano Riantiaro, see Michael Vatikiotis, "Parody or Punditry," *Far Eastern Economic Review*, November 1, 1990, pp. 54-55.

29. See Margot Cohen, "An Archipelago Struts Its Stuff All Over the U.S.," *Wall Street Journal*, September 20, 1990, p. A12.

30. Tanen, interview.

31. Cohen, "An Archipelago Struts Its Stuff."

32. For reports on the 1989 student protests, see Michael Vatikiotis, "Stirrings on Campus," *Far Eastern Economic Review*, April 6, 1989, p. 34; and Vatikiotis, "Tolerating Protest," *Far Eastern Economic Review*, April 20, 1989, pp. 27-28.

33. Michael Vatikiotis, "Looking for New Playgrounds," *Far Eastern Economic Review*, April 18, 1991, p. 52.

34. Ibid.

35. Jonathan Crary, "Capital Effects," *October*, no. 56 (Spring 1991): p. 121.

36. In a fairly straightforward instance of corporate sponsorship, oil was the principal inducement for sponsors of the Festival of Indonesia. Indonesia is the fifth leading oil-

producing nation in the world and the only Asian member of OPEC. Consequently, five major oil companies with leases in Indonesia were among the principal donors to that project, giving over $500,000 each. Mobil was the big spender, putting up $1.3 million to sponsor the exhibition The Sculpture of Indonesia. Mobil has been active in Indonesia since 1912. Following the nationalization of Mobil refineries in 1965, the oil giant incorporated Mobil Oil Indonesia in 1967. Working with the state-owned Pertamina, Mobil discovered the Arun natural gas field off North Sumatra in 1971. Still, Mobil operates in Indonesia at the discretion of the Indonesian government and must seek renewal of its right to operate in Indonesia in 1995.

37. Goldman, "Metropolitan Splendors," p. 16.

38. In this case, Philip Morris sought to build a cultural bridge to Turkey principally to improve business relations and to increase the visibility of their brand name, newly introduced to Turkey. Until mid-1984 — exactly the planning period of the show — the sale of foreign cigarettes in Turkey had been prohibited. But in remarks at the opening of the exhibition in Washington, Hamish Maxwell, chairman of Philip Morris, noted that the exhibition marked the company's "expansion into Turkey" (*Washington Post*, January 23, 1987). Since that time, Philip Morris has entered this market aggressively, commanding 68 percent of the total market share, first among American companies. In addition, Philip Morris is one of the leading exporters of Oriental tobacco from Turkey.

39. Tanen, "Festivals and Diplomacy," p. 370.

40. Ibid.

Contributors

Ariella Azoulay teaches theory of art at Camera Obscura School of Film and Photography. She is curator of the Bograshov Gallery in Tel Aviv, writes on art and culture, and is currently working on a book on critical and political art in Israel.

Frederick N. Bohrer teaches art history at Hood College in Frederick, Maryland. He has published on several aspects of exoticist theory and practice, and is currently completing a manuscript on the nineteenth-century rediscovery of Assyrian and related forms of Mesopotamian artifacts.

Chantal Georgel is a historian and curator who has worked at two Paris museums, the Musée National des Arts et Traditions Populaires and the Musée d'Orsay, where she is now curator with special responsibility for historical exhibits. She is the author of *XIXe Siècle: La rue* (1986) and organizer of such exhibitions as L'enfant et l'image au XIXe siècle (1988) and Une icône républicaine: Rouget de Lisle chantant *La Marseillaise* (1989). She is organizing a major exhibition on the history of the museum in France, scheduled to be held at the Musée d'Orsay in 1994.

Walter Grasskamp studied art history, history of literature, and philosophy in Cologne, Koustauf, and Aachen. He is now an art critic and professor of art history in Aachen. His publications include *Museumgründer und Museumstürmer* (1981); *Die Unbewältigte Moderne* (1989), and *Unerwünschte Monumente* (1989).

Boris Groys studied philosophy at the University of Leningrad and worked at the University of Moscow. In 1981 he emigrated to Germany and presently teaches philosophy at the University of Münster. He is the

author of *The Total Art of Stalinism: Avant-Garde, Aesthetic Dictatorship, and Beyond* (1992) and *Ueber das Neue* (On the new) (1992).

Anne Higonnet teaches in the art department of Wellesley College. She is the author, most recently, of *Berthe Morisot's Images of Women* (1992) and essays on visual culture for the nineteenth- and twentieth-century volumes of *The History of Women* edited by Georges Duby and Michelle Perrot, published in France and Italy, forthcoming in the United States, Germany, Greece, Holland, Portugal, and Spain.

Detlef Hoffmann is professor of art history at the University of Oldenburg and research fellow at the Kulturwissenschaftliches Institut, Essen. He has written extensively on museum pedagogy anad on card-playing culture. His current project concerns the museumification of the concentration camps of World War II.

Seth Koven teaches European history and women's studies at Villanova University. He co-edited *Mothers of a New World, Materialist Politics and the Origins of Welfare States* (1993). He is currently working on the links between representations of bodily deformity and the shaping of state policies for the disabled.

Dominique Poulot, member of the Institut Universitaire de France, teaches modern history at the University of Grenoble. He is the author of numerous articles on cultural studies, especially on the history of museums and the invention of national heritage. Among his recent essays is "Le Louvre imaginaire" in *Historical Reflections/Réflexions Historiques* (Spring 1991). A member of the *Publics et Musées* collective (Presses Universitaires de Lyon) and the Comité d'histoire des musées de France (Paris, Louvre), he is currently working on a book on French revolutionary museums.

Irit Rogoff received a doctorate in art history from the Courtauld Institute, London University, in 1987. She has written extensively on modern German and European art (*The Divided Heritage*, 1991, and the forthcoming *Margins of Modernism: Genders and Marginalities in German Art*). She teaches critical theory and visual culture at the University of California, Davis.

Daniel J. Sherman teaches history and French studies at Rice University in Houston, having taught previously at Harvard and Catholic universities and at the University of Rochester. He is the author of *Worthy Monuments: Art Museums and the Politics of Culture in Nineteenth-Century France*

(1989). He is currently working on a book about monuments, mourning, and commemoration in France after World War I.

Brian Wallis teaches cultural criticism and art history at the City University of New York Graduate Center; he is also senior editor at *Art in America*. He has published widely on contemporary art and theory and is the editor of several books, including *Art After Modernism* (1984), *Blasted Allegories* (1986), and *Democracy: A Project by Group Material* (1990). He was formerly a curator at the New Museum of Contemporary Art in New York, where he organized numerous exhibitions, including a Hans Haacke retrospective.

Vera L. Zolberg teaches sociology in the graduate faculty of the New School for Social Research in New York City. Having served as chair of the Culture Section of the American Sociological Association (1989), she is president of the Research Committee on the Sociology of the Arts of the International Sociological Association. Besides her book, *Constructing a Sociology of the Arts* (1990), she has written extensively on the sociology of cultural institutions, art censorship, criticism, and cultural policy. Her current research focuses on the sociology of the avant-garde movements of the turn of the century in the context of a new, emergent international status community.

Index

Compiled by Eileen Quam and Theresa Wolner